Editor:
Marcia Pointon, *University of Manchester*

Reviews Editor:
Gill Perry, *The Open University*

Consultant Editor:
Simon Shaw-Miller

D0120842

Associate Editor:
Paul Binski, *University of Cambridge*

Editorial Assistant:
Sarah Sears

Editorial Board:
Tim Benton, *The Open University*
Craig Clunas, *University of Sussex*
Thomas Crow, *University of Sussex*
Jaś Elsner, *Courtauld Institute of Art*
Briony Fer, *University College, London*
Ian Jenkins, *British Museum*
Lynda Nead, *Birkbeck College, University of London*
Desmond Shawe-Taylor, *University of Nottingham*
John Styles, *Royal College of Art/Victoria and Albert Museum*
Gilane Tawadros, *Institute of International Visual Arts, London*

Anthea Callan, *Chair, Association of Art Historians*

International Advisory Board:
Svetlana Alpers, *Berkeley*; Hubert Damisch, *Paris*;
Klaus Herding, *Hamburg*; Lynn Hunt, *Philadelphia*;
Natalie Kampen, *New York*; Serafin Moralejo, *Harvard*;
John Onians, *Norwich*; Jessica Rawson, *Oxford*;
Sigrid Schade, *Bremen*; Pat Simons, *Ann Arbor*;
John White, *London*

Blackwell Publishers
Oxford, UK and Cambridge, USA

ART HISTORY

Journal of the Association of Art Historians

Volume 19 Number 1 March 1996

Art History is published quarterly in March, June, September and December for the **Association of Art Historians** by **Blackwell Publishers**, 108 Cowley Road, Oxford OX4 1JF or 238 Main Street, Cambridge, MA 02142, USA. Registered charity no. 282579

Information for Subscribers: New orders and sample copy requests should be addressed to the Journals Marketing Manager at the publisher's address above (or by email to JNLSAMPLES@BlackwellPublishers.CO.UK, quoting the name of the journal). Renewals, claims and all other correspondence relating to subscriptions should be addressed to the Journals Subscriptions Department, Marston Book Services, PO Box 270, Abingdon, Oxon, OX14 4YW. Cheques should be made payable to Blackwell Publishers Ltd. All subscriptions are supplied on a calendar year basis (January to December).

SUBSCRIPTION PRICES 1996	UK/EUR	NA*	ROW
Institutions	£93.00	US$169.00	£105.00
Individuals	£55.00	US$108.00	£ 67.00

*Canadian customers/residents please add 7% for GST

US mailing: Second-class postage paid at Rahway, New Jersey. Postmaster: send address corrections to Art History, c/o Mercury Airfreight International Ltd Inc., 2323 E-F Randolph Avenue, Avenel, NJ 07001, USA. (US Mailing Agent)

Advertising: For details please contact the Advertising Manager, Ludo Craddock, 15 Henry Road, Oxford OX2 0DG, England. (tel/fax 01865 722964)

Articles for consideration to: Marcia Pointon, Editor, *Art History*, Department of History of Art, University of Manchester, Manchester M13 9PL, England.

Books for review to: Gill Perry, Reviews Editor, *Art History*, The Open University, Walton Hall, Milton Keynes MK7 7AA, England.

Membership of the Association of Art Historians is open to individuals who are art or design historians by profession or avocation and to those otherwise directly concerned in the advancement of the study of the history of art and design. The annual subscription, due on 1 January each year, is £34.00 (UK), £39.00 (Europe, including the Republic of Ireland); £45.00 or $80.00 (USA and Rest of the World), and includes four issues of both the journal *Art History* and the *Bulletin*. Student rates (UK) are available on application. Applications should be sent to Kate Woodhead, Dog and Partridge House, Byley, Cheshire CW10 9NJ, England. (tel: 01606 835517)

Back Issues: Single issues from the current and previous three volumes are available from Marston Book Services at the current single issue price. Earlier issues may be obtained from Swets & Zeitlinger, Back Sets, Heereweg 347, PO Box 810, 2160 SZ Lisse, Holland.

Microform: The journal is available on microfilm (16 mm or 35 mm) or 105 mm microfiche from the Serials Acquisitions Department, University Microfilms Inc, 300 North Zeeb Road, Ann Arbor, MI 48106, USA.

Printed in Great Britain by Hobbs the Printers of Southampton.
This journal is printed on acid-free paper.

© Association of Art Historians 1996 ISBN 0631-20074-6 ISSN 0141-6790

Art History ISSN 0141-6790 Vol. 19 No. 1 March 1996 ISSN 0141-6790

CONTENTS

'Concerts of everyday living': Cage, Fluxus and Barthes, interdisciplinarity and inter-media events
Simon Shaw-Miller 1

Klinger's *Brahmsphantasie* and the Cultural Politics of Absolute Music
Thomas K. Nelson 26

Klimt's Beethoven Frieze: Goethe, *Tempelkunst* and the fulfilment of wishes
Clare A.P. Willsdon 44

Paul Klee's Anna Wenne and the Work of Art
Paul Bauschatz 74

Catalonia and the Early Musical Subjects of Braque and Picasso
Stewart Buettner 102

Review Articles

Re-Reading the Greek Revolution: *Art and Text in Ancient Greek Culture* edited by Simon Goldhill and Robin Osborne
Mary Beard 128

Conversation Piece: *The Making of Rubens* by Svetlana Alpers
Joanna Woodall 134

The Popularization of History: *The Popularization of Images: Visual Culture under the July Monarchy* edited by Petra ten-Doesschate Chu and Gabriel P. Weisberg
Susan L. Siegfried 141

Tracing Dreams back to History: *The Temptation of Saint Redon: Biography, Ideology and Style in the Noirs of Odilon Redon* by Stephen F. Eisenman; *Odilon Redon: 1840–1916* by Douglas W. Druick with Gloria Groom, Fred Leeman, Kevin Sharp, MaryAnne Stevens, Harriet K. Stratis and Peter Kort Zegers
Richard Thomson 144

Museum Fiction: *On the Museum's Ruins* by Douglas Crimp; *The Cultures of Collecting* edited by John Elsner and Roger Cardinal; *Exhibiting Cultures: The Poetics and Politics of Museum Display* edited by Ivan Karp and Steven D. Lavine; *Inventing the Louvre: Art, Politics and the Origins of the Modern Museum in Eighteenth-century Paris* by Andrew McClellan; *Art apart: art institutions and ideology across England and North America* edited by Marcia Pointon; *Museum/Culture: Histories Discourses Spectacles* edited by Daniel J. Sherman and Irit Rogoff
Jennifer Gordon 150

Shorter Reviews

Domestic and Divine: Roman Mosaics in the House of Dionysos by Christine Kondoleon
Jaś Elsner
156

The Role of Art in the Late Anglo-Saxon Church by Richard Gameson
Nora Courtney
157

The Expression of the Passions: The Origins and Influence of Charles Le Brun's Conférence sur l'expression générale et particulière by Jennifer Montagu
Humphrey Wine
158

Painters and Politics in the People's Republic of China, 1949–1979 by Julia F. Andrews
Craig Clunas
160

NOTES FOR CONTRIBUTORS

Art History provides an international forum for original research relating to all aspects of the historical and theoretical study of painting, sculpture, design and other areas of visual imagery. The journal is committed to the publication of innovative, synthetic work which extends understanding of the visual within a well-developed interdisciplinary framework and raises significant issues of interest to those working both within the history of art and in related fields.

(1) *Two copies* of manuscripts should be submitted; the overall word length should not normally exceed 9,000 words. They should be clearly typewritten, *double spaced* with generous margins. The title page of the script should indicate the author's name, institution, address and telephone number, together with accurate estimates of text and footnote wordlengths; subsequent pages should be numbered and should carry an identifying running head. The author should retain an up-to-date copy of the typescript. Photocopies of illustrations should be included with initial submissions and originals supplied only on the editor's request. Manuscripts submitted in languages other than English will be considered but may be subject to delay.

(2) English spelling conventions should be followed in the text (e.g. colour, centre); foreign-language citations should be given in translation in the main text, with the original appearing in full in an accompanying footnote. All quotations within the text should be enclosed within *single* inverted commas. More extensive citations should be indented without quotation marks. All new paragraphs should be clearly indicated by indentation.

(3) Footnotes should follow the text and be double spaced. References should be kept to a practical minimum and should avoid unnecessary digression or redundant displays of erudition. Bibliographical references should correspond to the following examples:

> M. Baxandall, *The Limewood Sculptors of Renaissance Germany*, New Haven and London, 1980, pp. 20–1.
> P.F. Brown, 'Painting and History in Renaissance Venice', *Art History*, vol. 7, no. 3, September 1984, pp. 263–95.

Titles in French should follow the capitalisation conventions adopted by the Bibliothèque nationale, Paris, as in the following example:

> J.-C. Chamboredon, 'Production symbolique et formes sociales. De la sociologie de l'art et de la littérature à la sociologie de la culture', *Revue française de sociologie*, vol. 27, no. 3, July–September 1986, pp. 505–30.

(4) Illustrations should be used discriminatingly and should be confined to objects whose discussion forms a substantive part of the text. Good quality black-and-white plates should be provided upon acceptance of an article for publication. These must be clearly labelled and numbered, with accompanying typewritten captions on a separate sheet. Where indicated, measurements should be given in metric form; any details for reproduction from a larger image should be clearly indicated. Illustrations should be referred to as 'plate' in the text. All copyright clearance is the author's responsibility and full acknowledgement of sources should be included where appropriate.

(5) Corrections to accepted scripts should be kept to a strict minimum at proof stage. In view of the costs involved, the editor reserves the right to refuse any extensive alterations to authors' texts in proof. Prompt return of corrected proofs to the editor is essential.

(6) Manuscripts will not be returned to contributors.

LIBRARIES AND THE REPRODUCED IMAGE
FROM PRINT TO DIGITISATION
University of Edinburgh, 4 - 7 July 1996

The 1996 ARLIS/UK & Ireland conference takes as its topic
the reproduced image, past, present and future, in a library
context. It sets the scene - Scottish art of this century,
architecture in Edinburgh and the work of various Scottish
artists and illustrators - and then turns to the electronic image
in computer and CD-ROM environments from multi-media to
the Internet.

Papers on specific themes such as botanical illustration and
children's books will be followed by a visit to St. Andrews to
explore the University Library's renowned historical photography
collections and look at current exhibitions. On its final day the
conference raises further professional issues, of authenticity in
reproduction, the subject indexing and cataloguing of images, and
the problems of copyright in image reproduction.

The conference programme includes many other highlights: a
private view of the Giacometti exhibition at the Scottish National
Gallery of Modern Art and a walking tour of the New Town, as
well as visits to scenes of visual arts activity in Edinburgh.

For booking details, please contact one of the following:

Stephen Holland
National Library of Scotland
George IV Bridge
Edinburgh EH1 1EW
Tel: 0131 226 4531
Fax: 0131 220 6662
Email:
 s.holland@nls.uk

Sonia French
ARLIS Administrator
18 College Road
Bromsgrove, Worcs.
B60 2NE
Tel/fax: 01527 579298
Email:
 sfrench@arlis.demon.co.uk

Art History ISSN 0141-6790 Vol. 19 No. 1 March 1996 pp. 1–25

'Concerts of everyday living': Cage, Fluxus and Barthes, interdisciplinarity and inter-media events

Simon Shaw-Miller

Art history is and has always been, by nature, interdisciplinary.[1] This issue of *Art History* is concerned with a particular complex of these interdisciplinary relations: the movement between musical and verbal ideas and the visual. The title of this issue is taken from the collection of essays by Roland Barthes selected and translated by Stephen Heath, and first published as *Image-Music-Text* in 1977. One of the central conceptual strands of Heath's selection is the 'constant movement from work to text', when 'text' is taken to mean a methodological field and 'work' a 'fragment of substance', or perhaps an object. In the essay of this title ('From Work to Text')[2] Barthes begins by a discussion of the changing nature of the object of study:

> What is new and which affects the idea of the work comes not necessarily from the internal recasting of each of these disciplines [amongst others, linguistics, anthropology, psychoanalysis — we might add art history], but rather from their encounter in relation to an object which traditionally is the province of none of them. It is indeed as though the *interdisciplinarity* which is today held up as a prime value in research cannot be accomplished by the simple confrontation of specialist branches of knowledge. Interdisciplinarity is not the calm of an easy security; it begins *effectively* ... when the solidarity of the old disciplines break down ... in the interests of a new object and a new language ...[3]

This new object is, for Barthes, the *Text*. This article, too, is concerned with interdisciplinarity; with the hyphens, if you will, in Image-Music-Text. But I want to consider this set of ideas historically, through a particular case study, providing an introduction and context for the work, or more accurately texts, of a notoriously definition-defying group of artists: those who centred around the Lithuanian George Maciunas (1931–1978), the 'movement' known as *Fluxus*. The use of such a title itself signals the ambiguous and deliberately elusive nature of the activities and ideas of this group — one reason, no doubt, for their relative neglect by art historians. The concept 'flux' is not to be understood just as a noun, but also as a verb and as an adjective, and, as part of the dictionary definition has it, 'a continuing succession of changes'.[4] Their work raises fundamental issues about the nature of the art object and the boundaries of academic study, ranging

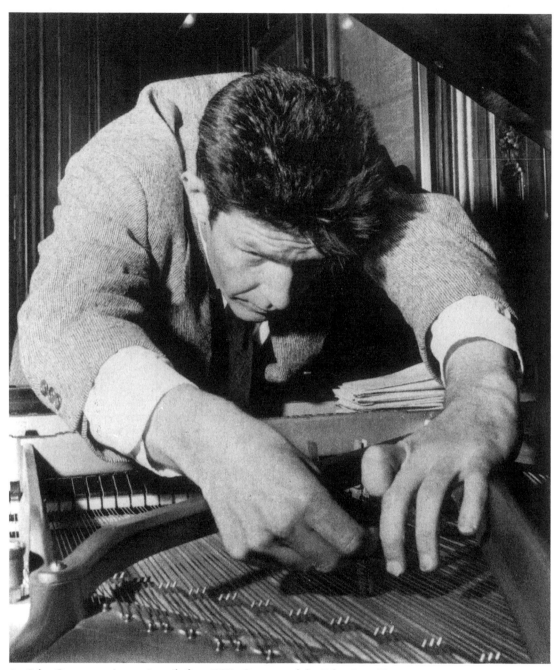

1 John Cage preparing a piano (before 1950). Courtesy of the John Cage Trust

as it does between the temporal and spatial arts. However, as Kristine Stiles has argued, the ontology of Fluxus is essentially performative.[5] Within the Fluxus aesthetic, the performance, or the concert occasion, is to be viewed as a complex *field* of activities — visual, textual and sonorous — one which, among other things, understands the concept of music as a *discourse*, opening it to evaluation on a number of levels, not the least of which is the visual, in both performative and textual terms.

Music is to be understood as a concept under which Fluxus presented many, if not most, of their ideas within this ontology. It is performative in the sense identified by Michael Kirby.[6] Music is not a theatrical performance in the common sense, for in performance musicians are not playing someone else as an actor might, but rather they 'play' themselves. So too do Fluxus artists perform or play as themselves, and hence what they perform is 'music'. It is only by being aware of the slips and slides between media that the work of Fluxus comes to signify; 'One key assumption of Fluxus works is that there are close analogies among things.'[7]

To understand this 'movement' effectively, we therefore need to develop the concept of 'inter-media'. This is to take up a methodological framework first suggested by Dick Higgins, who was a member of, and theorist for, Fluxus.[8] Inter-media can be defined as the conceptual ground *between* media or traditional art disciplines; an examination of the conditions under which epistemological distinctions function. Andreas Huyssen has suggested that T.W. Adorno's concept of *Verfransung* is close to this notion of inter-media, but carries with it a greater sense of dissolution and aesthetic entropy; it suggests not a unity of the arts but, rather, differentiation.[9] This entropy has today become part of the postmodern condition, where hybrid forms of art and culture often manifest themselves in technologically complex ways antithetical to the Fluxus 'low-tech' aesthetic. Nevertheless, even if Fluxus was an historical moment now past, the adoption of an *inter-disciplinary* approach, in the same sense as inter-media (or *Verfransung*), is an essential academic tool, especially in a postmodern context. It allows us to see (and hear) beyond the boundaries set up by the academy.[10] It offers a methodology which is willing to consider the fields which operate between and through disciplines, not in terms of a supposed unity (of the arts) but in terms of an analogical and/or dialectical relationship. This might bring to mind the concept of the *Gesamtkunstwerk*, but it is important that we understand the fundamental difference between this idea in its Fluxus, as opposed to its Wagnerian, manifestation. Whereas the nineteenth-century aim was an integration or merging of the arts, Fluxus was concerned with the ground between media, that which they already have in common, the locus of flux. It is, therefore, a less totalizing impulse; a micro not macro view.

I shall begin by placing the developments towards this position in context by looking at the way in which the definition of what is to be taken as 'music' expanded from Schoenberg, through Russolo, to Cage and beyond in Fluxus. As the 'object' of music was re-defined, so the visual emerges for consideration. Music's silent partner has always been the visual; what emerges in Fluxus is the symbiosis of this coexistence. Fluxus shows that 'interdisciplinarity is not the calm of an easy security; it begins *effectively* ... when the solidarity of the old disciplines breaks down ... in the interests of a new object and a new language.'[11]

The Sound of Silence: 4'33"

On 29 August 1952 at the Maverick Concert Hall in Woodstock, New York, David Tudor the avant-garde pianist came on stage to perform a new work by John Cage, the avant-garde composer (plate 1). Nothing happened. To be precise, nothing happened for four minutes and thirty-three seconds. To be even more precise, no sound was made by the performer for the duration of the three-movement work entitled 4'33", the time frame being arrived at aleatorically by the composer.[12]

But let us *look* more closely at this work (and I choose my words carefully). Conceived within the conventions of western art music, Cage's piece seems to deny the very *raison d'être* of music itself: sound. Or does it? On one level, as is relatively well known, there is no absolute silence. Even in an anechoic chamber,[13] as Cage discovered, one is assailed by the sounds of one's own body: the high-pitched impulses of the nervous system and the low-pitched drone of the circulation of the blood. Outside such a device we are even more constantly bombarded by the sounds of civilization and/or nature. Generally regarded as interruptions to music, Cage interrupted his 'music' to let such sound through. But how was this 'silence' achieved?

Tudor came on stage, sat at the piano, made as if to play, but instead, simply raised and lowered the keyboard cover at the beginning of each of the three movements. This was his interpretation of the composer's score, in which each of the three movements is simply marked *tacet*. It is interesting to note that the score therefore consisted of a written, textual instruction, an archetypal example of the 'methodological field' (*text*) that Barthes discusses. It is an instruction employing a conventional Italian musical expression, thus attaching it firmly to music custom, its avant-garde impact the greater for this. In contrast, the language used in Fluxus textual scores, which will be discussed later, was eminently straightforward. For the rest of the piece, after this action of opening and closing the keyboard cover, Tudor remained motionless and silent. A linguistic instruction thus produced not sound but simply a visual transformation, a performance action. This 'silence', however, was constituted by the sounds outside the frame of the musical score: in this instance, at Woodstock, the wind and rain outside the concert hall and the bewildered mutterings of the audience within it. It was, nevertheless, the piece itself which acted as a prism, which refracted these noises as sound, as music from the outside, the culmination of Cage's quest for the art of the non-intentioned.

Given this centralization on the visual elements of the performance of 4'33", it is significant that the origins of the work also have their roots in the visual field: the all-white paintings produced by Cage's friend Robert Rauschenberg in 1949. As Cage himself notes,[14] these paintings are no more empty or blank than his own piece was silent, for they act as environmental surfaces, on which motes of ambient dust or shadows may settle; they are a *field* of focus for the spaces they occupy. The frame acts for the painting as the 'concert occasion' acts for the 'music', as a point of elision between art and non-art, between text and context. These paintings gave him, as he said, 'permission' to compose a silent work.[15]

I wish to highlight two further consequences of the performance of 4'33".

Firstly, the audience was enabled to recognize their role in producing this noise and the potential for hearing such sounds as music: they were the music. Secondly, in being given nothing to listen to from the performer, they were made even more aware of the spectacle, the 'theatre' or visual nature of musical performance itself. In short, as the audience shifted to focus on something that was not there (the conventional sound of music), they watched something that was (the performer and his limited actions, the ritual of performance, the concert hall itself, the object of the piano, each other etc.), and then (but I do not wish to imply a sequence) recognized themselves as the producers of the 'cultural' sound. Sight (and site) and sound and performance and audience are thus shown as inextricably linked and interdependent.

Cage: from tone to noise

To make sense of this radical departure into the realm of music equalling all sound and the act of performing as a theatrical event, we need briefly to review the history of modernist music-making that fed into Cage's aesthetic. In many ways Richard Wagner (1813–1883) was the foil for most early twentieth-century music. In purely formal terms, it was commonly seen that he had pushed diatonic composition to an extreme, to the point where tonality, as the underlying structural principle, began to dissolve. More prosaically, he was also responsible for creating, or developing, many of the production aspects of musical spectacle. As Dent writes in his book *Opera*, 'We owe it to Wagner that the auditorium is darkened as a matter of course during a performance, that the doors are shut and latecomers made to wait outside ... that a soft prelude is heard in silence, and that applause [is] reserved for the end of an act', and later in the same book 'It is entirely to Wagner's initiative that we owe the modern developments of stage machinery.'[16] He has also been credited with being the founder of that most theatrical aspect of orchestral performance: the star conductor. So, in dramatic musical terms, as well as the more formal development of music, Wagner's influence was an inevitable point of debate for those who followed him.[17]

As Adorno, among others, saw it, there were, at this point, two main avenues down which music could technically progress.[18] One was retrogressive and culminated in a form of neo-classicism. The paradigm of this trend was, for Adorno, Igor Stravinsky (1882–1971). Alternatively, one could follow the logic of this Wagnerian impulse into the untrodden field of atonality. Arnold Schoenberg (1874–1951), as the hero of this 'atonal' revolution who consciously took on the mantle of Wagnerian musical language, argued that dissonance was relative and a correlative of consonance, rather than a peripheral element of musical language, or, more crudely, harmony's opposite. The distinction was only a matter of degree, not of kind: 'They are no more opposite than two and ten are opposite, as the frequency of numbers indeed show: and the expressions "consonance" and "dissonance", which signify an antithesis, are false.' He went on, 'It all simply depends on the growing ability of the analyzing ear to familiarize itself with the remote overtones, thereby expanding the conception of what is euphonious, suitable for art, so that it embraces the whole natural phenomenon.' Concluding

this theme in his book *Theory of Harmony* he states, 'What today is remote can tomorrow be close at hand; it is all a matter of whether one can get closer. And the evolution of music has followed this course: it has drawn into the stock of artistic resources more and more of the harmonic possibilities inherent in the tone.'[19]

Through the abolition of a strict tonal centre, Schoenberg slowly felt his way to the formation of the twelve-note or serial technique in 1923, with the fifth of the *Five Pieces for Piano*. Such an approach to composition (founded on the chromatic rather than diatonic scale) did not recognize tonal chord relations, or, in as much as it did, subsumed them within a meta-musical language which offered an alternative conceptual framework. Notions of what constituted euphony were thus expanded; all tones became equal and available to the composer.

With his subsequent emigration to the United States in 1933, Schoenberg took up the post of Professor of Music at the University of California at Los Angeles. Teaching a wide variety of students, he took on the young John Cage as a private student between 1935 and 1937, on condition that Cage dedicate himself to music. Cage's student works during this time show an interesting disregard for serial (twelve-note) orthodoxy, demonstrating rather, in works like his first published piano piece *Two Pieces for Piano* (1935), an interest in *ostinato* (repetition) and serial fragments.[20] His percussion works, *Quartet* of the same year and *Trio* of 1936, are similarly idiosyncratic in their concentration on rhythmic motifs.[21] With this focus on rhythm and renunciation of harmony, together with the use of repetition, Cage's early compositions surrender Schoenberg's *raison d'être*, the tone, in preference to unpitched sounds. By so moving away from Schoenberg's concerns, Cage, in his use of repetition and un-pitched sound, laid the foundations for much avant-garde art that was to follow. In 1937, soon after the composition of his first percussion pieces, he wrote a lecture 'The Future of Music: Credo', which, significantly, opens with the following declaration:

> ... Wherever we are, what we hear is mostly noise. When we ignore it, it disturbs us. When we listen to it, we find it fascinating. The sound of a truck at fifty miles per hour. Static between radio stations. Rain. We want to capture and control these sounds, to use them not as sound effects but as musical instruments.[22]

This declaration expands on his teacher's notion of euphony in music, but here it is not just a matter of all available tones, rather it is all available sounds: noise.

The impulse behind this move came from a fundamental questioning of the resources of music. The range of accepted sounds within the convention of western art music, even given Schoenberg's expansion of euphony, had remained confined within a relatively small compass. Until the development of electronic sound generators, the categories of woodwind, brass, strings and percussion had undergone little development. The issue was rather one of how to organize this finite set of sounds. Why this set of sounds should be privileged to the exclusion of all others was of little or no concern. However, Cage's development away from this convention was anticipated, perhaps not surprisingly, by a figure outside the

mainstream of art music; not a schooled musician, but rather an artist, the Italian Futurist Luigi Russolo (1885–1947), who said of himself, 'I am not a musician, I have therefore no acoustical predilections, nor any works to defend.' With the publication of his manifesto *The Art of Noises* in 1913, he set up an agenda that has echoes in Cage's own *Credo*.[23] He argued that music had grown apart from the world around the musician; it stood distinct and independent of life: 'a fantastic world superimposed on the real one'. Music thus held apart from the world addressed itself instead to 'purity, limpidity and sweetness of sound'. But the ear is not satisfied with such 'gentle harmonies', Russolo argues; our ears (and here he brings to mind Schoenberg's statements in his *Theory of Harmony*) become accustomed to the familiar and seek out new 'acoustic emotions'. 'Modern music ... struggl[es] in vain to create new ranges of tone.' He proposes instead that 'This limited circle of pure sounds must be broken, and the infinite variety of "noise-sound" conquered.' He suggests, as Cage might, that 'We find far more enjoyment in the combination of the noises of trams, backfiring motors, carriages and bawling crowds than in rehearsing, for example, the "Eroica" or the "Pastoral".'[24] This rejection of past music required the invention of new instrumental resources, the *intonarumori*, noise-intoning machines he built to play his 'noise' music. However, through such devices, and the music he wrote for them, he developed an aesthetic which worked in parallel to the sound/noise world around him. Russolo wished to avoid imitation, he hoped rather that the musicians' sensibilities would become attuned and develop a form of composition liberated from convention. Nevertheless, he maintained in this way the separateness from the 'outside' world for which he had chastised orthodox musicians in his writings.[25]

It is only with Cage that this project is taken to its logical conclusion: that any sound can be used as music. Importantly, there need not even be any intention to compose music for there to *be* music. What *4′33″* shows is simply the willingness or opportunity to attune our hearing to all aural phenomena. In other words, music no longer requires an author, performer or intentional organization, just someone willing to listen.[26] Consequently, the project set up by Cage's teacher Schoenberg to conflate the concepts of consonance and dissonance was expanded by Cage to the dissolution of a distinction between dissonance and noise. He concluded that it was meaningless to think of a border between sound and musical sound, for all sound had become musical sound.

Despite his theoretical assertion 'Let sounds be themselves', Cage's practice pursued a strategy of what we might call 'musicalization'. I mean by this that he adopted a formalist (or Modernist, in a Greenbergian sense)[27] conception of autonomy where the associative aspects of sound were placed to one side, if not disregarded altogether; 'music' becomes a concept into which *all* sound is placed. To put it another way, there is no sound outside music. His work *Variations IV* (in the *Variation* series) serves to illustrate this. Here the original context of the pre-recorded sounds is destroyed so that they can be heard in a 'purposeless' way; just as sound. Thus, the intention is to produce a collage of sounds that stand apart from their normal context. *Variations IV* utilizes a melange of sound sources: amongst others, excerpts from Beethoven's symphonies numbers 3, 5, 6 and 9, Schumann's *Carnaval*, language records, street noises, radio broadcasts, audience noises, Bach's *D Minor Toccata* for organ, and many more. It is not a

fixed musical object in the sense of its internal relations being constant, except with the record of the work[28] (which Cage has referred to as a variation on *Variations IV*);[29] the combinations of elements will be different with each realization. As the name suggests, this work is variable. It is, therefore, not so much an object as an 'occasion for experience'.[30] The meaning of, for example, the formal relations of tonal and rhythmic elements in a Beethoven symphony have been stripped of their original function and purpose, becoming purposeless, therefore, in this limited sense, yet fulfilling Cage's musical purpose.

In its utilization of such a wide range of sound sources this 'minestrone masterpiece of modern music'[31] creates an 'information overload' and can be related to Cage's friend Marshall McLuhan's vision of the world as a global village, but one that does not have the effect of 'homogenizing the village quarters'.[32] Rather, the effect is of pluralism. This is in marked contrast to the Fluxus concern with the singular. But within Cage's aesthetic there is a tension between the 'sound in itself', cut off from its original context, and the listening subject. For this Zen notion of the role of the artist, to alert his or her audience to the beauties of everyday life (art must not therefore be separate from life), places 'meaninglessness' and the accidental as central, for the unwilled creative process best 'imitates nature in her manner of operation.' However, this musicalization of 'life' does not take into account the more prosaic fact that no sounds heard by human beings are ever heard outside society and culture. Experience, memory and the endemic are ignored in the emphasis on 'absolute' sound.[33]

Like other Modernists (in Greenberg's sense), what Cage proclaimed, perhaps ironically, was the importance of the aesthetic in a century where culture was (is) becoming increasingly socially and politically mediated. As Huyssens has written, this impulse in the classic Modernism of Adorno and Greenberg, at both the time of Hitler's rise to power and then the rise of Stalin and the Cold War and the development of commercial mass culture in the West, was an attempt to 'save the dignity and autonomy of the art work' from the pressures of political control and/or the control of the market.[34] However, I would suggest that engagement with the aesthetic in this context need not be viewed as a passive activity, one which is merely 'disinterested' in a Modernist sense. On the contrary, the act of engagement can be self-reflexive. One becomes (within a postmodern sensibility) as much aware of the process of looking/listening as one is of the thing looked at or listened to. In other words, one is not just taken out of 'context' by aesthetic engagement or contemplation, but through awareness of the *act* of engagement, reintroduced to the contexts of engagement when the work is understood as a text. In Barthes's terms this process occurs because the text 'asks of the reader [viewer/listener] a practical collaboration.'[35]

This act of 'practical collaboration' will be discussed in more detail when we come to the idea of audience in the work of Fluxus. We can view Cage as sitting on the border of this 'great divide' — between the modern and the postmodern, between absolutism and pluralism. What Cage did was to bring extra-musical sounds (noise) into the fold of music; to make music *represent* more. But for music to be *music* it has to divest sound of association, so that it *represents* the intentions of the composer as culture, not nature.[36] If it does not do this, it is just noise; it *is*. Too close an association with the world will return sound/noise to the

extra-musical. This strategy is precisely what theories of postmodernism attack; the separation of the aesthetic from the socio-political world of actual listening or looking subjects. It is this difficulty, that representation is diametrically opposed to 'sounds in themselves', that Cage never resolved but which his work conjures. Even given the problems raised by Cage's ideas in practice, his aesthetic posed major difficulties for those who aspired to be 'post-Cage'. For in an anarchistic environment where *all* sound was available to the musician, when the sonic universe was set free, where do you go next?

As I suggested earlier, Fluxus had a micro view of artistic practice. The group was not concerned with epic projects, but with a rigorous reconsideration of music's sonic materials. They were not so much sonic pluralists, as Cage was, as sonic purists. George Brecht coined the term 'event' to describe the smallest unit of a 'situation'. It is the event that defines the parameters of a Fluxus musical act. However, they did consider the broader frame in which music signifies, through the exploration of the territory of musical practice and performance itself. This also involved the investigation of the *objects* of music-making. It is not always clear where one of these strategies ends and another begins, but if the diverse activities that make up Fluxus can be characterized, then just such an 'aesthetics of negation' comes close. For music, this meant the exploration of the borders of the concept of music and the spaces between it and the other arts; in short, what can and cannot be considered an act of music.

The borderline of sound

One of the starting points for the exploration of the sonic nature of music was the focus on what George Brecht, a prime mover in Fluxus circles, called 'incidental' music. This should not be confused with Cage's interest in aleatoric procedures, for in incidental music sound is produced as the *by-product* of action. This differs from conventional performance, where sound is the result of purposeful (musical) action, and from performances of Cage's work, where sound can be the result of accidental action. An example is Brecht's *Incidental Music* of 1961. Written for piano, it consists of five pieces, 'any number playable successively or simultaneously, in any order and combination, with one another and with other pieces'. No. 4 is scored thus:

> *Three dried peas or beans are dropped, one after another, onto the keyboard. Each such seed remaining on the keyboard is attached to the keys nearest it with a single piece of pressure-sensitive tape.*

Such a prosaic textual description in the role of a score is typical of Fluxus notations. It describes a series of actions, it does not describe the music in a conventional sense. The 'music' that results from these actions is ancillary to the score. It takes a large number of words to describe even a simple conventional musical perimeter; the scores used by Fluxus artists almost always provide instructions for setting up a situation in which the consequent actions are to be *seen* as music: 'The score is the agent that engages the reader-performer in the

theater of the act.'[37] However, many such text scores (or event scores as they are also known) are performable in the mind, as a thought, they do not *a priori* require physical performance. The active creation of the event by the performer/reader can be private or public and in their challenge to authorial power they meet Duchamp's claim that the creative act 'is not performed by the artist alone; the spectator brings the work in contact with the external world'[38] In this sense the scores are also *incidental*. In describing how he performed this piece, Brecht provides a definition of the notion of incidence:

> What you're trying to do is to attach the beans to the keys with nothing else in mind — or that is the way I perform it. So that any sound is incidental. It's neither intentional nor unintentional. It has absolutely nothing to do with the thing whether you play an A or C, or a C and a C sharp while you're attaching the beans. The important thing is that you are attaching the beans to the keys with the tape.[39]

This concept of incidence finds an important place in the work of La Monte Young, another member of Fluxus. In his *Piano Piece for David Tudor No. 2* (1960) he can be seen as making a comment on Cage's *4'33"*. The instructions require Tudor to concern himself with silence — by performing the same action as was used in the Cage piece to designate the 'end' of the three movements — raising and lowering the keyboard cover, but here specifically without audible sound. In suppressing sound the text score promotes the visual:

> *Open the keyboard cover without making, from the operation, any sound that is audible to you. Try as many times as you like. The piece is over when you succeed or when you decide to stop trying. It is not necessary to explain to the audience. Simply do what you do and, when the piece is over, indicate it in the customary way.*

The piece is therefore a series of visual, if not aural actions, concluded by the conventional 'theatrical' signifier of closure, the bow. From the audience's point of view this piece could well sound the same, whether or not the performer 'succeeds', as what is heard by the performer may, in any case, be inaudible to the audience, although this does not mean silence. It does, nevertheless, require focus and a level of skill and concentration from performer, and attentiveness from the audience, but these attributes are not, here, associated with notions of skill and attentiveness as in conventional music; moving the piano cover silently is a skill, albeit a different one from that associated with the dexterity required in performing a Chopin *étude*. This action focused on 'silence' is taken to another level by Young's infamous 'Butterfly piece' (*Composition No. 5*, 1960). The sound in this work is performed by the butterflies themselves, and draws attention to the fact that although in the *Piece for David Tudor No. 2* the sound might only be audible to the performer and not the audience, here no human present — neither the 'performer' who releases the butterflies, nor the audience — can hear the sound of the non-human 'instrument'. But the overwhelming effect is again visual. An insect recognized as being of great beauty, often understood as a symbol of

10

transformation in art, is here the instrument itself; its flight acts as a visual metaphor for the absent, or inaudible sound:

> *Turn a butterfly (or any number of butterflies) loose in the performance area.*
>
> *When the composition is over, be sure to allow the butterfly to fly away outside.*
>
> *The composition may be any length but if an unlimited amount of time is available, the doors and windows may be opened before the butterfly is turned loose and the composition may be considered finished when the butterfly flies away.*

Writing of this piece Young raises the issue of audibility as a prerequisite for music:

I felt certain the butterfly made sounds, not only with the motion of its wings but also with the functioning of its body ... and unless one was going to dictate how loud or soft the sounds had to be before they could be allowed into the realm of music ... the butterfly piece was music[40]

The problems of boundaries raised by this work are not just those of the nature of sound in music, nor the borderline of sight and sound, but also of the demarcation between culture and nature. Is the human ear, or perhaps more importantly, the limits of amplification technology, to define music? Can a music exist outside our species in nature (whale or bird song)? Such an approach, whilst questioning boundaries, also lays itself open to claims of anthropomorphism, for music *is* a human construct, *not* a natural phenomenon. But if music is just sound, then sounds are just as much a part of nature as of culture, as Cage argued. Consider this statement on a 'performance' of his *4'33"*:

I have spent many pleasant hours in the woods conducting performances of my silent piece, transcription, that is, for an audience of myself, since they were much longer than the popular length which I have had published. At one performance, I passed the first movement by attempting the identification of a mushroom which remained successfully unidentified. The second movement was extremely dramatic, beginning with the sounds of a buck and a doe leaping up to within ten feet of my rocky podium. The expressivity of this movement was not only dramatic but unusually sad from my point of view, for the animals were frightened simply because I was a human being. However, they left hesitatingly and fittingly within the structure of the work. The third movement was a return to the theme of the first, but with all those profound, so-well-known alterations of world feeling associated by German tradition with the A-B-A.[41]

The use of nature in such works draws attention to the ways in which culture

always frames nature;[42] natural sounds are placed between bar-lines. There is no unmediated encounter with nature; it is the human agent (the audience, Cage himself) who perceives such a context as music. This returns us to Duchamp's statement that no work of art is finished until completed by the spectator.[43] In an interview conducted in 1967–8 Richard Kostelanetz addressed to Cage the following question: 'If you say that music is random sound experience, then why do you compose music?'[44] His answer, begged by the above account, was in two parts. Firstly, he stated that it was problematic to ask the question 'why?' for to do so is to disconnect yourself from your environment, rather than to identify with it. It supposes a value judgement, a focus on one thing at the expense of another, and this is, of course, antithetical to his avowed intent to be 'unwilled'. His second, more prosaic answer, was simply, as we will recall, that he had promised Schoenberg that he would devote himself to music. Later in the same interview, he says that given his time over again, he would not choose to be a musician (perhaps instead a mycologist). However, he would not want to get rid of art but rather to aspire to identify it with life. The role of the artist is then simply to be a listener.[45]

To return to La Monte Young and his 'Butterfly piece', there is, apart from the issue of audibility, the associated issue of temporally fixing a sound so that it can exist long enough to be heard in the first place. For a sound to be contemplated it has to be arrested. Here two other important elements of the Fluxus aesthetic emerge: suspension and repetition. The former can be seen in Young's *Composition 1960 No. 7*:

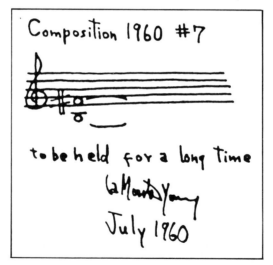

The scoring follows conventional western notation. A specific pitch relationship is designated, a perfect 5th. The image of the score has its visual impact and surprise through this extremely reduced and rudimentary statement. This notation system is precise in terms of pitch (within a range of twelve semi-tones per octave) but much less precise in terms of the disposition of pitches in time. The use of the treble clef gives the pitches a precise reference point (G), but as there is no tempo or metronome marking, the time element is arbitrary. The two semibreves and the open tie suggest a long duration but in themselves are

completely dependent on tempo. Young has added a brief written statement, although this again is also contingent. Both forms of instruction, therefore, contain an element of ambiguity which places the interpretive onus on the performer. But this work also lays stress on the act of listening as well as performing. The aural effect is not, as we might expect, a simple sound. Here a simple action produces a complex sound. For as the sustained sound interacts with environmental space the focus on the temporal nature of music is offset and replaced by the occupation of space — a transgression from the borders of the aural to the borders of the visual. In addition, a sound of certain volume can become almost palpable and corporeal when our body is vibrated by its air pressure waves. The physical nature of this environment (the site) can have a profound effect on reception of the sound. This issue is, of course, central to the science of acoustics. J.S. Bach (1685–1750), for example, in composing certain of his organ works for specific instruments in particular locations, was well aware of the acoustic and its effect on the reception of his music. His use of silences and articulation show cognizance of the effects of specific spaces/sites on his audience. Composing for instruments that were part of the interior of churches requires, from the sensitive composer, an awareness of such spatial characteristics, in order for the musical detail not to be lost in a reverberating acoustic. Therefore, space has often been part of the aesthetic parameters composers have had to take into account.[46] This spatial element in music is accentuated by our ability to focus attention. Shifts of concentration will transform the experience of the sound from one moment to the next. This is exaggerated in the case of monotonous sounds: the sound is suspended, but the context is constantly moving. Further, movement in space will change our perception of the character of the sound. This is perhaps more easily imagined in relation to repetition.

(Arabic Numeral — any integer) or *X for Henry Flint* (1960), one of Young's best-known works, requires the performer to play an unspecified sound, or group of sounds, in a regular one- or two-second pulse for as long as the performer wishes — Young's own performance consisted of around 600 beats on a frying pan. This monosonic approach is antithetical to Cage's more polysonic method, although the results may be similar in the emphasis they create on processes of listening. As Cage says,

> [Young] is able, either through the repetition of a single sound or through the continued performance of a single sound for a period like twenty minutes, to bring about that after, say five minutes, I discover that what I have all along been thinking was the same thing is not the same thing at all, but full of variety. I find his work remarkable almost in the same sense that *the change in experience of seeing* is when you look through a microscope. You see that there is something other than what you thought was there.[47] (author's italics)

As Cage had shown that 'silence' was in fact constituted by sounds on which there is normally no focus, so Young uncovers the variety that exists a priori in any act of listening, even in the case of the seemingly monotonous. As Barthes has written, 'Hearing is a physiological phenomenon; listening is a psychological act.'[48] This

moves us from the acoustic fact to the subject's interpretation, from the sound to the audience.

Outside the work of Fluxus it is those composers associated with so-called minimal or systems music who have been most concerned with repetition. Young himself is sometimes included in this group, along with Terry Riley (b. 1935) and the now better-known composers Philip Glass (b. 1937) and Steve Reich (b. 1936). Glass has written of his own work *Music in Changing Parts* (1970) in ways echoing Barthes: 'Psychoacoustictical phenomena are part of the content of the music — overtones, undertones, different tones. These are things you hear — there is no doubt that you are hearing them — even though they may not actually be played.'[49] One of the best-known performances of Young's *X for Henry Flint* is that performed by Brian Eno (formerly of the rock group Roxy Music) in *c.* 1967. In this instance Eno played the piece by bringing his forearms down on large clusters of notes, trying to strike the same cluster of notes each time, for the period of an hour (approx. 3,600 times). He later explained:

> Now, until one becomes accustomed to this fifty-odd note cluster, the resultant sound was fairly boring. But after that first ten minutes, it became progressively more absorbing. This was reflected in the rate at which the people left the room — those who didn't leave within ten minutes stayed for the whole performance. One began to notice the most minute variations from one crash to the next. The subtraction of one note by the right elbow missing its top key was immediately and dramatically obvious. The slight variations of timing became major compositional changes, and the constant changes within the odd beat frequencies being formed by all the discords began to develop into melodic lines. This was, for me, a new use of the error principle and led me to codify a little law that has since informed much of my work — 'Repetition is a form of change.'[50]

Eno employed an analogy based on his experience of such music — in fact based on the experience of hearing Reich's *It's Gonna Rain*, where that phrase is repeated over and over again on several tape players set at different speeds so the loops gradually shift in and out of phase. The analogy comes from an essay by Warren McCulloch, 'What the Frog's Eye Tells the Frog's Brain': in Eno's words,

> ... a frog's eyes don't work like ours ... a frog fixes its eyes on a scene and leaves them there. It stops seeing all the static parts of the environment, which become invisible, but as soon as one element moves [usually its next potential meal!] ... it is in very high contrast to the rest of the environment ... I realised that what happens with the Reich piece is that our ears behave like a frog's eyes ... The creative operation is listening.[51]

It is significant that the analogy is one based on sight,[52] for it draws attention to the role of reception, a perceptual field which compels the audience/viewer to confront and perhaps revise the borders between the physiological and psychological.

14

An important point here, therefore, is that although works such as these may be formally simple, such notions of repetition or suspension demonstrate that because of the influence of external factors (both physical and psychological, in the environment and in the listener), the effect, the sonic experience, is neither repetitious nor singular. Further, such a fixated concern fails to possess its subject, as the variety in music so-produced means that music still evades capture. From the mid-1960s Young was to develop and extend his concerns with suspension in his ensemble the Theatre of Eternal Music, which consisted of, in various permutations, Young and his wife Marian Zazeela (a painter and light artist), Angus McLise, Tony Conrad (a producer of 'minimal' films), John Cale and Terry Riley, and for much of this time he was developing his ideas within the framework of *The Tortoise, His Dreams and Journeys*. The title signals the metaphor (again based in nature) for a slowly evolving piece with, theoretically, neither beginning nor end; the work would ideally comprise sections performed every day, lasting a lifetime.

Zazeela's light environment *The Ornamental Lightyears Tracery* was an integral part of the Theatre of Eternal Music performances. She worked with the projection of colour to produce sites of sympathy for the performance of the music.[53] Part of this project was Young's *Drift Studies* (1966). Here he is concerned with that most elementary of sonic phenomena, the sine wave: possessing only one frequency component, all other sound wave forms are multiple.[54] This work makes explicit the role of an active audience, but in this case not just in the processes of listening but in physical activity as well. When a continuous frequency is generated in an enclosed environment, it causes the air to divide into high- and low-pressure zones, the sound being louder in the high-pressure zones, softer in the low-pressure areas; the space (the room) becomes the musical instrument. Because of the simple composition of the sine wave, the pattern of high- and low-pressure areas become easy for an audience to locate as they move through the space, inside the instrument, so to speak. Therefore, a passive listener, one unwilling to engage by moving through the space, will experience only a single monotonous sound, but the active listener creates their own piece by their physical motion. Variety is generated out of what is formally the most fundamental of sounds. The sculptural, three-dimensional aspect of music therefore becomes significant. One is allowed, in such spatially conceived music, to chart one's own course around and through the music in one's own time, much as one looks at a static work of visual art, which can be similarly affected by environmental context. This work makes explicit the spatial character of music. We have moved from music as temporally distinct from the visual arts, to a conception which addresses the spatial links or common ground between music and visual phenomena, and hence to a concern with the 'objectness' of music.

Musical practice, performance and objects

Fluxus research did not just concern itself with the reconsideration of the sonic materials of music and how there might be mutual ground in the perception of

music and visual phenomena. As the works by Young discussed above begin to suggest, the context of sound, in a wider sense, became just as much a focus as the sound itself. For music is not just sounds, it is also performances (realizations), objects and bodies, technologies, texts and institutions. In short, music is a *discourse* (in the Foucauldian sense of the concept). As Cage's *4'33"* drew attention to the visual aspect of musical performance — by evacuating 'music', sight/site rushed in to fill the vacuum — so Fluxus took up and developed the ritual around 'music', which, as mentioned above, Wagner had played no small part in establishing.

Young was also interested in the audience as a social situation. I mentioned earlier that Wagner was responsible for providing, or promoting, a darkened listening environment. Young's *Composition 1960 No. 4* similarly has the auditorium darkened, but when the lights are turned on again, the audience may (or may not) be told 'that their actions have been the performance'. Like *4'33"* the ambient sound is the music, and attention is drawn to the context and site of performance. The theatrical act of lowering the lights prepares the audience for a visual spectacle, but does not provide one (there is nothing to see). In addition it focuses listening, although nothing follows but the audience's own actions and sounds. The music slips out of the gap between expectation (lights go out) and realization — disappointment? — (lights come up). The implicit dialogue between sight and sound in a performance site is dramatized. *No. 6* of this series reverses the performer/audience relationship, again in relation to sight, by having the former *observe* the latter:

> The performers (any number) sit on the stage watching and listening to the audience in the same way the audience usually looks at and listens to the performers. If in the auditorium, the performers should be seated in rows on chairs or benches; but if in a bar, for instance, the performers might have tables on stage and be drinking as is the audience.
>
> Optional: A poster in the vicinity of the stage reading:
>
> COMPOSITION 1960 NO. 6
> by La Monte Young
> admission
> (price)
>
> and tickets, sold at stairways leading to stage from audience, admitting members of the audience who wish to join the performers on stage and watch the remainder of the audience.
>
> A performance may be of any duration.

Such an approach reverses the idea of audience as passive spectators in the most direct way. It makes sight (gaze) the sole communicative act. Thus, the visual element of musical performance is made conspicuous for it is, here, all there is. It also underlines the socialized nature of witnessing a musical performance.

16

Another Wagnerian development, the role of the star conductor, was similarly appraised by George Maciunas, in his *Solo for Conductor* (1965). This work focuses on the gesture or visual sign of recognition, performed by conductors to denote their acknowledgement as the author of a performance, at the start and finish of a work. Except that here the bow down is the start of the work and the rising up its finish. The 'body' of the piece consists of small, inconsequential or incidental activities concerned with the floor or with their shoes. Conductors communicate during a performance by visual gesture, a mixture of code (designating beats and cues) and expression, with their back to the audience. Their final 'public' gesture (as they turn to face the audience and acknowledge applause) is here sidetracked by the mundane (their shoes and/or the floor) in the process of acknowledging the profound (their interpretation).

The orchestra was also evaluated. Brecht, in his *Symphony No. 1*, for example, required the Fluxus Symphony Orchestra to play through life-size cutouts of a photograph of another orchestra, as one might pose for a photograph behind an 'end of the pier' cutout: 'Performers may hold instruments in the conventional way and attempt to play an old favourite.' In both these works the visual element of performance is highlighted. The conductor's elaborate gestures are reduced to a parody of acknowledgement and the orchestra's disposition and presence is masked by a visual representation of an absent group of professionals. The visual presentation, in this case, can get in the way of performing the music. The visual usurps the sonoric.

Perhaps the most disruptive intervention made by Fluxus artists on the conventional symphony orchestra was Nam June Paik's *Suite for Transistor Radio* (1963). Here the *allemande* of the suite is to take place between the first and second movements of Beethoven's *Symphony No. 5*. The performer is instructed to play the radio 'not very loudly', just as the second movement begins, either directly or, if diffident, by remote control. Here the aleatoric element would probably produce a telling clash of musical languages. It also, in a Cageian vein, introduces outside sound into the heart of a highly controlled musical environment and conflates disparate musical spaces. In all these works there is an explicit dialogue and investigation between those elements implicit in Cage's *4'33"*: sight, site and sound.

In a more elemental vein, Fluxus performances added to the use of (invisible) wind in the production of orchestral sound the elements of (visible) fire and water. In Young's *Composition 1960 No. 2* (written at the same time as the 'Butterfly piece') the performer is instructed simply to build a small fire in front of the audience: 'In the event that the performance is broadcast, the microphone may be brought up close to the fire.' Here a largely visual phenomenon generates the sound and involves other senses in the warmth and smell of the combustion. In a gentle way this recalls the use of pyrotechnics employed by Jimi Hendrix in his sacrificial guitar-burning stage antics.

George Brecht was particularly interested in the use of water as a musical element. This develops the fact that water as an element is present but suppressed in an orchestral context. As Cage had put it: 'Even a conventional piece played by a conventional symphony orchestra (is a theatrical activity): the horn player, for example, from time to time empties the spit out of his horn. And this frequently

2 Slides from George Brecht's 'Chemistry of Music' lecture, 1969. Reproduced from *Studio International*, November/December 1976, vol. 192, no. 984, p. 261

engages my attention more than the melodies.'[55] Brecht reverses this process in his *Water Yam* (1963) version of *Drip Music*, when water is poured from a ladder back into the bell of a tuba or French Horn.[56] Brecht's *Chemistry of Music* (1969) brings these two elements of fire and water together. The work started with music borrowed from Walter de Maria, a tape of sounds that modulate from drumming to crickets chirping (a move from culture to nature). Then Brecht, dressed in a white lab coat, delivered a visual lecture with slides, a number of which involved water and musical instruments in bizarre experiments (plate 2). To a number of these images he attached fireworks; '... in the slide where there's a man playing a flute, I attach a firework that makes a whistling sound. I attach that to the place on the screen where the embouchure of the flute is, and set it off, so that there's fire and a whistling sound.' In addition to pseudo-scientific diagrams (which normally place explanation over the representation of actual appearance, but here operate within these conventions, while denying simple explication), Brecht used a slide of a print of one of Katsushika Hokusai's *Thirty-six views of Mount Fuji* (*c.* 1820–9): 'For almost every slide there is a firework that goes with it. And for the final one — Mount Fuji — there's a little rocket set into two wire rings on the top that shoots up into the sky.'[57] Brecht had been a scientist and was interested in putting what seemed to be disparate areas into a common field (creating puns: the aperture of a clarinet and a volcano; moving from earth science to art and back again; woodwind instruments involved in chemical experiments; volcanoes becoming musical instruments and so on). If the essence of chemistry is the investigation of the changes brought about in and by the elements, then Brecht's work is a germane metaphor for Fluxus's approach to the concept of music in general.

The apogee of the idea of water as a sublimated musical element is probably

18

Nam June Paik's *Physical Music* (or the 'Fluxus Champion Contest', 1962). Here, as well as water being the producer of sound, the idea of the athletic virtuosity of the male performer is also parodied.

> *Performers gather around a large tub or bucket on stage. All piss into the bucket. As each pisses, he sings his national anthem. When any contestant stops pissing, he stops singing. The last performer left singing is the champion.*

Due to the international make-up of Fluxus as a movement, the anti-nationalistic dimension of this act has particular resonance.[58] The issue of virtuosity is also evident in Brecht's *Concerto for Clarinet* (1966) which has the important subtitle 'nearby', for the clarinet is suspended from a string tied to its central point of balance, so that it maintains a horizontal position about 6 inches above the performer's mouth. The virtuosity comes in the ability the performer might demonstrate in playing the instrument — with no hands! — by jumping or contriving to swing the reed end into their mouth. The act of performance, the physical visual action and visceral nature of engagement is accentuated in works such as these, so that the body becomes the sight/site of musical action.[59] Music is thus seen as a complex of elements, a field or discourse, and what is opened up to analysis and attention is the relationship between these elements of sound and vision. The critique of virtuosity through the unconventional use of musical instruments brings us to focus on Fluxus's exploration of the objects of music-making.

Paik's collaboration with the cellist Charlotte Moorman provides the most vivid example, for as Nyman has written, 'Moorman's cello has surpassed any other instrument, in any era, in the number of uses it has been put to.'[60] For example, it was frozen in a block of ice and then brought back to life by Moorman who bowed until she reached the strings. The physical visual action ended in sound. Together they also explored the issue of sex and music. As Paik has said, sex is underdeveloped as an element of musical discourse, in contrast to literature or the visual arts. This interest manifested itself most notably in his *Opéra Sextronique* (1967), which, in its critique of clothing as a style of visual presentation in relation to performance (why dress in black?), resulted in the arrest of Paik and Moorman and their detention for a night, having been found guilty of 'an act which openly outrage[d] public decency' (Moorman performed 'topless').[61] An interesting variation on this theme was their performance of Cage's *26'1.1499 for a String Player* in the Café à Go-Go in New York in 1965. This involved Paik (naked from the waist up) being played between Moorman's legs as a human cello (holding the string over his back). This work neatly inverts the art-historical tradition of stringed instruments' iconic reference to women's bodies — the classic modern example being Man Ray's *Le violon d'Ingres* of 1924[62] — and brings home the corporeal nature of all tactile engagement in musical performance and of its grounding in the body; the musical object becomes a subject.[63]

Paik's 'decorated' piano, *Klavier Intégral* (1958–63), similarly focuses on the musical instrument as object by rendering the object, in this case a piano, virtually

unplayable and turning it into a sculptural body (the decoration puns on the notion of body by including clothing — a bra). It could be considered as a joke at the expense of Cage's invention of the prepared piano, where objects are introduced in-between and onto the strings so as to modify the sound. Brecht also 'decorated' a piano (*Piano Piece*, 1962), but here it is an event-as-object. The score says 'a vase of flowers on(to) a piano', so a vase of flowers is either placed on a piano or simply observed on one.[64] In either case the act draws attention to an urbane domestic action, the silent piano as an item of furniture, a table, a mute object displaying a primary decorative function. His score of *Solo for Violin, Viola, Cello, or Contrabass* (1962) simply states 'polishing'. Here again a piece of musical 'housekeeping' is the sole objective of the work. The piece can be viewed as an ironic comment on the idea of the virtuoso as 'shining' performer,[65] although no technical skill is required. Furthermore, the sounds so produced are as equally a consequence of the material and form of the instrument as the sounds it produces when conventionally played. Young's *Piano Piece for David Tudor No. 1* (1960) also concerns itself with the care of musical instruments. A bale of hay and a bucket of water is offered as feed to that 'workhorse' of the virtuoso and composer, the piano. Such approaches to the instruments of music can obviously be seen to fetishize them.[66]

The counterpoint to this 'loving' approach is found in a number of works of a destructive nature. The frustration inherent in the acquisition of skill or experience when learning a musical instrument is dramatized as the obverse of the attachment performers feel for their instruments. Maciunas's *Solo for Violin for Sylvano Bussoti* (1962)[67] consists of twenty different instructions to the performer, from the simple inversion of 'hold bow to shoulders and bow with violin' (parodying Paganini's demonic presence and performance technique)[68] to the release of biting, drilling and throwing the instrument or parts of it at the audience. Paik wrote two works of a more destructive nature for violin in the early 1960s. *Violin with String* can be seen as a poetic, if violent, re-presentation of Paul Klee's famous reference to drawing as 'taking a line for a walk'.[69] Here, however, the 'line' is attached to a violin, which is dragged behind the performer 'on the street' — the violin reflecting Klee's interest in music as a structuring device for visual composition,[70] the 'line' adding a fifth string to the normal four of the violin.[71] His *One for Violin Solo* (1961) embraces this violent impulse more laconically. The violin, held by the finger board, is to be very slowly raised above the head of the performer. When the top of the arc is reached it is to be brought down with full force onto a hard object. This might again bring to mind Jimi Hendrix's and Pete Townsend's destruction of their guitars as the high point of their theatrical stage acts, conflating destruction and creation,[72] as well as answering Tristan Tzara's call in the Dadaist text *Unpretentious Proclamations* (1919): 'Musicians smash your blind instruments on the stage.'[73] This attack on the music of the past in a Futurist vein ('We will destroy the museums, libraries, academies of every kind ...')[74] has a modernist ring about it, in its forward-looking optimism, but as Kahn has pointed out, the recuperative power of high capitalism in an age of postmodernist ideology restored one of Hendrix's smashed guitars from 1967 to the status of prized possession when it was sold at Sotheby's in 1991 for $45,600.[75]

A more explicit connection with the cultic environment of rock may be found in Robin Page's 1962 Fluxus work *Block Guitar Piece*, which required performers to use their feet rather than hands to produce sound. They are to kick the instrument off-stage, out of the concert hall, round the block (hence the title), back into the hall and back on to the stage (having taken it for a 'walk'; recalling Paik). Such approaches to the objects of music are obsessive. Rather than seeing them merely as transmitters of music, they become sculptural objects, points of fixation and fetish.[76]

Perceiving Sound

We have seen that, for Fluxus, the concert occasion is to be viewed as a complex field of activities; that music viewed as a discourse is open to critique on a number of levels. Through the work of Cage, the role of the audience literally takes centre stage; they not only form a central part of the hermeneutic circle, they are often responsible for the sound of the music itself. This expansion of the notion of music leads to a focus on its other constituent elements. Principal among them is the visual (the act and body of performance, the objects of music, its sites, its texts), and we are best placed to comprehend this through the adoption of an interdisciplinary methodology. If we regard music as only that which is exclusively heard, we ignore music as an occasion or practice which incorporates an integral visual dimension; our definition is limited. Contrarily, to acknowledge that music consists of a visual interrelation between sound and sight (as the aesthetic of Fluxus compels us to do), our understanding is contextualized, or positioned; music is placed. It is through this that music acquires much of its conventional intelligibility. It is only with the advent of modern technologies of reproduction that music was released from its context of site/sight. But even here the employment of videos and sleeve design accompanies the sound with vision, providing a sight. On occasion, this technology can even liberate the 'mind's-eye' to construct pictures, or allow us to follow a score (a text, visual notation), but images of some kind are always present and are conventionally determined or reacted against. In a post-Cageian musical universe all sounds and time-events can be viewed through a musician's eyes and ears (defining 'musician' in the broadest sense); the interpretive onus is placed on us as audience. Within such an aesthetic, the traditional boundaries between disciplines are no longer as hermetic as is often assumed: things are quite literally in flux.

We must be active and broadly based in our references, willing to transgress boundaries. We should open our *eyes* to *hear* more clearly. Doing this can allow us, again in Higgins's words, to appreciate 'Concerts of everyday living'.[77]

<div align="right">

Simon Shaw-Miller
Birkbeck College, University of London

</div>

Notes

This article was given in a shorter, preliminary form to the *Son et Lumière* conference at the Gardner Arts Centre, University of Sussex at Brighton in November 1994. I should like to express my thanks to the University of Manchester for electing me to a Simon Senior Research Fellowship, which has provided me with the opportunity to research and write this paper. Also, as always, my thanks to Lindsey for her attentive support.

The lack of illustrations in this article is due solely to the prohibitive reproduction fees set by copyright holders, with the notable exception of the John Cage Trust.

1 As, for example, M. Pointon has written, '... art history is polymathic and we have long recognized its debt to philosophy, all branches of historical analysis, literature, archaeology and other disciplines. What used to be perceived as a weakness (it was difficult to accommodate art history into a departmental system ...) should now be acknowledged as a source of strength on political and academic grounds.' 'History of Art and the Undergraduate Syllabus. Is it a Discipline and How Should We Teach It?' pp. 147–56 in A. Rees and F. Borzello (eds.), *The New Art History*, London, 1986, quote p. 149.

2 R. Barthes, *Image-Music-Text*, selected and translated by S. Heath, Glasgow, 1982, pp. 155–64.

3 ibid., p. 155.

4 The term Fluxus was first coined by George Maciunas in 1961 as the title for a proposed magazine, but was soon adopted to describe a range of activities associated with those artists who shared Maciunas's vision. In his *Manifesto* of 1963 (held in the Gilbert and Lila Silverman Fluxus Collection, New York), Maciunas used part of the dictionary definition of flux in describing his ideas. It used seven subdefinitions but concentrated on three main concepts: 'purge', 'flow' and 'fuse'. 'Purge' was intended as purging the 'world of dead art' and 'Europeanism'; 'flow' was understood as promoting 'a revolutionary flood and tide of art' ('living art, anti-art and non-art reality'); and 'fuse' as fusing 'the cadres of cultural, social and political revolutionaries into united front and action'.

5 See K. Stiles, 'Between Water and Stone' in *The Spirit of Fluxus*, ed. J. Jenkins, Walker Arts Centre, New York, 1993, p. 65. She is here adopting J.L. Austin's term to refer to a class of expressions that are not descriptive and have no truth value but rather do something (e.g. I promise ...) (see Austin, *How To Do Things With Words*, Cambridge, Mass., 1975). The meaning, instead, resides in the *act* of performance. The exhibition for this was the catalogue toured from February 1993 to January 1995, opening in Minneapolis and closing in Barcelona. It provides a sympathetic and scholarly assessment and contains an excellent collection of essays.

6 M. Kirby, 'The New Theatre', *Tulane Drama Review*, 10, no. 2, Winter 1965, pp. 25–6. Here Kirby makes a distinction between what he calls 'matrixed' and 'non-matrixed' performance. This essay was reprinted in Kirby, *Art of Time: Essays on the Avant-Garde*, New York, 1969, pp. 75–102.

7 D. Higgins, 'Some Thoughts on the Context of Fluxus', *Horizons*, 93. See also 'Statement on Intermedia' in *De-Coll/àge* 6, July 1967 and 'Intermedia' in *foew&ombwhnw*, Something Else Press, 1969. Since using the term intermedia, Higgins has discovered that it was first used by Samuel Taylor Coleridge *c.* 1812 (see Higgins, *Some Poetry Intermedia*, Poster, 1976).

8 D. Higgins, ibid.

9 A. Huyssen, 'Back to the Future: Fluxus in Context' in *The Spirit of Fluxus*, ed. J. Jenkins (1993), pp. 149–50. See also T.W. Adorno, 'Kunst und die Künste', *Ohne Leitbild: Parva Aesthetica*, Frankfurt am Main, 1967, pp. 158–82.

10 In this sense it is to be viewed as a strength, both politically and academically (to recall Pointon, op. cit. [note 1]).

11 R. Barthes, op. cit.

12 Cage applied *I Ching* chance operations to determine the length of each movement. However, the length of the movements vary between the different versions. For example, Irwin Kremen's manuscript (a birthday gift from Cage) gives 30″, 2′23″, and 1′40″, as at the premiere, while the published score specifies 33″, 2′40″ and 1′20″.

13 Cage experienced Harvard University's anechoic chamber, an environment as soundproof and free from reverberation as was technologically possible, sometime in the mid-1940s. For Cage's recollection of this event, see *Silence*, London, 1968, pp. 8, 13, 23, 51, 168.

14 J. Cage, ibid., p. 103.

15 See A. Gilmore, 'Interview with John Cage (1973)', *Contact*, 14, Autumn 1976.

16 E.J. Dent, quoted after B. Magee, *Aspects of Wagner*, London, 1972, pp. 84–5.

17 Either explicitly, in the case of Schoenberg, or perhaps, through the establishment and consequent questioning of conventions, implicitly, in the case of Fluxus.

18 See T.W. Adorno, *The Philosophy of Modern Music*, trans. A.G. Mitchell and W.V. Bloomster, London, 1973, first published 1948.

19 A. Schoenberg, *Theory of Harmony*, London, 1983, originally published in 1911, Universal Edition, Vienna, as *Harmonielehre*, trans. R.E. Carter (based on third edition 1922), p. 21.

20 It should be noted, however, that Schoenberg did not teach his twelve-note method. Rather, as

such books as *Preliminary Exercises in Counterpoint*, London, 1963, *Fundamentals of Musical Composition*, London, 1967, and *Structural Functions of Harmony* (originally published 1954, reprinted and revised by L. Stein, London, 1983) demonstrate (all texts which are taken from his UCLA classes), he was keen to establish in his students a thorough grounding in conventional fundamentals. Similarly, he never looked at any of Cage's compositions. Therefore, Cage's independent approach should not be too surprising.

21 Edgar Varèse (1885–1965) had composed his *Ionisation* between 1929 and 1931 for thirteen percussion players. Cage may have heard the use of percussion instruments from different cultures (especially Balinese gamelan), but solo percussion pieces were, at this time, rare.

22 J. Cage, *Silence*, op. cit. (note 13), p. 3.

23 L. Russolo, *The Art of Noises*, in U. Apollonio, *Futurist Manifestos*, London, 1973, p. 88.

24 ibid., p. 76. We can detect elements of Russolo's connection with more orthodox musical practices in his notation system. In the score to his *Awakening of a City* (1914) we find a miswritten 3/4 time signature, bar lines and use of treble and bass clefs, all meaningless in the face of a graphic notation of *noise* in approximate time and pitch. Nevertheless, it is appropriate that he should invent machines to create his music, given the Futurists' obsession with machinery. As regards Cage's position towards music of the past, he had no such absolute rejection, but I mention him in relation to this quote because he did have a strong dislike of Beethoven.

25 Russolo's legacy allowed musicians like Edgar Varèse to allude to extra-musical sounds without becoming too referential; see O. Mattis' 'Varèse's Multimedia Conception of Deserts', *Musical Quarterly*, Winter 1992, vol. 76, no. 4, pp. 557–83. This article not only discusses Varèse's interest in electronic sound generation, but also his conception of a Gesamtkunstwerk with lights and projections and music of epic proportions: this sense of scale tends to relate Varèse to a more nineteenth-century aesthetic, despite his interests in electronic instrumental technology and friendship with Cage in the early 1950s. His Gesamtkunstwerk has more in common with Wagner than with Fluxus.

26 Here again we can make reference to Barthes; see 'The Death of the Author', op. cit. (note 2), pp. 142–8.

27 For a critical discussion of Greenbergian formalism, see S. Guilbaut, 'The New Adventures of the Avant-Garde in America: Greenberg, Pollock, or from Trotskyism to the New Liberalism of the "Vital Center"', in *October*, 15, Winter 1980, pp. 61–78.

28 *Variation IV*, in the second volume of the Everest recording (S-3230).

29 J. Cage, *For the Birds: John Cage in conversation with Daniel Charles*, London, 1981, p. 133. First published in French as *Pour les oiseaux*, 1976.

30 J. Cage, *Silence*, op. cit. (note 13), p. 31.

31 Quoted from E. Salzman's review of the work in *Stereo Review*, May 1969.

32 See M. McLuhan, 'Radio: The Tribal Drum', in *Understanding Media: The Extensions of Man*, London, 1967, p. 326.

33 For a discussion of this tension between the meaning of sound and its phenomenality, see F. Dyson, 'The Ear That Would Hear Sounds in Themselves: John Cage, 1935–1965' in D. Kahn and G. Whitehead (eds.), *Wireless Imagination: Sound Radio and the Avant-Garde*, Cambridge, Mass. and London, 1992, pp. 373–408. See also my own 'Towards a hermeneutics of music' for a detailed discussion of the history of the Idealist philosophical tradition, which positioned music as apart from the world and regarded 'absolute' music as paradigmatic. S. Miller (ed.), *The Last Post: Music after Modernism*, Manchester, 1993, pp. 5–26.

34 A. Huyssen, *After the Great Divide: Modernism, Mass Culture and Postmodernism*, London, 1986, p. IX.

35 R. Barthes, op. cit. (note 3), pp. 162–3.

36 My use of the concept 'representation' should not be confused here with the more restricted use associated with mimesis. This is discussed by P. Kivy in *Sound and Semblance: Reflections on Musical Representation*, Ithaca and London, reprinted 1991 from 1984. Rather, I use it in the literal sense of 'to stand for something else'.

37 K. Stiles, op. cit. (note 5), p. 66.

38 M. Duchamp, 'The Creative Act' in G. Battcock, *The New Art*, New York, 1966, p. 25.

39 M. Nyman, 'George Brecht: Interview', *Studio International*, November–December 1976, vol. 192, no. 984, p. 257.

40 Quoted after D. Kahn, 'The Latest: Fluxus and Music' in *The Spirit of Fluxus*, op. cit. (note 5), J. Jenkins, Walker Arts Centre, New York, 1993, p. 106. This was one of the first essays to raise important conceptual issues in relation to Fluxus 'musical' works. My own article has reconfigured a number of them but is more concerned with visual implications.

41 J. Cage, 'Music Lover's Field Companion' in *Silence*, op. cit. (note 13), p. 276.

42 For a recent disquisition on this subject, see S. Schama, *Landscape and Memory*, London, 1995.

43 See note 38.

44 R. Kotelanetz (ed.), *John Cage: An Anthology*, New York, 1991; supplemented and reprinted from 1970, p. 13.

45 ibid., p. 14.

46 Apart from the issue of 'acoustic space' there is also the issue of 'notational space'. The latter can be considered as the vertical element of scores which shows the temporal coincidence of different musical timbres and pitches. As Robert Morgan has put it, 'Thus many of the surface

aspects of musical scores are immediately apparent from the visual format of the score.' See 'Musical Time/Musical Space' in *The Language of Images*, ed. W.J.T. Mitchell, Chicago and London, 1980, pp. 259–70. Acoustic space will be further discussed below.

47 Quoted after H. Sayre, *The Object of Performance*, Chicago and London, 1989, p. 110.

48 R. Barthes, *The Responsibility of Forms*, trans. R. Howard, Berkeley and Los Angeles, 1985, p. 245. He goes on, 'It is possible to describe the physical conditions of hearing (its mechanisms) by recourse to acoustics and to the physiology of the ear: but listening cannot be defined only by its object or, one might say, by its goal.' He differentiates three types of listening: (1) *alert* the awareness of sound; (2) *deciphering* the recognition of aural 'signs', 'I listen the way I read, i.e. according to certain codes'; (3) is the awareness not of what is said or emitted, but who speaks, or emits. This last type is the birth of the inter-subjective space, '... where "I am listening" also means "listen to me"; what it seizes upon ... is the general "signify" no longer conceivable without the determination of the unconscious,' pp. 245–6.

49 H. Sayre, op. cit. (note 47), p. 114.

50 E. Tamm, *Brian Eno: His Music and the Vertical Color of Sound*, Boston and London, 1989, p. 25.

51 ibid., p. 24.

52 For Barthes there is a relationship or affinity between the gaze and music, in that both derive not from the sign, but from signification. Later he suggests, which is rather appropriate to our frog, that the direct, imperious gaze's effect is (quoting Lacan, *Seminaire XI*) 'to arrest movement and to kill life'. See 'Right in the Eyes' in *The Responsibility of Forms*, 1985, pp. 237–42.

53 This approach is part of a long history of synaesthetic and colour–sound experimentation, from Castel's ocular harpsichord in the eighteenth century, to Scriabin's interest in light, sound and smell in the early twentieth century, to contemporary light shows as part of rock concerts or in dance clubs. For these earlier experiments, see L.B. Castel, 'Difficultés sur le clavecin oculaire avec réponses', *Mercure de France*, March 1726. J. Zilczer, '"Color-Music": synaesthesia and nineteenth-century sources for abstract art', *Artibus & Historiae*, vol. 16, 1987. Also chap. 13 of J. Cage, *Colour and Culture*, London, 1993.

54 For a discussion of the relationships between this type of work and the aesthetics of minimalism in art and music, see my 'Hauer's Legacy and the Aesthetics of Minimalism in Music and Art' in *Konstruktiver Realismus im Zwoelftonspiel*, Vienna (forthcoming).

55 M. Kirby and R. Schechner, 'An Interview with John Cage', *Tulane Drama Review* 10, no. 2, Winter 1965, p. 50.

56 This might remind us of the use of water in Max

Neuhaus's *Water Whistle* pieces of 1971–74, where whistles placed underwater produced sound by having water pumped through them. See J. Rockwell, *All American Music*, London, 1985, pp. 146–7.

57 M. Nyman, op. cit. (note 39), p. 26.

58 For example, as already mentioned, Maciunas was Lithuanian, Paik was born in Korea but lives in Germany and America, La Monte Young is American, Robin Page was born in Canada and lived in England and Germany. Fluxus mainly operated on the German/American nexus but its 'membership' extended across Europe, Asia and the United States. This work also brings to mind my grandfather's description of a lavatory as a 'poor man's piano'.

59 L. Kramer has made a similar point in relation to nineteeth-century bravura performances: 'What the audience sees is a theatrical icon of the inspired musician; what it hears is a highly charged extension of the performer's touch, breath, rhythm: the body electric, in Walt Whitman's phrase. Hence the cultivation of certain physical peculiarities (Liszt's long hair, Paganini's emaciated pallor) and hence, too, the many cartoonlike caricatures of musicians like Paganini, Liszt, Berlioz and Wagner ... Robert Schumann recognizes much of this syndrome when he remarks that "the Viennese, especially, have tried to catch the eagle [Liszt] in every way — through pursuits, snares, pitchforks and poems. But he must be heard — and also seen: for if Liszt played behind a screen, a great deal of poetry would be lost"', *Music as Cultural Practice, 1800–1900*, Berkeley, Los Angeles and London, 1990, pp. 90–1. See also A. Durant, *Conditions of Music*, London, 1984, chap. 4, and R. Leppert, *The Sight of Sound: Music, Representation and the History of the Body*, Berkeley, Los Angeles and London, 1993. Barthes's essay 'The Grain of the Voice' in *Image-Music-Text* (pp. 179–89) discusses the body in relation to the voice. He identifies two types of voicing, 'phenotext' (attention to generic detail, phrasing, etc.) and 'genotext' (the eroticized voice beyond particular cultural meanings, the voicing of the body in language); 'The "grain" is the body as it sings' (p. 188). He links the decline of the latter to the increasing professionalization of music-making.

60 M. Nyman, *Experimental Music: Cage and Beyond*, London, 1974, p. 74.

61 See 'From Jail to Jungle, 1967–77: The Work of Charlotte Moorman and Nam June Paik' in G. Battcock and R. Nickas (eds.), *The Art of Performing: A Critical Anthology*, New York, 1984, pp. 278–88. Moorman's sentence for 'indecent exposure' was suspended. Paik was found 'not guilty', however, by virtue that the judge regarded the idea of pornographic music as impossible.

62 See my 'Instruments of Desire: Musical

Morphology in the Early Work of Picasso', *Musical Quarterly*, Winter 1992, vol. 76, no. 4, pp. 442–64. Here I argue that the female 'subject' is transformed into an 'object'. The expression *Le violon d'Ingres* is a French euphemism for a hobby, in reference to Ingres's favourite pastime of playing the violin. That an image of a nude woman (Man Ray's mistress Alice Prin, a cabaret singer known as 'Kiki de Montparnasse') should be so titled only serves to underline the idea of '*plaything*', whether Man Ray intended it ironically or not.

63 It is worth noting that the soundboard of instruments in the violin family are referred to as the 'belly', its upper part as the 'neck', the reverse the 'back', which is joined to the belly by the 'ribs'.

64 See also S.L. Scholl's 'String Quartet Performance as Ritual' in *American Journal of Semiotics*, vol. 9, no. 1, 1992, especially p. 128, on the symbolic references in the presentation of flowers in a musical context. Brecht's own assessment of the string quartet as ritual can be seen in his *String Quartet* (1965), where the four players shake hands mutually and depart.

65 It brings to mind Paganini's loving care and laborious preparations prior to a performance on his prized Guiseppe Antonio Guarneri ('del Gesù') violin.

66 This raises the issue of applying a psychoanalytic analysis. This, however, is outside the scope of the present study.

67 Maciunas also applied this destructive approach to keyboard instruments. He developed the piano's ability to sustain a note (this is what sets it apart from its predecessors such as the harpsichord) in his *Piano Piece No. 13 for Nam June Paik* (1964), by requiring the performer to nail down the keys, from the lowest-pitched to the highest, using a hammer. It is, of course, the hammer design that is in large part responsible for the piano's sustaining characeristics.

68 See L. Hunt in *Tatler*, 23 June 1831, quoted in P. Weiss and R. Taruskin (eds.), *Music in the Western World: A History in Documents*, New York, 1984, pp. 340–5.

69 See P. Klee, *Pedagogical Sketchbook* (first published in 1925 as *Padagogisches Skizzenbuch* [Bauhaus Books]; English trans. Sibyl Moholy-Nagy, London, 1953), 'An active line on a walk, moving freely, without goal. A walk for a walk's sake ...', p. 16, section 1.1.

70 See A. Kagan, *Paul Klee / Art & Music*, Ithaca, New York and London, 1983.

71 It can also be regarded as a literal *reversal* of Young's *Composition 1960 No. 10*; 'Draw a straight line and follow it.' Paik performed this work by Young at the first Fluxus festival in Wiesbaden, the Fluxus Internationale Festspiele Neuester Musik (Fluxus International Festival of New Music) in 1962. He dipped his head, hands and tie in a mixture of ink and tomato juice, then dragged them along the length of a sheet of paper (160 × 14 cm). He entitled it *Zen for Head*, a work which raises issues pertinent to Fluxus and this article, in that it starts as a composition, is formed as a performance and ends as an object.

72 As S. Frith and H. Horne have argued, the influence of Gustav Metzger's 'auto-destructive' art on Townshend (he lectured at Ealing while Townshend was an art student) might have been a post-hoc justification of a spontaneous act, but Metzger's influence may have been more direct in the use of acoustic feedback, 'when the very discovery of new noise always carried with it the threat (which the group couldn't control) of the destruction of the PA system.' Townshend's art school background, under the tutelage of Roy Ascott, therefore allowed him to view his own musical activities in terms of performance art. Another important visual art strain of influence was that of Pop art theory, which denied an aesthetic separation between high and mass art and informed much of the image of The Who. Such an awareness of art history and theory might lead us to suppose that the use of sounds from outside the mainstream of Western music (noise) have something to do with the influence of Cage and Russolo. See S. Frith and H. Horne, *Art into Pop*, London, 1987, especially pp. 100–101 and C. Small, *Music, Society, Education*, London and New York, 1977 (revised 1984), especially pp. 169–70, for a discussion of the new musical values of the so-called rock revolution.

73 T. Tzara, 'Unpretentious Proclamations' in *Seven Dada Manifestos and Lampisteries*, trans. B. Wright, London and New York, 1977, p. 16.

74 'The Founding and Manifesto of Futurism', 1909, in U. Apollonio, *Futurist Manifestos*, London, 1973, p. 22.

75 D. Kahn, op. cit. (note 40), p. 115.

76 See note 67. This destructive impulse can be seen as an example of a wider tendency in art of the late 1950s and early 1960s by such artists as Metzger, Wolf Vostel, Jean Tinguely, John Latham, Ralph Ortiz, and most notably in the work of the Vienna 'Actionists' (Gunter Brus, Otto Muhl, Hermann Nitsch, Rudolf Schwarzkogler, Alfons Schilling and Adolf Frohner).

77 See D. Higgins, 'A Child's History of Fluxus' in *Horizons: The Poetics and Theory of Intermedia*, Carbondale, Illinois, 1984.

Art History ISSN 0141-6790 Vol. 19 No. 1 March 1996 pp. 26–43

Klinger's *Brahmsphantasie* and the Cultural Politics of Absolute Music

Thomas K. Nelson

'All art is the same and speaks an equivalent language.'[1]

Max Klinger was so moved that tears of joy ran slowly down his cheeks as the music resounded through the dimly lit hall. Or so reported Alma Mahler upon the occasion of her husband's performance of his special arrangement of Beethoven's *Ninth Symphony* at the opening of the Vienna Secession's fourteenth exhibition in 1902.[2] The entire building had been turned into a temple to Beethoven, with Klinger's colossal monument to the composer placed as the centrepiece. This event marked the pinnacle of Klinger's artistic career. As one contemporary critic remarked, 'everything is calculated for its musical effect; it is for the eye what Beethoven's compositions are for the ear: it is *visible music*.'[3] By this assessment, Klinger had achieved his life-long aesthetic goal.

The antipode to Klinger's gargantuan public sculptures and paintings can be found tucked away neatly in library drawers. Unlike the polychrome aesthetic Utopia heralded by the Promethean Beethoven (pilloried by the Viennese art establishment), Klinger's mastery of, and innovations in, the graphic arts still command universal respect. In Klinger's hands, the small-scale black and white print could evoke a second world of intimate subjectivity, the true reality, in which our material existence is but an artificial representation. Klinger's transcendental world was not filled with heavenly sweetness and light, however. As a disciple of Schopenhauer's pessimistic philosophy, Klinger sought to represent the dark secrets of the Will. Anticipating the depth psychology of Freud and Jung, Klinger's path to the subjective subconscious led through dream and fantasy.

Schopenhauer's philosophy appealed to Klinger in another way: the philosopher had proclaimed music and the Will to be virtually equivalent. Of course, the idea that a composer could manifest his fantasy through his music had long stirred in the popular imagination. Beethoven or Schubert in the midst of musical reverie long remained an attractive image for the sentimentalizing artist, as the neo-Biedermeier drawing of Beethoven at the piano illustrates (plate 3). As a pianist himself, Klinger felt that when interpreting great Romantic music he too could enter the transcendent world of musical Will. Indeed, throughout his life, Klinger kept his grand piano not at home but in his studio.

For Klinger, music was 'absolute', but not just any or all music. Klinger's

3 Sigmund Walter Hampel, *Beethoven am Klavier*, pen drawing, 1927. Historiches Museen der Stadt Wien

lineage of absolute music ran from Bach to Beethoven through the quintessential Romanticism of Robert Schumann, and culminated in Brahms, the composer who, in the 1890s, found himself at the centre of a cultural war over the true meaning of absolute music.

Eight years before the Secession exhibited the Beethoven monument, Klinger had sent another attempt to make 'visible music' to Vienna, but in an intimate format meant for private contemplation at home, not for public display. Indeed, Klinger directed this work at a single, privileged recipient; the public knew nothing about it until excerpts were published later. This work is Klinger's 'Opus XII', the *Brahmsphantasie*, his homage to the Viennese composer he esteemed to the point of worship. Very few have ever, to this day, seen it complete.

Delivered in 1894 as a leather-bound presentation edition to Brahms himself, master of 'absolute music', the *Brahmsphantasie* contains the notation of five Brahms lieder plus his choral-orchestral setting of Hölderlin's *Schicksalslied*. Forty-one graphics, ranging from symbolic borders to a full-size graphic cycle of seven images depicting the Prometheus legend, intermingle with the music. The *Brahmsphantasie* demonstrates the virtuosity of Klinger's graphic technique, utilizing stone lithography for the borders and a combination of engraving, etching, aquatint and mezzotint on the copper plates for the larger interpretive images. This technical bravura is matched only by the intellectual ambition of Klinger's fusion of image, music and text.[4] This paper will focus on the

frontispiece of the *Brahmsphantasie*, 'Accorde' (plate 4), and its subsequent reception as a visual representation of absolute music. As the entry point to a monumental Gesamtkunstwerk — but for quiet contemplation in the privacy of the parlour — 'Accorde' constitutes a visual discourse on Romantic musical aesthetics.

Before embarking on an analysis of the print itself, followed by an account of its reception, it will be necessary to trace the trajectory of Klinger's aesthetic mission within the cacophonous cultural politics of so-called 'Absolute Music', as then raged in fin-de-siècle Vienna.

The politics of absolute music

Music has long been associated with the ideal world of the 'Absolute', be it as a metaphor for the harmony of the spheres, a tool of magic, or as a symbol for the mystical and religious. Indeed, the association of a theoretical music with mathematics in a realm above the other arts and nearest the ideal archetypes of Nature goes as far back as the ancient Greeks. The history of the idea of absolute music has seen many transformations, each implying particular, and often contradictory, modes of musical composition and proper reception.[5] In turn, this fluid aesthetic situation has made the musical absolute a controversial metaphor in cultural politics to this day.

During the eighteenth century music was understood by most European listeners in association with a specific text, operatic scenario, or explicit programme. The new vogue for instrumental music in the late eighteenth century elicited a sceptical distrust of any music without apparent meaning. Thus, Rousseau quotes Fontenelle's famous quip, 'Sonate, que me veux-tu?'[6] But in the wake of Kant's epistemology of subjectivity, in which the very act of judgement was described as a pleasurable 'harmony' or 'attunement' of the faculties of understanding and imagination, many music-loving intellectuals would only too gladly respond to the lure of the empty signifiers in instrumental music.

In the nineteenth century the idea of absolute music became a central tenet of German aesthetic ideology. At first a simple generic — even derogatory — reference to meaningless instrumental music, soon the absolute of music would refer to the spiritual essence of worthy music in any genre. Hegel sensed the importance of music as a paradigm for the new century. His attempt to describe the quintessential 'Romantic' includes this remarkable passage:

> Thus in romantic art we have two worlds: a spiritual real, complete in itself, the heart which reconciles itself within and now bends back the otherwise rectilinear repetition of birth, death and rebirth into the true rotation (i.e. return into self) and into the genuine phoenix-life of the spirit; on the other side, the realm of the external as such which, released from its fixedly secure unification with the spirit, now becomes a purely empirical reality by the shape of which the soul is untroubled. ... The inner, so pushed to the extreme, is an expression without any externality at all; it is invisible and is as it were a perception of itself alone, or a musical sound as

28

such without objectivity and shape, or a hovering (*Schweben*) over the waters, or a ringing tone over a world which in and on its heterogeneous phenomena can only accept and re-mirror a reflection of this inwardness of soul. To sum up in one word the relation of content and form in romantic art ... the keynote of romantic art is musical and, if we make the content of this idea determinate, lyrical.[7]

As an idealist philosopher, however, Hegel also took on an anti-Romantic position, and declared the end of art. Even if music could serve as a metaphor for the absolute at its most abstract, its lack of determinate concepts had long ago forced the ever-progressing spirit to seek out the conceptual richness of religion and, finally, philosophy. Hegel considered the continued enthusiasm for music to be a sign of the decadence of his era.

The early Romantic poet-philosophers, among them Tieck, Wackenroder, Jean Paul Richter, the Schlegel brothers and E.T.A. Hoffmann, favoured the power of 'music' as a stimulus to the imagination. Music took on a religious aura as a form of *cognito intuitiva*, offering 'intimations of infinity'. For them, instrumental music became absolute music, capable of expressing the inexpressible, representing the unrepresentable, of uttering the ineffable. This was possible because, from a Kantian perspective, music did not directly imitate nature like the visual and verbal arts, with pictures and descriptions of objects. Rather, the logical development of musical motives resembled the presentation of conceptless 'aesthetic ideas'.[8] Judged directly like nature itself, without reference through a submerged conceptual intention, as with the other arts, the contemplation of music's 'free beauty' could divulge insights directly from artistic genius.[9] If Hegel and his anti-Romantic following thought music to be philosophically inferior, the *poetic* rank of music would be elevated to the highest condition of the arts by the Romantic imagination.

The aesthetic debate over music's meaning hardened into two opposed visions of the absolute. And as an art tied to national identity, music became a potent metaphor for larger cultural and political ideals.[10] For those of a Romantic persuasion, music became a subjective language of pure cognition without need for concepts: thus, it could speak of the fullness of the universe. The listener's hermeneutic imagination, kindled by the spirit of the music, filled in the details. The task of the Idealist aesthetician, meanwhile, was to substantiate his speculations concerning music as a natural but abstract system with the analysis of actual music. This inductive process reduces the semiotic fullness of a musical object into the transcendental principles of its underlying tonal essence or motific kernel.

But perhaps this opposition reflected more of a political difference than an aesthetic understanding of music. Formalist methodology and positivist epistemology all too often sell Romantic subjectivity short. The Pythagorean and enthusiast notions of absolute music could be entertained simultaneously, as they often were among the Early Romantics, particularly Novalis and F. Schlegel. This could be called the metaphysics of *Schweben*, a metaphoric concept found extensively in the philosophy and poetics of both Idealism and Romanticism.[11] A re-reading of Romanticism in the light of this metaphor reveals an important anticipation of, or at least an affinity with, the postmodern perspective.

By 'hovering' between the poles of a paradox in a state of reflexive self-consciousness yet also androgenous indifference, one could embrace both heaven and earth, freedom and law, the ideal and real, imagination and reason, all in a unified acceptance of diversity without the compulsion to resolve the apparent contradiction. Kant's description of aesthetic judgement anticipates the condition of *Schweben*: a disinterest between the agreeable and the good; a purposiveness without purpose; the beautiful play of aesthetic ideas without concepts; the harmony of the understanding and imagination. As *Schweben*, the experience of art becomes its own reward. One can discover in music an infinity of decentred presence encompassing the entire universe, all within the intense, concentrated contemplation of an autonomous artistic monad.

To 'hover' near or between the poles of the Absolute does not, however, get you *to* the Absolute, even if the oblivious dispersal of Dionysus can be found in the focused concentration of Apollo. As a category of reception, the effect remains entirely within the imagination of the listener (or performer). For this reason, an undercurrent of self-awareness that the condition is not 'real' but must end accompanies this sort of aesthetic engagement. Hence, the *longing* for the unattainable. Moreover, the 'critical completion' of the empty signifiers of instrumental music remains entirely personal, and cannot be assumed to be universal, nor required of others in the same terms, as with Kantian judgements of pure taste. If one wishes to try to describe to another the aesthetic vision of the music (or any art) one has worked out for oneself, a second negotiation will be necessary with the instabilities of language. Perhaps the best way to describe such an experience would simply be to perpetuate it by representing it again in another artistic medium.[12] In many ways this sort of subjective, dialogical reception (and production of meaning) anticipates what Walter Benjamin would call 'allegory'. It favours the principles of the 'transitory, the contingent and the fugitive' which Baudelaire discusses, and eschews the eternal and immutable absolutes associated with the Goethian 'symbol', the Hegelian historical imperative and the immediacy of the word of God.[13]

Thus, the notion of absolute music begins with a split between two seemingly contradictory tendencies. On the one side, instrumental music engages the sensual and affective stirring of the soul with mystical or miraculous effects that reveal a rich and exciting world of insight and truth. Yet, *at the same time*, that alternative world remains autonomous, both organically and mathematically structured by means of pure principles and abstract, 'musical' essences. But the legacy for musical reception and cultural criticism for the remainder of the nineteenth century, as determined by the dominance of an anti-Romantic aesthetic, *divides* this paradoxical absolute into two opposed camps. As with mind against body, the refinement of formalism opposes the pathology of *Schwärmerei*.

Musical politics in Brahms's Vienna

When the *Brahmsphantasie* arrived in Vienna the city was embroiled in a politics characterized as that of the 'sharper key'. Because the political and cultural situation of fin-de-siècle Vienna has been studied so extensively, only a brief sketch will be offered here.[14]

The years 1867–97 have been called the 'Age of Liberalism' in Vienna; it would be fairer to call them the years of Liberal decline. The typical Austrian Liberal was well educated and of the upper middle classes. He would have advocated such ideals as individual rights, scientific method, *laissez-faire* economics, clear and distinct intellectual reasoning, the cultivation of high art, and the spiritual progress of their common cultural heritage. Although historical change was embraced as inevitable, 'progress' was understood as the discovery and refinement of verifiable truths based on reasoned logic, principles that were in their essence timeless and universal. Such progress did not occur by accident or caprice.

Yet many of those sympathetic to these ideals had perhaps too much faith that progress would be orderly, leaving governance to entrenched political professionals. By 1897, the year of Brahms's death, the Christian Socialist party had taken control of the city government on an anti-Semitic platform, employing the emotional rhetoric of disgruntled cultural chauvinism.

Brahms himself was very much a part of the Liberal political community, which included many Jews.[15] The inherent aesthetic conservatism of the Liberal notion of progress was reflected in what they saw in Brahmsian absolute music: logical development and fine craftsmanship but not mere façade, respect for tradition yet individual in expression. His music was intellectually sound, emotionally responsible and spiritually enlightened. The heritage of the entire musical legacy could be incorporated (sublated) into the new. This would simultaneously appeal to the aura of the timeless truth of the Classical aesthetic and serve to mark the distance travelled by the inspiration of genius.

By the end of the century musical education had regressed into an essentially literary orientation. Much to the consternation of the higher-minded Liberals, for whom genuine musical understanding remained a strictly musical affair, audiences came to depend on written programmatic descriptions even for symphonic and chamber music. Pressure was applied to composers of instrumental music to supply explanations; if they were reluctant or too vague, one would be supplied. 'The inexpressible became intolerable. Specificity in linguistic terms was demanded from music, which became understandable insofar as it could be translated explicitly, in either narrative or poetic terms ... and to a lesser extent, [in] painting.'[16] The Liberal partisans placed this debasement of the middle-class musical *Bildung* squarely in the camp of the 'New German School' of Wagner and Liszt, whose 'music drama' and 'programme symphonies' had pandered to the audiences by forcing music to serve the extra-musical.

In this overheated political climate, Brahms's advocates, led by the influential music critic Eduard Hanslick, were forced into a rather extreme anti-Romantic, formalist position in which any 'responsible' discussion of music was restricted to the autonomous movement of purely musical forms and ideas. The suspicion that music was inherently an art of idle feminized fantasy, an enervating waste of time for productive men, bordering on masturbation or homosexuality,[17] probably had less currency in the German-speaking lands than elsewhere. After all, the considerable legacy of great German music had helped to secure a unified cultural identity among a politically disorganized collection of independent cities and kingdoms. Nevertheless, whilst not denying music's ability to agitate the soul, any interpretation in emotional, literary or visual terms of that repertory designated as

4 Max Klinger, *Brahmsphantasie*, 'Accorde', engraving, aquatint, and mezzotint, 1894. 27.7 × 39.1 cm. Museum der bildenden Künste, Leipzig

'absolute' was considered 'pathological'.[18] In this way, the Liberal political correctness of individual and free expression became entwined with the conservative music aesthetics of law and order, but, as we will see, only by the sacrifice of Brahms's Romantic origins.

After Wagner's death in 1883, the Catholic symphonist Anton Bruckner became the hero of the radical right in Vienna. The Liberal press attacked the inarticulate and ungainly Bruckner on personal terms as an uncultivated *Untermensch* from the provinces who 'composed like a drunk'.[19] Bruckner's supporters among the Christian Socialists returned the screed. Brahms was accused of being at best academic, at worst a shameless plagiarist for his veiled allusions to past music. His pretentiously sophisticated (read: Jewish) style was condemned as very difficult to understand — to all but his enemies, that is, who could see through the sham.[20] The Brahms–Bruckner quarrel has been called 'one of the sorriest chapters in the history of music criticism'.[21]

Unlike the earlier Brahms–Wagner debate, the battle with Bruckner was waged between composers of instrumental music; thus the idea of absolute music became a central issue. The Liberals retreated to Brahms's chamber music, a pure music of concentration and intellect, rarely programmatic, and, because of the ensemble, not prone to improvised fantasy. The music theories developed around Brahmsian absolute music addressed the immanent musical logic in which every note contributed to the organic whole; a whole defined first by reference to a single all-encompassing tonality (the *Ursatz*), and secondly by the process of 'developing variation'.[22]

The musico-mystical outpourings of a *volkish* composer with strong religious ties, such as Bruckner, also made strong claims to the 'spirit world' of absolute music, but of a very different kind. To his supporters, Bruckner made music that was democratic, inspired, heart-felt, direct and bold. It was said that Bruckner had redeemed the symphony, declared dead by Wagner, by bringing the latter composer's musical language to it, thus superseding both Brahms and Wagner.[23]

The absolute music of 'Accorde'

The title Klinger chose for his allegorical ode to Brahms, 'Accorde' (plate 4), has an abundance of connotations. The extended meanings of the word (spelled in the French form with double 'c') include harmony or attunement in the philosophical sense, or even agreement or reconciliation between two parties in a socio-political negotiation, as in English. When taken together in the context of Klinger's imagery, the title could refer to the relationship between the pianist and the composer whose music he reads, or to the empirical music and the subjective heroic landscape behind. In either case, the *Brahmsphantasie* begins *in medias res*, in a dream of musical *Schweben* between the two worlds of material under-standing and subjective imagination.[24]

Consider the iconography and structure of 'Accorde'. A modern piano keyboard makes available a fully articulated, step by step, black and white universe of tonality.[25] Transfixed in his playing, the pianist sees only the musical score. The sun, near the horizon and hidden behind the curtain, symbolizes the

5 Max Klinger, *Toteninsel, nach Böcklin (Isle of the Dead, after Böcklin)*, etching and aquatint, 1890. 41.7 × 69.6 cm. Staatliche Kunstsammlungen, Dresden

spiritual source and goal of the musical absolute; it is evident only by what it illuminates. The woman in white represents the mediating muse who transforms the digital hieroglyphics of written music into the analogue of a sublime dream of transcendent crossing. From the veiled privacy of a musical performance on stage, a ladder leads down to the base of the harp, itself a primordial piano. The steps of this *Tonleiter*, like the strings of the harp, are ancient symbols of the continuity of the universe from the mundane to the divine, or, in this scenario, to the maternal depths of oceanic unconsciousness.[26] The muse completes the aesthetic circuit with doubled gestures to the harp and the piano. Two nereids swim in the swelling waters directly below her; their multiplied eroticism counterbalances the role of the chaste woman in white in this very male fantasy.

The harp's Dionysian mask suggests the tragic knowledge of a musical Will. Its howling face peers out to address the viewer directly. It emerges oriented from the paternal light, hoisted from the loins of a grimacing triton, whose profile echoes that of the pianist. This harp is strung backwards, its shape contorted towards that of a lyre, or perhaps even a heart. A smaller, winged bust behind oversees the uncanny instrument, much like Apollo rules over Dionysus. Again as an echo from above, one nereid touches the harp strings and looks out to the storm-tossed scene of transit from spiritual birth to the tomb beyond the waters. We know this sailor will reach his final home, however. For this is the familiar *Isle of the Dead* by Arnold Böcklin, at which arrival is assured (plate 5). The rugged mountainscape recedes as a coda of apotheosis, arpeggiating a return into the hidden primal light.

Perhaps the most remarkable formal detail of 'Accorde' is the placement of the woman's hand on the harp's saddle, well behind the mask of tragedy. When

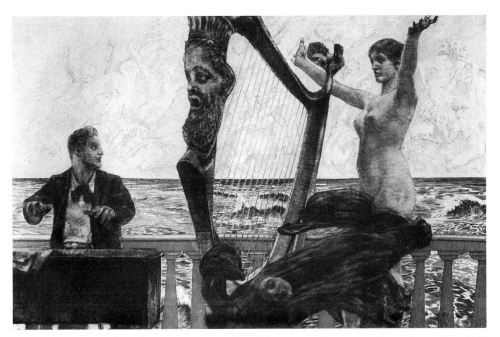

6 Max Klinger, *Brahmsphantasie*, 'Evocation', etching, engraving, mezzotint, and aquatint, 1894.
29.2 × 35.7 cm. Museum der bildenden Künste, Leipzig.

noticed, this subtlety suddenly intensifies the three-dimensional effect by thrusting
the harp out through the apparent foreground as defined by the pianist on the
dais. The image springs to life with a dizzy rotation.

It would seem hardly necessary to point out the phallic affinity of this bursting
forth harp-thing, emerging erect from the triton's lap beneath the ocean waves.
Nor how the women of 'Accorde' play their classic parts of supportive mother and
dangerous nymphs who threaten to flood the earth and capsize the sailor. Both
types touch the harp. Thus, Klinger's image of 'visible music' itself just barely veils
an allegory of procreation: blown by a wind from the harp, a lone seaman
struggles to enter the mouth of the maternal cave. Surely the gender roles of
absolute music could not be more clearly suggested.

If 'Accorde' shows the polar division of Woman in romantic male fantasy,
'Evocation', the corresponding print which opens part II of the *Brahmsphantasie*,
proposes that woman can be simultaneously the heavenly inspiration and erotic
content of absolute music (plate 6). The startled pianist looks up to see the
primordial woman of sublime music herself, her mask and dark cloak thrown
asunder, her arms raised to the resounding harmony of the harp. Neither muse
nor nymph, but both at once, she prepares to play on with the pianist. She is the
daughter of Elysium, the Eternal Feminine. Again, as he so loved to do, Klinger
has sublimated the iconography of the classical-mythological into the modern-
bourgeois in order to envision an aesthetic Utopia. This is Klinger's graphic art at
its most monumental and optimistic.

Klinger's rendering of his allegory of musical experience both resembles
and dramatizes the compositional techniques employed by Brahms in several

35

important aspects. Like the monotonality[27] of Brahms's music, so aptly symbolized in purely musical terms by the logical composing out of the Schenkerian *Ursatz*, the source and culmination of 'Accorde' is the hidden light, emblem of the Absolute. Klinger composes the heroic scene behind the pianist with a vivid step-by-step teleology from light to woman, to harp, to sea, to boat, to grave, to mountains, to sky, to light. Like a sonata by Brahms, each 'section' of Klinger's image is both a self-consistent idea and integrated into the meaning of the greater whole. Moreover, there are virtually no extraneous marks on the surface; Klinger's linear style admits only what contributes to the total effect. Likewise, every note of a Brahms composition can be shown (theoretically) to contribute logically to an organic structure. Klinger's image can be read both as a cyclical temporal sequence and as a totalized structure. In music the temporality obviously predominates, especially in its performance. But Brahms, perhaps more than any composer since Beethoven, attends to the 'deep structure' of his music, an aspect that encourages and rewards synchronic score study.

Finally, Klinger and Brahms share an aesthetic language rooted in the past and readily understandable by those brought up in the Western cultural milieu of the nineteenth century. Just as Klinger retains a linear style with full Albertian perspective, in which even strange and uncanny objects are clearly identifiable (if sometimes partially hidden), so too the archetypal sonata form of Viennese classicism underlies Brahms's instrumental music; his harmonic language remains that of Schubert, profoundly subjective but clearly understandable as a natural-sounding grammar. And like the rich musical semiotics of Brahms, Klinger too utilizes motifs that reference the historical canon of artistic iconography; some are specific homages, others are more paradigmatic, with a range between. Not everything becomes apparent on first reading: meanings and structures can be found only with considerable historical *Bildung*, familiarity with the personal ciphers of the artist, and extended contemplative engagement.

Make no mistake, Klinger's 'Accorde' does not literally represent any specific music by Brahms. The woman in white is not singing the lieder found in the *Brahmsphantasie*, nor is the pianist playing a vignette in the storm style to the accompaniment of the harp. Rather, 'Accorde' is an allegory of subjective musical experience; it shows the *jouissance* of musical *Schweben*. Klinger has excavated a symbolic order of the categories and stereotypes of musical content and telos, and has suggested how they interrelate on a deeper, more 'genealogical' level. Nevertheless, the music being allegorized here betrays a very specific set of aesthetic imperatives. Klinger shows Brahms's 'absolute' music to be assertive, tumultuous, driven on by an heroic impulse until its apotheosis in death, and libidinous in origin and motivation.

A hostile reception

In a positivistic age such as Klinger's, that favoured Realism over fantasy and pushed Romanticism into an autonomous style of mysterious enigma called 'Symbolism', Klinger's extravagant image of absolute music, rendered with such clarity of line and blatant iconography, would have appeared as epigonical kitsch

to some, revelatory to others. Indeed, after the turn of the century, 'Accorde' and other *Brahmsphantasie* images would be enlarged into poster art for a burgeoning market of *Bildungsphilister*, who could all too easily read into Klinger's images a nostalgic vision of musical plenitude tinged with the spiritual and national sanctity that they thought they heard in the music of Wagner and Bruckner.[28]

Brahms's circle of friends in Vienna, including the famous surgeon Theodor Billroth, the pianist Clara Schumann and Eduard Hanslick, would have nothing to do with Klinger's fantasies. 'Accorde' probably appeared to be just the sort of opium-induced phantasmagoria they despised. The aesthetic of absolute music associated with Brahms by his Viennese friends was diametrically opposed to the effusive subjectivity of the early Romantic musical absolute held by Klinger. Thus it fell to these friends, as well as to Brahms's champions of the following generation, such as Schenker and Schoenberg, to protect the legacy and artistic aura of the 'last master of German composition' from the contamination of the vulgar and debauched.[29] Their efforts were, for the most part, effective: when the Third Reich came to power, virtually the only use they could find for Brahms lay in his aggrandizement by Klinger.[30] Most of the larger plates from the *Brahmsphantasie* continued to be reproduced in arts and music periodicals during this period.

Today Klinger's role in Brahms's life is relegated by musicologists to a footnote. The *Brahmsphantasie* has been shrugged off as a mere symptom of its age. The eminent musicologist Carl Dahlhaus reduces 'Accorde' to what he calls a drastic assembly of the props of sublimity, assembled into glaring paradoxes, resembling a failed Baroque opera stage.[31] It would seem that Klinger's image still commits the same aesthetic crimes as the Liberal side accused Bruckner of committing in the 1890s, to wit, art made from a self-indulgent, hysterical fantasy, and not a tough, disciplined imagination.

Klinger's work has been rehabilitated and often revived in the German art world of late. However, the guardians of the Klinger legacy have followed a strategy of aesthetic purity of their own: the leather-bound book, the *Brahmsphantasie*, has been disassembled and purged of all its music where possible. Only the graphics remain, the larger ones isolated from one another in nicely matted and boxed portfolio packs; the many figurative borders that surrounded the music are piled up together like cord-wood. Exhibitions and catalogues of Klinger's work follow the same practice.[32] Klinger's artistic negotiation of text, music and image is a *Gesamtkunstwerk* no longer.

Brahms and Klinger in accord

But what of the primary recipient of Klinger's artistic efforts? What of the composer — himself a collector and connoisseur of art — who, presumably, would be in the best position to understand and pass judgement?

Brahms wholly endorsed Klinger's art and wanted dearly to lead his friends in an appreciation of its imagery. He realized that even his most cultivated friends might need help to see what was so apparent to him. His response to the artist includes this rare and remarkable aesthetic credo:

> Looking at [the *Brahmsphantasie*], it is as though the music therein resounds further into infinity and everything that I wanted to say is stated more clearly than is possible in music, and yet with just as much mystery and foreboding [*geheimnisreich und ahnungsvoll*]. At times I am inclined to envy you, that you can have such clarity with your pen, sometimes I am glad that I don't need to be, but finally, I must conclude that all Art is the same and speaks an equivalent language [*alle Kunst ist dasselbe und spricht die gleiche Sprache*].[33]

Brahms's notion of the 'language of art' thus quickly undermines the formalist doctrine of absolute music as only an autonomous abstraction. Music as language implies the power to suggest vivid intentional meaning via a dialogue utilizing specific communicative strategies. The statement that 'the music therein resounds further into infinity' corresponds to the open-ended process of contemplation as *Schweben*.

Hegel had theorized (quoted above) that the musical and the lyrical differ principally by degree of determinate conceptualization; Brahms says much the same, using the word 'clarity' (*deutlicher*). But while Klinger aspires to include graphic art with the musical and lyrical (poetic-verbal) as a medium of subjectivity, his style of visual clarity presents the greatest danger, particularly under the polarized cultural conditions of his day.[34] The high-art aesthetic of the *fin de siècle* preferred an art that would efface clarity with an abstract, purified conception, claiming 'all art aspires to the condition of music', a condition about which, 'because one cannot speak, one must remain silent.' From a purist's perspective, the absolute could not possibly be literally or clearly rendered without the medium disappearing into the air, like music.

Brahms addresses this issue with his emphasis on the 'mystery and foreboding' that will inevitably qualify any attempt at clarity, be it in music or art. Because instrumental music is both non-verbal and non-visual, it entails the highest degree of mystery among the aesthetic languages. Adorno would liken musical logic not to rational thought but to the logic of the dream; for him 'this quality as being a riddle, of saying something that the listener understands and yet does not understand, is something shared by all art.' Although Adorno agrees with Brahms that all art speaks the same language, his direct gaze into the divine light blinds his understanding of the elusive lure of mystery that produces and propels desire in the viewer.[35] In Lacanian terms, the 'lack' in the absent composer's music becomes the occasion for the pianist retroactively to 'quilt' in his own fantasy of self-representation, but on terms already demanded by the 'Big Other'. Thus the listener answers his own question — 'sonata, what do you want of me?' — by responding dialogically to the mystery and creating one's own understanding of how the music goes.[36]

Brahms also claimed that the arts shared a sense of 'foreboding'. This refers to the temporal quality of aesthetic experience itself. *Schweben*, like Beauty, like all art, is but an illusion that must come to an end. The escape into the mystery of the dream carries with it a *memento mori* foreboding of the inevitable reawakening into harsh reality.

Klinger too will follow the flight of the soul depicted in 'Accorde' with the

disillusionment of real life. This is foreshadowed by the self-reflexive role of the pianist amid his own musical dream. To see the two worlds together betrays the secret knowledge that the enchantment can be sustained only by means of wilful self-mystification. The music will run its course through the tomb and back to the light; the sun of 'Accorde' will set; the viewer will turn the page and return to mundane reality (plate 7).

On page two, the dais of Klinger's dream concert no longer hovers above the sublime waters from a vantage of safety, but rematerializes as the terrace of his roof-top studio overlooking the city of Rome, centre of the clear light of classical culture (plate 7). The piano remains abandoned in the room behind while the distraught pianist lies prostrate and dishevelled in the shadows, re-reading old love letters in the company of a spectral Cupid. The woman in white is a real person whose portrait he painted under the bright Italian sun (plate 8). Here begins the cycle of Brahms's lieder, selected and illustrated by Klinger, that charts a course of individual suffering from lost love through escapist fantasy to bitter despair. Part II of the *Brahmsphantasie* will broaden the perspective to the collective fate of man's tragic condition with a print cycle on the myth of Prometheus and Brahms's setting of Hölderlin's *Schicksalslied*.[37]

Conclusion

The reception history of Klinger's venture into musical hermeneutics demonstrates how the political issues of power and authority that surround cultural products have a profound effect on their acceptable — or even readable — meanings. Questions of class, race and gender, so apparent to the art historian, do not even appear on the musicological horizon, having been begged away by music's association with the 'Absolute'. With Brahms's wholehearted approval, Klinger divulges in the context of sophisticated high art some of the fantastic mysteries that the idealistic defenders of a phal*logo*centric music have tried for so long to keep hidden behind the skirts of autonomy. Ironically, Klinger's admission that music needs a Woman probably gave 'Accorde' and 'Evocation' their mass appeal in later years. The manly art of the Absolute, seeking to honour the Eternal Feminine in her role as aesthetic inspiration with complete seriousness, finds itself turned on its head.

Klinger lived in a time and place in which his modernist embrace of historicism found itself embattled by the challenges of late capitalism. When the *Brahmsphantasie* first appeared it commanded a price far in excess of any previous contemporary art work in the graphic media.[38] He limited the run to 150 copies and destroyed the plates in order to retain the artistic aura. But it was not long before the culture industry mechanically reproduced selected images from Klinger's *Gesamtkunstwerk* for sale at a reasonable cost. As we have seen, it is essential to Klinger's meaning that 'Accorde' be contextualized by the disillusion of page two. By itself, one sees the pianist as a divinely inspired composer of a metaphysical music, subsumed into the transcendent beauty of a love death. Thus the social and political significance of Klinger's transient allegory reifies into an ideological confirmation of a dangerous myth of German destiny.

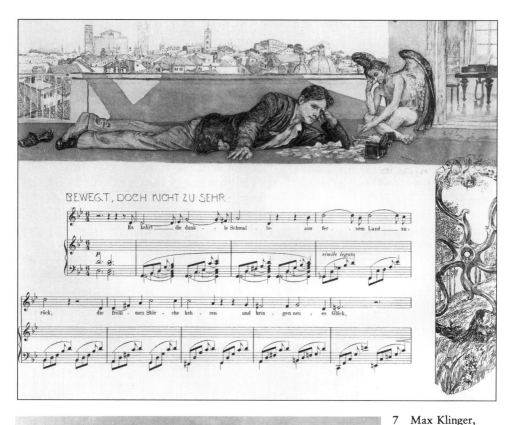

7 Max Klinger, *Brahmsphantasie*, page 2, 'Alte Liebe' ('Old Love'), etching, engraving, and aquatint, 1894. 11.2 × 35.4 cm. Museum der bildenden Künste, Leipzig.
8 Max Klinger, *Auf der Terrasse (On the Terrace)*, oil on canvas, 1891. 182 × 182 cm. Städtische Galerei im Städelschen Kunstinstitut, Frankfurt am Main.

Although the famous art critic Julius Meier-Graefe should have been able to understand Klinger's art from within its full and original context, the cultural and political crises of the first decades of the twentieth century would not allow him that luxury. Meier-Graefe, the steadfast voice of embattled Liberal cosmopolitanism, would sum up the work of the late Klinger in 1920: 'We owe to our metaphysics the world war ... burn the trash ... it is a metaphysical swindle. The only justice we can do to such people is to properly bury them.'[39]

For the most part, institutionalized musicology has resisted the turn toward the new methodologies that include a social or materialist reading of the great works, preferring instead to wallow in the bliss of the musical absolute so aptly depicted by 'Accorde'. The crisis in bourgeois music education that seemed so disastrous in Klinger's day has only been exacerbated by the jargon of academic music scholarship, the hero-worship babble of classical radio, and the continued isolation of music as somehow 'above' the other artistic and critical 'languages'. Gaining insight to the subjective operations of Romantic music remains an essential task for those of a 'Liberal' political bent in the postmodern world of today, as music is the media most mysterious in its semiotics, and thus the most powerful in its mystifications. As Schopenhauer observed long ago, aesthetic oblivion 'is only a beggar's dream, in which the beggar is king, but from which he must awake, in order to realize that only fleeting illusion had separated him from the suffering of life.'[40]

<div align="right">

Thomas K. Nelson
Minneapolis

</div>

Notes

This article is a condensation of a full-length version to be published shortly in book form; in this version I discuss at greater length the fate of Klinger's Romantic art in the postmodern world using Hampel's *Beethoven am Klavier* (plate 3) as a foil. I would like to thank Sanna Pederson, Charles W. Haxthausen and Robert Baldwin for their advice and encouragement.

1 Johannes Brahms, Letter to Klinger, 18 Oct. 1894.

2 Alma Mahler, *Gustav Mahler: Memories and Letters*, ed. D. Mitchell, 3rd ed., Seattle, 1973, p. 36.

3 As quoted in Peter Vergo, *Art in Vienna: 1898–1918*, London, 1975 (author's italics).

4 Klinger worked on the *Brahmsphantasie* concurrently with the formulation of an aesthetic theory, published as the monograph *Malerei und Zeichnung* (1st ed., 1891).

5 The two most comprehensive histories of absolute music are: John Neubauer, *The Emancipation of Music from Language*, New Haven, 1986; and Carl Dahlhaus, *The Idea of Absolute Music*, trans. R. Lustig, Chicago, 1989. See also Michael P. Steinberg, 'The Musical Absolute', *New German Critique*, 56 (Spring 1992), p. 17; and S. Miller, 'Towards a hermeneutics of music' in *The Last Post: Music after Modernism*, ed. S. Miller, Manchester, 1993,

p. 11.

6 'Sonate', *Dictionnaire de musique* (1767).

7 G.W.F. Hegel, *Aesthetics: Lectures on Fine Art*, trans. T.M. Knox, Oxford, 1975, pp. 128–9.

8 On aesthetic ideas and music, see sections 53 and 57 of the *Critique of Judgement*.

9 For an introductory discussion of the semiotics of the empty sign and further bibliography, see K. Barry, *Language, Music and the Sign*, Cambridge, 1987.

10 See Sanna Pederson, 'A.B. Marx, Berlin Concert Life and Germany National Identity', *19th-Century Music*, vol. 18, no. 2 (Fall 1994), pp. 87–107.

11 See W. Schulz, *Metaphysik des Schwebens: Untersuchungen zur Geschichte der Ästhetik*, Pfullingen, 1985. (Hegel uses the word in the quotation above).

12 The criticism of Beethoven's music by E.T.A. Hoffmann with its combination of both the

dithyrambic and analytical is symptomatic of this aesthetic.

13 Baudelaire, 'The Painter of Modern Life' (1859), as discussed in M.P. Steinberg, 'The Music Absolute', op. cit. (note 5), p. 19.

14 Studies of the cultural life in Vienna at the turn of the nineteenth century include: Carl E. Schorske, *Fin de Siècle Vienna: Politics and Culture*, New York, 1980; A. Janik and S. Toulmin, *Wittgenstein's Vienna*, New York, 1973; and A. Fuchs, *Geistige Strömungen in Österreich: 1867–1918*, Vienna, 1949. Art historians have seen a plethora of books and exhibition catalogues on this period, including those by W. Johnston, J. Kallir, H. Spiel, K. Varnedoe, P. Vergo, R. Waissenberger and many more. Of these the most relevant to the period of Liberal aesthetic culture is L. Botstein and L. Wientraub (eds.), *Pre-Modern Art of Vienna, 1848–1898*, Detroit, 1987. Studies of the politics of music for this period include: C. Floros, *Brahms und Bruckner: Studien zur musikalischen Exegetik*, Wiesbaden, 1980, pp. 30–4; M. Notley, 'Brahms as Liberal: Genre, Style and Politics in Late Nineteenth-Century Vienna', *19th Century Music*, vol. 17, no. 2 (Fall 1993), pp. 107–23; L. Botstein, 'Brahms and Nineteenth-Century Painting', *19th Century Music*, vol. 14, no. 2 (Fall 1990), pp. 154–68.

15 Klinger too hailed from a cultural background that was essentially Liberal; but he remained an unpolitical man, describing himself as a 'political pessimist'.

16 L. Botstein, 'Listening through Reading: Musical Literacy and the Concert Audience', *19th Century Music*, vol. 16, no. 2 (Fall 1992), p. 144.

17 See Richard Leppert, *The Sight of Sound: Music, Representation and the History of the Body*, Berkeley, 1993.

18 See Eduard Hanslick, *On the Musically Beautiful*, trans. G. Payzant, Indianapolis, 1986. The fifth chapter is entitled 'Musical Perception: Aesthetic versus Pathological'. Kant also associates the pathological with the sensuous 'Agreeable'.

19 See Notley, 'Brahms as Liberal', op. cit. (n. 14), p. 108.

20 See P. Gay, 'Aimez-Vous Brahms?' in *Freud, Jews and Other Germans*, New York, 1978.

21 C. Dahlhaus, *Nineteenth-Century Music*, trans. J. Robinson, Berkeley, 1989, p. 271.

22 Heinrich Schenker, a Viennese music theorist (1868–1935), developed the idea of the *Ursatz*, or 'primal [musical] thought' as the metaphysical chord of nature from which a composition unfolds in purely musical terms. The 'developing variation' is Schoenberg's way of explaining Brahms's musical logic.

23 Dahlhaus, *Idea of Absolute Music*, op. cit. (note 5), p. 123.

24 'Accorde' could almost be a rendering of the passage from Hegel quoted above.

25 Roland Barthes has written convincingly of the

jouissance of playing the piano, particularly the repertory found in Klinger's piano bench. See 'Musica Practica' and 'Loving Schumann' in *The Responsibility of Forms*, New York, 1985, pp. 261 and 295.

26 The German word for the musical 'scale' of notes is *Tonleiter*. There is a long iconographical tradition associating scales, ladders (Jacob's ladder) and consecutive strings of the harp or lyre (the piano shares this construction) with the chain of being from mundane to divine. The music of the spheres partakes of this tradition. Of the three principle icons of 'Accorde' — the tomb, the storm-tossed boat and the harp — the last enjoyed the richest heritage. Wackenroder would compare the *Harfensaiten* (harp strings) to *Herzensfibern* (heart's fibre).

27 'Monotonality' refers to the controlling influence of a single key for an entire composition.

28 See J.C. Jensen (ed.), *Brahms-Phantasien: Johannes Brahms — Bildwelt, Musik, Leben*, Katalog der Kunsthalle Keil, Holsten, 1983, pp. 51–2.

29 The quotation is Heinrich Schenker's pronouncement in the dedication of his book, *Beethoven's Ninth Symphony* (1912).

30 Besides the *Brahmsphantasie*, Klinger produced a large sculpture of Brahms which deifies the composer by showing him in contact with the spirit world.

31 *Nineteenth-Century Music*, trans. J.B. Robinson, Berkeley, 1989, p. 254.

32 The single exception appeared recently among the illustrations to: Ursula Kersten, *Max Klinger und die Musik* (Frankfurt am Main, Peter Lang: 1993). Inexplicably, 'Evocation' is moved from its location as introduction of part II to serve as pendant to 'Accorde'; the Prometheus cycle is missing entirely.

33 Letter from Brahms to Klinger, 12 December 1893, in *Johannes Brahms an Max Klinger*, Leipzig, 1925, p. 7 (author's translation).

34 In his treatise *Malerei und Zeichnung*, Klinger specifically associates graphic art with poetry and piano music (ed. A. Hübscher, Leipzig, 1985, p. 37).

35 T. Adorno, 'Music, Language and Composition', trans. Susan Gillespie, *Musical Quarterly* (1994), p. 410 (translation modified). Favouring Walter Benjamin, Steinberg offers a critique of Adorno's pessimistic foreclosure of the paradox of musical language into the tragedy of a blind immediacy. See 'The Musical Absolute', op. cit. (note 5). See also L. Kramer, *Classical Music and Postmodern Knowledge*, Berkeley, 1995, pp. 14–19.

36 An excellent introduction to the Lacanian psychoanalysis of ideology can be found in the work of Slavoj Žižek, in particular, *The Sublime Object of Ideology*, London, 1989.

37 A similar effect of disillusionment can be found in Brahms's *Fantasien*, opus 116 (1892), a piano cycle of seven miniatures: the page turns from

the affirmative ecstatic vision of no. 4 to the
alienation of no. 5.

38 See Max Klinger, *Malerei und Zeichnung*,
'Vorwort' by A. Hübscher, pp. 6–7.

39 'Max Klinger' in *Ganymed*, 2 (1920), pp. 130–5.

40 *Die Welt als Wille und Vorstellung*, trans. E.F.J.
Payne, New York, 1969, section 63, p. 352.
Klinger read Schopenhauer extensively, and
offered to guide his friends' reading.

Art History ISSN 0141-6790 Vol. 19 No. 1 March 1996 pp. 44–73

Klimt's Beethoven Frieze:
Goethe, *Tempelkunst* and the fulfilment of wishes

Clare A.P. Willsdon

When it went on show as part of the Vienna Secession's *Beethoven* exhibition of 1902, Klimt's frieze (plates 9–15) seems to have been as puzzling to his friends as to his foes. Edward Pötzl of the popular Viennese paper *Moderner Gschnas* dismissed it as fit only to adorn the female section of an Assyrian swimming bath, but even the Secession's loyal supporter Ludwig Hevesi, who hailed it as 'a pinnacle of modern decorative painting',[1] remarked: 'Klimt imagined mankind's yearning for happiness. Or something of the kind, it should be added, because you are not supposed to understand allegories completely.'[2] More recently, Vergo has commented that 'The reasons for the artist's choice of subject matter are somewhat obscure,'[3] whilst Klimt himself, notorious for his taciturnity and 'writing shyness', seems to have left no exposition. As he said,

> I am fluent in neither the spoken nor the written word, and certainly
> not when I am supposed to express something about myself or my art
> ... Whoever wishes to know something about me — as an artist, the
> side of me which alone is worth considering — should look at my
> pictures attentively and try from them to recognise what I am and what
> I intend.[4]

Salvaged by Schiele and others after the exhibition, the Beethoven frieze found its way into Wittgenstein's important Klimt collection, and today, following conservation, is now re-installed in Olbrich's Secession Building, for which it was originally created. Various commentators have attempted to interpret its enigmatic iconography, including Bisanz-Prakken and, more recently, J.-P. Bouillon,[5] but they have all returned to the association between the frieze and Beethoven's setting of Schiller's *Ode to Joy* in his Ninth symphony, which is made in the catalogue of the *Beethoven* exhibition, as the primary clue to its meaning. Whilst the final, *Kiss* section of the frieze was certainly identified in the 1902 catalogue with the words 'Freude, schöner Götterfunken' and 'Diesen Kuss der ganzen Welt' from Schiller's poem, Klimt's mural does not actually show a kiss, as would be unambiguously illustrated in his later easel versions, but instead an embrace, and this section of the frieze indeed reveals further anomalies when set beside the *Ode to Joy*. Likewise, the remainder of the frieze iconography offers no apparent connections with the Schiller poem at all.

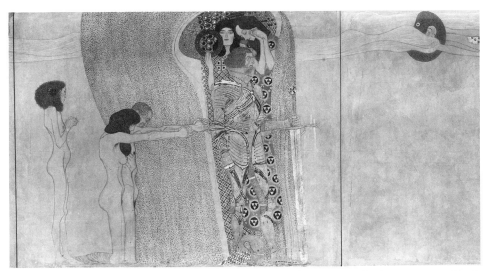

9 Gustav Klimt, Beethoven Frieze: detail showing mankind's *Yearning for happiness* (overhead floating figures); *The sufferings of weak mankind* (standing and kneeling figures at left); *The strong one in armour*, accompanied by *Compassion* and *Ambition*. Casein paint and other media, left-hand wall of left hand room in *Beethoven* exhibition, 1902.

Given the extraordinarily rich cultural context of pre-1914 Vienna in which Klimt moved and worked, and where his intimates included Gustav Mahler, widely connected artists like Karl Moll and Josef Hoffmann, and men like Max Burckhard, the Nietzsche-worshipping director of the Burgtheater, any assessment of the Beethoven frieze clearly needs to take account of the complex ferment of ideas which would have surrounded its genesis and shaped the attitudes of its viewers. In this situation Bisanz-Prakken and other writers have, not surprisingly, looked primarily to Klimt's close artistic contemporaries, such as Klinger, Hodler and Rodin, and to the rise of Wagner's notion of the *Gesamtkunstwerk* (total work of art) during the later nineteenth century, in order to find insight into Klimt's ideas and the purpose of his frieze within the multi-media *Beethoven* exhibition.

This article explores the extent to which more far-reaching roots of inspiration for the frieze can be found in late eighteenth- or early nineteenth-century Romantic sources, in particular the work of Goethe, which was highly regarded by both Wagner and Klimt's contemporaries Nietzsche, Freud and Mahler. Seen from this longer perspective, a number of very specific meanings emerge from Klimt's iconography, which in turn reveal fascinating links with Mahler's music and Freud's psychological investigations, and allow us to place the frieze at the apex of a Romantic revival in early twentieth-century Vienna, for which Wagner and Nietzsche had paved the way. Klimt's reluctance to provide an interpretation of his work is, in fact, a close echo in relation to visual art of an observation made by Goethe in response to questions about his dramatic poem 'Faust'.[6]

From the exhibition's catalogue it is clear that the frieze, occupying the upper level of three walls in the first room of the tripartite display (plates 14 and 15), was

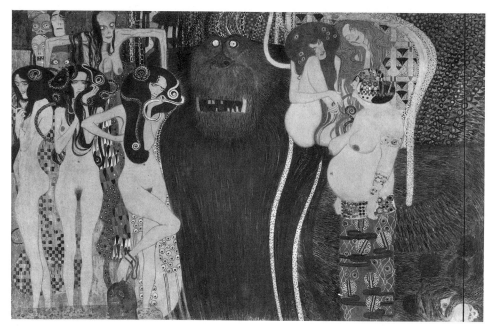

10 Gustav Klimt, Beethoven Frieze: detail from *The Hostile Forces* showing *Typhoeus* (centre); *The Three Gorgons* (left); *Disease, Madness, Death* (above left); *Intemperance* (right); *Sensuality* and *Lechery* (above right). Casein paint and other media, centre back wall of left-hand room in *Beethoven* exhibition, 1902.

part of a 'homage' from the Viennese to their German colleague Max Klinger, whose polychrome sculpture of Beethoven (plates 16 and 17) stood in the central room as the focus of the show. The first part of the frieze (plate 9) illustrates man's *Yearning for happiness* in the form of female personifications gliding through the air; a kneeling man and woman who are the *Sufferings of weak mankind*; and their appeal to 'the strong one in armour as the outer force and to compassion and ambition as the inner forces compelling man to take up the struggle for happiness'.[7] Compassion and Ambition are two women who stand behind the knight in armour. On the second, short wall are the *Hostile Forces* against whom the knight must fight and who include: 'the giant Typhoeus ... his daughters, the three Gorgons. Disease, Madness, Death. Sensuality and Lechery. Intemperance [plate 10]. Gnawing sorrow (or care) [plate 11]'. Above these figures, escaping from them, are again portrayed the wishes, or 'yearnings and longings of mankind', whilst on the third wall are Poetry (a figure with a golden lyre [plate 12]) and the Arts (plate 13), the agents of the Wishes' victory. The finale is a 'Choir of angels in Paradise' (plate 13) and an embracing couple; these are the groups named in the exhibition catalogue with the quotations from Schiller's *Ode to Joy*, 'Freude schöner Götterfunken' and 'Diesen Kuss der ganzen Welt'.[8] The frieze thus becomes a tribute to Beethoven who set this poem in the final movement of his Ninth symphony, and a condensed arrangement of part of this movement was made by Mahler and performed alongside Klimt's frieze by wind instruments under his direction. The frieze thus acted in fulfilment of the

46

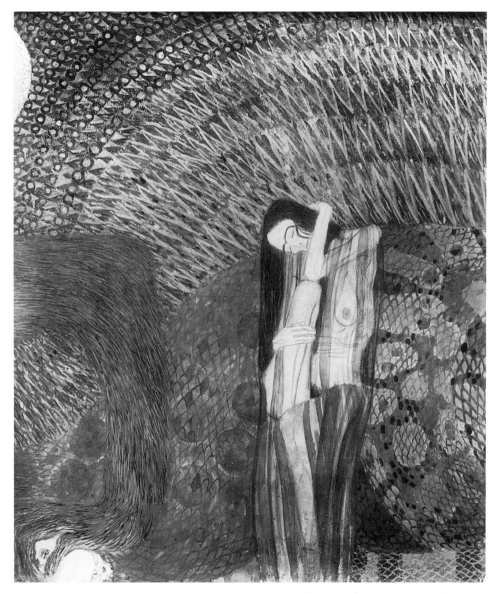

11 Gustav Klimt, Beethoven Frieze: detail from *The Hostile Forces* showing *Gnawing Sorrow* with part of one of Typhoeus's wings, his right hand holding a skull, and part of a snake. Casein paint and other media, centre back wall of left-hand room in *Beethoven* exhibition, 1902.

Secession's desire to make of the exhibition a form of modern 'temple art',[9] in which painting and sculpture worked together along with Mahler's music, 'in the service of the idea of the room'.[10]

This *Gesamtkunstwerk* was a realization of the principle spelled out by the German author and critic Dr Ricarda Huch in an article in the Secession's journal *Ver Sacrum* in 1898 on earlier nineteenth-century Romanticism: '... for ... the Romantic — or let us say artist or idealist — [the world] exists and signifies

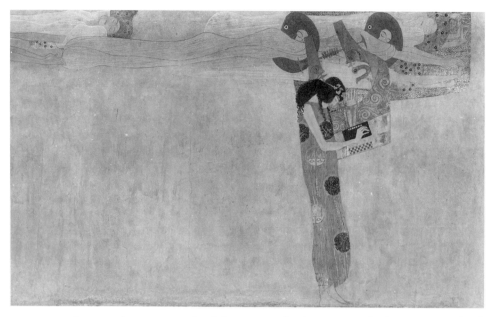

12 Gustav Klimt, Beethoven Frieze: detail showing mankind's *Yearning for happiness* (overhead floating figures) and *Poetry* (the figure with the lyre). Casein paint and other media, right-hand wall of left-hand room in *Beethoven* exhibition, 1902.

simultaneously',[11] and accordingly, 'Painting ... should expand its sphere; overflow into the neighbouring arts of music and poetry.'[12]

Huch's emphasis on what she termed 'symbolism of a hundred years ago'[13] is of greater relevance to Klimt's work, and in particular his Beethoven frieze, which of course deals with a theme from this era, than has hitherto been realized. Although the *Gesamtkunstwerk* concept is nowadays recognized as having been developed above all by Richard Wagner, and writers on Klimt such as Bisanz-Prakken have accordingly proposed Wagner's essay on Beethoven as Klimt's sources of inspiration,[14] close examination of the iconography of the frieze reveals remarkable correspondences with the Romantic source upon which Wagner himself drew in writing about Beethoven: Goethe's *Faust*. At the same time, these correspondences are notably different from the parallels which Wagner drew between *Faust* and the dramatic structure he perceived in Beethoven's Ninth symphony, and suggest that Klimt turned to *Faust* directly to evolve his own, highly distinctive synthesis of poetical and musical allusion. This meets exactly the 'Goal of the modern artist ... to embrace and give expression to the spirit of several arts in one',[15] and it is revealing that Huch's article had been illustrated with reproductions of Klimt's pictures which harmonized with the Romantic ideas she had discussed. Klimt's inspiration from *Faust* can in turn be shown to offer fascinating links with the ideas of Nietzsche, whose writings were significantly inspired by *Faust*.

Klimt himself was recorded by Alma Mahler, the wife of the composer, as always carrying in his coat pocket a copy of *Faust*,[16] and she also recollected how in 1906, when Mahler was setting the final scene of *Faust* II in his Eighth

48

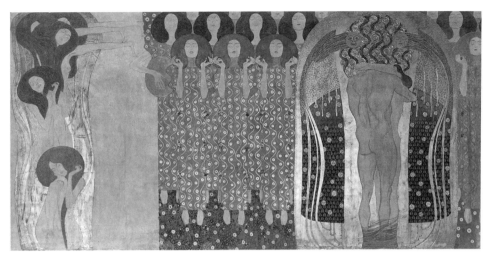

13 Gustav Klimt, Beethoven Frieze: detail showing *The Arts* (far left); the *Choir of Paradise Angels (Freude schöner Götterfunken)* (at centre and far right); and the embracing couple (*Diesen Kuss der ganzen Welt*; at right). Casein paint and other media, right-hand wall of left-hand room in *Beethoven* exhibition, 1902.

symphony, 'a much-thumbed volume protruded from his coat pocket: it was *Faust*'.[17] Mahler's features were portrayed by Klimt as the 'strong one in armour' of the frieze (plate 9), and although Bisanz-Prakken has proposed that he was responsible for guiding Klimt in its iconography,[18] the possibility of *Faust* II having been the source for this does not appear to have been considered, somewhat surprisingly, by either her or by other writers on Klimt or Mahler. Mahler's friend Dr Horn wrote of him 'Goethe and apples are two things he cannot live without'[19] and Mahler made many specific references to Beethoven's Ninth symphony in the musical fabric of his Eighth. He also wrote of the relationship which he perceived between *Faust* and Beethoven:

> [*Faust's*] truth shows a different face to each of us — and a different one to each of us at different ages; just as Beethoven's symphonies are new and very different at every hearing and never the same to one person as to another.[20]

A closer look at the iconography of the frieze prompts the question of how far Mahler's ideas may have been shaped by his participation in the Secession's Beethoven exhibition, and by Klimt's contribution in particular.

There are a number of hints in the catalogue description that Schiller's *Ode to Joy* is not the entire explanation of Klimt's subject and that his contemporary Arthur Roessler was thinking of *Faust* when he called the frieze a work which 'like so many of Goethe's poems expanded far beyond the meaning of the object which served as its actual motive ...'.[21]

The aim of man's yearnings and wishes is *Glück* (happiness), for example, a word which is entirely absent from the Schiller *Ode to Joy* ('*An die Freude*'). Where *Freude* occurs in the catalogue description, it is significantly in conjunction

with *Glück*, and it is *Glück* which features prominently in the conclusion of *Faust II* (the portion of the play which Mahler was to set in his Eighth symphony), as the state of ecstatic reunion achieved by Faust and Gretchen after their redemption from sin by angels scattering roses. Gretchen pleads of the Mater Gloriosa (the Virgin Mary),

> Ah, look down
> Thou rich in heaven's renown,
> Turn thou the grace of thy dear face
> On the fullness of my bliss [*Glück*].[22]

When he exhibited the frieze again in 1903, Klimt replaced the two Schiller quotations, 'Freude schöner Götterfunken' and 'Diesen Kuss der ganzen Welt', which had originally been appended to its final section, with the Biblical quotation 'My Kingdom is not of this world.' This had been used by Wagner in his Beethoven essay but, as we shall see, there is a gamut of Faustian allusion in this final section of the frieze which makes it entirely natural that Klimt should have chosen the quotation as a specific commentary on the theme of Faust and Gretchen's Christian redemption, and that the exhibition catalogue should have called the show '*Tempelkunst*' with 'the blessing of work which has destiny and purpose'.[23]

Tempelkunst and the interrelationship of the arts

Whilst, as Bisanz-Prakken has pointed out, 'every educated person was familiar with Nietzsche's philosophy' in turn-of-the-century Vienna,[24] Klinger in particular was a keen disciple of the German writer.[25] Like Wagner, Nietzsche believed in the integration of the arts, but had come to feel, in contrast to the composer, that music was pre-eminent amongst them rather than merely the servant of drama, because it pointed to realms beyond conscious understanding.[26] This belief is adumbrated in his *Birth of Tragedy from out of the Spirit of Music*, and it is in this book that we find a startling prefiguration of the *Ode to Joy* section of Klimt's frieze, when Nietzsche, trying to explain his principle of 'Dionysian' creative power, commands:

> Change Beethoven's 'jubilee-song' into a painting, and, if your imagination be equal to the occasion when the awestruck millions sink into the dust, you will then be able to approach the Dionysian. Now is the slave a free man Now, at the evangel of cosmic harmony, each feels himself not only united, reconciled, blended with his neighbour, but as one with him ... before the mysterious Primordial Unity ... he feels himself a god Man is no longer an artist, he has become a work of art Ye bow in the dust, oh millions? / Thy maker, mortal, dost divine?[27]

Nietzsche's vision here of a 'Primordial Unity' finds a resonance in Klinger's use of the term *Allkunstwerk* (comprehensive, all-embracing work of art) rather than the

Wagnerian *Gesamtkunstwerk* (co-ordinated work of art),[28] whilst the lines Nietzsche quotes from Schiller's *Ode to Joy* are precisely the same part of the finale of Beethoven's Ninth symphony that Mahler arranged for the exhibition. To celebrate music was, of course, Klinger's purpose in creating his *Beethoven*, which in turn the Secession artists wished to venerate through their exhibition. A clearly Nietzschean emphasis on music is likewise apparent from the exhibition catalogue's description of Josef Hoffmann's task in coordinating the show as 'sounding the great chord out of the simplest of means'.[29]

Because he felt music was greater than picture, word or drama (although it might draw upon them, as in Beethoven's setting of Schiller's ode in the Ninth symphony), Nietzsche regarded it as 'Dionysian'. It was able to 'make the spirit free, give wings to thought';[30] its highest form, moreover, was *monologische Musik*[31] — music with the character of a monologue. The supreme exponent of such music, he argued, was Beethoven, and his description of Beethoven's work is, from the point of view of the *Beethoven* exhibition, highly intriguing. He called it a 'sounding-out of its own accord of the deepest solitude' (*Von-selber-Ertönen der tiefsten Einsamkeit*)[32] — a phrase which directly echoes the opening of Faust's great monologue atop the 'Mountain Heights' at the start of Act IV of *Faust II*: 'downgazing here I view the deepest solitude' (*Der Einsamkeiten tiefste schau ich unter meinem Fuss*).[33] Nietzsche regarded Goethe, like Beethoven, as a great 'Dionysian'; and it was in turn this very line from *Faust II* that Klinger originally inscribed on the pedestal shaped like a mountain crag of his Beethoven statue, and which, as we shall find later in this discussion, stands at a pivotal point in the play, because it looks forward to Faust's redemption and reconciliation with Gretchen.

The idea of solitude as the pre-requisite of the creativity and transcendence of the heroic victor or, in Nietzschean terms, 'superman',[34] is implicit in Faust's monologue and the motive principle in Nietzsche's *Also Sprach Zarathustra*.[35] It is also, of course, readily identifiable in the solitary knight's confrontation with, and triumph over, the *Hostile Forces* in Klimt's frieze. As Klimt gave Mahler's features to this knight, the modern composer's lone struggles with the Viennese critics were soon associated by viewers with this episode in the frieze. Klimt clearly posited a chain of inheritance from Beethoven, since the year 1902 marked the centenary of Beethoven's Heiligenstadt Testament. In this, the composer's anguish at his 'life in solitude' caused by deafness is assuaged by his recognition that 'art' has been his salvation, and by his hope that confession of his ailment will enable the 'world [to] be reconciled with me after my death'.[36]

The 'allegorical' nature of the Beethoven frieze can be recognized as the direct complement to 'the Romantic belief that music utters the ineffable'.[37] Nietzsche's view of the supremacy of music lay in direct succession to earlier nineteenth-century views such as Goethe's own, that music was, of all the arts, the one which ranked 'so high that no understanding can reach it ... it is one of the best means to have an effect on man';[38] in turn, allegory had likewise become for the Secession artists a medium of entry into the subconscious and into 'states of mind', as Hans Bisanz has demonstrated with regard to Klimt's *Allegorien* designs of the 1890s.[39] In her *Ver Sacrum* article on German Romanticism, Huch had

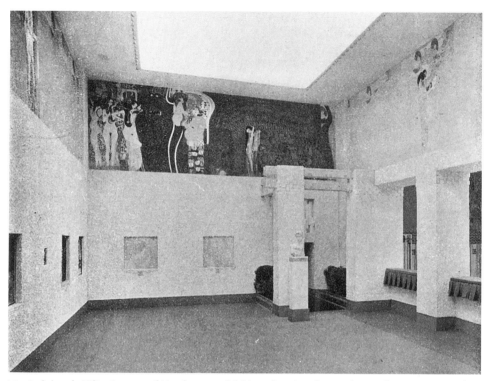

14 Left-hand, 'Klimt' room of *Beethoven* exhibition showing the Beethoven frieze *in situ* and a glimpse through to the centre room of the exhibition where Klinger's *Beethoven* statue was placed. Photograph of 1902.

illustrated one of these and argued that 'when allegory crosses over into the realm of reason, it leaves the territory of art'.[40]

In seeking to pay homage to Beethoven via Klinger and by means of a 'great chord' of painting, sculpture and architecture, accompanied by Mahler's music, the Secession was appropriating to the visual arts what was felt to be a prerogative of music, and a time-honoured device of literature. In particular, the exhibition's 'great chord' and Klimt's inclusion of the sun and moon behind the embracing couple in the *Ode to Joy* section of his frieze (plate 13) clearly paid tribute to the Pythagorean notion of the 'music of the spheres' which Neubauer has shown to have been a key inspiration to the Romantic concept of music as the route to deeper truths and feelings than could be expressed in thought or word.[41] As we shall see, it is perhaps not so much the 'rhythmic' spacing of the pictorial composition identified by Bisanz-Prakken[42] which makes Klimt's frieze 'musical', but rather its character as 'allegory ... you are not supposed to understand'. Goethe's *Faust* II was recognized as one of the great examples of allegorical literature,[43] with its famous lines, commenting on Faust's redemption,

> All things corruptible [i.e. transient]
> Are but a parable.[44]

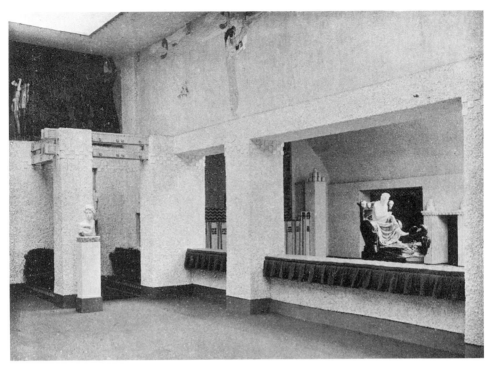

15 Section of 'Klimt' room in *Beethoven* exhibition, designed by Josef Hoffmann, and showing
part of the Beethoven Frieze (*Hostile Forces* to left and *Poetry* to right), with the view through to
Klinger's *Beethoven* statue in the central room. Beyond *Beethoven* one of the exhibition's
fountains can be seen as a dark recess in the wall; and behind the statue, part of Alfred Roller's
Falling Night mural. Photograph of 1902.

We can begin to understand why the performance, in conjunction with the
'allegorical' decorations by Klimt and his colleagues, of Mahler's arrangement of
the very section of Beethoven's Ninth symphony which had been cited by
Nietzsche in his call for a painting of its *Ode to Joy*, should have had the profound
psychological effect described by Alma Mahler in her recollection of the
exhibition's opening:

> All the walls were ... decorated with allegorical frescoes and in the
> middle Max Klinger's Beethoven statue was to be installed ... [Mahler]
> arranged the Chorus 'Ihr stürzt nieder Millionen? ...' for brass
> instruments alone, practised it with the brass from the Court Opera
> orchestra, and conducted the chorus, which, performed by such
> instruments in this way, rang out with the strength of granite. Shy Klinger
> entered the room and stood there as if rooted to the spot when these
> sounds came down from above. He could not restrain his emotion, and
> tears slowly ran down his face.[45]

More briefly, but no less tellingly, the *Neue Freie Presse* called the exhibition
'hypnotic'.[46]

The *Tempelkunst* of which Klimt's frieze formed such a crucial part was of a very different order from the conventional artistic *Huldigung* (homage)[47] of the kind created, for example, by Klimt's early mentor Makart in the 1879 *Huldigungsfestzug* (pageant of homage) for the Emperor Franz Josef on his silver wedding anniversary. Klimt celebrated not a temporal, but a spiritual 'Reich' as he made clear when he renamed the final *Kiss* section of his Beethoven frieze after the close of the exhibition, when it had to stand as an independent work of art without the explanatory context of the Beethoven theme, using the Biblical quotation 'Mein Reich ist nicht von dieser Welt' ('My Kingdom is not of this world'). Here we can recognize Huch's idea that the artist, by means of allegory and symbol, seeks not to portray 'the world as we are used to seeing it ... but instead as a transparent envelope for something eternal'.[48] Here also is the sequel to Klimt's 1895 'Allegory' *Love*, which anticipates the *Kiss* image of the frieze as well as its *Hostile Forces* iconography;[49] and to Beethoven's supposed belief that music offered 'entrance into the higher world of knowledge ... which mankind cannot comprehend'.[50] For us to seek what Klinger termed the 'allegorical or specifically symbolic foundation' upon which the 'destiny and purpose'[51] of the Beethoven exhibition's *Tempelkunst* were intended to rest is, in this context of thought, perhaps to risk comparison with the sort of people whom the Secession sympathizer and poet Hugo von Hofmannsthal likened to 'Apes, which keep on putting their hands behind a mirror, as if *there* must be found a body to touch'.[52] The gigantic ape Typhoeus, chief of the *Hostile Forces* in Klimt's frieze, indeed seems to offer a ready counterpart to Hofmannsthal's mocking metaphor, and a warning that 'you are not supposed to understand allegories completely' (plate 10).

Yet, if we take Klinger's statement in the exhibition catalogue that the creation of a 'spiritually' unified work of art, whether an individual item or a 'total interior', requires a 'purely poetic use of the materials',[53] and look at the two quotations from poetry which he originally inscribed on his Beethoven statue, we discover that the ape is but part of a complex sequence of allusions to Goethe's *Faust II*; and that the Christian dimension revealed through Klimt's re-titling of the *Kiss* section of his frieze is already implicit within this. *Tempelkunst*, in fact, involves a Goethean reconciliation of the Classical and Christian worlds, and a synthesis of Nietzschean influences with Wagner's concept of Beethoven as a 'Christ-like redeemer'.[54]

Klinger's Beethoven statue and the interpretation of Klimt's frieze

Because he wanted to make a 'purely poetic use of the materials' rather than to imitate poetry — to adopt its methods rather than copy it — Klinger presumably decided to omit from the final version of his *Beethoven* the two quotations from Goethe which it originally bore.[55] One of these, 'Whoever dares must suffer', was from Goethe's *Epigrammatisch* and was placed on the back of Beethoven's throne, whilst on the mountain crag upon which the throne itself stands, was written the line which opens Act IV of *Faust II* as the beginning of one of Faust's most important monologues, which we met earlier as the source for Nietzsche's belief in

54

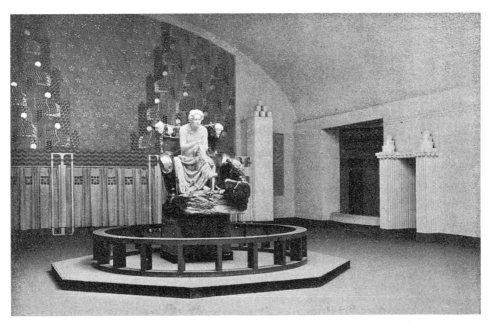

16 Part of the central room of the *Beethoven* exhibition, designed by Josef Hoffmann, and showing Klinger's *Beethoven* statue with Alfred Roller's mural of *Falling Night* behind it, and one of the fountains to the right of it in the wall recess. Photograph of 1902.

the supremacy of Beethoven's 'Dionysian' music: 'Downgazing here I view [beneath my foot] the deepest solitude.' This offered the motive for Klinger's portrayal of Beethoven as a solitary, striving individual enthroned high upon a rock, far above the mortal world, and with an implied abyss at his feet (plate 16). His hands are clasped in tension; his features, loosely modelled on Beethoven's life mask, are determinedly focused on some distant sight (plate 17).

At the start of Act IV of *Faust* II, Faust appears on 'Mountain Heights' as he steps from out of a cloud 'on an overhanging ledge' and atop 'a mighty summit of jagged rocks'.[56] As the cloud rolls away eastwards, he projects into its shape the love he has lost, seeing first the form of Helen, the perfect woman of Greek antiquity, after whom he has striven earlier in Part II, and then that of Gretchen, the unassuming German girl who had won his affection in Part I with such tragic consequences. He dreams that the cloud-vision bears away 'all that's best within my soul',[57] recognizing that Gretchen offered him true love and goodness. At this point, the evil Mephistopheles appears, the devil to whom he had sold his soul at the start of the play. He rudely shatters Faust's meditative contemplation which has afforded the latter a glimpse, however fleeting, of the redemptive powers of the highest form of love; of the pure love of homely Gretchen, a real woman as opposed to the ideal perfection of the mythical Helen. As Trunz points out, 'In this way, this monologue anticipates the conclusion of the whole work',[58] where Faust's soul — despite his pact with the devil — is saved by Gretchen's love, when her intercession for him achieves his redemption by angels acting on behalf of the 'Eternal Womanly'. We can now understand why, just as Faust sees Gretchen in the eastwardly moving cloud, so in the *Beethoven* exhibition Klinger's *Beethoven*

17 Detail from Max Klinger's
Beethoven statue. Marble, bronze,
ivory and other media, 1902.

faced Adolf Böhm's mural of *Dawning Day* on the opposite wall of the central
room. This showed maidens bearing flaming torches amidst a snaking wisp of
cloud (Faust on the mountain top sees Gretchen as a cirrus cloud, rather than
Helen who is a cumulus one) and accompanied by angels. On the wall behind the
Beethoven statue was a mural by Alfred Roller representing *Falling Night* (plate
16); both clearly provided a pictorial allegory of Faust's critical position at this
transitional moment in the play, as well as, at a further allegorical level, hinting at
the 'music of the spheres' concept and its perceived connection with Beethoven's
music, the language of the infinite and ineffable.

This interruption of Faust's moment of revelation throws the scene into a
grotesque subversion of the Temptation of Christ, as Mephistopheles taunts Faust
to avail himself once more of satanic powers to achieve his innermost desires.
Alluding to Matthew IV, he asks Faust:

> Did nothing charm you in our upper sphere?
> For there you saw, in pageant wide unfurled,
> The glory of the Kingdoms of the World.
> For you, with your insatiate mind
> Was there no tempting joy to find?[59]

Despite his glimpse but a moment before of the redemptive power of love, Faust
succumbs to Mephistopheles's offer of 'the glory of the Kingdoms of the World'.
Confessing his ultimate ambition to alter the course of the very waves of the
sea —

56

To soar beyond itself aspires my soul:
Here would I strive and this would I control — [60]

he dons knightly armour and takes advantage of Mephistopheles's dark powers to win victory in a battle which effectively makes him master of the seas. Already we can begin to identify imagery in this sequence of action which relates to Klimt's frieze, whose final *Kiss* section was subsequently entitled *My Kingdom is not of this world* and in which the hero wears armour and has 'longings and wishes' personified as undulating, almost wave-like beings. Before we follow these associations further, however, we need to look a little more closely at the implications of Klinger's allusion to this section of *Faust II* in relation to the exhibition's Beethoven theme.

Faust's submission to temptation in Act IV is the climactic phase of his relationship with the satanic Mephistopheles, and it leads inexorably to Faust's death. The very fact that he 'strives', however, permits his salvation through divine grace in the finale of the play in Act V, where angels from Paradise rescue his 'immortal part', explaining as they do so that

... he whose strivings never cease
Is ours for his redeeming.[61]

By identifying Beethoven with Faust in this way, Klinger created a figure who is God-like (enthroned above the world and accompanied by the eagle of St John, who is himself portrayed on the back of the throne), yet also fallible; a figure who is in need of redemption as much as one who offers it via the Ninth symphony. The sculpted angel heads which surround him act as a conventional inspirational host and as reminders of the angels who will save him. Klinger's interpretation of Beethoven can perhaps best be understood in the context of his admiration for Nietzsche, who had argued by reference to *Faust* in his *Birth of Tragedy* for 'the necessity for crime imposed upon the titanically striving individual'.[62] This, in turn, is an echo of Goethe's belief that precisely because music 'ranks so high that no understanding can reach it', it must 'contain something demonic'.[63]

Klinger's illustration of a confrontation between Biblical and Classical characters on the back of Beethoven's throne can be read as a Goethean 'struggle' to reconcile their traditionally contrasted worlds, just as elsewhere in the exhibition Ferdinand Andri's *Manly Courage and Battle* mural, and that by J.M. Auchentaller of the *Schöner Götterfunken* of Schiller's *Ode to Joy* (both featuring nudes), would have provided a 'classical' opposite to Klimt's frieze. If we turn to Klimt's iconography, we can now understand why its final *Kiss* section is not only an illustration of the Schiller *Ode to Joy* set to music in Beethoven's Ninth symphony, but also, at a deeper level, a portrayal of the conclusion of *Faust II* in which the striving spirit is saved by Gretchen and reunited with her after death by the intervention of the singing angels and the 'Eternal Womanly'. Klimt's renaming of this section with the phrase 'My Kingdom is not of this world' is not merely an allusion to words used by Wagner,[64] but, more specifically, a decisive rejection of the 'Kingdoms of this world' which Mephistopheles offered and obtained for Faust in the previous act of the play.

Faust II and the iconography of the *Kiss* section of the Beethoven frieze

Far from being a literal illustration of Goethe's poetic drama, Klimt's frieze offers a richly suggestive 'allegory' of its action. Let us look first at its final section, labelled with quotations from Schiller's *Ode to Joy* and showing the embracing couple against a backdrop of Paradise angels scattering roses (plate 13). Hodler's painting *The Chosen One* (1903, Karl Ernst Osthaus Museum, Hagen) has often been cited as its source,[65] but it is surely significant that where Hodler's angels have their lips closed and simply *hold* roses, Klimt's are visibly singing and allow their roses to drop to the flower-covered ground, just as in Goethe the chorus of angels explain the means whereby they have wrested Faust's *Unsterbliches* (immortal part) from the grip of Mephistopheles the devil:

> From fair sinners' hands these flowers,
> Roses we have scattered wide;
> Thus they made the victory ours,
> Penitent and purified;
> Flowers this soul, this prize have won us:
> Fiends, as we strewed, would flinch and shun us;
> Devils fled, dismayed, sore-bitten.[66]

The effect of the redemptive rose petals on Mephistopheles is conveyed by his calling himself

> ... Like Job, the man seen whole,
> With boil on boil, and sick of his own soul[67]

and this reference suggests that Klimt was looking primarily to Blake's *When the Morning Stars Sang Together*, an illustration to *Job*, rather than to Hodler's picture. Sources in Blake have been identified for other works by Klimt[68] and the clearly singing lips and closely serried arrangement of the angels — features absent from Hodler's picture — are further aspects of the *Morning Stars* which are directly echoed in the frieze and which, like Blake's morning symbolism, reinforce its Faustian overtones. For when Faust and Gretchen meet again in heaven, it is in the context of dawning light and as angels close ranks around them. The penitent Gretchen asks the audience to

> See, how he breaks from bonds of earth
> With every shackle shed at length,
> And ether's raiment of new birth
> Reveals his prime of youthful strength.
> Grant me to teach and guide him here,
> Him dazzled by new shining day.[69]

Spiritual and actual illumination are fused in the poetic imagery and Klimt correspondingly enwraps his embracing couple with a golden envelope which ripples into sinuous ribbons as if the shimmering 'ether's raiment'. Behind their

heads he places a golden, sun-like disc, itself composed of multiple whorl shapes but, just as Faust is blinded, so the male figure in the frieze turns inwards to the woman so that he does not actually see it. Both this 'sun' and the sun and moon emblems above the embracing couple bring to mind not only the 'music of the spheres' already discussed, but also the Mater Gloriosa's advice to Gretchen

> Come, rise to seek the higher spheres,
> And he, of thee aware, will take that way.[70]

The conjunction of motifs neatly brings us back to Beethoven, for French nineteenth-century authors, including Victor Hugo, on whom Hofmannsthal wrote a dissertation, had established an association between the music of the spheres, the 'Kiss of God' and Beethoven's music.[71]

Was Alma Mahler recollecting Klimt's image when she described her husband's conducting of the first performance in 1910 of his Eighth symphony, with its setting of this section of *Faust II*, as being when 'god or demon (he) turned those tremendous volumes of sound into fountains of light'?[72] The undulating gold patterns on the costumes of the Paradise angels seem to cascade downwards like water, whilst the male and female sun and moon medallion heads above the embracing couple — counterparts also to what Mahler himself identified as the dual forces reconciled in love in *Faust II*[73] — dissolve into rivulets and fountains of gold. Mahler himself originally conceived of the finale to his Eighth symphony as 'creation through Eros' and appears only subsequently to have chosen the *Faust* story as his vehicle for this idea. Was this because of his familiarity with, if not direct involvement in, the creation of the Beethoven frieze? (He had married Alma in March 1902, the month before the exhibition opened.) Was Mahler also thinking of the sun/halo and sun and moon emblems above the embracing couple in Klimt's frieze, when he told the conductor Mengelberg, in a clear allusion to the 'music of the spheres', that to attempt to explicate his Eighth symphony was to 'try to describe the whole universe beginning to ring and resound. These are no longer human voices, but planets and suns revolving'?[74] This imagery compares with Hofmannsthal's description of poetry as the intersection of 'a thousand threads spun together from the depths of infinity'.[75]

Klimt's *Kiss* offers further analogies with *Faust II*'s conclusion, which underline the specifically Christian emphasis given to the frieze by Klimt's eventual substitution of the phrase 'My Kingdom is not of this world' for the original *Ode to Joy* quotations which described its *Kiss* section. Faust's soul is saved through a sequence of intercession which culminates in that of the 'Eternal Womanly'. Gretchen is a crucial part of this, her example in 'rising to the higher spheres' with the aid of the Mater Gloriosa bringing about Faust's spiritual rebirth. Before this a chorus of penitent, biblical women have in turn interceded for Gretchen with the Mater Gloriosa. These include the woman at the well (Mulier Samaritana); the Magna Peccatrix of Luke VII, 36, who washed Christ's feet and wiped them with her hair; and Maria Aegyptiaca, who endured forty years' penance in the desert. The woman at the well chose the 'living water' of Christ in preference to her previous life of sin: can we therefore read Klimt's visual 'fountains of light' as an allusion to this? Maria Aegyptiaca's desert seems to be

evoked by the dotted, dust-like texture of the outermost arc of gold which curves around Klimt's couple, whilst the fine lines sweeping around the man's foot are surely not the symbol of 'the dangerous way ... sex ensares' seen by Schorske,[76] but instead the hair of the Magna Peccatrix. Whereas such hair enwraps only the woman's legs in the earlier *Sufferings of weak mankind* section of the frieze, the way it firmly sweeps round the man's legs in the *Kiss* section makes him, at a further symbolic level again, an ultimately Christ-like redeemer. The golden orb behind his head can be read not just as a sun, but also as a halo.

The apparent conflation of sinner (Faust) and redeemer (Christ) parallels exactly the association of ideas we have already met in Klinger's conception of Beethoven as being simultaneously the Wagnerian 'Christ-like redeemer' and, on account of his creative genius, the Nietzschean 'striving individual' upon whom is imposed 'the necessity for crime'. We are taken back to Goethe's belief that because music 'ranks so high that no understanding can reach it', it must 'contain something demonic'. Yet Klimt's renaming of this concluding section of his frieze with the phrase from St Matthew 'My Kingdom is not of this world' suggests that he wished the demonic, as in Goethe's play, ultimately to be overcome and transmuted into the divine and eternal. This was certainly to be the message of Mahler's Eighth symphony reading of *Faust* II. In this sense, however complex the symbolic imagery of the Beethoven frieze, its kinship remains essentially with the antique and mediaeval 'allegorical' device of psychomachia, the battle between the virtues and vices,[77] and with the inherently visual nature of such allegorical action.[78]

Klimt's interpretation of the redemption scene in *Faust* II as a scene of Christian transcendence is further suggested by the way the couple are superimposed on a growing rose bush, a symbol of the everlasting life afforded by the redemptive rose-buds, nurtured by the golden 'water of life' and blooming out of the 'desert', and also, of course, recalling the Madonna in the rose garden convention as well as the many 'growth' references in the finale of *Faust* II (Faust, say the angels, 'überwächst uns schon / An mächtigen Gliedern ...'.[79] ['Transcending us he towers, / Great-limbed ...']). Sensuality, Lechery and Intemperance (plate 10), the three debauched women in the *Hostile Forces* section of the frieze, suggest the biblical penitents in their former lives: their flowing hair, jewellery and erotically patterned backdrop are all transmuted into the ordered symbolism of the final scene. The golden bower, meanwhile, brings to mind an alchemist's crucible where base metals are turned into gold, a motif which echoes the alchemical imagery of the Homunculus scene of *Faust* II.

Klimt's renaming of the conclusion of his frieze with the quotation from Matthew IV has often been associated with Wagner's use of this to identify music with Christian revelation.[80] Where Wagner saw the role of spiritual revelation as reserved solely for music, however, Klimt specifically broadened it to include 'Poetry' (plate 12) and 'The Arts' (plate 13) who introduce the final scene of his frieze, thereby pointing us towards a number of further intriguing connections with Nietzsche's ideas. Nietzsche may have proclaimed that 'God is dead'[81] and won Mahler's distaste in so doing,[82] but, like Mahler, who nonetheless set text by Nietzsche in his Third symphony, Klimt was clearly inspired by the philosopher in significant ways.

The viewer and the frieze: Goethe's *Faust* 'revealed' in mural form

Wagner had already called his music dramas 'acts of music made visible'.[83] Nietzsche extended this idea to emphasize the visionary dimension of musical experience. In his *Birth of Tragedy* he had argued, with numerous references to *Faust* by way of support, that a transcendental, visionary union of spectator and performer should occur in true theatre. He felt that the chorus of Greek tragedy had the primary role in achieving this, because it was 'the beholder of the visionary world of the scene'[84] and thereby also its active creator. 'The poet is a poet only in so far as he sees himself surrounded by forms which live and act before him and into whose innermost being he penetrates'[85] he wrote, and it was likewise the chorus whose parts were 'in a sense the maternal womb of the entire so-called dialogue, that is, of the whole stage-world, of the drama proper'.[86] We realize, says Nietzsche, that

> the scene, together with the action, was fundamentally and originally thought of only as a *vision*, that the only 'reality' is just the chorus, which of itself generates the vision, and celebrates it with the entire symbolism of dancing, music and speech.[87]

In this sense, the embrace episode in the Beethoven frieze, enacted in its 'womb-like'[88] setting and before the chorus of Paradise angels whose eyes are closed — inwardly seeing — can be recognized as a counterpart to Nietzsche's chorus and their evocation of, and identity with, the hero on stage, 'the visionary figure together with its aura of splendour ... a visionary figure, born as it were of their own ecstasy'.[89] Nietzsche calls the visionary transport of the 'dionysiacally excited spectator', 'the Apollonian dream-state';[90] in this state, the chorus is, significantly, both *der Mitleidende* (the fellow sufferer/sympathizer) and *der Weise* (the sage).[91]

Mitleid (Compassion; Sympathy) (plate 9) is, of course, one of the two personifications who rise behind the golden knight in the frieze to support him as he goes into battle with Typhoeus; *der Weise*, it might be argued, is what Faust ultimately becomes through the redemptive agency of the 'Eternal Womanly'. Bisanz-Prakken has already related the personifications of *Mitleid* and her companion *Ehrgeiz* (Ambition) to Nietzsche's use of the concepts in *Die Leiden des Genius und ihr Wert*, but that Klimt was also thinking of Nietzsche's use of the word *Mitleid* to suggest the creative empathy of the active spectator with the hero on stage is suggested by earlier murals he had painted. In the Vienna Burgtheater in 1886–8 he had illustrated the antique theatre which had inspired Nietzsche. In his *Shakespeare's Theatre* panel there he places the audience, which includes himself and his brother alongside Queen Elizabeth I, on the same planar 'matrix' as the performance of *Romeo and Juliet* they are watching, so that they are literally *mitleidend* (suffering/sympathizing with). His *Nudas Veritas* of 1898 for *Ver Sacrum*, showing a naked woman holding a mirror up to the viewer, had yet further developed the idea of the spectator's self-reflection, and suggests that Klimt was thinking of Nietzsche's description of the hero in the *Birth of Tragedy* as 'the light-picture cast on a dark wall, that is, appearance through and through ... bright mirrorings'.[92] Nietzsche's characterization of the chorus' vision by

means of imagery of light and reflectivity thus offers an immediate context for the symbolic use of gold, both for the knight and in the Paradise angels' costumes and embrace episode in Klimt's frieze. The reflective materials 'draw' to themselves the presence of the viewer, like the mirror in *Nuda Veritas*. That a Nietzschean reading of Klimt's use of gold was readily adopted by contemporaries is clearly suggested by Hevesi's description of the 'flower-coloured light-form'[93] of 'Poetry' in the frieze, the figure bearing the golden lyre who is the agent of the knight's defeat of evil (plate 12).

The visitor to the Beethoven exhibition was likewise invited to share in the creative act of the *Allkunstwerk*, and the character of Klimt's work as a mural frieze significantly contributes to this union of artist, viewer and painting. Set above the viewer around the upper part of three sides of one of the side 'chapels' of the 'sanctuary' layout of the exhibition (plates 14 and 15), it would have forced the eye to rise heavenward, exactly as Faust and Gretchen are enabled to do at the conclusion of *Faust II*; real light, indeed, would have spread downwards, like that of Heaven, from the overhead windows. What Nietzsche wished to unite — the 'Apollonian dream state' of vision and the 'Dionysian' experience, which, as we have already seen, he identified in Beethoven's music — would have been tangibly fused together in a remarkable synthesis of music, literature and painting.

This use of mural painting and reflective materials to 'involve' the viewer also has close connections with Wagner's notion (derived from his reading of *Faust II*) of a 'Faust Theatre'.[94] In this the stage events, performed as in an Attic amphitheatre, or on an Elizabethan central stage, would 'press in upon the audience from all sides, as it were'.[95] The viewer of the frieze becomes part of the Paradise choir in the final section, 'beholding' and therefore, in Nietzschean terms, 'creating' the embrace scene exactly as if in the 'Faust theatre' or Nietzsche's Greek theatre. The 'vision' of the embrace in the frieze becomes an emblem or symbol for the creation of art itself. Art and redemption are equated; *Tempelkunst* has been created. We can compare this with the way in which, when he performed his Eighth symphony with its setting of *Faust II*, Mahler enlisted Alfred Roller, who had earlier designed the *Falling Night* mural in the *Beethoven* exhibition and stage sets for the Vienna State Opera, to ensure that

> the enormous hall was plunged into semi-darkness in which the black mass of the audience *coalesced* with the black and white mass of the executants.[96] (author's italics)

Within this overtly Nietzschean setting was heard, of course, the climactic Chorus Mysticus of *Faust II*'s conclusion, which 'ties in one brilliant knot ... the Chorus Mysticus and "Accende" and "Mater Gloriosa" themes'.[97] The 'Accende' theme is from the *Veni Creator Spiritus* setting which forms Part I of the symphony; like Klimt in the symbolism of his golden 'embrace', Mahler can be seen here as giving, through reference to *Faust*, a specifically Christian interpretation to Nietzsche's description of the cathartic and redemptive power of *Erscheinung* (appearance) in which the *Lichtbild* (light picture) conjured up by the chorus is a phenomenon that 'after our glance into the abyss, healing nature holds up to our eyes'.[98]

Klimt's embrace scene not only anticipates Mahler's integration in his Eighth

symphony of motifs from Beethoven's music with the words of the *Veni Creator Spiritus* and *Faust*, but also reflects the notoriously elaborate 'allegory' of *Faust* II itself.[99] Mahler's characterization of the final lines of the play, which reveal the mystical power of the 'Eternal Womanly', almost exactly parallels Hevesi's assessment of the Beethoven frieze as an allegory which 'you are not supposed to understand ... completely', further illustrating the Secession's association of allegory with the 'ineffable' nature of music, and showing the Romantic roots of their art:

> ... [they are] an allegory to convey something which, whatever form it is given, can never be adequately expressed. Only the transitory lends itself to description; but what we feel, surmise but will never reach (or know here as actual happening), the intransitory behind all appearance, is indescribable.[100]

Goethe himself had written that

> in ... compositions what really matters is that the single masses should be clear and significant, whilst the whole remains incommensurable; and by that very reason, like an unsolved problem, constantly draws mankind to study it again and again ...[101]

and he aimed to make *Faust* 'remain an evident riddle'.[102]

Typhoeus and the *Hostile Forces*

As we have begun to discover in the 'golden' embrace scene with its echoes of Goethe's as well as Nietzsche's imagery of light, Klimt's use of reflective materials such as gold and semi-precious stones acts as both cue to, and emblem of, this inner significance, thereby corresponding with Faust's own remark at the start of Part II that 'In mirrored hues we have our life and being.'[103] At the same time, Klimt realizes Klinger's precept in the exhibition catalogue that 'A work of art can, however, only be complete when it has been made from such material as allows the exhaustive expression of its fundamental idea.'[104]

Klinger's precept can be seen in respect of Typhoeus in the *Hostile Forces* section (plate 10), a horrifying beast whose gaze, meeting that of the viewer, took full advantage of the Nietzschean concept of the spectator's creative vision to place the latter in precisely the dilemma of confrontation with evil which is experienced by the knight. Standing in the exhibition, the viewer would have been side by side with the knight, and like him, meeting with Typhoeus head on. Klimt's use of materials further reinforces the horror of this experience; it is easy to see why the *Neue Freie Presse* spoke of the 'hypnotic' effect of a visit to the exhibition.

In classical mythology, Typhoeus was half-man, half-beast, his lower body consisting of snakes. He had wings and his eyes issued flames. Klimt gives him staring eyes of mother of pearl, a material which is, of course, formed by the

action of a parasite and therefore aptly encapsulates the character of this evil creature. Klimt significantly departs from the traditional conception of Typhoeus as having a hundred dragons' heads, however, by giving him the upper part of an ape and a mouth with fang-like teeth. These features allow us to read Typhoeus as a counterpart to Mephistopheles in *Faust II*, for the latter, already portrayed by Delacroix and others with simian features and wings,[105] disguises himself in the Classical Walpurgisnacht scenes of the play by physically bonding himself with the Phorkyads, or Graiae, to become Phorkyas. Daughters of Chaos, the Graiae shared only one eye and tooth between them; fused with Mephistopheles, they exclaim:

> What charms in our new sisterhood arise
> Our trio has two teeth now, and two eyes.[106]

In Klimt's mural, Typhoeus has several teeth, but one fang is very much larger than the others, just as the Chorus comments on how, from Phorkyas's 'horrible single-toothed / Mouth, what comes but foulest / Breathings fetched from a hateful maw?'[107] As the sisters of the Graiae were the Gorgons, we can also understand Klimt's inclusion of the latter amongst his *Hostile Forces* (plate 10). If we interpret Typhoeus as Phorkyas in this way, we can understand why Klimt portrays him (or her) on such a gigantic scale, for it is at the very end of Act III, just before Faust appears on the 'Mountain Heights' and utters the line Klinger originally inscribed on his Beethoven statue, that 'Phorkyas, in the proscenium, rears herself to giant stature, but steps down from the buskins and, removing mask and veil, reveals herself as Mephistopheles'[108]

Klimt's whole conception of the *Hostile Forces* scene is less a precise illustration of Goethe's Classical Walpurgisnacht — which was, significantly, Wagner's 'favourite section of *Faust*'[109] — than a parallel exploration of the same demonic, primitive underworld of Classical mythology as had fascinated Goethe. He may, for example, have been reflecting the scene in Act V where Faust, having died, is buried by Mephistopheles's team of devils, before the intervention of the angels saves him from a ghastly hell which Mephistopheles is preparing. This hell is described by the latter as being a frightful monster with 'side-fangs' which 'yawn'; the 'raging swill of fiery flood' which is 'spewed' by the beast with its 'molten red', in which 'the damned swim wildly, hoping to be saved',[110] can, for example, be easily compared with Klimt's image of the giant ape, which, if not actually breathing fire, nevertheless stands amidst a 'flood' of flowing gold lines and red, gold and black motifs which spills around 'Sensuality', 'Lechery' and 'Intemperance' (plate 10). Again 'Intemperance', portrayed by Klimt as a grossly obese evil woman, suggests an interpretation of the 'fat devils' who help Mephistopheles in this scene, just as the three emaciated 'Gorgons' in the frieze correspond with his 'skinny devils'.[111]

Klimt's *Hostile Forces* are, like his *Kiss* episode, a personal, imaginative response to Goethe's literary stimulus. They represent a natural development of Klimt's interest in an 'alternative', violent and 'instinctual'[112] antiquity in his earlier portrayals of Theseus and the Minotaur, Pallas Athena, and some of the pictures used to illustrate Huch's *Ver Sacrum* article.[113] The choice of Typhoeus

to personify the evil also found in Mephistopheles can be seen as Klimt's commentary on the Vulcanism-Neptunism conflict between the violent forces of volcanic activity and the more gradual ones of water, which emerged in Goethe's text. Typhoeus in antiquity was the personification of volcanic disturbance, and just as the 'gradualist doctrine'[114] of the processes of water prevails ultimately in *Faust*, so Klimt too allows the undulating *Wishes* (plate 9), gliding as it were through liquid rather than merely air, and comparable to the women of his *Fish Blood* (1898, drawing) and *Watersnakes* II (1904, Galerie Welz, Salzburg), to triumph over the *Hostile Forces*, and the 'water of life' to feature in the redemption imagery of the golden embrace. Could this be a deliberate allusion to the Secession's concern to subvert rather than overthrow the prevailing classicism of Ringstrasse Vienna? It certainly brings to mind Faust's desire to rule the waves, which he confesses to Mephistopheles after his monologue on the 'Mountain Heights'.

In the same way that Phorkyas stands for the forces of darkness in *Faust*, so Typhoeus's massive dark-coloured bulk contrasts with the brilliant gold of the knight who challenges him (plate 9), Poetry's lyre (plate 12) and ultimately the embracing couple (plate 13). When Phorkyas eventually succeeds in breaking in on Faust and Helen's ecstatic bliss, he actually asks 'Feel you not dark tempest rising?',[115] a question which could well have prompted Klimt's conception of Typhoeus, as the latter was also the father of violent winds (typhoons).

The 'Strong One in Armour', 'Poetry' and 'The Arts', and other imagery in the frieze

Faust's reaction to Phorkyas's interruption of his joy with Helen likewise offers a source for Klimt's conception of both 'the strong one in armour' (the knight) and 'Poetry':

> He only earns a woman's favour
> Who shields her with his strong right arm.[116]

The first such hero to appear is Faust and Helen's son Euphorion:

> Flowered he stands in broidered raiment ...
> In his hand the golden lyre, boyish image of Apollo,[117]

and then, as he reveals his ultimately tragic capability to overreach himself as what Trunz calls 'the fighter for high goals, the warrior',[118] he becomes

> Victor-like, in armour gleaming
> Bronze and steel glint not more bright.[119]

This anticipates Faust's own donning of armour in his battle in Act IV to win control of the seas, and thereby realize his ultimate ambition, an episode which has already been mentioned as the sequel to his 'Mountain Heights' monologue quoted on Klinger's statue. Although still willing to be aided by Mephistopheles in

this battle, it is his last occasion of such weakness, and already marks a turning point after which he will attempt to shake off the devil's influence, and turn his 'striving' to the good of others.[120] However misguided his previous behaviour has been, it is ultimately his willingness to go on 'striving' which enables his redemption. As the angels explain,

> ... he whose strivings never cease
> is ours for his redeeming.

Klimt's armoured knight can be taken as a metaphor for this vital, questing effort which will ultimately defeat evil, and which, as we have seen, lay also at the heart of Klinger's conception of Beethoven, transcending, and thereby paradoxically 'benefiting' from, the solitude of his deafness to reconcile mankind through his art. The story of Faust and his salvation, involving as it does the interaction of his striving for unattainable goals and his ultimate recognition of the need to help others, can be seen as an additional philosophical motive for the twin figures of 'Ambition' and 'Compassion' who direct the solitary knight in Klimt's frieze (plate 9). We have already met 'Compassion' (*Mitleid*) in relation to Nietzsche's idea of the involved spectator; now we can see that she also has a further level of significance in the context of *Faust II*.

The Faust 'connection', Mahler and Freud

It would, of course, be misleading to suggest that *Faust* alone was Klimt's inspiration for his frieze. As we have already seen, many of its ideas and motifs were transmuted via the writings of Wagner and Nietzsche before they took shape in Klimt's mural. A group of significant further relationships may be identified nevertheless as actually reinforcing or confirming the 'Faustian' dimension of the frieze. At the same time, these take us back to the essential nature of the frieze as an allegory which points, as music was believed to do, to meanings either 'spiritual' or beyond the rational. They also suggest that the frieze was in turn influential. The symbolic opposition of light versus dark, for example, which permeates the frieze's iconography can be found in texts apart from *Faust* which Mahler used. The mediaeval Latin hymn *Veni Creator Spiritus* set by Mahler for the first part of his Eighth symphony as the complement to *Faust II* in its second contains a remarkable correspondence in its German translation with both Klimt's illustration of 'the sufferings of weak [*schwach*] humanity' and the battle with evil symbolized by the knight and the *Hostile Forces*, whilst it is also shot through with reference to light, reflection, brightness, and the flowing of water as emblems of the Holy Spirit:

> Come, Holy Ghost ...
> Strengthen our weakness
> Through your miraculous power
> Let your light kindle our minds ...
> So that we become victors over everything evil.[121]

The repeated refrain 'Accende lumen ...' ('Let your light kindle our minds'), which is given dramatic prominence in the music, has been described as the 'key to the Mahlerian meaning of the whole symphony'.[122] If, as Bisanz-Prakken has proposed, Mahler helped Klimt with the iconography of his frieze, then this experience can surely now be seen as a formative experiment with the material of his own 'homage to Beethoven' in his Eighth symphony. It is possible that the Romantic poet Rückert's 'Um Mitternacht', which Mahler was setting in the very year of the Secession's *Beethoven* exhibition, also contributed to the frieze's imagery of the 'sufferings of weak mankind' (*Leiden der schwachen Menschheit*) and of the knight —

> At midnight
> I fought the battle,
> O mankind, of your sufferings[123]

The *Kiss* section of the frieze, meanwhile, looks forward to Strauss and Hofmannsthal's *Der Rosenkavalier*, which concludes with the embrace of Sophie and Octavian. Hofmannsthal certainly spoke of Beethoven as late as 1920 in terms which directly recall the symbolic, glittering media of Klimt's frieze, the midnight of Rückert and Mahler, and the Christian message of all three: 'In the hours without light the jewels of Heaven shine, and he is amongst them.'[124]

Modern discussion of Klimt's debts to Romanticism has concentrated on the linearity of his art,[125] but it was light and colour which were singled out by Hofmannsthal and also by Huch and Hermann Bahr, contributor to *Ver Sacrum*, as one of the most important legacies of German Romanticism for the modern artist, and indeed as his means in turn to demonstrate his modernity.[126] Light and reflectivity, as we have also seen, were of prime importance in Nietzsche's philosophical imagery. Clearly the Faustian 'subtext' to Klimt's frieze cannot be isolated from wider trends in contemporary Vienna which had led Hofmannsthal to remark as early as 1896, 'We are in a new age of Romanticism.'[127] At the same time, however, it points to connections with the new field of psychoanalysis being developed by Klimt's fellow Viennese Sigmund Freud. *Faust* was continually quoted by Freud in illustration of his theories as it had already been by Wagner and Nietzsche, and in 1930 he paid tribute to Goethe as a primary source for certain of his ideas by citing the *Dedication to Faust*, a passage which encapsulates many of the motifs also found in the frieze.[128] Freudian symbolism has often been read into the 'womb-like bower' of the embrace scene in the frieze,[129] but, when its *Faust* sources are recognized, the frieze as a whole offers a striking analogy, at a deeper level, to Freud's belief, first published in 1895, that 'Dreams are the fulfilment of wishes.'[130] Faust's motivating purpose in Part II is to regain in posterity the state of bliss he had experienced first with Gretchen and then with Helen: 'Space, time, all gone, I live a dream instead.'[131] Klimt portrays not only the personifications of man's longings and wishes at the start of the frieze, but also Poetry, the Arts and the Nietzschean chorus of rose angels with their eyes closed, and the embracing couple with their eyes hidden. Only the women 'Sufferers', the golden knight, 'Ambition' who motivates him, and Typhoeus and the other 'Hostile Forces' against whom he fights, have open eyes, exactly as Freud divided

the mind into the unconscious elements of desires or wishes and the more conscious ones 'which are concerned with adaptation to reality and the avoidance of external dangers'.[132] So too, Typhoeus prompts comparison with the nightmarish 'animal deliria' of Frau Emmy von N, which Freud had likened to the animal hordes 'of which Mephistopheles boasted himself master'.[133] Freud wrote that in her case study he had first 'employed the cathartic procedure to a large extent':[134] his methodology offers a counterpart to the mystical process of redemption and fulfilment through art portrayed by the frieze. Freud, in turn, as if acknowledging the impact of Klimt's frieze, adopted the same biblical phrase eventually used for its embrace section to define the nature of the 'artist or neurotic' as being 'one of those whose kingdom is not of this world'.[135]

The complexity of allusive overlay in the frieze is undoubtedly one of the reasons why contemporaries preferred to hint at, rather than explicate, its multiple meanings. *Nagender Kummer* (Gnawing Care), for example (plate 11), suggests both a Freudian neurosis and the old Hag *Sorge* (Care) who is the only being capable of affecting Faust and who ultimately causes his blindness and death. Her section of the frieze is significantly the only part devoid of reflective materials, and Klimt indeed originally sketched her in the posture of Blake's Los, the 'poetic principle' destined to downfall in his deeply pessimistic *Book of Urizen.*[136]

Whilst *Faust* II clearly provided a vital thread in the conception and presentation of the Beethoven exhibition, whether Klimt intended us to appreciate the full significance of his imagery is debatable. Klinger, after all, omitted from his final version of the Beethoven statue the quotation which provides a key to the connection with *Faust* of the exhibition as a whole. Given the relationships perceived by the Secession between allegory and music as two art forms pointing to the 'ineffable' and mysterious, the frieze was probably meant to be understood in terms of the caveat added by Mahler to Bruno Walter's programme for his Fourth symphony, also of 1902. In this, Mahler stated that his music was ultimately absolute and not susceptible to a literary interpretation, just as he told the conductor Mengelberg that his Eighth symphony with its *Faust* setting was 'so peculiar in content and form that it is really impossible to write anything about it'.[137] Walter in turn later wrote of Klimt's frieze as being 'daringly bizarre',[138] reinforcing the image of its enigmatic nature. The catalogue's listing of the secondary decorative panels in the exhibition by media rather than title (some of these are visible in plate 14) and Hoffmann's purely abstract bas reliefs both suggest a comparable motive. The fact remains, however, that apart from the latter, the works of art in the exhibition were recognizably figurative, and they can be seen to have close interrelationships with the Faustian symbolism of Klimt's frieze. The Christian meaning which *Faust* allows us to recognize in the embrace scene, for example, not only indicates a more specifically religious dimension to Klimt's art than has hitherto been appreciated, but also reveals a clear connection with the Christian motifs on the throne of Klinger's *Beethoven,* in which 'love as the salvation of the world is symbolized ... by the tragedy of Golgotha.'[139] The woman at the well allusion suggested by the imagery of the embrace scene would have been continued by the two wells or fountain structures (plates 15 and 16) included as part of the exhibition layout (which was masterminded by Hoffmann).

There are numerous further correspondences between the frieze and the other exhibits, while its Faustian-Nietzschean light/dark imagery was echoed in the central section of the display, where 'the kingdom to come' symbolized by Klinger's statue shone forth 'as if in a jewel'[140] in the context of 'Night' and 'Dawn' murals. Beneath Klimt's *Hostile Forces* were Stohr's designs of a young girl confronting death, and a fallen Medusa's head; Medusa was one of the Gorgons illustrated by Klimt. To the right of the Gorgons, whose glance turned men to stone, was a statuette by Klinger (under the *Hostile Forces* in plate 15).

Despite its purpose as homage to Klinger, it was Klimt's frieze which was felt to be the kingpin of the exhibition in that Schiele, Hevesi and others were responsible for saving it from destruction after what had been intended as a temporary show. Yet in this act they perhaps obscured its deepest level of Faustian symbolism, for the play concludes with the lines

All things corruptible [i.e., transient, fleeting]
Are but a parable.

Faust's implications for the Beethoven frieze are sufficient, however, to suggest that it was a fulcrum upon which was balanced the old Romantic order of the nineteenth century and the new, scientific thought of the twentieth. When Mahler decided to resign from the Vienna Opera in 1907, not only Klimt but also Hofmannsthal, Freud and Bahr wrote 'to express the gratitude of a number of individuals who owe you a great debt'.[141] The role of *Faust* as a shared source of inspiration throws intriguing new light on this meeting of minds and also suggests that Mahler, like Hofmannsthal and Freud in turn, owed a debt to Klimt.[142]

Contrary to Karl Kraus's condemnation of Klimt as being 'only a stylist', the Beethoven frieze, source of so much speculation and conjecture as to its meaning, can now be seen as a most creative, imaginative and successful interpretation of the *Faust* text, a multi-layered synthesis drawing upon Romanticism, theology, philosophy, music, Classical ideas and contemporary psychological theories. It is surely one of the most remarkable attempts to interrelate the arts in either the nineteenth or twentieth centuries.

The frieze's highly distinctive fusion of mural format, symbolic use of materials and richly allegorical message fulfilled an almost psychological function as the spur to a Nietzschean creative involvement on the part of its spectators. By engaging the viewer as an active 'participant' in the very formation of an *Allkunstwerk*, it tangibly demonstrated the Secession's concern to connect with and influence modern society. As their motto proclaimed over the entrance of the Secession Building where the exhibition was housed, 'To every age its art, to art its freedom'. Conventionally, the frieze has been seen as a 'manifestation of narcissistic regression and utopian bliss'; a 'refuge' in art and 'aestheticized inwardness',[143] yet it can surely now be recognized as the forbear of today's 'installation' and 'performance' art; a 'happening' whose very message of redemptive reconciliation born of solitude was intended to reach outwards forcibly to Everyman. Whilst we may trace Klimt's philosophical, literary and musical sources in the frieze, the emotively charged imagery of its nightmarish *Hostile Forces* and the extraordinary 'womb-crucible' of its *Kiss* section, in which

the universal brotherhood of the *Ode to Joy* becomes one with the salvation of the individual in *Faust*, ultimately exerts an almost subliminal pull upon the viewer's attention, fascinating today's generation as much as it 'hypnotized' Vienna in 1902. Klimt's interpretive synthesis of ideas from Goethe, Wagner, Nietzsche and Klinger results in something far greater than their sum, so that the very meaning of the frieze is actually its effect, exactly like Goethe's ideal of a work of art which, 'like an unsolved problem, constantly draws mankind to study it again and again'. Through his 'allegory ... you are not supposed to understand', Klimt was actually reaching out to, rather than retreating from, his fellow men, just as Beethoven intended in his Ninth symphony setting of Schiller's 'Be embraced ye millions', and Goethe in making *Faust* 'an evident riddle'. Hevesi concluded that the *Beethoven* exhibition was '... a church for art, which you enter for edification and leave as a believer'.[144] Klimt's frieze was a crucial ingredient in this remarkable work of *Tempelkunst*.

<div style="text-align: right">

Clare A.P. Willsdon
University of Glasgow

</div>

Notes

The author wishes to thank members of the Centre for European Romanticism of the University of Glasgow and in particular Professors C. Smethurst and R. Stephenson, and Mrs S. Sirc and Mr D. Andrews for their assistance and encouragement in the preparation of this article. I am also grateful to Prof. Marcia Pointon for a number of helpful bibliographical references. A Research Support Award from the Faculty of Arts of the University of Glasgow for the cost of photographs is gratefully acknowledged. All illustrations are by kind permission of the Österreichische Galerie, Belvedere, Vienna. All translations are by the author unless otherwise indicated.

1 L. Hevesi, *Acht Jahre Secession*, Vienna, 1906 quoted in C.M. Nebehay, *Gustav Klimt Dokumentation*, Vienna, 1969, p.299.
2 Hevesi, op. cit., in M. Bisanz-Prakken, *Gustav Klimt Der Beethovenfries*, Munich, 1980, p.46.
3 P. Vergo, *Art in Vienna, 1898–1918*, London, 1975, p.70.
4 G. Klimt, in G. Fliedl, *Gustav Klimt die Welt in weiblicher Gestalt*, Cologne, 1989, p.10.
5 M. Bisanz-Prakken, op. cit.; J.-P. Bouillon, *Klimt, Beethoven: The frieze for the Ninth Symphony*.
6 'The poet should not be his own interpreter ... The poet puts forth his creation into the world; it is up to the reader, the aesthetician, the critic, to investigate what he intended in his creation.' Goethe quoted in J. Vogel, *Max Klinger und seine Vaterstadt Leipzig*, Leipzig, 1923, p.98.
7 English translations of description in *Unsere XIV. Ausstellung* ... (catalogue for XIV. Ausstellung der Vereinigung bildender Künstler Österreichs), Vienna, 1902 from S. Partsch, *Gustav Klimt: Life and Work*, London, 1989.
8 English translations of Secession's fourteenth exhibition catalogue from ibid.
9 'Tempelkunst', *Unsere XIV. Ausstellung ...*, Vienna, 1902, p.10.
10 'Im Dienste der Raumidee', ibid.
11 R. Huch: 'Symbolistik vor hundert Jahren', *Ver Sacrum*, March 1898, p.8. This article was an extract from a book 'in preparation' by Dr Huch.
12 ibid., p.10.
13 This was the title of Huch's article.
14 See Bisanz-Prakken, op. cit., pp.48–9.
15 Huch, op. cit., p.12.
16 Quoted in Nebehay, op. cit., p.53, n.5.
17 Quoted in D. Mitchell: *Mahler Songs and Symphonies of Life and Death Interpretations and Annotations*, London and Boston, 1985, p.613, n.59.
18 Bisanz-Prakken, op. cit., p.59.
19 Quoted in N. Lebrecht, *Mahler Remembered*, London, 1987, p.210.
20 Letter from Mahler to Alma Mahler, June 1909, in Alma Mahler, *Gustav Mahler: Memories and Letters*, ed. D. Mitchell, London, 1973, p.320.
21 A. Roessler, *In Memoriam Gustav Klimt*, Vienna, 1926, quoted in Nebehay, op. cit., p.295.
22 Goethe, *Faust*, in E. Trunz (ed.), *Goethe Faust Der Tragödie Erster und Zweiter Teil*, Special Edition of the 'Hamburger Ausgabe' of Goethe's Works, Munich, 1989, p.363, lines 12069–72;

English trans. from introduction by P. Wayne, *Goethe Faust Part II*, Harmondsworth, 1959, p. 287.

23 'Tempelkunst (with) ... den Segen einer Arbeit, die Zweck und Bestimmung hat', *Unsere XIV. Ausstellung ...*, op. cit., pp. 10–11.

24 Bisanz-Prakken, op. cit., p. 52.

25 See G. Bussmann, 'Der Zeit ihre Kunst Max Klingers "Beethoven" in der 14. Ausstellung der Wiener Sezession', in D. Gleisberg et al. (eds.), *Max Klinger, 1857–1920*, Wuppertal, 1992, p. 40, and J. Vogel, op. cit., p. 102.

26 See T. Meyer, *Nietzsche und die Kunst*, Tubingen and Basel, 1993, p. 97.

27 Nietzsche, *Die Geburt der Tragödie aus dem Geiste der Musik*, in G. Colli and M. Montinari (eds.), *Nietzsche Werke Kritische Gesamtausgabe*, Dritte Abteilung, vol. 1, Berlin and New York, 1972, pp. 25–6; English trans. from O. Levy (ed.), 'The Birth of Tragedy' in *The Complete Works of Friedrich Nietzsche*, vol. 1, Edinburgh and London, 1909, pp. 27–8.

28 Klinger's term *'Allkunstwerk'* is quoted in Bussmann, op. cit., p. 43; for a discussion of the *Gesamtkunstwerk* concept, see P. Vergo, 'The origins of Expressionism and the notion of the *Gesamtkunstwerk*', in S. Behr, D. Fanning and D. Jarman (eds.), *Expressionism Reassessed*, Manchester, 1993, pp. 11–19.

29 *Unsere XIV. Ausstellung ...*, op. cit., p. 12.

30 '(Hat man bemerkt, dass die Musik) den Geist *frei* macht? Dem Gedanken Flügel giebt?', Nietzsche, quoted in Meyer, op. cit., p. 102.

31 ibid., p. 104.

32 Quoted in ibid.

33 Trunz, op. cit., p. 304, line 10039; English trans. from Wayne, op. cit., p. 215.

34 See introduction by R. J. Hollingdale, *Thus Spake Zarathustra*, Harmondsworth, 1969, pp. 109–10 for Nietzsche's message of the 'Superman'; and p. 23 for discussion of it.

35 Nietzsche himself wrote that 'My entire Zarathustra is a dithyramb on solitude' (Meyer, op. cit., p. 148).

36 Beethoven, *Heiligenstadt Testament*, quoted in H. C. Robbins Landon, *Beethoven*, London, 1974, pp. 83–5.

37 J. Neubauer, *The Emancipation of Music from Language Departure from Mimesis in Eighteenth Century Aesthetics*, New Haven and London, 1986, p. 205.

38 Quoted in ibid., p. 129.

39 H. Bisanz, 'The Visual Arts in Vienna from 1890 to 1920', in R. Waissenberger (ed.), *Vienna, 1890–1920*, New Jersey, 1984, p. 114. See especially Klimt's *Love* (1895, Historisches Museum der Stadt Wien) which prefigures the kiss/embrace imagery of the Beethoven frieze.

40 Huch, op. cit., p. 7.

41 See Neubauer, op. cit., p. 193ff.

42 Bisanz-Prakken, op. cit., p. 71; see also P. Vergo's discussion in 'Gustav Klimt's

43 Notably by C. H. Weisse, who held the chair of Philosophy at the University in Leipzig, Klinger's home town, for many years during the nineteenth century. See H. Schlaffer, *Faust Zweiter Teil Die Allegorie des 19. Jahrhunderts*, Stuttgart, 1981, pp. 113–15, etc.; and Schlaffer's own comment that 'Goethe did not simply use the mode of allegory, but made the necessity of its use the theme of [*Faust II*]', on p. 124.

44 Trunz, op. cit., p. 364, lines 12104–5; English trans. from Wayne, op. cit., p. 288.

45 Translation; original German in Bussmann, op. cit., p. 45.

46 A visit to it was something 'hypnotisches', *Neue Freie Presse* quoted in ibid., p. 45.

47 See G. Frodl and R. Mikula, *Hans Makart Entwürfe und Phantasien*, exh. cat., Vienna and Salzburg, 1975, pp. 16–19.

48 Huch, op. cit., p. 8.

49 See note 39; above the couple are ghostly faces including skulls and a toothless hag as reminders of mortality.

50 Comment by Beethoven as recorded for Goethe by Bettina von Arnim (also known as Bettina Brentano), quoted in A. Comini, *The Changing Image of Beethoven: A Study in Mythmaking*, New York, 1987, p. 118.

51 Klinger, *Malerei und Zeichnung*, quoted in *Unsere XIV. Ausstellung ...*, op. cit., p. 15.

52 Hofmannsthal, 'Bildlicher Ausdruck', in *Prosa*, vol. 1 (*Gesammelte Werke in Einzelausgaben*), S. Fischer Verlag, 1950, p. 333.

53 Klinger speaks of 'the spiritual side of painting in the "art of the room"' being important, and also of the need for "spiritual invention" in the creation of the ensemble; 'the unity of the room and the impact of its meaning' depend on 'a purely poetic use of the materials or media', op. cit., pp. 16–17.

54 W. S. Newman, 'The Beethoven Mystique in Romantic Art, Literature and Music', in *Musical Quarterly*, vol. 69, no. 3, Summer 1983, p. 360.

55 Vogel, op. cit., p. 23, notes that the quotation from *Faust II* was on the cliff part of the statue 'for a short period before the completion of the work'; eds. D. Gleisberg et al., op. cit., p. 330, refers to it being *'notwendig'* ('necessary') to remove the quotation in February 1902 when the sculpture was being assembled from its various component parts.

56 Trunz, op. cit., p. 304, stage directions for the start of Act IV; English trans. from Wayne, op. cit., p. 215.

57 Trunz, op. cit., line 10066; English trans. from Wayne, op. cit., p. 216.

58 Trunz, op. cit., p. 700.

59 ibid., p. 306, lines 10129–33; English trans. from Wayne, op. cit., p. 218.

60 Trunz, op. cit., p. 309, lines 10220–21; English

Beethoven Frieze', *Burlington Magazine*, vol. 115, 1973, p. 109ff.

trans. from Wayne, op. cit., p. 221.

61 Trunz, op. cit., p. 359, lines 11936–37; English trans. from Wayne, op. cit., p. 282.

62 Nietzsche, op. cit., p. 66; English trans. from introduction by W. Huntington Wright, *The Philosophy of Nietzsche*, New York, 1954, p. 999.

63 Quoted in Neubauer, op. cit., p. 129.

64 The words appear in Wagner's *Beethoven* essay: see Vergo, 1975, op. cit., p. 72.

65 ibid., p. 75.

66 Trunz, op. cit., p. 359, lines 11942–48; English trans. from Wayne, op. cit., pp. 282–3.

67 ibid., p. 355, lines 11809–10; English trans. from Wayne, op. cit., p. 278.

68 See J. Dobai, 'Zu Gustav Klimts Gemälde "Der Kuss"', *Mitteilungen der Österreichischen Galerie*, 12, 1968, p. 85, for a general discussion of the influence of 'linear' tendencies including Blake's art on Klimt and the Secession; and Nebehay, op. cit., p. 213.

69 Trunz, op. cit., p. 363, lines 12088–93; English trans. from Wayne, op. cit., p. 287.

70 Trunz, op. cit., p. 363, lines 12094–5; English trans. from Wayne, op. cit., p. 287.

71 See Newman, op. cit., p. 364.

72 Quoted in Mitchell (ed.), 1973, op. cit., p. 180.

73 See Mahler, letter to Alma Mahler, June 1909, quoted in ibid., p. 321.

74 Letter from Mahler to Mengelberg, August 1906, quoted in Mitchell, 1985, op. cit., p. 591.

75 Hofmannsthal, 'Dichter und Leben', op. cit., p. 334.

76 C. E. Schorske, *Fin de Siècle Vienna Politics and Culture*, Cambridge, 1983, p. 260.

77 See A. Fletcher, *Allegory, the Theory of a Symbolic Mode*, New York, 1964, for a discussion of this literary device.

78 ibid., p. 178.

79 Trunz, op. cit., p. 363, lines 12076–7; English trans. from Wayne, op. cit., p. 287.

80 See note 64 above.

81 Nietzsche, *Die Fröhliche Wissenschaft*, quoted in Hollingdale, op. cit., p. 14.

82 See Alma Mahler, op. cit., pp. 18 and 20.

83 R. Wagner, essay *On the Term Music Drama*, 1872, quoted in D. Borchmeyer, *Richard Wagner Theory and Theatre*, Oxford, 1991, p. 111.

84 Nietzsche, op. cit., p. 55; English trans. from Huntington Wright, op. cit., p. 987.

85 Nietzsche, op. cit., p. 56; English trans. from Huntington Wright, op. cit., p. 988.

86 Nietzsche, op. cit., p. 58; English trans. from Huntington Wright, op. cit., p. 990.

87 Nietzsche, op. cit., pp. 58–9; English trans. from Huntington Wright, op. cit., p. 990.

88 See Schorske, op. cit., p. 259.

89 Nietzsche, op. cit., p. 59; English trans. from Huntington Wright, op. cit., p. 991.

90 Nietzsche, op. cit., p. 60; English trans. from Huntington Wright, op. cit., p. 992.

91 Nietzsche, op. cit., p. 59; English trans. from

Huntington Wright, op. cit., p. 991.

92 Nietzsche, op. cit., p. 61; English trans. from Huntington Wright, op. cit., p. 993.

93 L. Hevesi, *Acht Jahre Secession*, Vienna, 1906, p. 392, quoted in Bisanz-Prakken, op. cit., p. 70.

94 See Borchmeyer, op. cit., chap. 4, for a discussion of the 'Faust theatre' concept of Richard Wagner.

95 Quoted in ibid., p. 45.

96 Recollection of Emil Gutmann, quoted in Mitchell, 1985, op. cit., p. 610, n. 42.

97 Mitchell, 1985, op. cit., p. 582.

98 Nietzsche, op. cit., p. 62; English trans. from Huntington Wright, op. cit., p. 994.

99 See Wayne, op. cit., pp. 12 and 17; and J. R. Williams, *Goethe's Faust*, London, 1987, and Schlaffer, op. cit., for detailed discussions of the layers of meaning in *Faust II*.

100 Mahler, letter to Alma Mahler, June 1909, quoted in Mitchell (ed.), 1973, op. cit., p. 320.

101 Letter from Goethe to Eckermann, 13 February 1831, quoted in Wayne, op. cit., p. 12.

102 Letter from Goethe to Zelter, 1 June 1831, quoted in introduction by W. Kaufmann, *Goethe's Faust*, New York, 1963, p. 11.

103 Trunz, op. cit., p. 149, line 4727; English trans. from Wayne, op. cit., p. 26.

104 M. Klinger, 'Malerei und Zeichnung', *Unsere XIV. Ausstellung . . .*, op. cit., p. 16.

105 See, for example Delacroix's lithographs for *Faust*. Klimt's image of Typhoeus as an ape of course also reflects the influence of Darwinism (for which see B. Djikstra, *Idols of Perversity*, New York and Oxford, 1986).

106 Trunz, op. cit., p. 243, lines 8030–1; English trans. from Wayne, op. cit., p. 140.

107 Trunz, op. cit., p. 267, lines 8885–7; English trans. from Wayne, op. cit., p. 171.

108 Trunz, op. cit., stage direction, p. 303; English trans. from Wayne, op. cit., p. 214.

109 Borchmeyer, op. cit., p. 43.

110 Trunz, op. cit., p. 350, lines 11644–9; English trans. from Wayne, op. cit., p. 272.

111 Trunz, op. cit., stage direction, p. 351; English trans. from Wayne, op. cit., pp. 272–3.

112 Schorske, op. cit., p. 223.

113 See, for example, the version of *Music* on p. 19 of Huch, op. cit.

114 Williams, op. cit., p. 155.

115 Trunz, op. cit., p. 284, line 9423; English trans. from Wayne, op. cit., p. 191.

116 Trunz, op. cit., p. 285, lines 9444–5; English trans. from Wayne, op. cit., p. 192.

117 Trunz, op. cit., p. 290, lines 9617–20; English trans. from Wayne, op. cit., p. 199. Klimt's 'Poetry' personification is, of course, female, but given his freely interpretive approach to his sources in Schiller, Beethoven, Wagner and Nietzsche, there is no reason why this should not have extended to Goethe's Euphorion figure also. The 'flowered . . . broidered raiment' of Euphorion is re-interpreted, for example, in the

floral headband of 'Poetry'; Hevesi, as we have seen, indeed wrote of 'Poetry's flower-coloured light-form'.

118 Trunz, op. cit., p. 685.

119 Trunz, op. cit., p. 297, lines 9853–4; English trans. from Wayne, op. cit., pp. 206–7.

120 See Trunz, op. cit., p. 721: at the very point of Faust's death, 'we also learn that Faust begins anew once more: he, ... who always thought of himself, learns to think of others, in the company of those who love.' The last act of the play, dealing with Faust's colonization project and his death and ultimate salvation, shows the working through of his essential duality of character, until good triumphs.

121 'Komm, Schöpfer Geist ...
Unsere Schwachheit
stärke durch deine Wunderkraft.
Entzünde deine Leuchte unseren Sinnen ...
so werden wir Sieger über alles Böse'
The German translation of the Latin is taken from the programme notes for Mahler's Eighth symphony, issued by the Gesellschaft der Musikfreunde in Wien, Saison 1982–3.

122 'Schlüssel zur Mahlerschen Sinngebung der ganzen Symphonie' analysis of Mahler's Eighth symphony by 'F.R.', in ibid.

123 'Um Mitternacht
Kämpft ich die Schlacht,
O Menscheit, deiner Leiden ...'
F. Rückert, Um Mitternacht; English trans. from S.S. Prawer (ed.), The Penguin Book of Lieder, Harmondsworth, 1964, p. 142.

124 H. von Hofmannsthal, Beethoven, speech given in Zürich, 1920, in H. von Hofmannsthal, Reden und Aufsätze, Leipzig, 1921, p. 7.

125 See note 24 above.

126 See Hofmannsthal's speech, Die Bühne als Traumbild (The Stage as Dream-Picture), 1903, in his Reden und Aufsätze I, 1891–1913, Frankfurt, 1979, which calls on the modern stage designer, via an analogy with Faust, to deploy 'the depths of colour in his own dreams' to penetrate a 'Beethovenian abyss of darkness'. His recognition of a cathartic role for colour was influenced in turn by Goethe's colour theory (see F. Norman (ed.), Hofmannsthal Studies in Commemoration, London, 1963, p. 45ff.). Huch's belief that colour was for the painter 'the direct expression of the inner being, the medium of the soul' ('Über Moderne Poesie und Malerei' in Ver Sacrum, 1898, reprinted in R. Huch, Gesammelte Werke, vol. 6, Berlin, 1969, p. 15), was based on her admiration for Romantic art. Bahr praised the avant-garde 'Junges Österreich' writers (who included Hofmannsthal) for recapturing the 'colouring

and lighting' identified by the Romantic Herder as distinctive to painting ('Das Junge Österreich' in Studien zur Kritik der Moderne, Frankfurt, 1894).

127 Translation from 'Ein Neues Wiener Buch', in Hofmannsthal, 1979, op. cit., p. 227.

128 See, for example, lines 12–16 and 25–9 (Trunz, op. cit., p. 9): these include 'Lieb', 'Glück', 'Sehnen', and Faust's 'Lied, der Äolshärfe gleich' ('love', 'happiness', 'longing', and Faust's 'song, like the aeolian harps').

129 See Schorske, op. cit., p. 259.

130 S. Freud, The Analysis of Dreams, from Project for a Scientific Psychology, Autumn 1895, in B. Bonaparte et al. (eds.), The Origins of Psychoanalysis Letters to W. Fliess, Drafts and Notes 1887–1902, London, 1954, p. 402.

131 Trunz, op. cit., p. 284, line 9414; English trans. from Wayne, op. cit., p. 191.

132 J. and A. Strachey (eds.), Studies in Hysteria by J. Breuer and S. Freud, Harmondsworth, 1974, Introduction, p. 19.

133 S. Freud, Case History of Frau Emmy von N, 1895, in Strachey (ed.), op. cit., p. 147.

134 ibid., p. 167.

135 S. Freud, Delusions and Dreams in Jensen's Gradiva, 1906, in The Pelican Freud, vol. 14; Art and Literature, Harmondsworth, 1988, p. 40.

136 Comparable, for example, with Blake's illustration of Los Howling in Dismal Stupor are the studies by Klimt for Gnawing Care reproduced in plate 58 of Bisanz-Prakken, op. cit. (private collection, Austria).

137 Mahler, letter to Mengelberg, August 1906, quoted in Mitchell, 1985, op. cit., p. 589.

138 B. Walter, Theme and Variations, London, 1947, p. 179.

139 Description of the Beethoven statue by Paul Kühn in Max Klinger, Leipzig, 1907, given in Bisanz-Prakken, op. cit., p. 22.

140 Unsere XIV. Ausstellung ..., op. cit., p. 12.

141 Address from the Committee members of the Composers' Association to Mahler, 1907, quoted in K. and H. Blaukopf, Mahler: His Life, Work and World, London, 1991.

142 The omission by Mahler in his Eighth symphony of the 'Blessed Boys' section of Faust II's final scene which has perplexed musicologists, can now be explained as a straightforward reflection of the way in which Klimt concentrates on the Paradise angels in his final portion of the Beethoven frieze, rather than including the Boys who are not yet received into the heavenly host.

143 Schorske, op. cit., p. 254.

144 Quoted in Bussmann, op. cit., p. 46.

Art History ISSN 0141-6790 Vol. 19 No. 1 March 1996 pp. 74–101

Paul Klee's Anna Wenne and the Work of Art

Paul Bauschatz

Very little attention has been paid to Paul Klee's interest in literature (particularly in poetry and in dramatic performance). Unlike Kurt Schwitters, who throughout his life was always on the brink of becoming what we now think of as a performance artist and who is remembered almost as much for his antics as for his art, Klee is still best known as a visual artist. Although the content of Klee's poems, along with that of the other writings scattered throughout his diaries and teaching notes, has been examined for information about his art, very little attention has been paid to the significant structural relations that exist in both Klee's verbal and visual art. Yet Klee's poems and pictures mutually inform each other. Reading the poetry carefully helps us to see and hear aspects of the visual art that, without this perspective, remain hidden or, at best, murky.

I Art, music and language

Thinking about the work of art with respect to Paul Klee necessitates noticing that 'work' involves both the labour or process of creating art as well as the artefact resulting from that labour. 'Art' is also an inclusive term encompassing not only pictorial art but aspects of verbal and musical art as well. Klee's interest in music has not gone unnoticed.[1] He came from a musical family and was a very accomplished violinist. His comments about himself and his work regularly make musical references or invoke musical analogies. It is also clear that he did not see his interest in music as fundamentally different or separate from his interest in other forms of art. From as early as 1898, he can mingle in his *Diaries* projects like the following (*Diaries* I, no. 59):[2]

> 3.13.1898. Little erotic poems. A touch of frivolity in these things.
> 3.23.1898. Plan of a book of lyrical songs, before a single song had been
> completed.
> 6.17.1898. Last night I felt so well disposed I would have worked till dawn,
> if my eyes had allowed it. Now I'll work at night, sleep in the
> daytime. For a future painter this is not quite the right method.[3]

The quotations, lined up in sequence from March to June, articulate poetic, lyric

74

and painterly concerns, as if one led to or incorporated the others. Klee makes a similar linkage in June 1902, after his Italian trip and during a period of deep self-reflection: 'Actually, the main thing now is not to paint precociously but to be or, at least, to become an individual. The art of mastering life is the prerequisite for all further forms of expression, whether they are paintings, sculptures, tragedies, or musical compositions.' (*Diaries* III, nos. 411–12)[4]

Such interdisciplinary thinking about the arts is striking. We traditionally separate artists out by their media. The temporality of music and language, in particular, regularly distinguishes their related art forms from more static and spatial pictorial art. Klee, to the contrary, will have none (or, at best, little) of this. From as early as May 1905, he remarks that

> More and more parallels between music and graphic art force themselves upon my consciousness. Yet no analysis is successful. Certainly both arts are temporal; this could be proved easily. At Knirr's they rightly spoke about the presentation of a picture, by which they meant something thoroughly temporal: the expressive motions of the brush, the genesis of the effect. (*Diaries* III, no. 640)[5]

Later, in the 'Creative Credo' of 1920, even Lessing's well-known theoretical concerns are discounted:

> All becoming is based on movement. In Lessing's *Laocoon*, on which we wasted a certain amount of intellectual effort in our younger days, a good deal of fuss is made about the difference between temporal and spatial art. But on closer scrutiny the fuss turns out to be mere learned foolishness. For space itself is a temporal concept.
> When a point turns into movement and line — that takes time.[6]

This interest in movement and its relation to lineation is fundamental for Klee, and it turns up again and again in his art work and in his pedagogical materials.[7] Klee speaks rather elegantly about the need to view the work of pictorial art temporally, and he is deeply concerned with finding the temporal aspect of the process of creation in the finished work itself.

If we can agree that the spatial contains or reflects the temporal and that the two are not fundamentally distinct, then we should also be able to find aspects of the spatial reflected in that which is temporal. Klee's comments help us find some of the temporal in the spatial, but we are rather on our own with the spatial in the temporal. To this end, it will be to our benefit to look at the ways in which Klee creates temporal phenomena or utilizes them in his visual art. The following examines language rather than music. Klee's musical practice is lost to us. Aspects of musical notation might work to some extent (and there are some examples of musical notation scattered through the *Diaries* and in the visual art).[8] Musical notation, however, is greatly restricted and much less an immediate feature of Klee's visual art than language. Klee's linguistic practice is readily available in his poems, in his diary entries, and in his pedagogical notations and exercises. Language also occurs frequently in his visual art.

Language, despite its shared temporality, is not music. Unlike music, whose unique function is largely aesthetic, language is dual: it has an aesthetic function that it shares with music and a second function, a discourse or expository function, that is solely its own. The discourse function of language pulls it away from its aesthetic surface. Ordinary language discounts its surface and concentrates its force upon the sense of what it articulates. As a result, ordinary language has great conceptual power. Unlike music, where the relations among notes, rhythm, tempo, etc. are active participants in evolving artistic structure, ordinary language discounts its surface, whether sonic (spoken) or visual (written), to the advantage of the concepts of the discourse it creates.

Klee was fully aware of this problem. In his Jena Lecture of 1924, he encourages his audience to perceive the elements of a picture as being like those composing a tree: sap, roots, leaves, trunk. That is, he wants both the image of the tree and the process whereby the tree comes into being together as one. As he remarks,

> It is hard to gain an overall view of such totality, whether it be nature or art, and it is still harder to communicate the view to others.
> The answer lies in methods of handling spatial representation which lead to an image that is plastically clear. The difficulty lies in the temporal deficiency of language.[9]

Klee is presenting his idea through language, and language is beset by 'difficulty'. The nature of the difficulty becomes clearer in his next statement: in language 'there is no way of seeing many dimensions at once.'[10] As ordinary language runs in time, it will constantly urge us forward, away from the signs it uses toward the discourse it is communicating.

As an artist, Klee values language's aesthetic function over its discourse function. This comes out clearly in his comments on various uses of language in diary entry no. 840 from 1908. Here comments about the construction of visual art are interspersed with comments about different kinds of verbal constructions:

> Books are made of split words and letters, split until they are sufficient in number. Only the professional journalist has time for this. A noble writer works to make his words concise, not to multiply them.[11]

(One needs to read *split* as 'replicated' to get the appropriate effect.) This replication at length, and in time, creates what a professional writer (reporter, narrator, journalist, etc.) gets paid for. This task will not take the time needed to look carefully at letter as letter, word as word, phrase as phrase, or poem as poem. This, however, is just what Klee sets out to do.

The following comments examine Klee's artistic presentation of linguistic material. First, there is a very specific accounting of the spatial in Klee's poetic practice: how he ensures our attention to the uses of words as words. Then, the comments proceed to investigate the operation of language in some visual contexts and relate them to the poetic practice. To do this we will have to work primarily from the German. Finally, the shared principles of spatialization, as they

76

occur in both media, are joined. Some general comments about the interrelation of spatial and temporal art conclude the examination. But, first, the poems.

II The poems of 1914

In 1914, right about the time of the outbreak of World War I, Paul Klee made a number of 'poetic' entries in his *Diaries* (III, nos. 929–48). Almost all these have subsequently appeared, edited into conventional verse form, in the *Gedichte*.[12] Beyond such expected features as rhyme and metre, these entries regularly exhibit word repetition, parallelism of syntax or morphology, opposition or contrast of image or idea, etc. Some poems are fragmentary; others are epigrammatic. The poems deal directly with *Gott* (God) and *Schöpfung* (creation) — not only of the world itself but also of art and the *Werk* (work of art). These interests in being 'godlike' are counterposed to matters of the most fundamental physicality: love-making, *platzen* (bursting or exploding) of *Blasen* (vessels or bladders), departure (not only in physical travelling *hier* [here] and *fern* [far], but also in *Tot* [death]).[13] The poems use repetition to create contrast and opposition, and the resulting associations often express contradictory feelings about art and human endeavour in general.

Among the poems dealing directly with the nature of artistic endeavour, diary entry no. 944 is particularly detailed and well formulated. Here is the version in the *Gedichte*:[14]

Formbildung
ist energisch abgeschwächt
gegenüber Formbestimmung.

Letzte Folge beider Arten von Formung
ist die Form. 5

Von den Wegen zum Ziel.

Von der Handlung zum Perfektum.

Vom eigentlich Lebendigen
zum Zuständlichen.

Im Anfang 10
die männliche Spezialtät
des energischen Anstoßes.

Dann das fleischliche Wachsen des Eies.

Oder:
zuerst der leuchtende Blitz, 15
dann die regnende Wolke.

Wo ist der Geist am reinsten?
Im Anfang.

Hie Werk, das wird
— zweiteilig — .　　　　　　　　　　　　　　　　20
Hie Werk, das ist.

Although the poem spends much of its time opposing various aspects of process to other aspects of product, it is rather more interested, finally, in affirming the mutual interrelatedness of both. This is first caught in the opening five lines where *Formbildung* (form construction or the shaping of form) and *Formbestimmung* (form determination or the determining of form) are contrasted.[15] The roots *-bildung* and *-bestimmung*, upon which these two words are respectively built, embody a number of concepts. *Bildung* suggests natural or naturally evolving things or concepts — that which of its nature evolves. *Bestimmung*, on the other hand, suggests imposed shaping (from without), or purpose or definition — that which is shaped to some end. *Formbestimmung* is clearly the more active word here (although both *Formbildung* and *Formbestimmung* are nouns). *Formbestimmung* embodies the idea of energy or impulse, with respect to which the more passive *Formbildung* is said to be *abgeschwächt* (diminished or weak). Lines 4–5, however, suggest that 'The final consequence of both ways of forming is form.'[16] Thus, whether we credit the *bild(en)* of *Formbildung* or the *bestimm(en)* of *Formbestimmung*, they unite in giving us *Form-ung* and lead to the outcome of *Form*. This move of excision, which articulates a *Form-bild-ung* and a *Form-bestimm-ung*, reduces first to *Form-ung* and finally to *Form*.

The next four lines enforce similar movements. The process of *Formung* is set in analogy with three things: *Wegen* in line 6 (paths or ways), *Handlung* (7) (act or action), and the *eigentlich Lebendigen* (8) (the genuinely living thing). The outcome, *Form*, on the other hand, is analogous to *Ziel* (6) (goal), or *Perfektum* (7), and the *Zuständlichen* (the objective thing).[17] The lines link physical activity (means and ends) and focus toward the realization of some objective conclusion. They also link *Handlung* with *Perfektum* (7). This pair is odd in some respects; *Handlung* is a rather broad term referring in general to 'action', while *Perfektum*, imbued with the idea of accomplishment or perfection, is directly linked to the grammatical concept of the perfect aspect of verbal activity, the expression of completed or enclosed actions. The introduction of grammatical concepts into the poem, itself a piece of linguistic action, is not surprising, even though the poem has been more broadly expressive of concepts of form, which we had first taken as more immediately relevant to three-dimensional reality than to linguistic reality.[18] As the poem progresses, however, its formal interests enlarge to encompass more general creative activity. Artistic activity has become any that begins with 'living impulse' and realizes some kind of objective expression as goal or outcome.

The poem enlarges its creative context even more in lines 10–18. These are enclosed by the repeated lines *Im Anfang* (10, 18) (In the beginning) with their joining of the poem's initial artistic impulses to biblical expressions of the primal genetic act. These lines link the generation of life (10–13) to the generation of meteorological events (15–16). Both are natural acts. The poem asserts that the

initial force or impulse is *männliche* (masculine) and that this force provides the energy that drives creation. This masculine force provides the *energischer Anstoß* (energetic shove) toward creation. The adjective *energisch* appears twice in the poem (2, 12). It seems to describe the force that actively drives *Formbestimmung* over *Formbildung* as well as the force that defines the male, active *Anstoß* (stimulus, impulse, nudge) over implied female, passive receptivity. *Anstoß* is an odd word; it moves quickly in connotation from 'nudge' to relatively unpleasant or untoward ideas: 'shock, scandal, offence'; *anstößig* (offensive, obnoxious, indecent). It leads to the more overtly sexual context of its following line (13), *Dann das fleischliche Wachsen des Eies* (Then the corporal growth of the egg). Actually, sexuality had been latent in the poem since the *abgeschwächt* of line 2 earlier. Its root *schwach* (weak) or *Schwäche* (weakness, impotence), and the noun's senses of 'ravishment' and 'seduction' set up a context which the later sexual references enforce — not only through the noun's sense but through the similarity of sound of *abgeschwächt* (2) and *Wachsen* (13).[19]

Through the meteorological analogy of lines 15–16, sexuality becomes part of a more comprehensive natural structure. Active masculine energy includes not only the sexual creative impulse but lightning flashes: purer energy, purer impulse. All this comes more fully to the fore in lines 17–18: 'Wo ist der Geist am reinsten? / Im Anfang.' The *Geist* (spirit) is both the creative instinct as well as the spirit of God over the waters (which had begun to rain in line 16) at the beginning of the book of Genesis. If we perceive here the spirit of God in the act of creation, we will also hear his voice, as in a very real sense the universe is spoken into existence. If we tie this act to the creation of *Form*, which the opening five lines of the poem have presented, we will be able to find there, in the relation of *Formbildung* to *Formbestimmung*, both the created forms, shapes and images of *bild-en* embedded within *Formbildung* and their assertion into reality through their *bestimm-en* in *Formbestimmung*. *Bestimmen* itself has at its root the *Stimm-e* (voice) that the perlocutionary act of *Bestimmung* asserts, the act of making something so through its being spoken. Thus, we have not only a sacred realm to which the artistic creation of images in the real world relates, but also a sacred realm to which the creation of verbal artefacts also belongs. The artistic universe is a multifaceted, created *Perfektum*, its ends enclosed by its *Anfang*.[20]

The work is both the acting and the created act together. There can be no ends without means; nor does the end eclipse or supersede the means. Rather, in a fundamental way, ends co-exist with means. The created act exists through the relation of oppositions within itself. The last lines of the poem (19–21) present directly this yoked opposition:

Hie Werk, das wird
— zweiteilig — .
Hie Werk, das ist.

The two-fold nature of *Werk* appears as the two phrases pivot rhetorically around their central *zweiteilig* (two-part or dual). The phrases of lines 19 and 21 are balanced. Each contains the location *Hie* (here) and *Werk* (work), as well as the opposed *wird* (becomes) (19) to *ist* (is) (21). This pivotal balance is even more

obvious in Klee's original script where these three lines appear as a single linear artefact:[21]

Hie Werk das wird (zweiteilig) Hie Werk das ist.

As Klee sets this up, we might expect to hear the pair *hie und da* (here and there). If we do, we get a surprise. Instead of *da*, we get more *hie*. The two halves of the utterance are in the same place semantically. *Hie* is not *wird* and *da*, *ist*; rather, it is *hie* where both *wird* and *ist* co-exist. They are, as the central pivot encodes, 'two-fold' and read upon each other. The line (or the three lines of the poem as printed) exists in an asymmetric yet balanced form. Lines 19 and 21 are alike syntactically but different in their verbal insistence upon becoming and being. In the relationship between these phrases, we are invited to discover a link between the paradigmatic (selectional) differences of the verbs (*ist* following *wird*) within the syntagmatically (combinatory) similar frame (*Hie Werk das* ...). The full sense comes through only as we are impelled to read *wird* into *ist*. As Klee actually wrote the line, the two-fold nature of its linguistic axes lures us forward through it from left to right; yet, having read it, inevitably we note the repetition, that the beginning phrase and the ending phrase are significantly alike. On the other hand, the visual structure of the line with its central parenthesis suggests stasis and balance. The line's visual asymmetry is revealed only when individual orthographical details emerge: that is, the two *hie*s are not at opposite ends of the line, but tilted toward the left; the letter W appears more to the left; a full stop appears only after *ist*, and there is no full stop after *wird*. It is a balance of asymmetry.[22]

The sense of the end of the poem includes within itself the act of reading the poem. This is consonant with everything we have so far noted about what the poem expresses. It is not only in the concluding three lines (19–21), through the incorporation of *wird* into *ist*, that this happens. The poem regularly reads itself into itself throughout. The opening lines (1–5) place much emphasis on the emergence of *Form*. As we have seen, the root morpheme *Form-* appears in various guises a few times before it appears, starkly alone, at the end of line 5. *Form-*, in one form or another, has been present throughout lines 1–5, actually from the first syllable of line 1. (As we learn later, it is there *im Anfang*!) Put otherwise: *Form* is even there before we are cognizant of the emergence of *Form*. The repetition, visual and linguistic, provides an impulse for and enforces our notice. The repetition of *Im Anfang* from line 10 in line 18, although it provides a neat framing device, necessitates our seeing the presence of *Anfang* itself at the end of the segment it frames. That is, what was the *Anfang* (beginning) at the beginning remains literally present as *Anfang* at the conclusion. In no way throughout the poem can beginning and end, impulse and act, becoming and being be separated, even as they are, in fact, separated. This unseparated separation is both visual and linguistic.

As we have noted, this yoking together of events obtains because our space-time perception of things involves our seeing them as plotted along opposed axes uniting the combinatory-syntactic-temporal aspect of events with the selectional-paradigmatic-spatial aspect of those same events. Klee's poetry from the teens of

the twentieth century focuses particularly on the opposition of the paradigmatic and syntagmatic nature of language and its resulting asymmetry. Any poetic utterance provides a balance to the syntagmatic forward motion of language and places restraints upon it. Poetry of this type relies heavily on repetition — of sounds, of words, of phrases — to create these effects. We hear this repetition as we listen or as we read. Repetition also realizes itself orthographically and, therefore, visually as well as acoustically. We find a case in point in these lines of diary entry no. 936:[23]

> Nur eines allein ist wahr:
> im Ich ein Gewicht, ein kleiner Stein.

The lines run almost exclusively on the vowel sounds [aɪ] (*eines, allein, ein, kleiner, Stein*) and [ɪ] (*ist, im, Ich, Gewicht*). Further, the [aɪ] diphthong is always followed by [n], which six times produces words having within them embedded variants of the form *ein* [aɪn] (one, sole, alone). These provide a framing device for the central (although off-balanced) pairing of the words *ich* and *Gewicht*. We see here too that the *Ich* [ɪç] (I) is embedded within the word *Gewicht* [gəˈvɪçt] (weight, heaviness, importance). The stressed (or partially stressed) vowel contour of the lines runs (including the repeated vowel-consonant patterns already noted):

[u] > [aɪn] > [aɪn] > [ɪ] > [aː] /
[ɪ] > [ɪç] > [aɪn] > [ɪç] > [aɪn] > [aɪn] > [aɪn]

The constant repeating slows the line and overlays a retrograde, impeding motion upon the forward-moving syntax. The line sinks its speaker, its *Ich*, under the weight of its own *Gewicht* as it reconfigures itself as a thing apart or alone, *ein*, in *Stein*. Repetition always does this, but the extent to which it is taken here works a violent reconstruction upon the lines and asks us not only to hear it as halted but to see the centre of the second line as centrally weighted and focused. Thus, the off-centre balance of the line exists in a hard-won and precarious relationship with the repeating [aɪn] combinations. Such attention also alerts us to a central contradiction in the lines: the *Gewicht* (weight) is not linguistically in *Ich* (ı); rather, the *Ich* is in the *Gewicht*. Thus, I must be perceived as in the weight as the weight is in me. Nor are any of the *ein*s of the poem left fully 'alone'.

III Anna Wenne and others

III.A Anna Wenne for the first time
In 1922 Paul Klee produced the picture *Schaufenster für Damenunterkleidung* (plate 18). It is small and drab. Greyish green and washed-out yellow provide the dominant colours within its contrasting black border. The picture presents what its title suggests: a window display with informative advertising. Composed of two separate sheets of paper, the picture divides vertically as if into two separate panes of glass. In the window are what seem to be stylized female mannequins displaying (perhaps) slips, suspender belts (Am.E. garter belts) and corsets. The

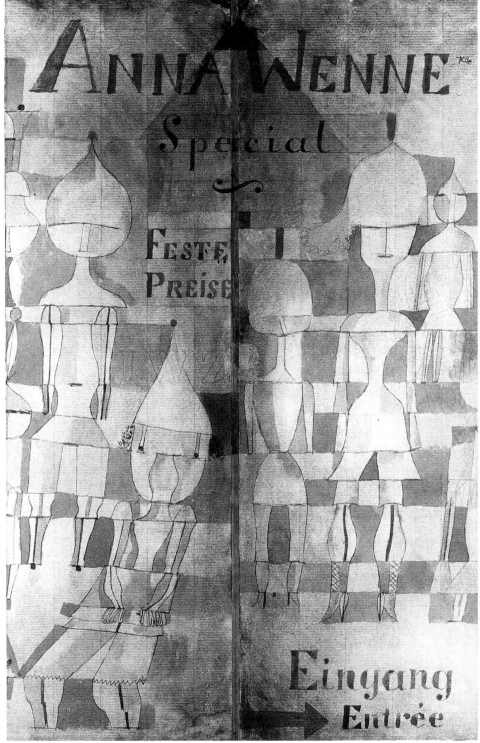

18 *Schaufenster für Damenunterkleidung (Window display for lingerie)*, 1922/125. Pen and black ink with watercolour on two sheets of laid paper, mounted on cardboard. 41.9 × 27 cm. The Metropolitan Museum of Art, The Berggruen Klee Collection, New York (1984.315.29).

high stylization of these forms at once turns them into repeating patterns that seem to be superimposed upon themselves so that it is often hard, if not impossible, to tell where one begins and another leaves off. Some of these dummies appear to be full figures; this is true, for example, of the central figure in the right panel and also of the figure to our left (its right). On the other hand, a third figure, to the right (as we see it) of the central figure, and apparently further 'back' in the display, is curiously disembodied: its head and shoulders seem detached from its torso; it may or may not have the upper portion of its legs.

This problem of body segmentation affects all the figures in the left panel of the picture window. Of the two mostly visible figures, the leftmost suffers the same segmentation problems as the rightmost figure in the 'back' of the right panel. The other figure in the left panel seems to be the furthest forward in the picture. We sense this by the apparent loss of the figure's feet below the bottom of the window. But what can we make of the rest of this figure? It is the only one in the display with fingers, but they (nothing corresponding to hands being in view) seem to be attached directly to its arms. And what about this figure's head? If it is a head, which way is it facing? Is it wearing some kind of pointed hat that drops some 'things' down over its eyes? On the other hand, this might be the back of something, and the apparent eyes and yellow hat (actually the brightest objects in the window) might be part of a slip with a suspender belt. The more one looks at all these figures and the geometric green and grey background from which they emerge, the more one becomes unsure of exactly what one is seeing.

The advertising on the window itself, however, is quite clear. The word *Special* spreads itself across both panels of paper (window) in the upper centre. *Special* is not German; it could be English, but it is more likely (given the picture's content) to be French. Below it, one sees a small flourish (ᔕ). Below that, to the left, appear the words *Feste* above *Preise*. At the bottom right are the words *Eingang* above *Entrée*, preceded to its left by a right-pointing arrow. And, of course, spread across the top of the shop window and the picture itself appears in brown watercolour the name in capitals: ANNA WENNE. We assume this to be the name of the owner or proprietor of this shop, that her commercial enterprise offers us strange, enticing merchandise such as that which we have perused in the window, that it features 'special' quality merchandise at 'fixed prices', and that all we need to do is enter — to the right.

III.B. Anna Wenne, again-e

In 1923 Klee created a second picture in which the name *Anna Wenne* figures: *Ein zentrifugales Gedenkblatt* (plate 19). The picture is technically one of the 'magic square' pictures that Klee was composing at about this time. That is, it is composed of a number of deeply textured rectangles or squares arranged so as to give an almost architectural sense to the picture, with the rectangles and squares painted in contrasting dark and light colours.[24] These are placed so as to create a compositional balance that is usually neither static nor symmetrical. Large rectangles can be set off against groups of smaller rectangular shapes; or a larger shape can be painted with a light colour and set off against a smaller, similar shape painted in a darker colour; or shapes of a primary colour can be set off against similar shapes of complementary colours, and so forth.[25] The shapes

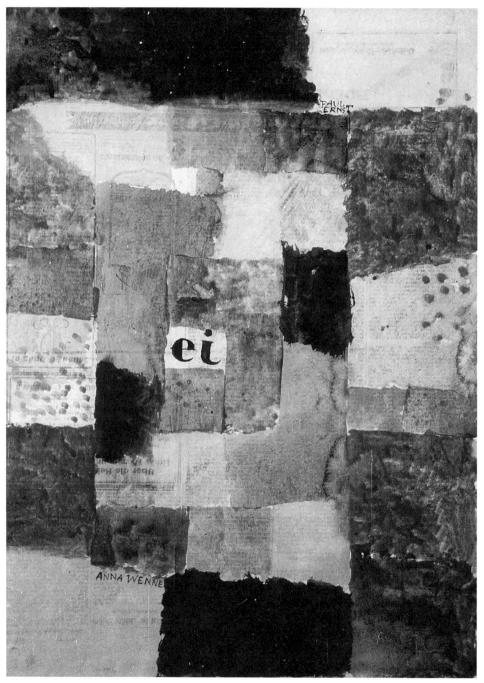

19 *Ein zentrifugales Gedenkblatt (A centrifugal memory page)*. 1923/171. Watercolour on newspaper. 34.7 × 41.7 cm. Private collection.

utilized seldom achieve geometrical perfection. More often than not, the imperfect borders and colours of the shapes overlap each other, giving the surface of such works an agitated, restless feeling. The balance achieved is oriented toward movement.

Ein zentrifugales Gedenkblatt is quite typical in all these respects. The picture is dominated by large rectangles (or perhaps parallelograms). The dominant colours are yellow and brown, but there are also reds, blues, turquoise and a lavender that occasionally mixes with brown. Balance is created in a number of ways. First, the size of the rectangles enlarges toward the perimeter of the picture. The small, very dark rectangles with longer vertical axes in the centre of the picture are the same colour (dark brown) as the large rectangles with longer horizontal axes in the middle of the top and bottom margins of the picture. The two imperfect squares with obvious dots (blue) in the middle of the left and right margins of the picture are lavender (the square on the left is somewhat smaller and lower than the square on the right). Some features are more elaborately patterned. For example, across the top, from left to right, one sees light-brownish lavender, dark brown and yellow; across the bottom, from left to right, one sees the reverse: yellow, dark brown and light-brownish lavender. Colours and shapes in the middle of the picture are also balanced; the ⌐ and ⌐ shapes (the former *above* the small dark-brown rectangle to the left of centre and the latter *below* the small brown rectangle to the right of centre) are almost identical in size and of the same turquoise colour.

There are only two white squares in the picture. These stand out quite clearly against the other colours.[26] One lies just to the left of centre and contains the letters *ei*. They suggest that we read them as *Ei* (egg). Above the *e*, about halfway up the picture, lies the second white square. It is much smaller than the *ei*-containing white square. It helps to pull the eye up and starts it moving around the central 'egg'. One is encouraged to move anti-clockwise by the interrelation of the non-rectangular shapes near the centre of the picture. The balance of lighter against darker colours does this as well. Other effects also create anti-clockwise movement. For example, the square immediately beneath the *ei*-containing white square is blue; the square immediately to the right of the smaller white square above the *e* is also blue, rotating the effect 90 degrees anti-clockwise.

Circling the *ei* square at least twice, one finds oneself in the lower left portion of the picture. Here one is deposited in the large, yellow rectangle that sits in the picture's lower left-hand corner. We see there, in this rectangle's upper right corner, the letters composing the name of our old friend *Anna Wenne*. In no way as prominent as the letters allowed her in her shop window, these hover in a horizontal line, almost hidden. As the letters read forward toward the bottom of the picture's centre, they are constrained by the shapes above them and in front of them. They seem to stop there. It is only with great difficulty that we can proceed around the edge of the picture and move upward toward the upper right, where in the counterposed, second, yellow rectangle, the words *Paul Ernst* appear. These are also very small. Unlike *Anna Wenne*, which is all on one horizontal line, *Paul* is above *Ernst*, so that *Paul* begins slightly to the left of *Ernst*, and *Ernst* concludes slightly to the right below *Paul*. The picture has moved us anti-clockwise right around its centre to the lower left where it halts; then, on to its

upper right-hand corner. The *ei* (egg) lies still in the centre, something around which the movement circulates. In this circulation, the names are caught, but, to the central *ei*, they have only the most tenuous connection. Nor do the names seem clearly connected with each other. They are similar in orthography but opposed in placement. They are balanced but not symmetrical. The whole sense is disjoint, centrifugal.

Unlike the earlier *Schaufenster für Damenunterkleidung*, where the words are easily perceived to be at one with the object portrayed (that is, they are readily understood as advertising), in the later *Zentrifugales Gedenkblatt* there is no such possibility. The work is not representational. There is no more reason or excuse for the letters, words or names to be in the picture than there is for the colours and shapes composing it to be there. Unlike the apparent advertising, we must deal with these linguistic forms as an aspect of the picture's aesthetic construction. The words suggest some linguistic part of memory just as their arrangement within the rectangles offers some momentary halting or suspension of the picture's centrifugality.[27] The *ei* of the centre suggests an egg, a source from which, or perhaps around which, the rectangular shapes and words grow or arrange themselves. If these are names, they are male and female, and they seem to be diagonally opposed. Neither the male nor the female principle is easily seen as united with the egg, which alone sits in the centre. Whether we are to perceive its visual prominence as a manifestation of its *fleischliche Wachsen* which displaces both the *urmännlich* and *urweiblich* aspects of its origin is not clear. Perhaps it is a self-generated, self-fertilized *ei*.

The names *Paul* and *Ernst* are suggestive. There is the poet-novelist-essayist Paul Ernst (1866–1933). He was quite well known in the early 1920s, and it is possible that Klee is making a reference to him here.[28] On the other hand, the names *Paul* and *Ernst* are Paul Klee's own given names, and *Paul Ernst* might be taken to refer to Klee himself.[29] Whether *Paul Ernst* refers to one Paul Ernst or another, however, it stands to reason that *Anna Wenne* ought to have a 'real' referent as well. Attempts to find a suitable Anna Wenne (indeed, any Anna Wenne) have failed.[30] If Klee has a real person in mind in any of these cases, he has hidden the identity very well.

There is a similar situation in another picture, *Das Vokaltuch der Kammersängerin Rosa Silber* (1922), which also plays off letters, sounds and names (plate 20). No 'real' referent has been found for Rosa Silber either.[31] It should be noted that Rosa Silber and Anna Wenne share adjacent inventory numbers in Klee's Works Catalogue for 1922: *Schaufenster für Damenunter-kleidung* is no. 125; *Das Vokaltuch der Kammersängerin Rosa Silber* is no. 126. In each case, a fantasy woman is envisaged with 'real' linguistic attributes; Anna Wenne's shop with its advertising; Rosa Silber with her initials, *RS*, and the vowels, *a, e, i, o* and *u*.[32]

III.C Anna Wenne and Anna Blume

In August 1919 Kurt Schwitters's 'An Anna Blume' first appeared in *Der Sturm*. The poem became an instant success, and during the years that followed Anna Blume became almost an alter ego for Schwitters's aesthetic self. Certain aspects of Schwitters's poetic creation seem to have transmuted themselves into some of

86

20 *Das Vokaltuch der Kammersängerin Rosa Silber* (*Vocal fabric of the singer Rosa Silber*).
1922/126. Watercolour and plaster on muslin, mounted on cardboard. 62.3 × 52.1 cm. The
Museum of Modern Art, New York.

Klee's visual creations of this time.[33] To begin with, both Schwitters's poem and Klee's two Anna Wenne pictures share *Anna*. Schwitters never tired of noting that the name is palindromic (lines 27–31):[34]

> Weißt Du es Anna, weißt Du es schon,
> Man kann Dich auch von hinten lesen.
> Und Du, Du Herrlichste von allen,
> Du bist von hinten, wie von vorne:
> A——N——N——A.[35]

Klee's Anna likewise shows the same amazing ability both to come and go at once. A second point: there may be more than a chance analogical connection between Schwitters's heroine and the peculiar pictorial indeterminability of the position (front or back?) of the left-central, yellow-hatted mannequin in Anna Wenne's *Schaufenster*. Schwitters's Anna Blume is also addressed: 'Du trägst den Hut auf Deinen Füßen und wanderst auf die Hände' (l. 7).[36] There is also something of this mix-matching of clothes and body parts in Klee's picture.

A third point of coincidence: at the centre of Schwitters's poem (lines 14–17) is posed the well-known 'Prize question':

> *Preisfrage:*
> (1) Anna Blume hat ein Vogel,
> (2) Anna Blume is rot.
> (3) Welche Farbe hat der Vogel.[37]

The illogicality of the question as well as the implied 'cuckooness' of its premise render it insoluble. The phrase *einen Vogel haben* means literally 'to have a bird'; in its idiomatic usage, it means 'to be crazy'. Its use in the *Preisfrage* literalizes it, although the ungrammaticality of the poem makes it impossible to know who has whom.[38] In 1921 Klee produced a drawing *hat einen Vogel* (plate 21). The drawing, showing a female figure upon whose head sits a cup-like, hat-like appendage, within which there is a bird on an egg, similarly literalizes the phrase. In addition, the poem's play on word and idiom suggests that its *Preis* is at once a *Preis* or 'prize' to be attained at great (if not unaffordable) *Preis* or 'cost'. At the centre of Anna Wenne's *Schaufenster*, we have *Feste Preise* (fast prices) if we see the two words as linked into a noun phrase of adjective modifying noun. *Feste*, however, is at once the adjective 'fast, fixed' and the plural noun *Feste* meaning 'festivals, celebrations'. We might have here two nouns, one on top of the other, not linked syntactically: *festivals* ('good times', I suppose) and *prices* or *prizes*.

This leads us to yet a fourth connection between Klee's Anna and Schwitters's: the whole of Schwitters's poem is suffused with sexual suggestion (a feature not uncommon to much of Schwitters's poetry). It is, after all, an ungrammatical love song which fairly drips with *Rindertalg* (beef-tallow) and lustful liquifaction. Anna Blume's body parts, voice, colours, physical activities are separated and eulogized. These become more and more sensual as the poem progresses, joining animality with ungrammaticality at its conclusion (lines 34–35):

21 *Hat einen Vogel.* 1921/221.
Pen and ink on writing paper,
mounted on cardboard. 27.3 ×
10.6 cm. Kunstsammlung
Nordrhein-Westfalen, Düsseldorf.

> Du tropfes Tier,
> Ich——liebe——Dir![39]

Implied sexuality is not absent from Klee's *Schaufenster* either. The washed-out, greyish colour provides the effect of twilight or dawn, as if we were examining the merchandise not during business hours but at night or in the small hours of the morning.[40] The window, with its promise of body parts and *Damenunter-kleidung*, becomes fetish-like. Its 'specials' with their *Feste* and their *Preise* come to suggest a sideshow with the possibility of what kinds of perverse pleasures? Is this a brothel with its wares on display? All we need to do is enter at the lower right by the *Eingang* (in stolid bourgeois fashion), or we might wish (Heaven help us!) the more cosmopolitan *Entrée*, French no less (and all that that entails). Whatever is Anna Wenne selling now?

Even the more abstract *Zentrifugales Gedenkblatt* is not devoid of sexuality. We have already noted its connection to the poems of 1914 and their sexual/creative metaphors. Around its central *ei* are to be found a horizontal *Anna Wenne*, invitingly stretched out, easily available, and a self-contorted name-upon-name *Paul Ernst*. They may be in flight not only from the *ei* but from each other. Whether the *ei* is but some creative idea or some more physical, sexual egg is not clear. Nor need these alternatives be separate.[41] As the *ei* is a name, it becomes the focus of the other names of the picture. They express themselves as they are perceived to circle and to flee whatever is central. There is no easy joining here, no harmonious linking. *Paul Ernst*'s cramped onomastic positioning provides evidence of dis-ease, to which the easy, visual, linear elongation of *Anna Wenne* invites contrast. Schwitters's palindromic *A-N-N-A* does not exhibit more equanimity vis-à-vis the impassioned vocalic outpourings of her incoherent admirer.

III.D Anna Wenne ohne Anna Blume

Of course, Klee's Anna Wenne pictures are not illustrations of Schwitters's poem. Anna Wenne shares the equivocal-reciprocal name *Anna*, but Schwitters's Anna Blume belongs to the family of flowers, as his own translation, 'Anna Blossom', makes clear. Anna Wenne has no obvious denotative or referential family; *Wenne* is not a German word. It is not even closely related in phonology or etymology to any such family, except to conjunctive *wenn* (when, whenever, if, in case) — not particularly helpful if we are searching for extra-linguistic reference. Anna Wenne is an even more purely linguistic construct than Anna Blume.[42] We can see that not only Anna Wenne's beginning A-N-N-A but its conclusion E-N-N-E are alike palindromic, pivoting around the central W (itself a 'reversible' letter). Flip W around and it is still W; try that with B, for example, and you are in trouble.[43] Thus, A-N-N-A-W-E-N-N-E divides into two in more ways than does Schwitters's Anna Blume:

$$\text{ANNA} - \text{W} - \text{ENNE}$$

whereas,

$$^*\text{ANNA} - \text{B} - \text{LUME}$$

Anna Blume fails in this attempt rather abysmally. The language and orthography of the name *Anna Wenne* provide a balance in which the various elements create an apparent symmetry around its central W. The full name, however, does not read the same backwards and forwards:

*ENNEWANNA.

Although a balance appears with respect to each of its separate parts, its symmetricality is virtual.[44] Superficial appearance belies a fundamental imbalance, which is embodied in the vocalic doubleness of *A* to the left and a corresponding doubleness of *E* on the right. The symmetry is ultimately illusory, even though the balance of As against Es remains.

In orthographic terms the name Anna Wenne is balanced around its central W by the paired Ns on each side although, as read, it moves from *A* to *E*. In both *Schaufenster für Damenunterkleidung* and *Ein zentrifugales Gedenkblatt*, the name ANNA WENNE is all capitals. In the *Schaufenster*, this practice is repeated in the words *FESTE* and *PREISE*. The other words — *Special, Eingang* and *Entrée* — have only their first letters capitalized. The repetition of capital *Es* is quite noticeable, particularly in the right half of the picture. This is odd because, in purely numerical terms, the Es are evenly distributed: four to the left in *FESTE* and *PREISE*; four to the right in *WENNE, Eingang* and *Entrée*. The right capitals, however, are larger and three of them are in brown, while the left capitals are all black and smaller. The whole effect is greatly to foreground capital *E* at the expense of the other letters.

In the *Zentrifugales Gedenkblatt*, an orthographic reversal takes place. This picture presents most prominently, in lower case, *ei* in the near-central, white rectangle. The light background and the large, lower-case letters stand out clearly and direct one's attention immediately to that position. It is also the case that the right-curving bottom of both the *e* and its adjacent *i*, as painted, start our eye on the anti-clockwise, centrifugal motion that the rectangular positioning of the picture encourages. The letters of both ANNA WENNE and PAUL ERNST, both tiny and both capitalized throughout, do little to call attention to themselves. Curiously, the lower is bigger and the upper is smaller. Nor are the names given any height variation, as are the *Schaufenster's Anna Wenne, Eingang* and *Entrée*, where the initial upper case capitals exceed in size the other letters of these words.

In phonetic terms, these vowels provide a move from the [a], a low-central or low-back vowel to [ɛ], a lax, mid-front vowel. This vocalic move provides a lightening, a sense that [ɛ] is less 'dark' than [a], resulting from the decrease in vocalic gravity as the vowel sound [a] moves toward [ɛ].[45] There is a sense of 'rise' in this move as well. Other words appearing in *Schaufenster für Damenunterkleidung* utilize quite similar sounds in similar ways. The move from [a] to [ɛ] is reversed in *Special* [ˈʃpetsial], where the first vowel [e] is, like [ɛ], a mid-front vowel, but tense rather than lax.[46] Thus, *Anna Wenne, special* runs [a] > [ɛ]/[e] > [a], dark > light > slightly lighter > dark again. The mid-portion of the picture with *Feste,* [ˈfɛstə] and [ˈpraizə] reasserts the perception of lightness. By the time we arrive at the lower right with its mixed-language message, we see that *Eingang* [ˈaɪnˌgãŋ] begins as does *Preise,* but it moves toward the darkening of [a].

Entrée, however, moves toward mid-front [ãtʀe:], its vocalic phonetics (in spite of its orthography) mimicking those of *Anna Wenne* herself! The picture's visual lighting effects correspond to those of the words that it includes. *Anna Wenne* lightens to its right; the whole of the picture is lighter on the right than on the left, the lower right-hand corner being among the lightest portions of the picture. As well, the top mid-centre of the picture around the final *a* of *Anna* and the *W* of *Wenne* is dominated by a black triangle reflecting the darkness beneath it to encompass *special* before dissipating itself into the lower central portion of the picture, where only a dark right-pointing arrow leads us toward the manifold promises of *Entrée*.

Ein Zentrifugales Gedenkblatt uses its similar language in similar ways. Diphthongal *Ei* [aɪ] sits in the centre in the lightest part of the picture. It replicates the vowels of the first syllables of both *Preise* and *Eingang* and provides an even greater disparity in gravity between its beginning and ending ([a] to [I]) than does the shift from [a] to [ɛ] in *Anna Wenne*. The diphthongal lift and brightness is more apparent in *Ei* because the 'word' is made up solely of this vowel sound. *Anna Wenne* is also somewhat elongated through the presence of its repeated nasal [n] sounds and the open syllables which conclude *Anna* -[na] and -*enne* - [nɛ]. Not so, however, *Paul Ernst*. Not only is its vocalic gravity pattern reversed, beginning with [aʊ] and ending with [ɛ]: [ˌpaʊlˈɛrnst], but the sputtering of consonants at the end of *Ernst* shuts off the forward, rising movement of [aʊ] to [ɛ] and provides the sound with a consonontal clustering that stops the word in its tracks and buries the rising effect of *Ernst*'s vowel [ɛ], as it might be perceived following diphthongal [aʊ].[47] The abrupt, cramped nature of the name's orthographical presentation in the picture replicates itself in the sound, just as the linear physical elongation of *Anna Wenne* provides a visual analogue to its melifluous sound pattern.

III.E Asymmetrical Anna Wenne

All this talk about the symmetrical aspects of the name *Anna Wenne*, both in its acoustics and in its orthography, is belied by its visual reality. We do not find *Anna* to the left of a central *W* and *enne* to its right. These letters just do not move about the *W* as if it were a pivot. The initial *A* of *Anna* is regularly a capital, as is the *W* of *Wenne*, and Anna's *A* offsets and displaces the apparent centrality of *W*. This is exactly the configuration of the name at the top of the *Schaufenster*'s advertisement. As the picture divides itself spatially into two vertically elongated rectangles, the name divides as well: *Anna* atop the left panel; *Wenne* atop the right. The *W*, which is linguistically central, is decentred right. Rather than the *W* being at the picture's central, vertical division, we find closest to that point the dark, black, triangular arrowhead, which casts its shadow over both the final *a* of *Anna* and the *W* of *Wenne*, as well as encompassing the word *Special* beneath it. This word is also decentred right: *Spe-* to the left, *-cial* to the right of the vertical division. This displacement right aids our progress through the picture, which is directed 'right' by both its illumination and its figuration. This right-directed movement, however, is impeded almost immediately, as the right-displaced figures (letters, shapes, etc.) are regularly counterbalanced, just as the initial *A* of *Anna* counterbalances the initial *W* of *Wenne*. The capital *S* of *Special* adds weight to

the left side of that word. (That, too, is counterbalanced in the height of the word's final -*l*.) The flourish beneath *Special* (a 90 degree clockwise-rotated capital *S*) lies athwart the central axis in a balanced but asymmetrical way. Other elements both visual and linguistic are placed and balanced to keep the asymmetry of the centre, although atilt, in place. The effect keeps us within the structure of the picture whilst simultaneously encouraging us to move through it and to leave it, ironically, at the *Eingang*.

The arrow pointing us out (in) stands in orthogonal relation to the picture's central vertical division, which has itself become an arrow. If the arrows move in the directions of their orientation and in that movement suggest the initiating thought of their actions, then this picture is conflicted, held captive by two mutually exclusive thoughts.[48] The first (vertical) moves toward the essence of Anna Wenne, the larger but less focused concept; the second (horizontal), more focused and clearer, is toward escape. These arrows seem to create the vertical and horizontal axes of a graph which contains, plots and traps contradictory impulses. The individual parts of the picture decompose into smaller rectangular-like elements (of different shades of grey, grey-green and washed-out yellow) against which both the linguistic material and the mannequins of the display are perceived. No one of these gains significant prominence over the others.

This same horizontal/vertical division governs even more forcefully our perception of *Ein zentrifugales Gedenkblatt*. In that work, however, the horizontal and vertical 'axes' are most marked by the placement of the two names: *Anna Wenne* horizontally along the bottom quarter of the picture and *Paul Ernst* vertically about three quarters of the way to the right. The vertical is widely decentred (unlike the central vertical of *Schaufenster*). Here the decentring makes the axial connection in the lower right part of the picture. The *ei* lies just left of the picture's centre. Thus, what seems to be the centre of the picture is decentred, left. What had been held in place in *Schaufenster* spirals outward here. The centrifugal anti-clockwise motion gives greatest emphasis to the bottom quarter and right vertical quarter of the picture. As the eye slides anti-clockwise, it passes by *Anna Wenne* with some difficulty, then either out of the bottom or up. Perhaps with diligence one progresses further right and up to the contorted *Paul Ernst*. From here one exits easily, leaving the white of the *ei* in the centre of nothing.

IV The two-fold nature of asymmetry and simultaneity

The appearance of symmetry, which both the Anna Wenne pictures manifest, is just that, an appearance. Portions of the works are set off against each other in such a way that our first impressions, which seem to be of symmetrical relations, are immediately tilted or disrupted by real asymmetries. The neat division of Anna Wenne's *Schaufenster* into two apparent panes is by every other aspect of the picture belied. It is only through assiduous attention to the placement and balance of detail that even the appearance of symmetry remains. The central *ei* of *Ein Zentrifugales Gedenkblatt*, which seems so poised in its centrality, is precariously eccentric, and the picture begins to move round even as we begin to view it.

The linguistic forms in the pictures are part of this relation of balance and

movement. The shape and the sound of the *ei* [aɪ] start us moving anti-clockwise. The placement and sound of the linguistic elements add their own blandishments and enticements to the other items on display in Anna Wenne's shop window. The shape and sound of what we see and say moves us well beyond our initial window shopping, and we find ourselves entering both these pictures in ways we had not at first anticipated. We have encountered similar strategies, both visual and verbal, in the poems of 1914, where the apparent symmetry of rhetorical balance played a role in providing restraint to the headlong forward (right-directed) motion of the language's syntax. The poems seem to be static even as they proceed. These balancing effects work differently depending upon whether or not Klee's medium is fundamentally visual or verbal, but the means employed in all cases are the same. Balanced asymmetry encourages the eye to move (and the ear to listen) within the visual sphere; it arrests the temporal movement of the eye (and ear) in the medium of language.

The pictures of 1922–1923 present in striking form the temporal (phonetic, syntactic) aspects of language caught in visual form. Their effects derive from the tension created between this forward (right) motion of spoken language (as it is read in its orthographic forms) and the static placement of the written words themselves. The surrounding visual context insists upon some balance and stasis in this language in spite of everything else linguistic that propels it forward. The pictures, of course, place the visual at the centre of our attention and let the language work within that. The poetic materials of 1914, on the other hand, value the temporal over the visual (or spatial), but, even there, their formal sense derives from our perception of some asymmetric balance restricting and structuring motion.

The pictures and the poems come at the same thing but from different directions. Klee elsewhere formulates this particular phenomenon in other words as, for example, in 1917: 'Polyphonic painting is superior to music in that, here, the time element becomes a spatial element. The notion of simultaneity stands out even more richly.'[49] Replace *music* by *language* or *speech*, and we have just what has been noticed here.

Klee's concerns with polyphony began much earlier than this. His musical training made him fully conversant with literal uses of the term. With respect to visual art, he came in contact with it at least from his earliest contacts with Analytic and Orphic Cubism — if not before. In 1912 Klee visited Paris, met Robert Delaunay, and translated his 'La lumière'. The essay expounds at once a value for the simultaneity of multiple visual points of view, along with a 'celebration of universal light-symbolism'.[50] The essay explicitly denies value to auditory as opposed to visual perception: 'auditory perception is not sufficient for our knowledge of the world ... its movement is *successive*, it is a sort of mechanism....'[51] Klee would surely have agreed with the first part of the statement, that auditory phenomena are not alone sufficient for full perceptual knowledge. The second part of the statement, however, that they are successive, surely gave him pause.

Klee's knowledge of music would have told him that temporal succession is not discrete in time. We do not forget what has gone before as soon as it is heard. Musical composition, from simple melody to the most complex contrapuntal structures, exists because of our abilities to hold together relations among

sequences even as they succeed one another in time.[52] Language must be held similarly in the 'ear' if it is to be understood. Klee knew that the idea of simultaneity can be conceived only by our abilities to hold together a number of different voices or different visual patterns through a series of temporal moments.

A purely synchronic analysis of anything, whether it be of a spatially structured medium like painting or of a temporally structured one like poetry or music, cannot alone discover simultaneity. No single chord of a piece of tonal music can tell us anything about the overall musical structure of the piece.[53] No contrapuntal musical work will reveal its polyphonic structure synchronically. Heard alone, the third beat of the twenty-fourth measure of any fugue will not reveal itself as fugal, no matter how-many-voiced the fugue may be. Even an instantaneous glance at any visual construct will not reveal pattern (or any structural relations) without time to reflect, no matter how many visual points of view it might contain. Only in time can the understanding of structural relations occur. As a result, the perception of the simultaneity of events, whether they are sound events or sight events, exists only in retrospect. Even prospective simultaneity must be projected retrospectively *out of* some pattern of events already perceived. Klee's sense that polyphonic events spatially constructed are superior to those temporally constructed seems to rest upon the realization that, with spatial events, our time is, as it were, our own. We, as spectators or observers, control the pace of the revelation of simultaneity.

Such control, however, has both positive and negative aspects. It behooves the polyphonic visual artist to 'move' the spectator in time, to encourage the spectator to perceive not just more details but, more significantly, the dynamic relations among details. Klee particularly effects this movement by the balanced asymmetry of his constructions. This is generally true of Klee's visual work well beyond the two pictures examined here. As we approach any work by Klee, we are constantly being required to adjust our perspective to help keep things in balance. As well, linguistic materials in any picture suggest that we read them, and this reading is itself asymmetric in time and space, always moving us visually away from where we started. Linguistic reading always leads us, in this sense, forward.

With an art that is fundamentally temporal, an artist must find the means to control the forward temporal motion to allow auditors the possibility of participating in aspects of the event that are paradigmatic; that is, we must be given the opportunity of bringing to any temporal event immediately before us those related events and experiences bearing upon our understanding of it. These are related to what we experience most immediately, but they are not always most obviously or most directly apparent. To find the *Ich* in *Gewicht* or the *ein* in *allein*, we will need some encouragement to slow our progress and to let ourselves reflect. Such readings always lead us, in this sense, backward.

Repetition and difference are at work in all these instances. We see that which is the same as we perceive that which is different. We see the two frames or windows of Anna Wenne's *Schaufenster* as paired, but different, even though they are showing us the same things. We perceive that *Eingang* and *Entrée* are the same word, although they are obviously different words in different languages. The *Ich* in *Gewicht* is composed of the same letters but is, under other conditions, semantically different. The phrases *Hie Werk das wird* and *Hie Werk das ist* are

syntactically alike throughout and anaphorically alike in word choice. Only their concluding verbs differ. They are, as Klee tells us, *zweiteilig*. Our perception of asymmetry is *zweiteilig* in just the same way, and it looks as if our understanding of simultaneity is *zweiteilig* as well.

The work of art requires a good sense of balance. Perhaps it is no wonder that Klee, throughout his career, liked so often to portray artists of all kinds in precarious situations. The artist must continually strive to hold means and ends together as art articulates itself. Nothing wholly static can come alive, nor must that which is most temporal and fleeting be allowed an easy evanescence. As Otto Werckmeister has shown, a number of aspects of Klee's artistic character matured during the teens of this century.[54] Not only were the teens and early 1920s a time for thinking about how titles and pictures related to each other, they also provided Klee with an opportunity for articulating the artistic enterprise more comprehensively:

> A picture can often be compared to something. . . . Something poetic, poetic I say, not literary, something that also seems to speak symbolically, as though a certain diffidence stopped it from putting things the way they are. To write poetry means to choose words and arrange them in such a way as to produce balance and impressive images. To this is added the freedom of creating.[55]

In the poetry and art of this time are mixed some of Klee's most profound thoughts about the nature of the work of art.[56]

<div style="text-align: right">

Paul Bauschatz
University of Maine

</div>

Notes

1 Just about everybody who writes about Klee notices this. Studies that focus extensively on the musical aspect of Klee's art include A. Kagan, *Paul Klee: Art and Music*, Ithaca and London, 1983; R. Verdi, *Klee and Nature*, New York, 1985; and K.P. Aichele, 'Paul Klee's Operatic Themes and Variations', *Art Bulletin*, vol. 68, 1986, pp. 450–66.

2 As finally edited by Klee himself, there are four separate diaries, comprising 1134 entries numbered consecutively throughout. The entries begin before 1900, with an account of his childhood, and conclude in December 1918. All references to the diaries in this text are cited by entry number. German versions of the entries are from *Paul Klee Tagebücher, 1898–1918*, ed. Wolfgang Kersten, Bern and Stuttgart, 1988 (hereafter *Tagebücher*). References to the English translation are from *The Diaries of Paul Klee, 1898–1918*, ed. Felix Klee, Berkeley and Los Angeles, 1964 (hereafter *Diaries*).

3 *Diaries*, p. 18. The *Tagebücher* (p. 25) offer '13.3.98. Erotische Gedichtchen, ein Anflug von Leicht-/ sinn in diesen Dingen./ 23.3.98. Plan eines lyrischen Liederbuches, bevor/ ein einziges fertiges Lied vorlag./ 17.6.98. Gestern nacht war ich gut disponiert, bis/ zum Morgengraun hätte ich gearbeitet, wenn die/ Augen gewollt hätten. Jetzt nachts thätig sein,/ tags schlafen. Für einen zukünftigen Maler/ nicht ganz das Wahre.'

4 *Diaries*, p. 119. 'Zur Beruhigung: es glit jetzt nicht, frühreife Sachen zu/ machen, sondern menschlich etwas zu sein, oder doch zu werden./ Das Leben meistern, eine Grundbedingung für produktive/ Äusserungen (in meinem Fall). . . . Seien es dan[n] Malereien, Plastiken, Tragödien oder Musiken.' *Tagebücher*, p. 148. Notice that the English phrase 'paint precociously' in the translation is not the literal equivalent of the German 'frühreife Sachen zu machen' ('to make precocious things'), a much less specific phrase and one more appropriate to the mixed aesthetic

context.

5 *Diaries*, p. 177. 'Immer mehr drängen sich mir Parallelen zwischen Musik u. bildender Kunst auf. Doch/ will keine Analyse gelingen. Sicher sind beide Künste zeitlich, das liesse sich leicht nachweisen./ Bei Knirr sprach man ganz richtig vom Vortrag eines Bildes, damit meinte man etwas/ durchaus zeitliches: die Ausdrucksbewegungen des Pinsels, die Genesis des Effektes.' *Tagebücher*, p. 215.

6 This is from the translation of the 'Creative Credo' that appears in Jürg Spiller (ed.), *Paul Klee: The Thinking Eye*, New York and London, 1961, p. 78. This is, itself, a translation of the 'Schöpferische Konfession', as given in Spiller's *Paul Klee: Das Bildnerische Denken*, Basel and Stuttgart, 1956: 'Bewegung liegt allem Werden zugrunde. In Lessings Laokoon, an dem wir einmal jugendliche Denkversuche verzettelten, wird viel Wesens aus dem Unterschied von zeitlicher zu räumlicher Kunst gemacht. Und bei genauerem Zusehen ist's doch nur gelehrter Wahn. Denn auch der Raum ist ein zeitlicher Begriff./ Wenn ein Punkt Bewegung und Linie wird, so erfordert das Zeit.' (p. 78) (The pagination of the English and German editions of Klee's texts corresponds throughout.)

7 This, too, is regularly noted in accounts of Klee's work and is hard to miss. The most complete account of its working out throughout Klee's career can be found in A. Mösser, *Das Problem der Bewegung bei Paul Klee*, Heidelberg, 1976.

8 Some examples are given in P. Klee, *Gedichte*, ed. Felix Klee, 2nd ed., Zürich, 1980, pp. 109–16.

9 'Est ist schwer, ein solches Ganzes, sei es Natur oder Kunst, zu übersehen, und noch schwerer ist es, einem andern zum Überblick zu verhelfen./ Das liegt an den allein gegebenen, zeitlich getrennten Methoden, ein räumliches Gebilde so zu verhandeln, daß eine plastisch-klare Vorstellung sich einstellt. Das liegt an der Mangelhaftigkeit des Zeitlichen in der Sprache.' (*The Thinking Eye/Das Bildnerische Denken*, p. 82) The Jena Lecture (first published in 1945 as 'Über die moderne Kunst' ['On Modern art', 1947]) is included as section 11: 'Survey and Orientation in Regard to Pictorial Elements and their Spatial Arrangement'/'Übersicht und Orientierung auf dem Gebiet der bildnerischen Mittel und ihre räumliche Ordnung', pp. 81–96 of part 1 ('Towards a Theory of Form-production'/ 'Begriffliches zur Gestaltungslehre') of *The Thinking Eye/Das Bildnerische Denken*.

10 'Denn es fehlt uns hier an den Mitteln, eine mehrdimensionale Gleichzeitigkeit synthetisch zu diskutieren' (*The Thinking Eye/Das Bildnerische Denken*, p. 86). The German makes the point more directly than the translation. A translation more to the point might suggest that 'to discuss synthetically a multidimensional simultaneity fails for us in the means'. These 'means' (*Mitteln*) suggest language, certainly, but also all spatio-temporal phenomena. Note, too, that there is no explicit reference in the quotation to *Sprache* (language) or the verb *sprechen* (to speak). The verb is *diskutieren* (to discuss), a direct reference to language's discourse function.

11 *Diaries*, p. 231. 'Bücher sind aus gespaltenen/ / Worten und Buchstaben gemacht, so lang gespalten bis ihrer genug sind. Dazu kan[n]/ nur der professionelle Zeitungsschreiber Zeit haben. Ein Edler arbeitet an der Knappheit/ des Wortes, nicht an seiner Vielheit.' (*Tagebücher*, p. 281) This passage, with much of its surrounding context about visual art, is incorporated into a pedagogical exercise that Klee prepared for the Bauhaus for 3 July 1922 (*Das Bildnerische Denken*, p. 449). The English passage in *The Thinking Eye* concludes: 'But the truly creative person works with the lapidary quality of language, not with its multiplicity.'

12 *Gedichte*, pp. 81–9. On the importance of Klee's conception of the creative act in both his poetry and his art, see R. R. Hubert, 'Paul Klee: Modernism in Art and Literature', in M. Chefdor, R. Quinones and A. Wachtel (eds.), *Modernism: Challenges and Perspectives*, Urbana and Chicago, 1986, pp. 212–37.

13 In the expression of these concerns, certain words reappear, sometimes quite expectedly, sometimes rather startlingly, alone or in compound forms: *Tropfen* (929, 940, 948), *Gewicht* (929, 936), *Tief* (931, 948), *Genesis* (932, 943), *Ende* (933, 948), *Tier* (935, 937), *Berg* (940, 947), *Mond* (940, 942), *Anfang* (943, 944, 948), *Form* (943, 944), *Wolke* (944, 945) and *Seele* (945, 947).

14 *Gedichte*, p. 86. The English version following is from H. Watts (ed.), *Three Painter-Poets: Arp, Schwitters, Klee: Selected Poems*, Harmondsworth, Middlesex, 1974, p. 159:

> Form construction
> is diminished in energy
> in contrast to form determination.
>
> The final consequence of both means of forming
> is form itself.
>
> From paths to the goal.
>
> From act to Perfectum.
>
> From state of change
> to final state.
>
> In the beginning
> the masculine speciality
> of the energetic shove.
>
> Then the corporal growth of the egg.
>
> Or:
> first the lightning flash,
> then the raining cloud.

Where is the spirit purest?
In the beginning.

Here work that is becoming,
two-part.
Here work that is.

15 The glosses are from Watts, *Three Painter-Poets*,
p. 159, and from the *Diaries*, p. 312, in the order
given.

16 This is from the *Diaries*, p. 312.

17 The glosses for both *eigentlich Lebendigen* and
Zuständlichen are from the *Diaries*, p. 312.
Although the adjective *zuständlich* denotes
something like 'neutral', 'inactive' or 'objective',
its uncommon appearance here as a noun
suggests 'general conditions' or 'the way things
are' or 'the condition of things which they have
finally settled into'. *Zuständlich* is not a common
adjective. It does occasionally form a noun, but
more often as *Zuständlichkeit*, so its occurrence
as *das Zuständliches* is doubly striking.

18 Klee had linked *Zustand* and *Handlung* earlier.
In a diary entry in 1908 (no. 824), he describes
one method of painting the human figure:
Ich werde Figurenbilder in vertiefter Weise
nach der Natur malen, und zwar/ unter
getrennter Behandlung zweier Zeiten./
(1) Zustand (imperfectum): Der Raum, die
Umgebung, und zwar muss/ dies Stadium
auch trocknen./
(2) Eintretende Handlung (Perfectum, passé
défini, aorist): Die Figur selber./
(*Tagebücher*, p. 270).
The *Diaries* render this somewhat less than
satisfactorily, losing the parallelism between
Zustand and *Handlung* (although the
grammatical parallels are largely maintained):
I shall paint human figures from nature in a
deeper sense, dividing them into two time
periods and treating each separately.
1st state (imperfect): the space, the
environment; this stage must be allowed to
dry too.
2. Action begins (perfect, passé défini,
aorist): the figure itself (p. 226).
In diary entry no. 832 (also from 1908), we have
the even more striking and immediate
connection: 'Handlung is aoristisch,/ muss sich
abheben von Zuständlichem' (*Tagebücher*,
p. 274). 'Action is in the aorist tense; it must be
contrasted with a static situation'. (*Diaries*,
p. 229)

19 The explicitly sexual nature of the creative act is
perhaps even more obvious in diary entry no.
943, which precedes the poem we have been
considering (*Tagebücher*, p. 363). It precedes this
poem, as well, in the *Gedichte*, p. 86. Its five
statements follow:
Die Genesis als formale Bewegung ist das
Wesentliche am Werk.
Im Anfang das Motiv, Einschaltung der
Energie, Sperma.

Werke als Formbildung im materiellen
Sinne: urweiblich.
Werke als formbestimmendes Sperma:
urmännlich.
Meine Zeichnung gehört ins männliche
Gebiet.
Watts, *Three Poet-Painters*, p. 158, offers the
following version:
Genesis, as formal movement, is the essence
of a work.
In the beginning, the motif, intervention of
energy, sperma.
Works as form-building in the material
sense: primordially feminine.
Works as form-determining sperma:
primordially masculine.
My drawings belong to the masculine
realm.
Apart from its explicit connection to *Meine
Zeichnung* (my drawing in line 5), the passage
reads as a summary of what appears in the poem
of diary entry no. 944. The *männlich* and
weiblich aspects of the creative act are here. The
masculine *Energie* (energy) is here; as we are
likewise told, it is here *Im Anfang*. The play
back and forth between *Formbildung* and
Formbestimmung (not exactly the two nouns, but
the idea is present in the participle
formbestimmendes) is also here. *Sperma* (sperm),
is twice articulated, and it is directly connected
to all the creative impulses we have already
detailed in the poem of entry no 944. Entry no.
943, alone, to this point at any rate, has
suggested how archetypical all this *urmännliches
Sperma* and *urweibliche Formbildung* is.

20 It should be pointed out that all the material we
have so far examined from the poem in diary
entry no. 944 was incorporated verbatim into
Klee's pedagogical materials for the Bauhaus (6th
exercise: Monday, 3 July 1922) (*The Thinking
Eye/Das Bildnerische Denken*, p. 453). (This same
exercise also incorporated the passage from diary
entry no. 840 about working to make words
'concise' not 'to multiply them', already quoted
above.) The poem's lines do not appear there as
they do in the *Gedichte*, of course. In addition,
the first four statements from diary entry no.
943, noted just above, are also quoted in the
same pedagogical entry (p. 457).

21 The *Tagebücher*, p. 364, give the citation with a
period after (*zweiteilig*). There is likewise a
period in the *Diaries*, p. 312, after (*dual*).
Inspection of the original manuscript, however,
reveals no evidence of such a stop. There is only
the full stop at the right-hand end of the line.

22 In the *Tagebücher*, p. 364, this line is set off from
all the preceding lines of the poem by an asterisk.
Yet it is clear that this line belongs with all that
precedes it in entry no. 944. Perhaps this helps to
indicate how essential or focal it is to all that
precedes.

23 In the *Gedichte*, p. 85, this entry is published as

part of a single poem composed of diary entry nos. 935–8 and 940. The two lines offer a relatively simple statement, something like the version in Watts, *Three Poet-Painters*, p. 121:

> One thing alone is true
> In the 'I', a weight, a small stone.

or in the *Diaries*, p. 310:

> Only one thing is true: in me, a weight, a little stone.

Both translations give some idea of the sense of the German words, but neither expresses the feeling of impeded movement inherent in the original.

24 The grey and green rectangular background to the window display in *Schaufenster* shows some of this texture, but in that picture the 'squares' are definitely relegated to the background. The feel of the picture is monochromatic, a static grey against which subtle effects of light and shade can play.

25 Klee outlines and illustrates these effects in great detail in his technical and pedagogical notes. They dominate most of the materials published in *The Thinking Eye/Das Bildnerische Denken*, particularly sections II — 'Ways to Form, How Form Comes into Being, Ways to the Basic Forms'/'Wege zur Form, wie Form wird, Wege zu den Grundformen' (pp. 101–292) and v — 'The Order and Nature of Pure Colours'/'Die Ordnung und das Wesen der reinen Farben' (pp. 465–511) of 'Contributions to a Theory of Pictorial Form'/'Beiträge zur bildnerischen Formlehre'.

26 In Klee's 'canon of totality' for colours, neither black nor white lies within the colour plane. The introduction of white creates an additional colour axis vertical to the picture plane, one that runs from black to white. This also creates a 'centrifugal' effect from what should be the 'grey' centre of the picture. The diagram of the canon of totality is reproduced in colour on p. 488 of *The Thinking Eye/Das Bildnerische Denken*.

27 Some of the print from the newspaper on which the picture is painted shows through the surface, particularly in the lighter rectangles. To what extent this is to be incorporated into the picture's *Gedenk-* (memory) or to what extent the picture is a literal attempt to escape from or obliterate the *-blatt* (leaf, sheet, newspaper) is unclear. The picture, however, does little to discourage such associations, nor do Klee's remarks, cited above, about *der professionelle Zeitungsschreiber* (the professional journalist).

28 What, exactly, this reference might be, however, is hard to say. Ernst did make some interesting comments about aesthetic theory, especially about the relationship of form to content. His early novel, *Der schmale Weg zum Glück* (1904), attempts 'to transform experience into objectivity'. The quotation is from Karl August Kutzbach's *Dichtung und Volkstum* (1935) (A.K. Domandi [ed.], *Modern German Literature: A Library of Literary Criticism*, vol. 1, New York,

1972, pp. 210–16). There are also the essays, *Der Weg zur Form* (1906) and the *Erdachte Gespräche* (1921), which are closest in time to Klee's picture. *If* Klee is glancing at Ernst here, and *if* he has in mind Ernst's ideas about form and content, then the writing-himself-into-a-corner effect of the picture may hint at the futility of trying to separate means and ends; for Klee, the two are joined, as Klee's 1914 poem, above, demonstrates. This is, however, a big *if*; to my knowledge, Klee nowhere else makes any reference to Ernst or to his aesthetic theories.

29 R. Verdi, op. cit., p. 206.

30 S. Rewald, *Paul Klee: The Berggruen Klee Collection in the Metropolitan Museum of Art*, New York, 1988, p. 168.

31 K.P. Aichele, op. cit., p. 459.

32 For an excellent account of this picture, see R. Crone, 'Cosmic Fragments of Meaning: On the Syllables of Paul Klee', in R. Crone and J.L. Koerner (eds.), *Paul Klee: Legends of the Sign*, New York, 1991, pp. 32–6.

33 S. Rewald, op. cit., p. 168.

34 K. Schwitters, *Das Literarische Werk*, Band I — (Lyrik), Cologne, 1973, pp. 58–9. 'An Anna Blume' remains Schwitters's best-known poem. Its popularity spawned parodic imitations quickly (B. Scheffer, *Anfänge Experimentelles Literatur: Das Literarische Werk von Kurt Schwitters*, Bonn, 1978, pp. 74–90). Schwitters's employment of word-structure games, playing with words backwards and forwards (*Hannover > Revonnah > Re von nah*, 'backward from near'), clippings (such as *Merz* from *Kommerz- und Privatbank*), and acronyms (like *Kdee* from *Kathedrale des erotischen Elends*), etc. abound in his work. Good examples appear in K. Schwitters, op. cit.; in W. Schmalenbach, *Kurt Schwitters*, Cologne, 1967, pp. 203–51; and in Scheffer, op. cit., pp. 116–54. There are English translations in H. Watts, op. cit., and in K.T. Steinitz, *Kurt Schwitters: A Portrait from Life*, trans. Robert Bartlett Haas, Berkeley and Los Angeles, 1968, pp. 123–202.

35 The following English 'translations' of the lines are Schwitters's own (K. Schwitters, op. cit., pp. 150–1):

> Does thou know it, Anna,
> Does thou already know it?
> One can also read thee from behind,
> And thou, thou most glorious of all,
> Thou art from the back, as from the front:
> A-N-N-A.
>
> ('Anna Blossom has wheels', ll. 32–7)

36 'You wearest your head on your feet and wanderst on your hands' (l. 9). In the original, *Hut* means 'hat', not 'head'.

37 Price question:
 1. Anna Blossom has wheels.
 2. Anna Blossom is red.
 3. What colours are the wheels?

> (ll. 16–19)

The 'Price' in line 16 is suggestive, but these wheels do not do much for an English speaker. The poem has also been translated by Schwitters's son Ernst, in collaboration with Philip and Ursula Granville, as 'To Eve Blossom' (H. Watts, op. cit., pp.74–5):

Prize-question: 1. Eve Blossom is nuts.
2. Eve Blossom is red.
3. What colour are the nuts? (ll. 14–16)

38 As the phrase *ein Vogel* lacks its accusative *-en* inflection, it cannot grammatically be the object of *hat*. Actually, the phrase here logically reads 'A bird has Anna Blume.' If Anna Blume is red and 'a bird has her', then the colour the bird has is red. So much for grammar and logic!

39 Thou drippes animal,
 I
 Love
 Thine! (ll. 40–3)

40 Klee knew of painted shop windows from the work of August Macke (1887–1914), who, in turn, learned about windows from the work of Robert Delaunay (1885–1941). Klee had come to know Delaunay's art in 1911–12. Delaunay's 'fenêtre' paintings had been exhibited in the *Blaue Reiter* exhibition in Munich. In 1912 Klee also translated Delaunay's short essay 'La lumière' for *Der Sturm*. It was not until early 1914, however, when Klee and Macke travelled to North Africa, that Delaunay's colouristic influence, mediated by Macke, came to affect Klee's art directly (A. Kagan, op. cit., pp. 28–9, 54–8; J.M. Jordan, *Paul Klee and Cubism*, Princeton, New Jersey, 1984, pp.116–49). There is little trace of either Macke or Delaunay in Klee's *Schaufenster*. Macke often painted women standing in front of stores. For Macke, the window acted as a 'mirror allow[ing] him to catch the animated life of the street as it unrolls outside the frame of the composition' (J. Cassou, E. Langui and N. Pevsner, *Gateway to the Twentieth Century: Art and Culture in a Changing World*, New York, 1962, p.346). Unlike Klee's *Schaufenster*, Macke's pictures are generally bright, sunlit and suggestive of busily trafficked commercial streets. Unlike Macke's, Klee's window has no shopper — only us, and what the picture 'reflects', we alone imagine.

41 R. Verdi, op. cit., chap. 6: 'Creating like Nature: The Eventual Goal', pp.191–210. Verdi discusses this picture (pp.205–206) in the context of Klee's other pictorial 'eggs'. He also cites the material from diary entries no. 943 and no. 944 (pp.196–7).

42 The purely linguistic nature of the 'name' suggests the beginning of some sentence that trails off into inexplicitness: 'Anna wenn ...'; that is, once the name is uttered, it strands us within some fragmented portion of linguistic performance leaving matters open: 'Anna, when ..., if ...', etc. The pieces of language embedded in both the pictures here discussed are themselves syntactically fragmented. Anna Wenne merely

renders this fragmentation the more problematical.

43 'For Klee letters and figures had an expressive value of their own.... In connection with letters and numbers Klee inquired into the "causal principle", the essence and appearance of the written sign': 'Buchstaben und Ziffern hatten für Klee einen ursprünglichen Ausdruckswert.... Bei Buchstaben und Zahlen stellte Klee die Frage nach dem "Ursächlichen", nach dem Wesen und der Erscheinung der Schriftzeichen' (J. Spiller, editor's note in *The Thinking Eye/Das Bildnerische Denken*, p.516). For 9 January 1922, Klee gave his students an exercise with letter forms 'in balance as linear-active polyphonies' ('im Gleichgewicht als linear-aktive Polyphonien'). Klee distinguishes between 'balanced' letters (like H, A or M) and 'unbalanced' letters (like P and F). The compositions that the students are to create are to be either 'solemnly static' ('feierlich Statik') or 'in a dynamic position' ('in dynamischer Position') (*The Thinking Eye/Das Bildnerische Denken*, p.215). The W is clearly a 'balanced' letter, but the whole of Anna Wenne is 'in a dynamic position'.

44 A philological-historical perspective on this operation reveals that the changes of *Wenne* to *Wanna* (and *vice versa*) are not as disruptive as they might at first appear. In modern German, adverbial *wann* and conjunctive *wenne* derive from like sources, such as Old High German *wanna* > Middle High German *wenne*, *wanne*. They separate in Modern German. A look at the syntactic and semantic problems outlined in note 42 above reveals that *Anna Wenne*'s 'Anna if ...' can read both to the right from the central W, and to the left from the central W. By this point, our reversed *ENNEWANNA continues to read in just this syntactically inexplicit way. How much historical depth we might be justified in discovering here is, however, moot.

45 Gravity, as an acoustic term pertinent to vowel sounds, refers to the height of the second vowel formant: low second formants create vowels that are 'grave' in character; high second formants produce 'acute' (i.e., 'non-grave') vowels. In articulatory terms, front vowels are more acute (less grave) than back vowels. Within the group of front vowels, higher front vowels (like those of *beet* and *bit*) are more acute than low front vowels (like that of *bat*). Within the group of back vowels, higher back vowels (like those of *boot* and *put*) are more grave than those of lower back vowels (like those of *boat* or *bought*, for example). Experimental studies in the sound sense of vowels regularly discover a link between increasing acuteness (higher second-formant height), as one vowel is heard in relation to others, and a sense of 'rising' or 'brightness'. Conversely, the perception of darkening or lowering is directly linked to decreasing acuteness

(= increasing gravity and lower second-formant height) as one vowel is heard in relation to others. Studies of vocabulary and the uses of vocabulary in natural languages to create 'brightening' and 'darkening', 'rising' and 'falling' effects discover the same associations. Good summaries of much of this research can be found in R.W. Brown, *Words and Things*, New York, 1958, pp. 110–54; L.E. Marks, 'On Coloured-hearing Synesthesia: Cross-modal Translations of Sensory Dimensions', *Psychological Bulletin*, vol. 82, 1975, pp. 303–31, and L.E. Marks, *The Unity of the Senses: Interrelations among the Modalities*, New York, 1978; P.L. French, 'Toward an Explanation of Phonetic Symbolism', *Word*, vol. 28, 1977, pp. 305–22; and R. Jakobson and L. Waugh, *The Sound Shape of Language*, Bloomington, Indiana, 1979. Roman Jakobson ('On the Verbal Art of William Blake and Other Poet-Painters', *Linguistic Inquiry*, vol. 1, 1970, pp. 3–23) has noted such effects in Klee's poetry; I have elsewhere noted it, to a limited degree, in the language employed in Klee's visual art ('Paul Klee's Speaking Pictures', *Word and Image*, vol. 7, 1991, pp. 149–64).

46 I have spoken this *Special* into German, although the orthography denies this. The effect described here works equally well for French [spesial]. English [ˈspɛʃəl] does not work so well.

47 How different the presence of the possible surname *Klee* [kleː] would be here: same vowel position, open syllable, light and air. Just the opposite effect!

48 'The father of every projectile, whether fired or thrown, hence also of the arrow, was this thought: how shall I increase my range in that direction?': 'Der Vater jedes Bewegungs- oder Wurfgeschosses, also auch des Pfeils, war der Gedanke: Wie erweitere ich meine Reichweite dorthin?' (*The Thinking Eye/Das Bildnerische Denken*, p. 407). The importance of the arrow to Klee's thinking can hardly be overestimated. With respect to the pedagogical materials from 1922, the arrow dominates chap. 5: 'Cause, Effect and the Figuration of Dynamic Forces' (pp. 403–30) of section 3: 'Basic Concepts of Development' of *The Thinking Eye*. The material also is given in aphoristic, summary form in sections 37–43 of Klee's *Pedagogical Sketchbook* (trans. Sibyl Moholy-Nagy, New York, 1953, pp. 54–61).

49 *Diaries* [no. 1081], p. 374. 'Die polyphone Malerei ist der Musik dadurch überlegen, als/ das Zeitliche hier mehr ein Räumliches ist. Der Begriff, der/ Gleichzeitigkeit tritt hier noch reicher hervor' (*Tagebücher*, pp. 441–2).

50 J.M. Jordan, op. cit., p. 52. Delaunay is an exponent of Orphism or Orphic Cubism (V. Spate, *Orphism: The Evolution of Non-figurative Painting in Paris, 1910–1914*, Oxford and New York, 1979, pp. 161–228). His use of colour comes greatly to influence Klee's colour developments in the later teens. Delaunay's is not the only 'Cubist' influence in Klee's work, however. Klee's compositional technique comes to differ significantly from Delaunay's. J.M. Jordan (op. cit., chap. 6, 'Cubist Composition: 1914', pp. 116–49) has a detailed account.

51 The text is the one given in H.B. Chipp (ed. and trans.), *Theories of Modern Art: A Source Book by Artists and Critics*, Berkeley and Los Angeles, 1968, p. 319 (italics original).

52 A similar idea had been articulated by Leonardo da Vinci. The ear must somehow retain the notes it hears:

> unless it preserved the impression of the notes, [we] could never derive pleasure from hearing a voice alone; for when it passes immediately from the first to the fifth note[,] the effect is as though one heard those two notes at the same time, and thus perceived the true harmony which the first makes with the fifth; but if the impression of the first note did not remain in the ear for an appreciable space of time, the fifth, which follows immediately after the first, would seem alone, and one note cannot create any harmony, and consequently any song whatsoever ... (*The Notebooks of Leonardo da Vinci*, ed. Edward MacCurdy, vol. 1, New York, 1938, p. 534).

Klee's comments about Leonardo are always approbational. The two men as thinkers were much concerned with art, nature, movement and balance (G.C. Argan, 'Preface' to *The Thinking Eye* [English edn only], pp. 11–18). Leonardo also plays a role in the development of Klee's concept of the polyphony of colour depth (A. Kagan, op. cit., pp. 68–74).

53 Unless, of course, the chord happens to be the final, resolving chord of the piece. Even this can tell us only that the piece is in F major or C# minor. It bears no information about the metrical or prolongational structure of the piece. It can reveal nothing more about phrasal grouping than tonality. (See Chap. 5: 'Introduction to Reductions', in F. Lerdahl and R. Jackendoff, *A Generative Theory of Tonal Music*, Cambridge, Massachusetts and London, 1983, pp. 105–23).

54 O.K. Werckmeister, *The Making of Paul Klee's Career, 1914–1920*, Chicago and London, 1989.

55 'Man kann ein Bild oft vergleichen.... Es ist etwas Dichterisches, ich sage Dichterisches, nicht Literarisches, das fast gleichnisartig spricht./ Gleichnis, als wäre da eine Scheu da, etwas so auszusprechen, wie es ist. Dichten heißt die Worte so wählen und stellen, daß ein Gleichmaß entsteht und eindrückliche Bilder erzeugt werden. Hinzu kommt, daß die Freiheit der Gestaltung vorliegt' (*The Thinking Eye/Das Bildnerische Denken*, p. 430).

56 I wish to thank Richard Sheppard, Jeremy Adler, K. Porter Aichele and the staff of the Paul-Klee-Stiftung of the Kunstmuseum Bern for their timely help in the preparation of this essay.

Art History ISSN 0141-6790 Vol. 19 No. 1 March 1996 pp. 102–127

Catalonia and the Early Musical Subjects of Braque and Picasso

Stewart Buettner

The musical iconography of Cubism has often been the subject of general discussion.[1] Only recently, however, has a picture of the artists' musical inclinations during the early Synthetic Cubist years begun to emerge. This expanded vision is based largely on the lettered names of composers and song titles, and on the inclusion of collaged portions of sheet music found in many of these compositions.[2] The musical iconography of work done in the earlier, more 'hermetic' phase of Cubism has proved especially elusive because Braque and Picasso had not yet evolved a means, provided by lettering and collage, to make recognizable the musical allusions behind their work. In fact, so little is known about the origins of the iconography of Braque's and Picasso's musical subjects that the topic has never been explored in depth. It is my intention in this essay to point to sources in the regional music of Catalonia that inform some of Braque's and Picasso's musical subjects of 1911, a critical period in the development of Cubist musical iconography.

Based on the internal evidence supplied by the painted lettering and collaged sheet music contained in the musical still lifes produced from 1912 onwards, a distinction can be made between the musical tastes of Braque and those of Picasso. Braque was mainly inspired by 'classical' or serious music, Picasso by popular music. When examined more closely, however, this distinction begins to break down. As the work of Simon Shaw-Miller has recently shown, there is much in these two worlds, particularly in the musical instruments found in the paintings, that ties them together.[3] Indeed, these two very general categories of music are fused in the type of music the artists would have experienced in the Pyrenees between the years 1911 and 1913.

Neither Braque nor Picasso wrote about the musical influences on their work during these critical years. Moreover, there are few reliable, first-hand explanations offered by individuals close to the two artists to explain the initial appearance of musical subjects in Cubist painting. Unfortunately, none of those explanations that do exist affords the kind of insight into the relationship between music and the visual arts that is available to us in the comparable cases of Wassily Kandinsky and Piet Mondrian. Yet, by 1913, the last of the years Picasso visited Céret, the subject matter of more than half of his and Braque's works was derived from the world of music.

In statements made later in life, Picasso said virtually nothing about the

musical subjects he painted during the early Cubist years. In 1923, however, he would comment that, 'Mathematics, trigonometry, chemistry, psychoanalysis, *music* and whatnot, have been related to Cubism to give it an easier interpretation. All this has been pure literature, not to say nonsense, which has only succeeded in blinding people with theories.'[4] Picasso also denied any knowledge of music to the most important, first-hand source of information about him during the early years of Cubism, his lover from 1905 to 1912, Fernande Olivier, and he reiterated similar disclaimers later in life.[5] Picasso, however, was not a very reliable source when it came to his own art.[6] These denials create the impression of an artist who had little interest in revealing the musical sources that lay behind his paintings, or who wanted to create an image of himself as musical naif. Even though Picasso had no formal training in music, he undoubtedly absorbed musical impulses in much the same manner as he did visual ones, that is to say from whatever sources were immediately available to him.

In 1954 Braque offered with hindsight a more helpful explanation for his choice of musical instruments between 1909 and 1914 in an interview with Dora Vallier:

> During this period, I painted many musical instruments, in the first place
> because I was surrounded by them, also because their modelling and
> volume put them in the category of still life painting, as I understand it.
> Finally I was already on my way toward a tactile, physical space, as I like
> to call it, and a musical instrument is an object with a peculiar feature: one
> can bring it to life by touching it.[7]

It is critical to remember that these remarks were made forty years after the works in question were painted. Photographs confirm that Braque had a number of musical instruments in his studio during the early Cubist years. The other reasons given in his explanation, the desires for increased plasticity and a more tangible space, seem at least in part to advance basically formal arguments for the use of musical iconography.

Braque's and Picasso's musical backgrounds

Georges Braque was the only one of the two who possessed musical training, though he would be thought of as an amateur musician, both then and today. He could certainly read music and played several instruments, none of which is represented with anything approximating the frequency achieved by the guitar, mandolin and violin found in his musical still lifes. While at the École des beaux-arts in Le Havre, Braque studied the flute with Gaston Dufy, Raoul Dufy's brother. He also played the accordion with 'feeling and dignity', for which he gained certain recognition around Montmartre, notably from Picasso himself.[8] Unlike Picasso, his favourite composers — Bach, Rameau and Couperin — were not his contemporaries, but came from the seventeenth and eighteenth centuries. Terms like '*aria*', '*duo*' and '*étude*', associated with different types of serious music, are found in his works, starting in 1912. The painted word '*valse*', or waltz,

also appears frequently. This term and Bach's name first appear in Braque's paintings while the latter was living in Céret, in French Catalonia, in late 1911.

It was Braque who was responsible for introducing to Cubism the still life with musical instruments which, in its manifold variations, proved the most versatile and durable of the various types of Cubist musical subjects. This type of still life had been almost totally ignored in the European tradition since the time of Chardin and Vallayer-Coster, both of whom often employed musical instruments, along with other objects, primarily as glorifications of the arts. In their exclusive focus on musical instruments, Braque's earliest musical still lifes, dating from 1908, represent a reversion to an even earlier kind of musical still life, an entire Baroque subgenre created by Evaristo Baschenis, Bartolomeo and Bonaventura Bettera, all of Bergamo.

Picasso's musical background was quite different from that of his French colleague. Unlike Braque, Picasso never studied music, which perhaps accounts for several instances in which violinists depicted by the artist hold their instruments in the wrong hand.[9] Fernande Olivier proves the greatest source of information about the painter's musical tastes during these years: '... he might have liked [orchestral music] if he'd not been afraid of making foolish judgements, for he knew nothing about it at all ... he never went to a concert.' She would also venture that the Cubists (Picasso, Braque and, at that time, Derain) had little appreciation of serious music.[10]

While this may be true, Picasso was exposed to a number of accomplished musicians during his formative years. His paternal grandfather loved music and played double bass in the Málaga opera orchestra; his father attended performances of the Philharmonic Society and Conservatory in Málaga.[11] Upon his family's arrival in Barcelona in 1895, the young Picasso was to live off and on for the next eight years in a city that had a growing reputation for musical excellence, both in Spain and in western Europe. The capital of Catalonia was a city whose musical life was rich, varied and seemingly well supported by its wealthier citizens. Though the city might not have been considered one of Europe's musical centres by major critics or performers of the day, the majority of its thriving musical institutions were younger and, in many instances, more vital than those found in Berlin, Dresden, London, Paris or Vienna.

Barcelona was perhaps best known for its choral societies, chief among them l'Orfeó Català. Founded in 1891 by Amadeu Vives and Lluís Millet, the Orfeó was to gain its reputation from performing works in Catalan, sponsoring new works from the region, bringing visiting performers from other parts of Europe and, beginning in 1904, publishing a review of Catalan musical life: *Revista Musical Catalana*. In large part inspired by the success of l'Orfeó and other groups, Picasso's friend, the composer and conductor Enric Morera, founded another choral organization in 1896, Catalunya Nova, which he was to direct for fourteen years.[12]

Although Picasso was almost certainly unfamiliar with most aspects of Barcelona's burgeoning world of serious music when he resided there, he was to encounter some of its musicians, and in some cases get to know them fairly well. There, through his friendship with Ramon Pichot, he met talented members of the Pichot family: Lluís, a violinist; Ricard, a cellist; and Maria Pichot de Gay, a

22 Pablo Picasso, *Enric Morera*, 1900. Charcoal, 18 × 13 cm. Jordi Ginferrer Collection, Banyoles. © 1995 Artists Rights Society (ARS), New York/SPADEM, Paris.

singer, all of whom graced the city's concert halls with their performances for more than three decades. Sometime in the late 1890s Picasso also met Pablo Casals.[13]

Both Isaac Albéniz and Enrique Granados performed at Els Quatre Gats, the popular Barcelona tavern frequented by Picasso; Vincent d'Indy, head of the influential Schola Cantorum in Paris, was also among the featured guests there. It is possible that Picasso heard some of these musicians perform; certainly he must have known about them through his own visits to the tavern, or through friends who frequented the establishment. One performer working between the worlds of serious and popular music with whom Picasso enjoyed a friendship was Enric Morera, whose music was performed on at least two occasions at Els Quatre Gats.[14] Picasso drew Morera's portrait (plate 22), and Morera owned several works by the artist.[15] A pupil of the father of modern Catalan music, Felipe Pedrell, Morera laboured tirelessly throughout a career in which he composed opera and symphonic music, wrote and directed musical settings for the painter Santiago Rusiñol's *festas modernistas*, and directed for almost all Barcelona's different concert associations. He led his own choir, Catalunya Nova, in concerts

of popular music; programmed folk songs at other times when he conducted; and went on to compose almost two hundred popular songs, some, like his beloved *Santa Espina*, intended specifically as vocal counterparts of the Catalan national dance, the sardana.

That Picasso knew Morera and other important musicians in Barcelona does not mean that they had an immediate impact on him. In fact, the limited number of musical instruments and venues portrayed in Picasso's work between 1895 and 1903 militates against such a conclusion. Instruments, the guitar in both intances, appear in only two major paintings of the early years: *The Old Guitarist* (1903) and *At the Lapin Agile* (1905). The instruments in those few drawings that contain musical subjects are clearly incidental to the scenes of Spanish folk life in which they are found. From this it would seem safe to conclude that Picasso's interest in the music of Spain and Catalonia, to which he might have been exposed in Barcelona, lay dormant until 1910 at the earliest.

It was in that year that the opera *Héliogabale*, composed by another of Picasso's friends, Déodat de Séverac, was first staged, out of doors, at the arena in Béziers. It is unlikely that Picasso, in Cadaqués at the time, made the trip to hear his friend's opera. But a concert version of *Héliogabale* was performed in Paris on 26 February 1911. An unidentified reviewer for *Le Guide musical* praised the 'beauty and natural aspect [of] a sound, balanced score in which choir and orchestra fuse in big sonorities, in forceful spirit, the former full of lyricism, the latter descriptive, hot and colourful ...'.[16] Not least among the novel features of *Héliogabale* was the inclusion of members of the Catalan cobla orchestra, tenora and tiple, in the opera's third act. Both Braque and Picasso were to include at least one of these instruments in their paintings later that same year.

On 29 April 1911, four movements of Séverac's *Cerdaña: Études pittoresques pour piano* were given their Paris premier by the Spanish pianist Ricardo Viñes. In reviewing this performance, the critic Charles Cornet took the opportunity provided by the premier to lay out for his readers at least some of the reasons why Spanish music found such sympathy among French audiences in 1911:

> The evolution of Spanish music pursues a modern form which is successfully combined with local rhythm to achieve picturesque effects which are at the same time animated and powerful; [Spanish music] strains to break away from systematic traditions, from popular themes and colourful attempts at outrage, from operetta banalities, all in a more fertile effort to achieve an inspiration that is deeper, more reflective and more human, to achieve a more musical study of the classics. After the dramatic Ruperto Chapi, Albéniz was moulded by his studies at the Schola [Cantorum], and improved the melodic exuberance of his brilliant ideas by cultivation of French and German masters. Today there is a strong group of successors [to Albéniz] ... from which we have recently heard work seductively interpreted by the very personal, virtuoso talents of Manuel de Falla, [Enric] Morera, and Joaquín Turina.[17]

In reviewing M.J. Cassado's Spanish Fantasy *Hispania*, performed by the Société musicale indépendante a month later, Cornet extended these remarks,

106

commenting that it was '... the sincerity, the line, the rhythmic development, the movement of thought ...' that had brought Spanish music into its ascendancy in the concert halls of Paris.[18]

In large part because of the number of important Spanish composers living in Paris, a wave of interest in Spanish music swept the concert halls of that city in early 1911. April alone saw performances of works by Isaac Albéniz, Manuel de Falla, Enric Morera and Joaquín Turina.[19] By 1907 Albéniz, Casals, de Falla (all of whom studied and lived for a time in Barcelona when Picasso was there) and Turina had moved to Paris, taking up residence at one point in their various stays in parts of the 9th and 18th *arrondissements* favoured by poor Spanish artists, not far from where Picasso lived at the time.[20] These Spanish masters were, by and large, welcomed by their French counterparts Claude Debussy, Paul Dukas and Maurice Ravel, all of whom had been profoundly influenced by Spanish music and who had incorporated many of its unique rhythms, modal melodies and harmonies, and its tonal ambiguities in their work.

At the Salon d'Automne of 1910 Joaquín Turina, a young Spanish composer from Seville, who was just beginning his career in Paris after having studied at the Schola Cantorum, premiered one of his earliest compositions, a string quartet subtitled 'de la guitarra'.[21] A quartet with guitar was not necessarily a novel idea, but playing one that featured the instrument at an annual salon of more venturesome artists certainly was. Turina also performed at the piano at the Salon d'Automne the following year. The number of musically derived subjects that appeared in the work of visual artists displayed at the 1911 Salon d'Automne, together with the five concerts given at that exhibition, led the critic Raymond Bouyer to proclaim 'Music is in everything ... at our salon.'[22]

Braque's and Picasso's musicians of 1911

The flourishing of music in Paris, drawn in large part from the folk tradition of Spain, may in part account for the revitalized interest Picasso took in musical subjects in 1911. In a few short months in the spring of that year he began to represent musical subjects with renewed vigour, more than doubling his output of the same type of subject painted throughout the previous two years. He also began work on a slightly different type of subject: musicians, that is to say individuals capable of performing on the instruments they hold — as opposed to his earlier preference for models whom he posed holding instruments. Roland Penrose relates the interesting story of Fanny Tellier, one of Picasso's favourite models, who called in on the artist's studio and kept him from working on the subject he originally wanted to paint. Instead Picasso was compelled to pose Tellier nude with a mandolin that must have been in his studio at the time.[23]

A number of features help distinguish performers in the process of making music from models merely holding instruments. As early as 1908 Braque had included some loosely painted staffs and notes on the sheet music in his still lifes. By 1911 paintings such as Picasso's *Clarinet* (National Museum, Prague) and Braque's *Pedestal Table* (Musée national d'art moderne, Paris) reveal that both artists were exploring the use of a variety of different elements of musical notation

(clefs, sharps and naturals, staffs, notes) floating in space to suggest aspects of live musical performance. Figures of performers were, in some instances, posed with heads tilted, eyes closed, while making music. Or, slightly later, there may also be lettering, derived from posters or signs, that indicates something about the nature or type of music being played, or about the general locale in which it was being performed. These criteria help distinguish a group of approximately a dozen musicians (whose identities remain unknown) painted in 1911, all but two of which were done by Picasso. Among the most important of this group are Picasso's *Accordionist* (plate 23), *Mandolin Player* (Galerie Beyeler, Basel) and '*Ma Jolie*' (*Woman with a Guitar or Zither*) (plate 30), and Braque's *Man with a Mandolin* (Museum of Modern Art, New York) and *Le Portugais* (Öffentliche Kunstsammlung, Basel).

Picasso's approach to musical subjects changed rather dramatically in the summer of 1911 with *The Accordionist* (plate 23), which he created in Céret. The lone musician's mouth seems open as if he is singing; fingers line up beside the keys of the accordion. The bellows of the instrument are also recognizable. The scrolls in the lower corners of the painting form a typical Cubist double entendre. Earlier, they had appeared in Picasso's work as the decorative scrolls of an armchair. It was not until 1911, however, that they were to be seen in his musical paintings, where they can also be read as the lower half of a treble clef sign, or, in later works, as the scroll of a violin. Likewise, the arc beside the scroll to the right can be taken as an inverted bass clef sign. These possible borrowings from musical notation are tentative, but Picasso had been working with musical signs for only a short time, since the spring of that year.

It is possible, in fact, to identify with a fair degree of certainty the music being sung by the accordionist in this, the earliest of the important Cubist paintings of musicians. A drawing on stationery of the Grand Café de Céret (plate 24) shows a linear figure with the same asymmetrical, triangular framework and position of the hands as those in the *Accordionist*. Picasso himself wrote out a stanza, in Catalan, of the song the accordionist must have been playing at the time the drawing was made:[24]

> Friends, let's sing 'La Ceretana',
> From the sea to the Canigou,
> Before covering ourselves to go to Catalonia,
> It is the pearl of Roussillon.

The stanza appears to be a variant of the popular *corranda*, a short, four-line verse, with an ABAB rhyme scheme, on a range of subjects from love to religion. Like the lyrics above, many corrandas also celebrate a local area in the Pyrenees and were set to music.[25] Patricia Leighton has proposed the identification of the musician in the *Accordionist* as Braque, who played that instrument. However, it seems more likely that Picasso chose a musician who was playing a song while singing, undoubtedly from the area around Céret, rather than his friend, who was in Paris at the time the painting was begun.[26]

The most popular form of local music in Catalonia, then and now, was the *sardana*, played to accompany a regional dance of the same name.[27] The sardana

23 Pablo Picasso, *The Accordionist*, 1911. Oil on canvas, 130 × 89.5 cm. Guggenheim Museum, New York, gift of Solomon R. Guggenheim, 1937. Photograph: David Heald, © The Solomon R. Guggenheim Foundation, New York. © 1995 Artists Rights Society (ARS), New York/SPADEM, Paris.

24 Pablo Picasso, 'Amics cantem la ceretana', 1911. 26.8 × 21.4 cm. Musée Picasso, Paris. © 1995 Artists Rights Society (ARS), New York/SPADEM, Paris.

has been called the 'perfect expression of Catalan psychology. With the growth of political aspirations, it has become a symbol of Catalan freedom.'[28] In fact, according to local legend, the sardana originated in Céret.[29] Fifty years after Picasso's initial stay in that city, he could still dance the sardana and remembered its rhythms.[30] The artist, who liked to think of himself as Catalan, would instinctively have been drawn to music like this which appealed on an emotional level to his love of Catalonia.[31]

Picasso also worked on two paintings showing an instrument generally thought to be a clarinet while he was in Céret: *The Clarinet* (National Gallery, Prague) and *Man with a Clarinet* (private collection, France). In both instances, typical Cubist fragmentation and simplification make secure identification of the type of instrument impossible. Braque, who arrived in Céret a month after Picasso, became equally fascinated with the musical life he found there. One of the still lifes Braque produced in Céret — *The Mantelpiece* (plate 25) — contains a musical instrument also identified as a clarinet.[32] This painting is of critical importance in determining the kind of music to which Braque and Picasso were exposed during their stays in French Catalonia. The instrument in Picasso's two paintings from Céret that bear the word clarinet in the title is generally shaped like a clarinet. There is nothing in either painting, however, that makes this identification certain. In Braque's *Mantelpiece* the reed of the instrument (not shown in Picasso's paintings) is triangular and sectional. The clarinet is a single-reed instrument with a one-part, tapered mouthpiece. The instrument in *The*

110

25 Georges Braque, *The Mantelpiece*, 1911. Oil on canvas, 81 × 60 cm. The Tate Gallery, London. © 1995 Artists Rights Society (ARS), New York/ADAGP, Paris.

Mantelpiece and in other Cubist paintings of the period said to contain clarinets, has recently been identified as a tenora, a regional reed instrument central to the Pyrenean cobla orchestra.[33] Similar to the oboe and English horn, the tenora is usually made of metal with an extended, double-reed mouthpiece that is 'short and triangular and [has] a wider opening than any other kind of double reed'.[34] The tenora, and its sister instrument the tiple, are both members of the shawm family, an historical instrument that was the forerunner of the modern oboe (plate 26). Though generally obsolete, shawms, in the form of tenora and tiple, are preserved in the cobla orchestra today; the two instruments were also featured in that orchestra during Braque's and Picasso's stays in Céret.[35]

Both tiple and tenora are similar in shape, though the tenora is the larger instrument by almost a foot, and is pitched a fifth lower. It also possesses more complex keywork running down both sides than does the tiple. The simplicity, proportion and detailing of the shawms found in these paintings by Braque and Picasso make it more likely that the instrument featured in them was a tiple, rather than the more elaborate, longer and bulkier tenora. In fact, the striking simplicity of the instrument found in Cubist work — generally shown with only body, reed, finger holes and bell — indicates that both Braque and Picasso may have been representing the nineteenth-century forerunner to the tiple, the tarota, which lacks the sophisticated extension keywork found on its twentieth-century successor.[36] Since it is impossible to identify with certainty which of these three instruments — tenora, tiple or tarota — is found in early Cubist paintings, it seems most accurate to refer to them simply as shawms.

The pictorial record reveals no evidence that Picasso was aware of the tarota, tiple or tenora during previous stays in Catalonia. Braque almost certainly could not have known these three folk instruments until he heard the music of the cobla, as he must have done during a stay in Céret that lasted more than five months. Since these shawms do not appear in Cubist paintings before the summer of 1911, their presence during and after that date indicates that the two artists heard and responded to regional music performed in and around Céret to the extent that they included representations of instruments of the cobla orchestra in their paintings.

The standard cobla orchestra dates to the middle of the nineteenth century when Pep Ventura, father of the sardana, modernized the tenora and incorporated it in an orchestra composed of two trumpets, trombone, two fiscorns, double bass, flabiol, two tiples, two tenoras. The version of the cobla orchestra found in Roussillon in northern Catalonia, where Céret is located, generally utilized a smaller number of musicians, but retained the same number of tiples and tenoras, hence increasing the authority of these two instruments.[37] With its metal bell, again an invention of Ventura, the tenora is capable of a fully dynamic range, from *pianissimo* to a brilliance more powerful than a trumpet, which it uses to great advantage in the many solos given to the instrument. The length and material of the tenora give it a darker, throatier character. The tiple, on the other hand, is a higher, more piercing instrument that frequently alternates with the tenora during a performance.

The sardana is danced to very melodic, rhythmic music with clearly demarcated sections and repetitions. All these qualities are necessitated by the

112

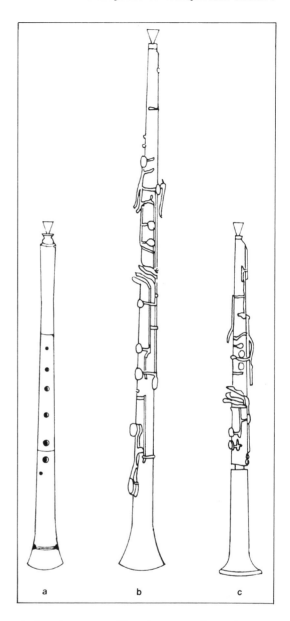

26 Shawms of the Cobla Orchestra:
a. tarota, b. tenora, c. tiple.

complex, highly structured nature of the dance itself. The typical sardana is divided into sections in which the dancers, moving in a circle with both hands joined to those of their neighbours, execute a series of short and long steps. The music must be known by the dancers, who keep a strict count of the number of measures to know when either to repeat a section, or to change to a different step. In many respects, the sardana is a dance of the mind, or as Henry Pépratx-Saisset has phrased it: 'To dance [the sardana] properly it is necessary to count, or at least to know the basic rules of the dance, to know what to count, how to count, why to count, and to know by observing in the first part of the dance what succession

[of steps] can be presented.'[38] The rigorous mathematical and conceptual nature of the sardana must have appealed to Braque and Picasso, who were painting some of the most abstract, geometric works of their careers when they were in Céret. Certainly, the music of the cobla orchestra contributed to the precision, to the divisions and subdivisions, and to the many repetitions found in the canvasses of the later half of 1911. It would also seem that the two artists saw in the sardana a similar type of mental pattern to the one that they were attempting to fix on their canvasses at that time.

The closest thing to a first-hand account of the music the Cubists might have heard during their time in Céret comes in the form of a lengthy prose-poem, 'Honneur de la sardane et de la tenora', written by Max Jacob during his stay with Picasso in Céret in the spring of 1913, and subsequently published in *Le laboratoire central* in 1921. In the poem Jacob took great care to set the scene, describe the town, the people, the music and the dance. At the heart of the poem, two lines explain the type of visceral, emotional impact the sardana had on the poet: 'The music brings tears to our eyes/ The artless music grips our chests.'[39] It is difficult to escape the conclusion here that, with the words 'nos yeux ... nos poitrines', Jacob was speaking not only of his own response, but that of his companion at the time — Picasso. If that is so, the sardana appealed to the Cubists not only by virtue of its structured, mathematical basis, but also because of its emotional content. To a degree, this helps explain the complexity of the paintings of this period. Far from being dry, conceptual exercises, they also attempted to evoke at least in part the affective aspect of musical performance. In a lengthy prose interlude of 'Honneur de la sardane', Jacob explained the power of the sardana:

> I will remember all my life the instrument which is called the 'Tenora'; it is long like a clarinet and can compete, says a musician, with forty trombones. Its sound is dry, like that of a cornemuse. I heard the 'Tenora' at Figueras, a city in Catalonia, in a small orchestra [that played] in the public square. ... One dances the sardana and before each dance the orchestra plays a long introduction in an eloquent manner. The voice of the tenora is supported by other instruments competing with one another. This admirable music is composed by local musicians, unknown in France. ... After the introduction, the rhythm of the dance begins. The rhythm is so strong I do not think one could wish for anything more powerful. The polka-like rhythm blends abrupt stops and long embellishments.[40]

If nothing else, this accurate, sensitive description demonstrates Jacob's keen musical sensibilities.[41] While Picasso had Déodat de Séverac available to him in Céret to help explain some of the workings of the sardana, Jacob's 'Honneur de la sardane et de la tenora' shows that Picasso's close friend could further have facilitated this process.

There is yet another clue contained in Braque's *Mantelpiece* (plate 25) about the type of music Braque and Picasso heard while they were in Céret. The word *valse* appears in stencilled script just under the cobla shawm. This is, in fact, the

first time the term *valse* appears in Cubist painting. Included in the presence of a cobla shawm, the term makes seeming reference to a variant of cobla music found particularly in that small portion of Catalonia, Catalunya Nord, in the French Pyrenees. In the remainder of Catalonia, the sardana is the dominant type of music assigned to the cobla orchestra. The greater freedom given to the cobla orchestra in Catalunya Nord inclined musicians to other popular dance forms, one of the chief among them being the waltz.[42] These waltzes, once again written by local musicians, have a different form than the sardana, though to a degree they preserve that dance's repetitions and parts of its structure. The standard introduction of the flabiol found in the sardana, and mentioned by Max Jacob, is eliminated in favour of a longer orchestral introduction. Triple meter is used throughout, and greater emphasis is placed on virtuoso passages by the tenora. The music itself has the combined flavour of the sardana and the sprightlier Viennese waltz. Amateur musician though he was, Braque certainly would have been able to recognize the unique character of the cobla waltz of northern Catalonia and seems to have paid tribute to it in *The Mantelpiece*. This suggests that, in the many subsequent references to the waltz found in Cubist paintings, Braque, Picasso and even Juan Gris may have been recalling this unusual type of dance music which they heard in Céret.

The chief function of the cobla orchestra was to perform at festivals, most of them religious in origin, held in cities and towns of Catalonia. In the earlier part of the twentieth century these festivals often took place after church services, and involved elaborate processions, acrobatics and dancing, with participants dressed in colourful costumes. Each city, town and village had its own festival days, usually held in conjunction with important religious feasts, those of Christ, the Virgin and local patron saints.[43]

During 1911, when Braque and Picasso first began incorporating elements of Catalan folk music in their compositions, both artists were in Céret for the *festa major* at the end of August. Among the many festivities held in conjunction with this, the most important of the annual festivals, music of the cobla, and the dancing that went with it must have impressed both artists, if only because the two art forms were so different from those to which both men would have been exposed in the cabarets and music halls of Paris.

That year Picasso arrived in Céret on about 15 July, two weeks after the Festival of St Ferriol, a popular brigand saint of Catalonia who had the unique distinction of being murdered, then interred beneath a wine cask that preserved his body perfectly.[44] Publicized as far away as Perpignan and Barcelona, the festival that year was an especially important one that celebrated the twenty-fifth anniversary of a local choir, L'Harmonie du Vallespir.[45] The focal point of the festivities was music, which was provided by bands and choirs drawn from all over the region, under the sponsorship of the Federació de les Societats Musicals del Mig-dia. This musical association was led by Déodat de Séverac, who also composed a march, *Souvenir de Céret*, and a special new cantata, *Lo Chant del Vallespir*, which was sung in the arena by L'Harmonie du Vallespir as the high point of the festival.

Picasso's *Piano with Still Life* (plate 27) is generally regarded as having been started in the summer of 1911 in Céret, and completed the following spring.[46]

27 Pablo Picasso, *Piano with Still Life*, 1911–12. Oil on canvas, 50 × 130 cm. Collection Heinz Berggruen, Geneva. © 1995 Artists Rights Society (ARS), New York/SPADEM, Paris.

In addition to a variety of typical café still-life objects, the painting contains several musical elements. Fragmented segments of a violin, the scroll of which may double as repeated lower halves of a treble clef, appear in the upper right, with portions of a piano keyboard below. The freehand letters CER[ET] GRAN[DES] FETES are visible beneath some overpainting to the left. Picasso seems to have reworked portions of the canvas in the spring of 1912, and to have added the four large stencilled letters CORT slightly above their fainter counterparts. At least in part, Picasso intended both sets of letters as an allusion to the music of Déodat de Séverac performed at the feast of St Ferriol just before the Spanish painter arrived in Céret. Posters announcing the event may still have been visible on the walls of the city.[47] The letters CORT can also be read as another of Picasso's puns, in this case on the name of the French pianist Alfred Cortot and on the word CORTège. In the later instance, Picasso would have been making reference to the processions that accompanied the celebration of St Ferriol, staged during that important, twenty-fifth anniversary year. In *Piano with Still Life* Picasso would seem to be painting more than a simple still life. Here he established a context, a café, in which live music might have been performed, with a poster on an outside wall, and a procession passing by. That particular procession would necessarily have been imaginary, as Picasso arrived in Céret after the festival of St Ferriol had been celebrated, and, in any case, he added the procession, or verbal reference to it, months after his return to Paris.

The letters CORT in the painting also refer to Alfred Cortot who had premiered the first performance of Séverac's *Les Muletiers devant Christ de Llivia* (for his suite *Cerdaña*) on 8 June 1911 in Paris for the Société nationale de musique. Picasso may have attended the premiere of the piece; if not, the composer could have supplied the performer's name. One of Séverac's most poignant, expressive compositions, *Les Muletiers* depicts the devotion of the mule-drivers of the small village of Llivia in the Cerdaña region of Catalonia. Cortot himself would later write of Séverac:

116

Everything in his origins and temperament incited [Séverac] to incorporate in his music the tangy songs of Catalonia, that melodic vitality, those frank and characteristic rhythms, that intense feeling of popular speech that allow him — like the shepherds of Languedoc — to invent a song, one of the true songs of nature, so right and perfect that it seems to surpass the anonymous soul of the century.[48]

In adding the letters CORT, Picasso also appears to have been responding to Braque's *Violin: Mozart Kubelick* of 1912 (private collection, Switzerland), in which the French painter was recalling a concert held at the George Petit gallery on 28 April 1911. At that time, the famous Czech violinist Jan Kubelik played pieces of Mozart on a violin previously owned by Ingres.[49] *Piano with Still Life* clearly demonstrates the extraordinarily multivalent nature of Picasso's visual and verbal punning in the different musical, religious and historical events to which the words in the painting make seeming reference.

Déodat de Séverac

The composer Marie-Joseph-Alexandre Déodat de Séverac (1872–1921), whose work Cortot had performed that June for the Société nationale, came from the small village of Saint-Félix de Lauragais, near Toulouse.[50] His father Gilbert de Séverac, and both his aunt and uncle, were painters of distinction in the region. After receiving local training, Déodat de Séverac left for Paris to study at the Conservatoire. There he quickly tired of the traditional academic regime and transferred to the recently established Schola Cantorum. From 1896 to 1907 he went through the Cours de Composition under Vincent d'Indy. In 1900 he also served as an assistant in piano classes offered by Isaac Albéniz. Despite his rigorous studies, Séverac also found time to compose. His pieces were generally brief, for voice and piano, and on themes associated with rural France.

Séverac made regional music the cornerstone of virtually all his mature compositions. This distinctive, regional flavour can be gleaned from his suite for piano, *En Languedoc* (1903–4), the individual movements of which depict the county, the seasons, the times of day, the people and their religious festivals. This is true not only of *En Languedoc*, but of virtually all Séverac's compositions from the time of *Le Chant de la terre* in 1901.

Upon graduation from the Schola, Séverac left Paris, a city in which he had never felt completely comfortable. He eventually decided to live in the *département* of Roussillon, whose regional music was to inspire him for the remaining fourteen years of his life. At the urging of Picasso's friend Manolo, whom Séverac had known since 1902, the composer took up residence in the town of Céret. Apparently, he arrived sometime between early 1910, just after Manolo settled there, and 1911.[51] An article in the Barcelona paper *La Publictat* actually had Picasso, Manolo and Séverac living in the same house in Céret during the summer of 1912.[52]

There are at least two drawings of Séverac by Picasso, one dating to that same year, 1912 (plate 28). In it, the composer is seated at the keyboard of his favourite

28 Pablo Picasso, *Déodat de Séverac*, 1912. Pencil and ink, 34 × 22 cm. Musée Picasso, Paris. © 1995 Artists Rights Society (ARS), New York/SPADEM, Paris.

instrument, the piano, playing from a score bearing his own name. Olivier informs us that Picasso and Séverac also saw one another in Paris, though Picasso is recorded as telling the composer, 'My dear fellow, I know nothing about [music], and I understand music too little to follow it without getting it wrong.' Then Olivier adds in her own voice, 'What pride that remark reveals.'[53] While the general sentiment of this recollection may be correct, Picasso certainly liked music, especially that which he associated with Spain and Catalonia. Séverac appreciated the same music. If anyone could have shared theoretical ideas on that subject with Picasso, it would have been his friend from Céret.

It was soon after his arrival in Roussillon that Séverac's opera *Héliogabale*, which incorporated elements of the cobla orchestra, was performed at Béziers. After that, Séverac secured the services of Albert Manyach-Mattes — composer, masterful tenora player and leader of one of the local cobla orchestras — to show him how to write music for these folk instruments, which he wished to include in his orchestral scores.[54]

In many respects, Séverac's surviving compositions, like those of Albéniz and de Falla, ignore the ideas of Wagner and so much Symbolist theory to which those ideas gave rise. Instead, they more closely resemble the Impressionist works of

Debussy and Ravel. Mature pieces such as *En Languedoc* and *Cerdaña* can be loosely termed descriptive, in some ways similar to the very loose type of local context Picasso provided in *Piano with Still Life*. Séverac is principally a tone painter whose late compositions sensitively transcribe images of local colour and events. In *Cerdaña*, first performed in Paris in that luminous musical spring of 1911, the composer attempted to paint the musical picture of a journey through small towns in that particular region in northwestern Catalonia. If much of his music seems more the province of the painter than the composer, it may be helpful to recall that Séverac's father, aunt and uncle were well-known regional painters. In addition, Séverac found himself in the company of the Cubists in Céret from 1911 to 1913. Thinking in this highly pictorial way, he must have had little trouble communicating with these artists, despite Picasso's professed lack of knowledge about musical ideas.

Braque and the Bach revival

Given the degree to which Braque chose to celebrate the local music of Catalonia in paintings such as *The Mantelpiece* (plate 25) of the last half of 1911, it seems very odd indeed to find the name of Johann Sebastian Bach included in a work done in Céret, *Homage to J.S. Bach* (plate 29). This represents the first appearance in Braque's work of the eighteenth-century master's name, one he would repeat frequently in 1912 and 1913. The reasons cited for this, that Bach was one of Braque's favourite composers, and that the painter was making a play on words inspired by the similarity in the two men's names, offer only partial explanations for the choice of this curious subject when considering the nature of the music Braque had available to him at the time he painted *Homage*.[55]

Among other recognizable objects shown on the canvas are portions of a violin and, to the right of Bach's name, four — possibly five — pipes of various lengths. The violin, seen in the almost totally dismembered and semiotic way of paintings done earlier that year in Céret, is recombined in *Homage* so that the sound box, scroll, strings and bridge appear roughly in their logical positions as on an actual violin, seen from a limited number of points of view. The pipes can be read as another Cubist pun, a visual one this time. They can be taken either as panpipes with five puffy fingers covering the tops, or as an abbreviation of organ pipes with air rising from them. Braque may well have intended both readings.

Four linear, vertical pipes drawn side by side appear in the lower right corner of Picasso's *'Ma Jolie'* (*Woman with a Zither or Guitar*) (plate 30), painted at the same time as *Homage to J.S. Bach*, but after Picasso had returned to Paris from Céret. As in the Braque, these would seem to be panpipes, a folk instrument not normally found in a Parisian bistro or café. If this reading is correct, the panpipes represent another musical reminiscence of Picasso's sojourn in Céret. In Catalonia the *flauta de pan*, the panpipes, were used in local villages to announce the approach of travelling tradesmen. The instrument's vernacular name, *castrapuercas*, refers specifically to itinerant pig gelders.[56] If Picasso knew this Catalan term for the panpipes, it would add yet another level of sexual ambivalence to those already proposed for a painting which celebrates his love for

29 Georges Braque, *Homage to J.S. Bach*, 1911. Oil on canvas, 54 × 73 cm. Collection Carroll and Conrad Janis, New York. © 1995 Artists Rights Society (ARS), New York/ADGAP, Paris.

Marcelle Humbert.[57] The panpipes may have also had special significance for Braque, as they were a distant predecessor of the instrument on which he trained: the flute. Of course, they also provided Braque with a unique way of fusing high and low culture, combining the music of Bach with that of itinerant merchants in rural Catalonia.

If Braque also intended these pipes to be taken as organ pipes, they would be perfectly appropriate in a painting that is a homage to one of the greatest composers for that instrument. Portions of an organ and a violin, depicted in the same painting, might indicate that Braque was thinking of a particular, smaller-scale composition by Bach, a sonata or concerto perhaps, combining both instruments. Unfortunately, no such work exists. There is, however, another explanation for the unusual combination of violin, organ pipes and composer's name: performances of Bach's B minor Mass that featured, as instrumental soloists, the violinist Joan Massià and the famous French Bach organist and scholar Albert Schweitzer, at the Palau de la Música Catalana in Barcelona, in November 1911.

While ground for the French Bach revival had certainly been broken by others, Schweitzer was the figure most responsible for bringing the music of the eighteenth-century composer to the attention of readers, first in France and then in other parts of the Western world.[58] One of the great organ virtuosos of the day,

120

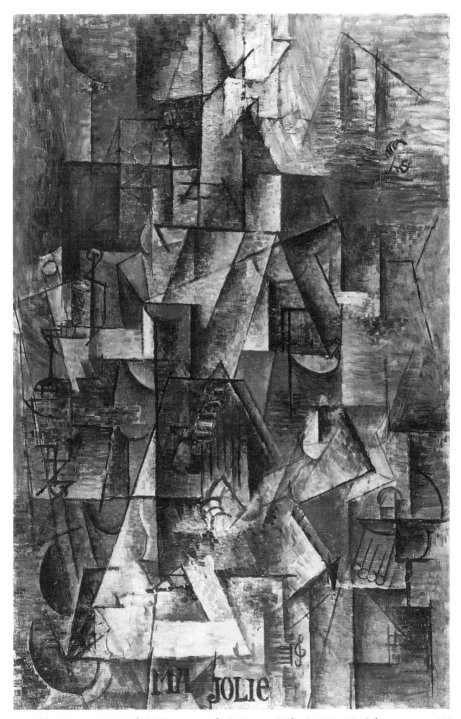

30 Pablo Picasso, '*Ma Jolie*' (*Woman with Guitar or Zither*), 1911–12. Oil on canvas, 100 ×
65.4 cm. New York, Museum of Modern Art, Lillie P. Bliss Bequest. Photograph: © The Museum
of Modern Art, New York. © 1995 Artists Rights Society (ARS), New York/SPADEM, Paris.

121

Schweitzer served as principal organist for the church of St Wilhelm in Strasbourg and in the same capacity for the Paris Bach Society. His knowledge of organ music led him to promote Bach's vocal works in France, then in Spain. In addition to his musical gifts, Schweitzer was an eloquent spokesman, promoting Bach through his various writings, speeches and personal contacts. He met Lluís Millet, director of Barcelona's Orfeó Català, in Paris, where the two became friends. It was through Millet that Schweitzer was first invited to perform at the Bach-Handel Festival in Barcelona in 1908.[59] Before that time, there had been limited but growing interest in Bach's music in Spain, much of which was spread by the Orfeó Català. The *Revista Musical Catalana*, published by the Orfeó, promoted Bach through a series of articles written as early as 1904, the initial year of the *Revista*. The Orfeó also offered motets, chorales and cantatas by Bach from 1905 to 1907. In Barcelona, a city that prided itself on its vocal groups, it was Bach's choral music that was given precedence. In May of 1907 one of the *Revista*'s greatest Bach proponents, Vicents de Gibert, noted: 'L'Orfeó Català has undertaken a great task, beginning with the Motets of Bach. With time, if God wishes, there will follow the Cantatas, the Oratorios, the *B minor Mass* and, finally, the *Passion According to St Matthew*. What a beautiful hope.'[60]

The city's new concert hall, the Palau de la Música Catalana, was finished the following year. At the instruction of the Orfeó, the Palau was furnished with an organ designed, in no small part, to facilitate the performance of Bach's work. The programme of the inaugural concerts on 13 and 15 February boasted Bach's *Toccata and Fugue in D minor*, the *Prelude and Fugue in G minor* and the *Prelude in E minor*.[61] Even though Schweitzer was a leading authority on the Bach organ, it appears that he had no role in the design of the new organ.[62] However, he became a member of the board of the *Revista Musical Catalana* as early as 1908 and visited Barcelona for the first time in October of that year for the first of the annual Autumn concerts, which were, at that time, dedicated to both Bach and Handel. A year later Schweitzer returned to Barcelona, once again for the annual Autumn concerts. On this occasion, interest in Bach had grown to such an extent that the festival was wholly dedicated to him. Schweitzer performed at two of the three concerts and also gave a lecture 'On the Personality and Art of Bach' at the Palau. At the festival's conclusion, he performed a separate recital, highlighting a variety of Bach's works, which he discussed with his audience through an interpreter. Schweitzer ended the session in a fashion designed to please his audience; he played a collection of Catalan pieces.[63]

There was no Bach Festival in 1910, but the second festival devoted to his music was held between 19 and 29 November 1911. The central work of that festival was the first performance in Spain of the entire *Mass in B minor*. The mass was split into parts, and portions heard at different concerts during the first week of the festival. Then the entire work was presented at the concluding formal concert on 28 November. At all these performances Schweitzer and the violinist Joan Massià were among the featured soloists. The two musicians also held a '*Sessió íntima*' at which Schweitzer spoke and he and Massià illustrated the organist's remarks with selections from Bach.

Céret is only one hundred miles from Barcelona. It is entirely possible that Braque visited the capital of Catalonia for a portion of the Bach Festival in

122

November 1911. Even if he did not, the concerts were given extensive coverage by leading Catalan newspapers in November and December of that year. Reporting on the third concert of the series, the reviewer of *La Veu de Catalunya* commented, 'Even though it seems impossible, the third [sic] Bach Festival resulted in a musical session superior in merit and artistic emotion to the second [sic] festival. The result was a most rarified event in the world of art. It will be a memorable date in the history of Catalan music.'[64] The laudatory nature of this review and the hyperbole that accompanied it illustrate the general level of popular enthusiasm that greeted the second Bach Festival in Barcelona. Whether Braque attended the festival in person or simply read about it in the Barcelona papers, his *Homage to J.S. Bach* shows him recording, in much the same manner as the reviewer of *La Veu de Catalunya*, his own response to the wave of popular sentiment that greeted the Bach revival in Catalonia.

When Braque and Picasso returned to Paris after their initial stays in Céret, they lost direct access to the different types of music they had heard in Catalonia. Many of the new iconographic features from the world of music that first appeared in significant fashion in their work there, however, remained: the use of an expanded vocabulary of musical notation, the depiction of the cobla shawm, stencilling and printing of the names of composers and different types of musical selections. Nevertheless, once back in the French capital, the music they heard there gained precedence. For Picasso it was the popular music of the café, cabaret and music hall which supplied inspiration, titles, phrases and sheet music for his paintings, and indeed for the earliest of his collages that can be dated. On the other hand, Braque continued to pursue the interest in serious music first expressly depicted in *Homage to J.S. Bach*. These divergent interests were by no means mutually exclusive; even then there was a 'crossover' between the two musical worlds, Parisian and Catalan, serious and regional, especially in the form of the waltz.

If anything, the musical elements found in early Cubist work produced in Catalonia demonstrate that Braque and Picasso were very much products of their times. The more blatant aspects of some of their work which features instruments such as the Catalan shawm, and composers of the order of Bach, tend to make at least some of the musical impulses recorded in early Cubist paintings seem almost historical in derivation, when they were anything but rooted in the past. In choosing these, and other subjects, Braque and Picasso were reacting to musical currents very much in the air at the time, though less than apparent today. More than anything, however, the two artists listened and reacted to music that was in their immediate environment. It did not matter so much whether it came from high or low, national or regional culture; if that music stirred them, as that of the cobla orchestra must have, if it offered new correlates for thinking about the abstract nature of their joint project, they used it, in many cases repeatedly, but always in ways that challenged perceptions about the nature of art.

Stewart Buettner
Lewis and Clark College

Notes

I wish to thank M. Henri Frances of the Centre internacional de musica popular in Céret and also Nicole Aas-Rouxparis, Ron Johnson, Patricia Leighton, Reinhard Pauly, Beverly Stafford and Antonio Tellez for their help at various stages in the preparation of this article.

1 Cubist musical subjects, primarily by Picasso, done after 1911 have been treated by D. Cooper, *Picasso Theater*, New York, 1968; R. Johnson, 'Picasso's Musical and Mallarmean Constructions', *Arts Magazine*, vol. 51, no. 7, March 1977, pp. 122–7; M. Martin, 'The Ballet Parade: A Dialogue between Cubism and Futurism', *Art Quarterly*, n.s. 1, no. 2, Spring 1978, pp. 85–111; J. Russell, 'In Detail: Picasso's Three Musicians', *Portfolio*, vol. 1, no. 2, June–July 1979, pp. 12–18; O. Pukl and P. Spielmann, 'Kubismus und Musik', *Homage à Picasso: Kubismus und Musik*, exh. cat., Museum Bochum, Bochum, 1981, n.p.; J. Langer, 'Figur und Saiteninstrument bei Picasso', *Pantheon*, vol. 60, no. 2, 1982, pp. 98–113; J. Laude, 'La stratégie des signes', in N. Worms de Romilly, *Braque, le cubisme, fin 1907–1914*, Paris, 1982, pp. 50–3; A. Martin, 'Georges Braque et les origines du langage du cubisme synthétique', in I. Monod-Fontaine, *Georges Braque, les papiers collés*, exh. cat., Musée national d'art moderne, Paris, 1982, pp. 43–56; T. Reff, 'Picasso's Three Musicians: Maskers, Artists and Friends', *Art in America*, vol. 67, no. 10, December 1986, pp. 124–42; W. Rubin, *Picasso and Braque: Pioneering Cubism*, exh. cat., Museum of Modern Art, New York, 1989, pp. 31–40.

2 R. Rosenblum, 'Picasso and the Typography of Cubism', in R. Penrose and J. Golding (eds.), *Picasso in Retrospect*, New York, 1973, pp. 57–60; W. Rubin, *Picasso in the Collection of the Museum of Modern Art*, New York, 1972, pp. 70 and 206. Research devoted exclusively to the musical subjects of the years 1912–14 has been especially significant since 1990: J. Weiss, 'Picasso, Collage and the Music Hall', in K. Varnedoe and A. Gopnik (eds.), *Modern Art and Popular Culture: Readings in High and Low*, exh. cat., Museum of Modern Art, New York, 1991, pp. 82–115; S. Miller, 'Instruments of Desire: Musical Morphology in the Early Work of Picasso', *Musical Quarterly*, vol. 76, no. 4, Winter 1992, pp. 443–64; L. Kachur, 'Picasso, Popular Music and Collage Cubism (1911–1912)', *Burlington Magazine*, vol. 135, no. 1081, April 1993, pp. 252–60. Also see S. Bowness, 'Braque and Music', in *Braque, Still Lives and Interiors*, exh. cat., South Bank Centre, London, 1990, pp. 57–67; K. von Maur, 'Music and Theater in the Work of Juan Gris', in Christopher Green (ed.), *Juan Gris*, exh. cat., Whitechapel Art Gallery, London, 1992, pp. 267–82.

3 Miller, op. cit. (note 2), pp. 444–7.

4 P. Picasso, 'Picasso Speaks', *The Arts*, vol. 3, May 1923, in P. Picasso, *Picasso on Art: A Selection of Views*, ed. D. Ashton, New York, 1972, p. 6 (author's italics).

5 F. Olivier, *Picasso and His Friends*, trans. J. Miller, New York, 1965, pp. 134, 166; H. Parmelin, *Picasso dit ...*, Paris, 1966, p. 71; W. Spies, *Sculpture by Picasso*, New York, 1971, p. 47.

6 W. Rubin, 'From Narrative to "Iconic" in Picasso: The Buried Allegory in *Bread and Fruitdish on a Table* and the Roll of *Les Demoiselles d'Avignon*', *Art Bulletin*, vol. 65, no. 4, December 1983, p. 643; P. Leighton, 'The Dreams and Lies of Picasso', *Arts Magazine*, vol. 62, no. 2, October 1987, p. 53.

7 D. Vallier, 'Braque, La Peinture et Nous', *Cahiers d'art*, vol. 29, no. 1, October 1954, p. 16: 'J'ai peint à cette époque beaucoup d'instruments de musique, d'abord parce que j'en était environné, et puis parce que leur plastique, leur volume rentraient dans le domaine se la nature morte, comme je l'entendais. Je m'étais déjà acheminé vers l'espace tactile, manuel, comme je préfère le définir, et l'instrument de musique en tant qu'objet, avait cette particularité qu'on pouvait l'animer en le touchant.'

8 H. Hope, *Georges Braque*, New York, 1949, p. 37; P. Leighten, *Re-Ordering the Universe: Picasso and Anarchism, 1897–1914*, Princeton, 1989, p. 116.

9 Langer, op. cit. (note 1), p. 112, n. 12.

10 Oliver, op. cit. (note 5), pp. 125, 171.

11 J. Richardson, *A Life of Picasso*, New York, 1991, p. 18; J. Sabartés, *Picasso, Documents Iconographiques*, Paris, 1954, p. 22. Recently, Federico Sopeña Ibañez (*Picasso y la musica*, Madrid, 1981, p. 26) and Richardson (pp. 266 and 338) have proposed that Picasso may have been influenced by the *verismo* of Puccini's operas, especially in the work of the blue period. Richardson cites Geneviève Laporte (*Un amour secret de Picasso*, Monaco, 1989, p. 8) as the source for his supposition that Max Jacob had taken Picasso to see Puccini's *La Bohème* (and perhaps also Leoncavallo's *I Pagliacci*). Actually, Laporte (p. 18) is quite clear that they went to the theatre: 'Max adorait le Théâtre. ... Surtout *La Vie de Bohème*. Chaque fois que nous allions voir cette pièce, il pleurait. ... Nous allions souvent au théâtre des Batignolles.' In France, Puccini's opera *La Bohème* is frequently performed under the title of the play on which the opera was based: *La vie de Bohème*. The context of the statement makes it probable that the two friends saw the theatre piece, not the opera. The Théâtre des Batignolles served as a venue for café-concert and theatrical, not

operatic performances, at the turn of the century.

12 M. Gornia, *Història de la Música Catalana*, Barcelona, 1969, pp. 136–7; M. Saperas, *El mestra Enric Morera*, Barcelona, 1969, pp. 15–29; 'Taula General de Materias', *Revista Musical Catalana*, vol. 1, 1904, p. XIV.

13 P. Casals, *Joys and Sorrows*, New York, 1974, p. 106.

14 M. McCully, 'Els Quatre Gats and Modernista Painting in Catalonia in the 1890s', Ph.D. diss., Yale University, 1975, p. 338.

15 Saperas, op. cit. (note 12), p. 63.

16 A. Goullet, 'Concert Hasselmans', *Le Guide musical*, vol. 57, no. 9, 26 February 1911, pp. 169–70: '... de belle et franche allure, une partition saine bien equilibrée où les choeurs et l'orchestre fusionnent dans de larges sonorités, dans de vigoureux élans, ceux-là, pleins de lyrisme, celui-ci, descriptif, chaud et coloré ...'.

17 C. Cornet, 'Société nationale de musique', *Le Guide musical*, vol. 57, no. 19, 7 May 1911, pp. 367–8: 'L'évolution de la musique espagnole se poursuit en effet sous la forme moderne heureusement combinée avec le rythme local pour réaliser l'expression d'un pittoresque à la fois animé et puissant; elle tend à se dégager des traditions systématiques, des thèmes populaires et truculents ressassés à outrance, des banalités d'opérette dans un effort plus fécond vers une inspiration plus profonde, plus réfléchie, plus humaine, vers une étude plus musicale des classiques. Après le dramatique Ruperto Chapi, Albéniz s'était formé aux travaux de la Schola, affinant par la culture des maîtres français et allemands. ... Et c'est aujourd'hui la belle phalange de ses successeurs ... dont nous entendimes tout recemment les productions séduisantes interprétées par un talent de virtuose très personnel, Manuel de Falla, Morera, Joaquim Turina.'

18 C. Cornet, 'Société musicale indépendante', *Le Guide musical*, vol. 57, nos. 26 and 27, 25 June and 2 July 1911, p. 456: '... la sincérité, la ligne le développement rythmique, le mouvement de la pensée'

19 C. Cornet, 'Société nationale', *Le Guide musical*, vol. 57, no. 15, 2 April 1911, p. 271; R. Brancour, 'La Société musicale indépendante', *Le Guide musical*, vol. 57, no. 16, 16 April 1911, p. 310. In addition to reviewing these different performances, *Le Guide musical* ran lead articles on Chabrier in preparation for a choreographed arrangement of the French composer's *Espagna* at the Paris Opéra on 3 May 1911, and on Laparra's *La Jota* (G. Servières, 'Chabrier avant "España"', vol. 57, no. 16, 16 April 1911, pp. 304–6; H. de Curzon, 'La Jota de Raoul Laparra', vol. 57, no. 17, 30 April 1911, pp. 327–9).

20 E. Brody, *Paris: The Musical Kaleidoscope, 1870–1925*, New York, 197, p. 186.

21 *Le Guide musical* identifies the piece by Turina

22 R. Bouyer, 'Musique au Salon d'Automne', *Le Guide musical*, vol. 57, no. 48, 19 November 1910, p. 720: '"La musique est dans tout" à nos salons'

played at the Salon d'Automne only as a string quartet in manuscript form (6 November 1910 [vol. 56, no. 45, p. 721]). Since 'de la guitarra' was the next quartet Turina was to publish (1911), it is most likely that which was performed at the 1910 Salon d'Automne.

23 R. Penrose, *Picasso: His Life and Work*, Berkeley, 1981, p. 165. See also Langer, op. cit. (note 1), p. 102. It is extremely unlikely that Tellier could play the instrument. In fact, many of the figures Picasso posed with instruments around the time of *Girl with a Mandolin (Fanny Tellier)* (1910, Museum of Modern Art, New York) appear to be nudes, painted more because the female figure was Picasso's favourite subject at the time than for their innate abilities as musicians. Braque initiated Cubist musical subjects; Picasso put musical instruments in the hands of individuals who, with proper training, could play them. Even with figures added to the scenes, Cubist musical subjects painted through early 1911 remain silent. With the figure, however, they move a step closer to making music.

24 'Amics cantem la certana/ De la mar fins al canigó/ Ans se cofant a la catalana/ Es la perla del Rosselló.'

25 P. Bohigas, *Cançoner popular català*, vol. 1, Monserrat, 1983, pp. 119–20.

26 Leighten, *Re-Ordering*, op. cit. (note 8), p. 116; Rubin, *Picasso and Braque*, op. cit. (note 1), pp. 375–6.

27 J. Poueigh, *Chansons Populaires des Pyrénées Françaises*, vol. 1, Paris, 1926, pp. 175–6.

28 V. Alford, *Pyrenean Festivals*, London, 1937, p. 46.

29 G.-D. Bo i Montegut, *Légendes populars des villages du Roussillon*, Saint-Génis-des-Fontaines, 1978, p. 109.

30 G. Brassaï, *Picasso and Company*, trans. F. Price, New York, 1966, p. 238; J. Mainar and J. Vilalta, *Iconographia de la sardana en l'obra de Picasso*, Barcelona, 1981, p. 9.

31 J. Palau i Fabre, *Picasso en Cataluña*, Barcelona, 1966, pp. 36 and 148; Sabartés, op. cit. (note 11), pp. 42–3.

32 The title given this painting by William Rubin (*Picasso and Braque*, op. cit. (note 1), p. 203) is *Clarinet and Bottle of Rum on a Mantelpiece*.

33 J. Palau i Fabre, *Picasso Cubism (1907–1917)*, New York, 1990, p. 505; since this paper was drafted, Lewis Kachur (op. cit. [note 2], pp. 252–3) has also identified the 'clarinet' in Braque's and Picasso's musical still lifes as a tenora. In acknowledgement of the appearance of Catalan shawms in Cubist paintings starting in late 1911, the Museum of Modern Art has recently renamed Braque's 1913 collage (which previously bore the title *Clarinet*) *Still-Life with Tenora*.

34 A. Baines, *Woodwind Instruments and Their History*, London, 1967, p. 114.

35 H. Besseler, 'Katalanische Cobla und Alta-Tanzkapelle', in *Report of the Fourth Congress of the International Musicological Society, 1949*, Basel, 1949, p. 60; Poueigh, op. cit. (note 27), p. 110.

36 E. Francès, *Andreu Toron i la tenora, 1815–1886; Història de la musica dels joglars a Catalunya-Nord al segle XIX*, Collioure, 1986, p. 134.

37 ibid., p. 78; W. Starkie, *Spain, a Musician's Journey through Time and Space*, Geneva, 1958, pp. 51–2.

38 H. Pépratx-Saisset, *La Sardane, la danse des Catalans*, Perpignan, 1956, p. 109: 'Pour danser proprement, il est donc indispensable de compter ou au moins de connaître les élémentaires règles du jeu, savoir ce qui se compte, comment on compte, pourquoi on compte, et savoir, en l'ayant observé dans la première partie de la danse, quelle alternative peut se présenter.'

39 M. Jacob, *La Laboratoire central*, Paris, 1921, p. 13: 'La musique a fait pleurer nos yeux/ La musique ingénue a gêne nos poitrines ….'

40 ibid., p. 12: 'Je me souviendrai toute ma vie de l'instrument de musique qui a nom "Tenora"; c'est long comme une clarinette et ça lutterait, affirme un musicien, avec quarante trombones. Le son en est sec comme celui de la cornemuse. J'ai entendu la "Tenora" à Figuras, ville de la Catalogne, dans un petit orchestre sur la place publique. … On dansait la sardane et avant chaque danse l'orchestre exécutait une longue introduction d'une allure grandiloquente. La déclamation de la "Tenora" était soutenue par les autres instruments serrés l'un contre l'autre. Ce sont les musiciens de la ville qui composaient cette admirable musique; leurs nom son inconnus en France. … Après l'introduction, le rythme de la danse commence; ce rythme est d'une solidité telle que je ne crois pas qu'on puisse souhaiter davantage: un rythme de polka coupe de silences brusques de longues fioritures.'

41 With the exception of Déodat de Séverac, Max Jacob was the most musical of Picasso's friends during these years. Jacob played the piano well enough to give lessons on that instrument and he sang a varied repertoire from popular songs to operetta arias. A. Salmon, *Souvenirs sans fin, deuxième époque (1908–1920)*, Paris, 1956, pp. 89–91; Olivier, op. cit. (note 5), pp. 68–9.

42 Francès, op. cit. (note 36), p. 80.

43 The town of Céret was no exception; four important festivals were held there during the year: the feast of St Paul (25 January), Easter, the feast of St Ferriol (2 and 3 July) and the feast of *festa major*, usually held on the last weekend of August between the feasts of the Assumption and Nativity of the Virgin. Pépratx-Saisset, op. cit. (note 38), pp. 29–31; H. Schmidt, 'Die Sardana, Tanz der Katalanes', Ph.D. diss., University of Hamburg, 1985, pp. 208–14; J. Prat and

J. Contreras, *Les festes populares*, Barcelona, 1987, p. 77. Palau i Fabre (*Picasso Cubism*, op. cit. [note 33], p. 222) identifies the dates for the feast of St Ferriol as 24 and 25 September. *L'Indépendant* (Perpignan, 1 July 1911, p. 2) gives the dates for the celebration of the city's patron saint as 2 and 3 July.

44 Starkie, op. cit. (note 37), pp. 53–4.

45 *L'Indépendant* (Perpignan), 1 July 1911, p. 2; *Revista Musical Catalana*, vol. 8, no. 89, May 1911, p. 157.

46 P. Daix and J. Rosselet, *Picasso, the Cubist Years, 1907–1916*, Boston, 1979, p. 278; Rubin, *Picasso and Braque*, op. cit. (note 1), p. 27.

47 ibid., p. 375. Picasso could have arrived in Céret probably not much earlier than 10 July 1911, nor later than 16 July, when he wrote to Braque from the Hôtel Canigou (in Céret).

48 A. Cortot, *La Musique française de piano*, vol. 2, Paris, 1942, pp. 200–1: 'Tout le conviait, origine et tempérament, à incorporer sans sa musique, tel le savoureux chantre catalan, cette vitalité mélodique, ces rythmes francs et caractérisés, se sentiment intense de l'inflection populaire qui lui permettrait — semblable en ceci au berger de ses campagnes languedociennes — d'inventer un chant, un de cas vrais chants de natur, si justes et si parfaits qu'il y semble passer l'âme anonyme des siècles.'

49 Rubin, *Picasso and Braque*, op. cit. (note 1), pp. 56–7, 373–4.

50 The most helpful sources for Déodat de Séverac's life and compositions are B. Selva, *Déodat de Séverac*, Paris, 1930; E. Brody, 'The Piano Works of Déodat de Séverac: A Stylistic Analysis', Ph.D. diss., New York University, 1964; E. Brody, 'Déodat de Séverac: A mediterranean musician', *Music Review*, vol. 29, 1968, pp. 172–83.

51 J. Pla, *Vida de Manolo*, Barcelona, 1947, p. 157; Brody, op. cit. (note 50), p. 181; Palau i Fabre (*Picasso en Cataluña*, op. cit. [note 31], p. 160) dates Séverac's arrival to sometime just after New Year's Day in 1910. Certainly the composer felt enough at home in Céret to have composed his cantata, *Lo Chant del Vallespir*, for performance in the arena there in early July 1911 (Selva, op. cit. [note 50], p. 112).

52 Palau i Fabre, *Picasso en Cataluña*, op. cit. (note 31), p. 257.

53 Olivier, op. cit. (note 5), p. 166.

54 Selva, op. cit. (note 50), pp. 63–8.

55 D. Cooper and G. Tinterow, *The Essential Cubism: Braque, Picasso and Their Friends, 1907–1920*, New York, 1984, p. 82.

56 A. Palacin, 'Spain, Folk Music', *New Grove Dictionary of Music and Musicians*, vol. 17, London, 1980, p. 795.

57 The term was also the nickname Picasso used for his new girlfriend, Marcelle 'Eva' Humbert. Rubin, *Picasso in the Collection*, op. cit. (note 2), pp. 70 and 206; Miller, op. cit. (note 2), pp. 444–56; Rosenblum, op. cit. (note 2), p. 57; Weiss, op.

cit. (note 2), p. 83.

58 Performances of the *B minor Mass* were the cornerstone of the second Bach Festival held in Barcelona. In themselves, these festivals were part of a larger Bach revival that started in Germany toward the beginning of the previous century, and did not reach France, except in peripheral ways, until the 1880s. It took another twenty years for sustained interest in Bach to develop in France. The Foundation J.S. Bach, a group dedicated both to the master's chamber pieces and to the revival of forgotten works of early composers, was established in 1903. Two years later Gustav Bret founded the Paris Bach Society, which concentrated on performing Bach's cantatas. In the same year Schweitzer's ground-breaking study, *J.S. Bach*, was first published, followed the next year by his *Deutsche und französische Orgelbaukunst*, which won for Schweitzer the title of 'father of the organ movement'. Schweitzer's *J.S. Bach: Le Musicien-Poète*, was first published in Paris in 1905. After rewriting and amplifying the text considerably, Schweitzer brought out the German edition in 1908. The English translation first appeared in 1911.

59 E. Jacobi, *Albert Schweitzer und die Musik*, Wiesbaden, 1975, p. 12.

60 V. de Giberts, 'La Missa en "Si Menor" ', *Revista Musical Catalana*, vol. 6, no. 41, May 1907, p. 100: 'L'Orfeó Català ha emprès una obra magna, comensant pels *Motets* de Bach. Ab el temps, si Déu vol, anirà seguint ab les *Cantates*, els *Oratoris*, la *Missa* en *si menor* y, finalment, la *Passió segons Sant Mateu*. Quina bella esperansa.' In fact, *The Passion According to St Matthew* was given its Spanish premier in Barcelona by the Orfeó Català in February 1921. Plans for earlier performance were interrupted by the outbreak of World War I. A. Schweitzer, 'Die erste Aufführung von J.S. Bachs "Matthäus-Passion", in Spanien', *Revue musicale suisse*, vol. 61, no. 12, 1921, pp. 127–8.

61 V. de Giberts, 'L'Orgu de L'Orfeó Català', *Revista Musical Catalana*, vol. 5, no. 50, February 1908, pp. 37–40.

62 Schweitzer made his distaste of concert-hall organs known in *Aus Meinem und Denken*, Leipzig, 1933, pp. 68–9.

63 'Concerts de tador', *Revista Musical Catalana*, vol. 6, no. 71, November 1909, pp. 345–51.

64 'Palau de la Musica Catalana, Festivals Bach', *Revista Musical Catalana*, vol. 8, no. 96, December 1911, p. 382: 'Encara que sembli impossible, el III Festival Bach resultà una sessió musical superior en mèrit y en emoció artístichs a la del II Festival. Resultà una sessió selectissima en l'ambient del art; serà una data memorable pera la historia de la música a Catalunya.' The reviewer here was counting the 1908 Festival, dedicated to both Bach and Handel, as the first Bach Festival, which would have made that of 1911 the third. Other newspapers carrying articles on the concert were: *Diario de Barcelona*, *La Vanguardia*, *El Poble Català*, *El Correo Catalán*, *Las Noticias*, *Diario del Comercio*, *La Actualidad*, *Cataluña*, *El Diluvio*. That some of these papers were available in Céret while Braque and Picasso were there can be seen in the front page of *El Diluvio*, featured in Picasso's *Guitar* collage (Museum of Modern Art, New York), done while he was in Céret, sometime immediately after 31 March 1913.

Art History ISSN 0141-6790 Vol. 19 No. 1 March 1996 pp. 128–155

REVIEW ARTICLES

Re-Reading the Greek Revolution
Mary Beard

Art and Text in Ancient Greek Culture edited by *Simon Goldhill* and *Robin Osborne*, Cambridge and New York: Cambridge University Press, 1994, 341 pp., 34 b. & w. illus., £40.00

Classical art history in Britain ought to be better than it is. It would be enormously improved by a large injection of theory, by a closer understanding of recent — and not so recent — developments in the art history of other periods, and (most of all perhaps) by a much greater awareness of its own institutional history, and the reasons why it has come to be practised as it is

That, at least, has been the refrain of a motley group of dissidents (myself included) for the last twenty years or so. The publication of the first volume to be born of these particular discontents, in the series of 'Cambridge Studies in *New* Art History and Criticism',[1] provides an opportunity to reflect not so much on whether the strident claims are true (for, in broad terms, they surely are), but on whether the New Classical art historians have succeeded in opening up any very clear path *out of* the doldrums they identify. My own regretful suspicion is that if anyone is bothered, a hundred years hence, to write the history of this subject, they will not find it quite so easy to identify its heroes and villains as we might hope; that the Young Turks (for all that right is on our side) are maybe not much less blinkered, and in some cases a lot more ignorant, than the benighted Old Guard. We perhaps have to try a bit harder yet.

Classical art history in this country is, for all kinds of reasons, a very strange sub-discipline of art history as a whole. It is, for a start, tiny — with no more than a dozen or so permanent teachers in university departments;[2] though these are augmented by staff in major museums. It is also awkwardly uncertain about its true intellectual home, floating perilously at the margins of Classics, Archaeology and Art History (proper). Of course, the institutional shifts in those related disciplines over the last century must bear some of the responsibility for this unsatisfactory state of affairs. For there was a time when, to put it crudely, Classics included Archaeology, and when Classical Archaeology *was* a version of Art History; when, in other words, the business of the 'archaeologist' was seen as an integral process that led seamlessly from the discovery and excavation of great works of art to their dating, classification and interpretation. But Archaeology as a discipline quickly moved on — not just to emancipate itself from Classics in general, but (even within the study of the Classical Mediterranean) to concentrate on remains that were defiantly *not* Great Art, to embrace field survey, mortuary practice and new archaeological theory in preference to Phidias and Praxiteles. The effect of all this was to leave Classical Art History rather like a piece of academic flotsam, owned by no one — except, in one crucial respect (that of *training*), by Classics. Almost every Classical art

historian in Britain is a Classicist, not an art historian, by formal training, a fact of institutional history that on its own sets the British version of the subject apart from most of its European and American counterparts.

This marginality can be (and occasionally has been) turned to the subject's advantage. There are some scholars, for example, who have used the shared borders of Classical Art History and Archaeology to escape from the constraints implied by the study of Art (with a capital A); and have tried to focus on the whole *material* and *visual culture* of the classical world (from terracotta lamps to bronze statues) in a way that could even provide a model for periods where art history has a firmer footing.[3] But such radical programmes have not been the norm. It has much more often been the case that Classical art historians have given the impression (at least) of justifying and defending a narrow, rather embattled, specialism, strongly asserting its traditional and unique skills against all those who might threaten to encroach.

For many years the best-known, and most distinguished, spokesman of this dominant strand in the subject has been Sir John Boardman, until 1994 Lincoln Professor of Classical *Archaeology* (the title is, of course, significant) at Oxford. Boardman is a man of phenomenal learning, with a range of interests and publications that spans Greek history and archaeology, as well as almost all the sub-branches of Greek art (sculpture, painting, gem-engraving ...). But he is now almost equally well known for his trenchant views on theory and method within his subject: for his defence, on the one hand, of the work of his most famous — though now controversial — predecessor at Oxford (Sir John Beazley, the Morelli of the Classical World, who pretty well single-handedly 'identified' the artists of the whole surviving corpus of Athenian vase-painting);[4] and for his strident denunciations, on the other, of fashionable theorists (especially Continental ones) and 'slick art-historical generalizations',[5] the *nouvelle cuisine* of the intellectual world, as he puts it, 'seductive in appearance, but nutritionally unsatisfying'.[6]

In the eyes of his opponents Boardman's rhetoric has come to stand for the ideals and aspirations of traditional Classical art history. In some respects this may be unfair. Boardman himself clearly loves the fight, and revels in the application of a choice turn of phrase in just the spot where it is most likely to annoy. But his overall output reveals a much more sophisticated and interesting mind than this unreconstructed backwoodsman talk would ever suggest. The virulent anti-theory of some of his best *bons mots* is no longer (if it ever was) representative of very much Classical art history today — at least not in that extreme form. In the British Museum, for example, often supposed to be a bastion of Boardman-approved connoisseurship, you need only take a glance at the new classical galleries and recent museum publications to spot much wider approaches being deployed.[7] Nonetheless, even seen as rhetorical jests, these side-swipes from the most powerful man in the subject at almost every art-historical theory of the century[8] attests to a collusive insularity in Classical art history, which has (not surprisingly) provoked its critics. These have come both from within the sub-discipline itself,[9] and from Classics more generally, where there has been a gradual attempt by Classical literary critics and historians to fill the theoretical vacuum of Classical art history. These are my 'motley group of dissidents'.

Art and Text in Ancient Greek Culture draws together contributions from a wide variety of the disaffected: from three classical literary critics (Simon Goldhill, John Henderson, Froma Zeitlin); an ancient historian-cum-archaeologist (Robin Osborne); two Continental art historians and keen observers of the British scene (Herbert Hoffmann, François Lissarrague); one classicist turned Courtauld art historian (John Elsner); and (the ubiquitous) Norman Bryson. I might as well make clear at this point that all these contributors are (so far) my friends and fellow travellers; and that I have either taught, or taught *with*, a good half of them. It is then entirely predictable that (while the quality

inevitably varies) I think most of the essays are well worth reading for anyone in any field of art history, and that some of them are very good indeed. So, for example, Robin Osborne's discussion of the centaur (the half-man/half-horse of Greek mythology) in classical sculpture includes one of the best analyses of the sculptural programme on the famous temple of Zeus at Olympia I have ever come across; while John Henderson's re-reading of a handful of Greek pots, out of the many that depict the mythical warrior women, the Amazons, and their conflicts with the military forces of Greek manhood, expertly re-invests these apparently trite visual stereotypes with (ancient and modern) significance — the best sort of cultural and visual history.[10] My concerns here, however, are not so much with the individual essays, but with the project as a whole: how far it hangs together; with the programmatic statements it makes as a (self-proclaimed) manifesto for a new style of Classical art history; and whether it has any hope of converting the unconverted.

The collection is introduced by Goldhill and Osborne with a chapter entitled 'Programmatics and Polemics'. This lays out the unifying themes of the volume, setting the individual contributions (which range from the iconography of Greek pottery painting, through the writing *on* pots, to ancient literary ecphrasis) within a common project. The editors are particularly concerned with the problems of iconographic 'identification', and with the interpretive closure that follows from the common practice of 'labelling' the scenes depicted on Greek ceramics or in sculpture. As they make clear, this drive to *name* the often anonymous figures on a pot, to *fix* a scene as 'Dionysus and Aphrodite' (rather than, say, 'Dionysus and Ariadne'), precludes the free play of interpretation that the anonymity should have prompted; and at the same time it turns the images of Greek Art into secondary *illustrations* of a master text (or myth) rather than themselves being active players in the process of making and re-making Greek cultural (and mythical) meaning. This is particularly clear in the traditional classificatory division between scenes 'of myth' and scenes 'of everyday life'. It is not just that it is very hard in many cases to know whether what is represented is drawn from the register of elevated divine tales or from the homely atmosphere of an Athenian backyard. More crucially, such a sharp division occludes the crucial overlap and interplay between those two categories — preventing us from seeing that myth is constantly mapped onto everyday life; that, for example, a representation of the mythical Hector saying farewell to his wife before his final battle with Achilles *is* simultaneously (or, at least, always may be) a representation of *any* Athenian warrior going off to the wars.

Much of this is excellent good sense, and certainly needs saying. My problem is with how far this spirited and self-confident polemic, with its straw men and strategic omissions, has over-simplified the traditional practices of Classical art history; and with how far this over-simplification will actively mislead any non-classicist using this book as an introduction to the current state of play in the sub-discipline, at the same time as it will give the Old Guard a perfect excuse to ignore what is being said. Classical art history is, to be sure, under-sophisticated; but it may not be quite so benighted as Goldhill and Osborne would have us believe. If the 'enemy' is to be effectively dealt with, they need to be represented *accurately*. So, let us look in more detail at a couple of points in their argument to see how this misrepresentation has crept in.

The chapter starts with a strident attack on Thomas H. Carpenter, whose Thames and Hudson 'World of Art' volume entitled *Art and Myth in Ancient Greece* is taken to exemplify most of the conceptual errors in 'identification' and 'labelling' that Goldhill and Osborne are concerned to put right. In particular, five pages are devoted to a deconstruction of Carpenter's 'identification' of one female figure in the central roundel of a black figure cup as 'Aphrodite'; to an analysis of the mistaken theoretical and methodological assumptions that underlie this, or any such, process of the identification;

130

and to a detailed rebuttal of Carpenter's premise that 'identification' and 'interpretation' are two separate activities and that 'interpretation' (in Carpenter's words, my emphasis) 'can only *follow* careful examination, identification, determination of chronological context and recognitions of patterns of development'.

I hold no brief for Carpenter.[11] I feel some sympathy for him as the butt of what turns into a rather undignified, bullish, *ad hominem* tirade; but in the particular intellectual conflict that is at stake, my allegiance is entirely with Goldhill and Osborne.[12] It is far less clear to me, however, that it was reasonable or helpful for them to take Carpenter and his book to stand here for the rest of traditional Classical art history. They do, in fact, offer a justification for this choice, on the grounds that Carpenter is 'a distinguished art historian' and that his book appeared in a 'series ... that is itself a major institution within art history' (p. 1)[13] — two claims which may be true, as far as they go. But to judge the achievements of academic art history on the basis of what is published between the covers of the money-spinning 'World of Art' series (an 'institution' in its way, if you like) is quite simply a cheap trick; about as fair to the subject as judging contemporary historical thought on the basis of Antonia Fraser's biography of Mary, Queen of Scots (or, for that matter, modern work on the novel on the basis of 'Coles Notes' to *Great Expectations*).[14] If Carpenter's line of approach is typical of the subject as a whole (which, in some senses, it may be), we need better proof of it than a single volume of 'The World of Art'.

But concentration on the supposed follies of Carpenter skews the argument of this introduction in yet more misleading ways — with a series of quite extraordinary omissions. One of the central chapters of Gombrich's *Art and Illusion*, entitled 'Reflections on the Greek Revolution', attempted to explain the startlingly rapid rise of *naturalistic* representation in Greek Art through the rise of *narrative* representation. Put simply, Gombrich was claiming that the revolutionary naturalism of classical Greece could be explained by the artists' desire *to tell a story*. He was almost certainly wrong;[15] but his radical claims stimulated a good deal of new work in the field of Classical Art in Britain as various scholars ventured to test out the theory, producing (in particular) a sophisticated set of debates on the nature of the 'narrative' representations on early Greek pottery, and on the relationship between the Homeric epics and visual culture.[16] All this must be directly relevant to the concerns of *Art and Text*; but neither Gombrich nor any of the studies that followed and debated his claims are even mentioned here (or anywhere in the book, for that matter). It is, of course, easy for us Young Turks to forget that there have been generations of Young Turks before; and in Classics, in particular, it is easy to forget that the subject has *always* harboured its innovative theorists as a counterbalance to its better known fusty antiquarians. But Goldhill and Osborne's omission of Gombrich (and the Gombrich debate) is amnesia on a colossal scale. Such a wilful misrepresentation of their predecessors only serves to damage an otherwise powerful argument.

We are dealing throughout this programmatic introduction with a classic case of not knowing when to stop, combined with extreme reluctance to give any credit at all to 'the other side', even where some is due. Richard Gordon (another dissident) will no doubt be touched to find his excellent article in *Art History*[17] on ancient (particularly religious) imagery credited as the major authority on the 'artistic' status of Greek pottery: 'As Richard Gordon has argued at length, the later associations of the word "art" and "artist" are inappropriate for the pots and potters who provide most of the source material for Geek imagery.' (p. 7) But the implication here that it was Gordon who first noticed this problem is either ridiculous or ill-informed. For debates on the status of Greek pottery as 'art' (or not) have been central to the subject ever since Sir William Hamilton was first forced to engage Pierre D'Hancarville to convince a sceptical public that his 'pots' really were 'vases', works of genius and worth a lot of money;[18] and they have continued, at length, ever since.[19] When Boardman reads all this credited to Gordon,

he will, I imagine, feel entirely justified in putting the book down — even though there is buried here a cogent attack on his vision of the subject.

But to return finally to the question of how far the book as a whole offers a model of a new approach to the art history of the Greek world: I have already made it clear that there are excellent individual contributions; but these hardly add up to the 'programme' that the introduction prompts the reader to expect. The essays certainly do not follow very closely the methodological lines suggested by Goldhill and Osborne. It is only John Henderson, for example, who consistently and successfully avoids the sin of 'identification'. And, in fact, the characteristically lively piece by Herbert Hoffmann ('Heroic Immortality on Athenian Vases') — with such phrases as 'owls and olives (= Athena)' or 'The meaning of the emblematic owl seems clear' — looks as if it might, under other circumstances, have been a candidate for the Carpenter treatment. Besides, half the contributions (Bryson, Elsner, Goldhill, Zeitlin) are concerned almost exclusively with ecphrasis and literary description. That, of course, is entirely legitimate in a book concerned with *Art and Text*, and they are indeed (as you would expect from their authors) powerful essays. But, as usual with modern studies of ecphrasis, large claims are made for its centrality in any art-historical enterprise — for its crucial role, that is, to our understanding of the (ancient) culture of *viewing*. In this case, however, as in many, it remained unclear (to me at least) what kind of model of viewing was actually being posited, and what its significance would be for Classical art-historical practice more generally.

But perhaps here, as elsewhere, I have missed the point.

Mary Beard
University of Cambridge

Notes

1 P. Holliday (ed.), *Narrative and Event in Ancient Art* appeared in the same series in 1993, but from a largely trans-Atlantic 'team'. For reasons that will become clear, the (theory and) practice of Classical art history is strongly determined by national boundaries. From this side of the Atlantic, Goldhill and Osborne have now been followed in the same series by J. Elsner's *Art and the Roman Viewer*; and will shortly be joined by a companion volume, *Art and Text in Roman Culture*. I do not intend the criticisms that I offer in this review to apply to any of these other books.

2 The latest register of research *interests* of all 'classical employees' of British universities (whether in Classics departments or not, and including part-time 'research associates') shows fewer than thirty who even mention Classical Art (or its sub-branches): *Classicists in British Universities*, Classical Association, 1992.

3 A strong advocate of this position is A.M. Snodgrass; see especially his *An Archaeology of Greece: the present and future scope of a discipline*, Berkeley, 1987. For another excellent adventure in combining Archaeology and Art History, see J.F. Cherry, 'Beazley in the Bronze Age? Reflections on attribution studies in Aegean Prehistory', in *EIKON, Aegaeum*, vol. 8, Liège, 1992, pp. 123–44.

4 Beazley, 1885–1970; he retired from the Oxford chair in 1956. See, for example, the hommage in Boardman's *Athenian Red Figure Vases: the archaic period*, London, 1975, p. 8: 'These chapters inevitably rely heavily on the writings of Sir John Beazley, who on his death in 1970 had earned an international reputation and authority in his subject unrivalled in the history of Classical scholarship. I have seldom deviated from the order of his lists or hesitatingly queried conclusions which he was himself always ready to revise in the light of new evidence or experience.' For different sides in the current 'Beazley debate': M. Robertson and M. Beard, 'Adopting an Approach I & II', in T. Rasmussen and N. Spivey (eds.), *Looking at Greek Vases*, Cambridge, 1991, pp. 1–35; M. Vickers and D. Gill, *Artful Crafts: ancient Greek silverware and pottery*, Oxford, 1994, *passim*.

5 *Athenian Red Figure Vases*, op. cit. (note 4), p. 8.

6 'Classical Archaeology in Oxford', in D. Kurtz (ed.), *Beazley and Oxford*, Oxford, 1985, pp. 52–3.

7 See, for example, I. Jenkins, *The Parthenon Frieze*, London, 1994, which elegantly takes

Boardman (and others) to task for treating the frieze as a puzzle-object, waiting for its 'answer'.

8 Boardman elsewhere (in 'Classical Archaeology: whence and whither?', *Antiquity*, vol. 62, 1988, pp. 795–7) seems to be under the impression that Classical art history invented all the good theories first anyway: '... art-historians of other periods are barely approaching in the last generation the position achieved in classical art history nearly a century ago' (pp. 795–6). This is preposterous.

9 Note especially the work of Michael Vickers (see, for example, *Artful Crafts*, op. cit. (note 4), and further references there) — a professional 'internal enemy' within the subject.

10 Another reviewer (Oliver Taplin, *TLS*, 11 November 1994, p. 24) complained that Henderson's 'real mission ... is to get his reader to think through relentless meshes and mashes of word plays, knowing allusions, cajolings and patronizing instructions'. Henderson would no doubt agree that his mission was 'to get his reader to *think*'.

11 Though I admire his jointly edited (with C. Faraone) collection, *Masks of Dionysus*, Ithaca and London, 1993.

12 On the other hand, an astute colleague did suggest to me that most students, having read these pages, would rush in flight from the clever stridency of Goldhill and Osborne, back to the 'safe' hands of T.H. Carpenter.

13 See also pp. 7–8: 'We have chosen to open our volume with this polemical critique of Carpenter partly because his volume is a well-respected, well-reviewed volume in a series which is still how most students are introduced to Greek art. Thus — and we hope he will forgive us ... — he may be taken as a particularly clear and forthright example of an approach that can be seen in each of the volumes on Greek art in this series (and many others elsewhere).'

14 Henderson too suffers from a bad case of overvaluing Thames and Hudson: 'Between such key institutions as, say, the Ashmolean and Thames and Hudson ...' (p. 94). Here I should

confess that some of my quotations from Boardman (notes 4 and 5) are also drawn from his 'World of Art' volumes.

15 For specific discussion of Gombrich on Greece, see my 'Reflections on "Reflections on the Greek Revolution"', *Archaeological Review from Cambridge*, vol. 4, 1985, pp. 208–13.

16 Among the most important contributions are: J. Carter, 'Narrative Art in the Geometric Period', *ABSA*, vol. 67, 1972, pp. 25–58; A.M. Snodgrass, 'Poet and Painter in Eighth-century Greece', *PCPhS*, vol. 25, 1979, pp. 118–30; and more recently, Carol G. Thomas, 'Greek Geometric Narrative Art and Orality', *Art History*, vol. 12, no. 3, September 1989, pp. 257–67. This is not to mention such major monographs as (in the USA) Richard Brilliant's *Visual Narratives: storytelling in Etruscan and Roman art*, Ithaca and London, 1984, whose intellectual origins at least in part must be traced to this debate. See now (too late for Goldhill and Osborne to take account of) P. Holliday (ed.), *Narrative and Event*, op. cit. (note 1).

17 'The real and the imaginary: production and religion in the Graeco-Roman world', *Art History*, vol. 2, no. 1, March 1979, pp. 5–34.

18 See Vickers and Gill, *Artful Crafts*, op. cit. (note 4), pp. 6–27.

19 The issues are reviewed in detail by M. Robertson in 'Adopting an Approach I', op. cit. (note 4), pp. 1–12. The problem is regularly posed in general surveys of Greek pottery. See (chosen pretty much at random) B. Sparkes, *Greek Pottery: an introduction*, Manchester, 1991: '... runs the risk of placing the vases in the category of art objects, to the exclusion of other considerations' (p. 2); A. Lane, *Greek Pottery*, London, 1947: 'Now why should Greek pots be "vases", a phenomenon different in kind from all other pottery?' (p. 1). Even if traditional accounts have tended to answer this question with a justification of the status of the pots as 'art objects', they have not — and this is crucial — been blind to the issues at stake in that designation.

Conversation Piece

Joanna Woodall

The Making of Rubens by *Svetlana Alpers*, New Haven and London: Yale University Press, 1995, 178 pp., 54 col. plates, 73 b. & w. illus., £25.00

Love it or loathe it, Svetlana Alpers's work has undeniably altered our understanding of seventeenth-century Netherlandish art. A slim volume entitled *The Making of Rubens* brings to four her books in the field, beginning with the appearance of her weighty contribution to the Corpus Rubenianum Ludwig Burchard in 1971.[1]

Her two studies of Rubens make an illuminating comparison. The Corpus, inaugurated in 1962 in honour of the eminent Rubens scholar Ludwig Burchard, is a set of catalogues raisonnés plus analytical essays covering sections of Rubens's oeuvre. Each is written by a different expert, building upon the schema and documentation bequeathed by Burchard to the Antwerp-financed Rubenianum, part of the Belgian National Centre for the Plastic Arts in the sixteenth and seventeenth centuries. Alpers's contribution, for example, concerns the Ovidian decorative programme which Rubens masterminded in the late 1630s for Philip IV of Spain's hunting lodge, the Torre de la Parada,[2] while that of her friend Elizabeth McGrath, which regrettably has yet to appear five years after the submission of the text, deals with Rubens's depiction of subjects from history. In 1968 it was envisaged that 'the complete embodiment of our improved knowledge of Rubens' work' would ultimately comprise twenty-six volumes.[3]

The Making of Rubens consists of just 178 small pages. The text is printed with noticeably wide margins, interspersed with copious illustrations. At just three chapters long, and written in a sparse, familiar style, the book clearly stands as an extended essay rather than as a claim to definitive completeness. The title itself wittily rejects objective fixity in favour of an open-ended process in which authorship is deeply implicated: 'She was the making of him.' This rhetorical informality is beautifully complemented by the book's design, a squarish shape which is easy to handle, easy to pick up and leaf through, like a personal journal or a sketchbook. In addition to conventional plates, there are small marginal illustrations which, like mental notes, are sometimes difficult to decipher and full-page, marginless details which invite intimate viewing and privilege experience of aspects of the painting over an awareness of any frame.

In contrast, the Corpus Rubenianum Ludwig Burchard dismembers a colossal, superhuman body in order painstakingly to examine it and ultimately reassemble it in improved form. Independent, intellectual labour is undertaken under each author's proper name, but in a spirit rendered cooperative by financial considerations and the revered memory of a common progenitor. The editorial function of the Rubenianum inserts another element into the composite — the presence of a formidable national, civic and institutional body as well as the personal child of Burchard's engagement with Rubens.

The resulting figure is intended to be greater than the sum of its parts and ideally to deny the complexity and tensions of its process of creation. Such aspirations ascribe a shared identity to the individual contributors, comprised of their common adherence to certain fundamental principles. These principles include an ideal of objective history guaranteed by empirical proof, a textually based conception of the subject of interpretation and specific notions of artistic intention and historical function as ways of circumscribing the contexts within which such interpretation takes place.

134

It is tempting to describe this as a humanist project, in that the aim is to appreciate and celebrate named genius through an effort which, although collaborative, never directly challenges the integrity of the individual. That the groups of seventeenth-century humanists among whom Rubens twice chose to depict himself[4] would have assumed rather different ideas of personal identity, history, interpretation and the relationship between text and image reminds us, however, that humanism is an historically conditioned stance. The humanism in which Rubens participated actually placed a more open emphasis upon conversation, in person, letters and the explicit intertextuality of their publications, than the Corpus endeavour acknowledges in its component parts.[5]

In *The Making of Rubens*, Svetlana Alpers revitalizes this conversational hermeneutics, according it the intellectual and sexual stylishness of France. Conversation is reformulated as a kind of intercourse, a begetter of meanings which still, in the end, expose and explore the exclusivity and uniqueness of creative individuality. Conversation is explicitly invoked in the second of the three chapters, which uses the debate between the Rubenists and the Poussinists in late seventeenth- and eighteenth-century France to explore the role of Rubens's afterlife, as produced in the writing of Roger de Piles, in the constitution of a discourse of the artist. De Piles's privileging of the representational means peculiar to painting (*colore*) over the represented subject (*disegno*) is ascribed to an account of the relationship between painting and viewer as like entering into an intimate conversation rather than undertaking a formal *lecture*.[6] The crucial, barely stated link between *colore* and conversation is their common reliance upon embodied presence, rather than a view of the subject as abstract Idea.

Attention to the body, process and dialogue permeates the whole enterprise. The confiding opening sentence, 'This book has been long in the making', sets the tone for a rhetoric and structure which self-consciously points to personal work in progress and implicitly reveals an ongoing labour of love. Alpers immediately proceeds to acknowledge the importance not only of formal presentation and discussion of her work within the academic community, but also of conversation with particular individuals. The genesis and final articulation of her position is said to be dependent upon continuing, supportive engagement with three figures of different intellectual persuasion: Elizabeth McGrath, Margaret Carroll and Michael Baxandall.[7]

Furthermore, the central thesis of the book is produced dialectically, through the three chapters. In the first, which is a case study of *The Kermis* in the Louvre, the visual characteristics (mimetic and material) of a single painting are understood with reference to sets of historicized 'circumstances'. The contexts invoked — of high politics, economics and national identity — conform with predominant concerns of what can loosely be termed social art history. This approach generally pays at least lip service to reception, to the viewer, but here such circumstances are skilfully assimilated into the embodied identity of the artist by inflecting them through Rubens's biography and linguistic usage.

In this way, the author retains a hold on the artist's intentions, albeit an intentionality quite different from the intellectual Idea espoused by the Corpus:

> The aim [of the first chapter] was to reconstruct Rubens's intentions — the engendering in the sense of the begetting of the *Kermis*. I wanted to see what description I could give of the relationship between the making of a picture and its circumstances. I was not trying to offer a reconstruction of what might have been in the artist's mind when he started the work, but rather the intentionality of the work itself.[8]

The second chapter takes, as Alpers aptly puts it, a different tack. Whereas the first privileges close, visual engagement with a single work, we are now turned towards the

critical text as the site of the artistic persona. The interpretive course of these two chapters seems to be directed by the breezy force of Foucauldian history. In the first, which is historically concerned with the earlier seventeenth century, meaning is produced by linking an object with a set of circumstances. In the second, which addresses the period of Foucault's classical episteme, meaning consists in the difference between historically contingent positions ascribed to Rubens and Poussin.

This dualism provides the pretext for the introduction of a way of grasping Rubens which will become crucial to the third chapter: '[I]t was a system of difference between two kinds that came, not surprisingly, to be couched in gender terms. It is of interest that in the eighteenth century, the Rubens mode was, initially, gendered female.'[9]

The third chapter, the finale, recalls the thematics of the opening chapter in its sustained concern with a single, Bacchanalian image: here the *Drunken Silenus* in the Alte Pinakothek, Munich. However, the construction of the artist as an historical, embodied, creative individual (Rubens) is now imbued with the gendered understanding of the artist as pictorial mode (Rubenism) developed in the second chapter. This is achieved, I think, by marrying the conception of intentionality (and thus identity) quoted earlier with a definition of identity in terms of gender. Engendering and generation thus become inherently linked with questions of gender. Although both conceptions of the self are locatable in the sexual body rather than the Cartesian intellect, it might be objected that the unselfconscious, transgressive play of desire cannot ultimately be identified with culturally produced, historically conditioned categories of gender.

Nevertheless, the marriage produces the powerful, provocative and problematic figure of Silenus as the pictorial embodiment of 'Rubens's own sense of identity and gender as an artist'.[10] Alpers's Silenus-Rubens is a figure feminized by impotence, out of the mind intoxication, womanly flesh and anal penetration by the black man who bears up behind in the Munich picture. Yet out of this oppressed situation comes a glorious, vital, philosophical song: 'My sense is that in his identification with the disempowered, fleshy, drunken singer Silenus, Rubens evokes a desire for access to a potent, ecstatic mode of creating.'[11] Silenus provides a wonderfully fertile alternative to a dualist conception of the artist as Jupiter, the instiller of his prior, abstract *Logos* into separate, passive matter. Even Prometheus, the witty, tortured deceiver, remains dependent upon this patriarchal notion of genesis in that he animates his clay models of a man and a woman with the fire he has stolen from Jupiter. But Silenus moves towards a more equal partnership:

> Instead, like a painter embodied in his paintings as a given, from the start as it were, Silenus is part of the songs that he is making. This is to picture an artist fused with his work, not standing back but in the process of making. This is not performing as for an audience, but performing in the sense in which a dancer performs in the midst of 'making' his/her dance. It is an ecstatic or, to invoke Nietzsche's distinction ... a Dionysian rather than an Apollonian notion of art.[12]

Yet Alpers's identification of Rubens with Silenus seems problematic. This is because the precise nature and historical status of the resulting figure is extremely ambitious. In view of the historical tenor of the first two chapters, it is legitimate to ask in what, if any, sense we are concerned with an entity which can be historically located. Although confined largely to the footnotes, the debate over whether the black man, or to speak historically the Ethiopian, is 'actually' engaged in sexual intercourse with Silenus focuses this issue most acutely.

For art historians loyal to intentionality in the sense of the conscious, premeditated, intellectual Idea, the authoritative evidence provided by textual sources, iconography and preliminary drawings indicates that the Ethiopian supports Silenus but does not enter him.

136

However, Alpers's view of intentionality as the unconscious, intuitive, bodily voiced 'song' of creative process enables attention to be paid, and credence given, to the idiosyncracies of Rubens's account of the Silenus story in the Munich picture. The precise positions and intense physical proximity of the two figures, the gripped thigh of Silenus, the rutting goats which parallel the couple's progress across the visual field, invoke, even if they do not represent, bodily commerce between the decrepit, unstable, pensive white hulk and the strong, laughing black youth.

Alpers's ambition lies in the attempt to unite 'her' kind of creativity with concepts of historical truth and autonomous genius which are associated with (if not dependent upon) identity as virile Idea. For example, immediately after stating that Rubens might not 'consciously have been willing or even able to acknowledge' the significance of his involvement with Silenus, she authorizes her interpretation of two unusual drawings of this subject through a learned and impeccably documented discussion of Rubens's reading of Virgil's *Sixth Eclogue*. In the end, she wants to have it both ways:

> the drawing also confirms his taking up of the text he read in a *pictorial* sense. Rubens transforms and internalizes the serial verbal invention into drawing. ... The two Silenus drawings are not isolated instances. The condition of Virgil's Silenus — in a textual but also in a bodily sense — can be said to resonate throughout Rubens's works.[13]

Besides this claim to the authority of the classical text, Alpers determinedly confines her Dionysian creativity to Rubens, who remains a lone colossus amongst his supporting contemporaries, like her isolated, asocial Silenus.[14] For instance, she ignores the work of Jacob Jordaens, whose popular 'vulgarity', specialization in satyrical themes and self-depiction as a drunken bagpipe player locates deployment of the Bacchanalian mode within the wider society of seventeenth-century Antwerp. Jordaens's powerful depictions of *The King Drinks*, a local Christmas-to-Epiphany celebration in which the world is turned upside down, might be seen as a Flemish version of Silenus's entertainment at the court of King Midas before being returned, on the eleventh day, to his rightful place at Bacchus's side.[15] Looking even further afield, the Bacchic initiation rites of the Bamboccianti, the informal confraternity of northern artists in seventeenth-century Rome, suggests that Dionysian creativity may have identified these foreigners in opposition to the Apollonian prestige attributed to Italian artistry.[16]

The seductive appeal of Alpers's attempt to locate resolution of the difference between word and image, mind and body, masculine and feminine, in a single, named individual, is a notion of personal freedom. She picks up the resonant term *liberté*, employed by Roger de Piles to describe drawings which seem to express the spontaneity and ease of a practised hand explicating the idea in the artist's mind.[17] This concept can be related historically to courtly notions of nonchalance and grace, but it is redeployed by Alpers to refer to Rubens's abandonment of himself to the pleasures of painting, like the dancing peasants in *The Kermis*. This deft social transposition of *liberté* places a self-absorbed, retiring Rubens beyond the workings of power, outside any political realm.

My major criticism of this fascinating and inspiring book lies here. In its struggle for freedom from the alienation and oppression involved in being situated on the other side of difference, the text attempts to abolish difference altogether. While I share this *desire*, it seems vital to recognize that actual social existence entails acute and complex distinctions in the resources and experiences available to the range of positions between rich and poor, power and powerlessness, privilege and deprivation, the courtier and the peasant. Denying difference does not engage with this. Neither does reducing it to a stark opposition between an oppressive masculinity and a repressed femininity, because gender is

ultimately an historical construction rather than an essential, natural fact. What is actually at issue is power.

To take a contentious example, a difference in power is articulated in the freedom to research and publish an essay on Rubens in the form of a carefully designed and lavishly illustrated book by a prestigious press, while the remaining Corpus Rubenianum volumes are delayed by lack of human and financial resources. Although it would be difficult to deny that reputation, money, personality and perhaps even nationality have played their part in producing this difference, Alpers might well respond that all these things are ultimately connected with the superior value, the more genuine creativity, evident in her essay. My point is that *even if this is the case*, it does not justify a failure to define precisely, in embodied terms, the relationship between her own position and that of other scholars in the field, and between *her* Rubens and other historical accounts of the artist.

This need to recognize and engage with differences seems especially necessary in an account which claims the status of history.[18] While evidently generated and shaped by the concerns of its authors, history relies upon recognition of distinctions to avoid a total assimilation of the past into a necessarily self-interested version of the present. A history blind to different positions and potentials sees hierarchy and suppression as inevitable, if not justifiable. Comprehension of change is dependent upon an appreciation of the separateness, strangeness and complexity of the historicized subject.

The Silenus figure makes *historical* sense not as the essential Rubens but as an enacted, implicit, Flemish-humanist counterpart to acknowledged, international, heroic exemplars of creativity, such as Hercules and Jupiter. Rubens was more explicitly and individually identified with these prestigious figures than with Silenus. For instance, Hercules rather than Silenus was the acknowledged exemplum of the self-promoting decoration of Rubens's house, and a seventeenth-century portrait print after Erasmus Quellinus shows Rubens with Jupiter's thunderbolt and a cornucopia.[19] Interestingly, the corresponding portrait of Van Dyck represents him with the flowers and doves of Venus, creating a gendered opposition to set against Rubens's subsequent feminization in relation to Poussin. This use of opposition to produce identity also subverts any rigid chronological distinction between an episteme of analogy and an episteme of difference.

Alpers is, of course, absolutely cognizant of heroic, intellectual versions of Rubens. The book is introduced as a response to this figure, supposedly

> the quintessential art historians' artist because his life and works seem to fit the preferred categories of research: that is to say, he was exemplary in his relationship to traditions both artistic and literary, in his manner of invention, his workshop organisation, his collecting of art, his keeping up of a public correspondence, and, last but not least, his involvement with rich and powerful patrons. With the return to an interest in ideology and figuration ... his pictorial versions of absolutism might receive some attention. But unlike ... Rembrandt, Rubens has not been of compelling interest to the late twentieth-century world.[20]

Yet this tends to situate a monolithic, conservative Rubens in a version of present, rather than seventeenth-century Antwerp, thus reducing the significance and complexity of the historical hero. Divine Jupiter and labouring Hercules had important, differing connotations within a Counter Reformation, aristocratic, yet civic culture.

Furthermore, although acknowledgement of the traditional picture of Rubens is dutifully made throughout the essay, its principal aim seems to be to appeal above and beyond the mass of boring, conservative old art historians, who maintain this view and single-handedly make Rubens popular, lovable to 'the late twentieth-century world'. To this end, then, are the attractive, manageable format, the wonderful plates, the informal

prose and explanation of the northern and southern provinces of the Netherlands as roughly corresponding to Holland and Belgium.[21] No doubt this popular appeal is to some extent due to the economics of publishing, but such a readership is unlikely to be equipped to produce the informed, critical response which the book requires in order to make historical sense.

In fact, the book's rhetorical and structural sophistication, and the theoretical, empirical and historiographic knowledge upon which it draws, implicitly enter into conversation, or at least debate, with various kinds of specialist interest. Some of these interests occupy very different positions from Alpers's own, and certainly oppose her, but some of them share, appreciate and are actively pursuing many of the ideas and concerns that she enunciates. The 'interpretative community', which may be discerned in the twentieth century as well as the early modern period,[22] consists of a range of distinct, circumstantially more or less explicit and powerful voices, rather than a simple, binary split between masculine authority and feminized suppression. An unwillingness fully to acknowledge, differentiate and communicate with this range of 'readers' represents a failure in a text which purports to promote conversational interpretation, as distinct from either lecture or dispute.

Genuine engagement with the other(s) is particularly crucial in that *The Making of Rubens* is, in some respects, profoundly dependent upon the separate work of fellow art historians. Alpers herself does not venture far into contemporary sources or the dreaded archives to substantiate and develop her brilliant hypothesis. And why should she, as her particular, extraordinary skill lies in an intensely creative, critical response to what might be called the discourse on Rubens, a literature ranging from Roger de Piles to the Corpus Rubenianum? In a proper conversation, there would be no necessity for everyone to claim personal competence in all aspects of historical endeavour, and no special virtue nor superiority in what used to be called primary research.

However, such collaboration requires the (mutual) ability not only to assimilate, but also to separate and situate the various embodied voices involved. In her considerable reliance upon, and assumption of the authority of, 'evidence' constituted to serve the cause of the heroic, intellectual Rubens, Alpers implicitly divides some of her partners in conversation into an interpretive 'mind', which she rejects, and a powerful empirical 'body', which she assimilates. Rendered practical, as opposed to intellectual, the exercise of certain hard-won investigative skills can be left to the conservative, unimaginative camp. Yet, as everyone knows, the evidence produced by even the dullest detective provides supposedly significant answers to questions which he assumes will help him to solve his particular mystery. Thus, the interests and preconceptions of authorities whose views Alpers aims to displace are allowed to determine, in quite fundamental ways, the materials which she so eloquently and movingly exploits.

Joanna Woodall
Courtauld Institute of Art

Notes

1 *The Decoration of the Torre de la Parada*, London, 1971; *The Art of Describing: Dutch Art in the Seventeenth Century*, Chicago, 1983; *Rembrandt's Enterprise*, London, 1988.

2 S. Alpers, Corpus Rubenianum Ludwig Burchard IX, *The Decoration of the Torre de la Parada*, London and New York, 1971.

3 J. Martin, Corpus Rubenianum Ludwig Burchard I, *The Ceiling Paintings for the Jesuit Church in Antwerp*, London and New York, 1968, Foreword, p. x. Alpers describes Elizabeth McGrath and Margaret Carroll as 'two scholars/friends' on p. viii.

4 *Self-Portrait with Mantuan Friends*, 1600–8?,

Cologne, Wallraf-Richartz-Museum; *Self-Portrait with Justus Lipsius, Philip Rubens and Jan Woverius*, 1611–12, Florence, Pitti Palace.

5 For a discussion of Rubens and humanist conversation, see K. Bomford, '"Living Voices and Common Lives": Rubens's "Justus Lipsius and his Pupils" and the Construction of Humanist Friendship', MA thesis, University of London, Courtauld Institute of Art, 1994.

6 I mean to imply the French senses of reading and perusal, as well as the English idea of a lecture.

7 From amongst Elizabeth McGrath's numerous publications on Rubens, Alpers cites 'Rubens's *Art of the Mint*', *Journal of the Warburg and Courtauld Institutes*, vol. 37, 1974, pp. 191–217; 'Le Declin d'Anvers et les Décorations de Rubens pour l'Entrée du Prince Ferdinand en 1635' in J. Jacquot and E. Koningson (eds.), *Les Fêtes de la Renaissance* III, Paris, 1975, pp. 173–86; 'Pan and Wool' in *Papers presented at the International Rubens Symposium: The Ringling Museum Journal*, 1982, pp. 52–69; 'Rubens's *Susanna and the Elders* and Moralizing Inscriptions on Prints' in H. Vekeman and J. Muller Hofstede (eds.), *Wort und Bild in der niederlandischen Kunst und Literatur des 16 und des 17 Jahrhunderts*, Erfstadt, 1984, pp. 73–80. Margaret Carroll's publications include 'Civic Ideology and its Subversion: Rembrandt's *Oath of Civilis*', *Art History*, vol. 9, 1986, pp. 10–35; 'Peasant Festivity and Political Identity in the Sixteenth Century', *Art History*, vol. 10, 1987, pp. 289–314; 'The Erotics of Absolutism: Rubens and the Mystification of Sexual Violence', *Representations*, 15, 1989, pp. 3–30. Michael Baxandall's work includes *Painting and Experience in 15th Century Italy*, Oxford, Clarendon Press, 1972; *The Limewood Sculptors of South Germany*, New Haven, Yale University Press, 1980; *Patterns of Intention: on the historical explanation of pictures*, New Haven, Yale University Press, 1985; *Shadows and Enlightenment*, New Haven, Yale University Press, 1995, and, with S. Alpers, *Tiepolo and the Pictorial Intelligence*, New Haven, Yale University Press, 1995.

8 S. Alpers, *The Making of Rubens*, p. 65.

9 ibid., p. 68.

10 ibid., p. 101. Silenus, according to ancient sources, was half-god, half-man. The son of Pan, or Mercury, or perhaps the Earth herself, he became foster father, tutor and attendant to Bacchus, whom he accompanied on his journey to the East. 'Silenus is generally represented as a fat, jolly old man, riding on an ass, crowned with flowers, and always intoxicated' (J. Lemprière, *Lemprière's Classical Dictionary*, first published 1788, London, 1994, p. 630).

11 Alpers, *The Making of Rubens*, p. 153.

12 ibid., p. 140.

13 ibid., pp. 142–3.

14 ibid., pp. 120–2.

15 For recent discussions of *The King Drinks*, see A. Van Wagenburg-Ter Hoeven, 'The Celebration of Twelfth Night in Netherlandish Art', *Simiolus*, 22, 1993, pp. 65–97, and R. Wood, 'Revelry and Revelation: Interpretations of Jacob Jordaens' *The King Drinks*, 1640–45 (Vienna Kunsthistorisches Museum)', MA thesis, London University, Courtauld Institute of Art, 1994. Ovid relates in the *Metamorphoses* how Bacchus once lost Silenus when he was captured by Phrygian peasants 'as he tottered along on feet made unsteady by age and wine. They had bound him with chains of flowers, and taken him to their king Midas, who had once been instructed in the Bacchic mysteries When Midas recognized him as one who was the god's companion and partner in his mysteries, he celebrated . . . with continuous festivities for ten days and nights on end. On the eleventh day, when Lucifer had shepherded away the flock of stars on high, the king . . . in great good humour . . . restored Silenus to his young ward. (M. Innes [trans. and ed.], *The Metamorphoses of Ovid*, Harmondsworth, 1955 [1979], p. 248.)

16 T. Kren, 'Chi non vuol Baccho': Roeland van Laer's burlesque painting about Dutch artists in Rome, *Simiolus: Netherlands Quarterly for the history of art*, vol. 11, 1980, pp. 63–80.

17 Alpers, *The Making of Rubens*, p. 63. De Piles actually uses the term *esprit*.

18 Alpers's direct, apparently artless claim to a place within historical discourse can be compared with Mieke Bal's disavowal of her work's status as traditional history, and discussion of the presence of the critic as inseparable from historical knowledge in *Reading Rembrandt: Beyond the Word-Image Opposition*, Cambridge, 1991, introduction. Although very different in their deployment of 'theory', both these books attempt to move beyond a dualist position through a gendered consideration of the work of a single, canonical, seventeenth-century Netherlandish artist. Alpers's work might thus usefully be read (as) in conversation with Bal's.

19 Many thanks to Elizabeth McGrath for this reference. Details of the print, which was published by F. Huberti, are given in her 'Rubens's *Musathena*', *Journal of the Warburg and Courtauld Institutes*, vol. 50, 1987, pp. 233–45; p. 244, n. 82.

20 Alpers, *The Making of Rubens*, p. 1.

21 ibid., p. 26.

22 The concept is borrowed from M. Sullivan, *Bruegel's Peasants: art and audience in the northern Renaissance*, Cambridge and New York, Cambridge University Press, 1994, p. 5, referring to H.R. Rauss, *Towards an Aesthetic of Reception*, which emphasizes the specificity of the audience.

The Popularization of History
Susan L. Siegfried

The Popularization of Images: Visual Culture under the July Monarchy edited by *Petra ten-Doesschate Chu* and *Gabriel P. Weisberg*, Princeton and London: Princeton University Press, 1994, 299 pp., 103 b. & w. illus., £33.50

Popularization is a concept that tends to be associated with populist politics. In more triumphant narratives, the effects and articles of upper- and middle-class culture are seen to make their way through ever lower echelons of society, recycled and simulated perhaps, but nevertheless spread out and down as part of the inexorable process of democratization that characterizes the modern age. In the visual arts this phenomenon is usually associated with prints and other reproductive media; typically, it is assumed that the social process involved is the classic trickle-down effect. Another more plausible way of looking at the matter is to assume that the process of popularization operates at the monied levels of society, as ever-different segments of the middle class embrace a practice, or behaviour, or thing. This more socially exclusive popularization seems to have characterized the mechanisms of cultural change in Europe from the Renaissance through the Enlightenment, and there is no particular reason to think that it would suddenly change in the early nineteenth century, when the middle class was busy consolidating its power. If there is some evidence of a trickle-down effect, the extent to which middle-class enthusiasms penetrated to the working classes would have been severely limited before the Industrial Revolution. If demonstrating a populist version of popularization is what is at stake, to be useful an investigation of popularization during the nineteenth century would need to encompass the entire century, and probably part of the twentieth century as well, and more countries than France. The social processes involved would require careful analysis, as would the mechanisms and artefacts in play. For example, the booming production of small-scale oils and statues that artists of all kinds began to undertake in the 1820s, as a new type of 'niche' marketing, seems to indicate popularization at a middle-class level. If the types of art under consideration are extended beyond prints, other neglected but vitally important categories such as illustrated magazines and the expanding women's press also warrant study.

Popularization is an evasive concept, however, even in the best-conceived studies, and this book does little to pin it down. The issue announced in its title, *The Popularization of Images*, does not mean very much in the end, partly because only half the essays in the collection address it, and those that do fail to examine their assumptions. There is a predictable tendency to equate popularization with print culture and downward social spread. One of the best esssays in the group introduces an interesting twist into this equation, however, through an interpretation that actually undermines those populist assumptions. James Cuno's essay, on the caricatures of social types published by Charles Philipon during the July Monarchy (1830–48), speaks to the book's theme of popularization, but not in the triumphant terms of a grand narrative about the ever-expanding democratization of culture. To the contrary, the strength of Cuno's argument lies in the question mark he places next to traditional interpretations of these prints as 'popular' in their supposed sympathies with the working class. Taking his cue from Judith Wechsler, he argues instead that the satires of 'typical' characters worked to shore up middle-class identity in the context of fears about socal dislocation.[1]

The book's titular subject is off-base in another way as well, for it is difficult to demonstrate that the July Monarchy had any special claim to popularization, particularly in the modern, populist sense. The essay that makes this claim is Petra ten-Doesschate Chu's, which is the primary source and justification of the book's title. She argues that historicism was symptomatic of a new kind of popular culture, which blurred the old distinction between high and low or folk culture of the seventeenth and eighteenth centuries, and anticipated the mass culture of the twentieth century. This idea is very suggestive, although I think she gets the emphasis wrong by being more interested in making a case for popularization than in analysing historicism. Her essay is mostly concerned with showing that a 'craze for history' existed (to which end she surveys a range of cultural forms) and that it was widespread (which she supports with data on 'the public', increased literacy rates and the social composition of the Paris population). She has to stretch the available evidence in order to make the point that the trickle-down effect of cultural popularization was getting under way even during the July Monarchy. Quite apart from the question of whether populist notions of culture are appropriate to this period, her central idea of a transitional popular culture could be applied to almost any period of the nineteenth century. The particular form taken by popularization under the July Monarchy is another matter, however, and here the period's fascination with history deserves to be probed, particularly with respect to the visual arts. In adopting a 'cultural studies' approach, Chu takes over the methods and data of literary studies without adapting them to the study of visual culture.[2] She offers a survey of recent work on literature, theatre, fashion, etc., but unfortunately does not pursue the relationships she tantalizingly suggests existed between, for example, painting and *tableaux* in theatre. It is also symptomatic of the essay's misplaced emphasis that Delaroche does not figure importantly in Chu's story about the popularization of history (which might have been a more apt title for her study).

The most interesting work in the collection is on the staging of history, perhaps because there was something there in the material itself for scholars to sink their teeth into. The most rewarding essays are those that treat historicism as an issue and analyse, rather than merely describe, its manifestation in the visual arts. Michael Marrinan, for example, examines the relationship between viewing conditions and paintings in order to make sense of how history worked in the visual arts at this time. He argues intriguingly that the history museum at Versailles elicited a different kind of picture-making to the Paris Salon exhibitions, because the museum's narrative structure created a special set of viewing conditions and pictorial demands. Horace Vernet understood these conditions better than most artists, and Marrinan offers the best interpretation yet of Vernet's art. Echoing a tenet of the old social art history, he insists perhaps too strongly on a division between the aesthetic realm of the Louvre exhibitions and the strictly historical realm of the Versailles museum, as if wayward aesthetic considerations never entered into the painter's conception or viewer's experience of paintings meant to function primarily as illustrations in an historical narrative. Marrinan's argument is, however, sophisticated and rich, and comes to grips with interesting discrepancies among contemporary understandings of these once very popular battle paintings.

In an essay of great insight and clarity, David Van Zanten discusses 'Louis-Philippard' principles of architectural design and urban planning, which do a great deal to elucidate the period as a whole. These design principles understated creative design in favour of enhancing the existing built fabric, preserved different historical styles, and created urban *tableaux* through axial arrangements. Van Zanten calls these 'memory theatres' and points out how, at the new École des beaux-arts, Duban's architecture and Delaroche's painting were complementary exercises in summarizing the past. The government's efforts to make 'the historical texture of the city transparent' to its middle-class citizens elicits

from Van Zanten some eloquent prose: 'Louis-Philippe and his designers were opening the city — as their predecessors in the eighteenth century had proposed and as their successors in the Second Empire would accomplish — but they were opening it in a peculiar way: surgically, delicately, to reveal its monumental organs in a rhetorical, clarified transformation of their original state.' (p. 210) In a brief aside, he also captures the fragmentation of urban planning at this time — the fact that there was no overall plan for the city but rather a series of pragmatically determined, segregated arrangements. This fragmentation is analogous in character to Charles Barry's contemporary work in England, with its contingent mixture of architectural styles and abrupt transitions from one historical atmosphere to another.

Essays such as these suggest that had historicism been adopted as the organizing theme of the book, its scope might easily have been expanded beyond France. The political necessity of studying history in France after the nation's defeat at Waterloo has been discussed elsewhere,[3] but much more needs to be said about the effects this emphasis had on the staging of history in the visual arts. Was the concern with history simply part of the process of middle-class consolidation, or was new value placed on old monuments, in Paris as in London, because the past was disappearing in the face of urban expansion? One also wonders whether the limited ambitions and relative lack of pretensions of the French generation of the 1830s and 1840s were shared in other countries. Certainly in France, the accomplishments of this period would be overwhelmed by the extravagance and grand gestures of the Second Empire, and by the shift to fundamentally different conceptions of urban space and social issues.

The editors of this new collection of essays on visual culture under the July Monarchy, Petra ten-Doesschate Chu and Gabriel Weisberg, hope to build upon the scholarly momentum of the 1970s and 1980s, but their volume does not really manage to achieve this. The recent wave of scholarship on the art of the July Monarchy attempted to modify the negative legacy of Léon Rosenthal's pioneering study of 1914, *Du Romantisme au réalisme*, by bringing out the significance of distinctive types of art which played a role in the period, notably caricature, book illustration, landscape painting and aspects of history painting.[4]

There are several interesting individual essays, but no significantly new approaches emerge, nor new areas of investigation. The basic categories of art previously mapped out for study of the period remain the same: the graphic arts, specifically social satire (Cuno, Menon, Driskel); the new historicism (Marrinan, Munholland, Chu); and questions about the dominant artistic style of the period (Weisberg, Boime). It is refreshing to see David Van Zanten's essay on architecture, which is the only piece to present new material and which offers a welcome variation from the book's conventional focus on two-dimensional art. New ways of looking at culture, such as those signalled by women's studies and cultural history,[5] are not incorporated, at least not in a way that contributes to our understanding of the visual arts.

Several contributors seem merely content to plough the furrows they have already turned. Albert Boime and Gabriel Weisberg revisit old ground in terms that are regrettably defensive. Taking issue with criticisms of their work on the juste milieu and 'proto-realism', respectively, these senior scholars engage in pointed and often petulant refutations that do no honour to the field. Such wranglings are of little interest even to specialists and give the impression of a self-perpetuating industry of scholarship.

The book is part of the Princeton Series on nineteenth-century art, culture and society. Despite its limitations, it is still a welcome addition to the literature on the subject. Nevertheless, the series editors, Jacques de Caso and Petra ten-Doesschate Chu, might in future consider casting their net wider than the United States for contributions to subsequent volumes. This selection has a utilitarian feel, having been based on a

conference of American scholars held at the University of Minnesota, and supplemented by some solicited essays. In a series such as this, more effort should be made to bring together the most interesting work being done internationally on a given subject.

Susan L. Siegfried
University of Leeds

Notes

1 J. Wechsler, *A Human Comedy: Physiognomy and Caricature in 19th-Century Paris*, Chicago, 1982.
2 The cultural studies approach adopted by Chu represents a response to some of the criticisms levelled against art-historical literature on this period: C. Rosen and H. Zerner, *Romanticism and Realism*, New York and London, 1984, pp. 111–29 and 113–79; M. Marrinan, 'The Modernity of Middleness: Rethinking the *Juste Milieu*', *Porticus: Journal of the Memorial Art Gallery of the University of Rochester*, vols. 12–13, 1989–90, pp. 42–61, and 'The July Monarchy', *Art Journal*, vol. 49, 1990, pp. 301–305; and M.-C. Chaudonneret, 'La Peinture en France de 1830 à 1848: Chronique bibliographique et critique', *Revue du l'art*, vol. 91, 1991, pp. 71–80.
3 P. Nora, *Les Lieux de mémoire: La Nation*, Paris, 1986.
4 These studies are summarized in the useful bibliographic essay that concludes *The Popularization of Images*, pp. 263–5. One important study not mentioned there is N. Green, *The Spectacle of Nature: Landscape and Bourgeois Culture in Nineteenth-Century France*, Manchester and New York, 1990.
5 Represented by, for example, J. Matlock, 'Censoring the Realist Gaze', in M. Cohen and C. Prendergast (eds.), *Spectacles in Realism*, Minneapolis, 1995; and J. Bergman-Carton, *The Woman of Ideas in French Art, 1830–1848*, New Haven and London, 1995. Another new research area has been undertaken by N. McWilliam, *Dreams of Happiness: Social Art and the French Left, 1830–1850*, Princeton, 1993.

Tracing Dreams back to History
Richard Thomson

The Temptation of Saint Redon: Biography, Ideology and Style in the *Noirs* of Odilon Redon by *Stephen F. Eisenman*, Chicago and London: The University of Chicago Press, 1992, 290 pp., 157 b. & w. illus., £47.95

Odilon Redon: 1840–1916 by *Douglas W. Druick* with *Gloria Groom, Fred Leeman, Kevin Sharp, MaryAnne Stevens, Harriet K. Stratis* and *Peter Kort Zegers*, London: Thames and Hudson, 1994, 464 pp., 200 col. plates, 375 b. & w. illus., £48.00

Redon was a difficult and unsettling artist. This was the view of many of his contemporaries and, on the evidence of the recent exhibition of his work at the Royal Academy, it is hard to disagree. The images are strange, joltingly juxtaposing the ordinary and the bizarre, suspending the imagination's phenomena in space devoid of gravity. The choice of medium is disconcerting too, with the scruffy medium of charcoal used to conjure up forms which have the oddly assorted qualities of irony, mystery and concision. Pastel, so uniquely adapted to render the textures of skin or stuff, is drafted in to register

the intangible, an aura or a mood. Redon's unswerving determination to make an unmistakably personal art out of his inner life has led to his marginalization by modernist art history, a fate similar to that of the equally disturbing and independent Max Beckmann in this century. But, like Beckmann, Redon was no *isolé*; their art, hauled up from the deepest wells of the psyche as it may appear at first acquaintance, is at least as nourished by the more homely compost of intellectual debate, social change and rank commercial need. The purpose of both these rich and ground-breaking publications on Redon's career is, as Douglas Druick and Peter Zegers avow, to 'restore it to history'. Stephen Eisenman puts the same point another way: 'This *particular* life called for this *particular* art.' The objective is challengingly and variously achieved in Eisenman's tautly argued monograph and the impressive book that accompanied the vibrant retrospective exhibition held in Chicago, London and Amsterdam, masterminded by Druick. The two studies considerably extend the territory of Redon studies, combining detailed scholarly analysis of the artist's imagery and personal life, founded on new documentation such as the papers of Redon's friend and biographer André Mellerio, now owned by the Art Institute of Chicago, with the exhaustive analysis of the intellectual contexts of Redon's career. Without detracting from the magic of his imagination and craftsmanship, both books also make stimulating use of comparative illustrations, so that Redon's imagery appropriately loses some of the rogue quality which has deterred so many.

The old template for understanding Redon's career looked something like this. He developed as an outsider, pupil of the *lithographe maudit* Bresdin. After 1880 his *noirs* gradually won him some kind of status in the Parisian art world, largely thanks to support from literary figures such as Huysmans. By the 1890s the obscurity of Redon's art set him up in the Symbolist pantheon as a pictorial equivalent to Mallarmé, but by the twentieth century his image-based art had been superceded by the formal innovations of more radical painters. 'Alienated', 'inexplicable' and 'literary' are the kind of words which toll repetitively through the Redon bibliography.

A much richer pattern is now in place. Redon's childhood at Peyrelebade, the family estate near Bordeaux, appears not only to have been disturbed by his mother's apparent indifference towards her second son but also by epilepsy, a condition which in the nineteenth century was regarded as shameful to the family. The young Odilon's exile thus carried a double burden, from which he sought relief by playing with the local children of the peasant community, but this only ingrained within him a confusion and guilt about his privileged class position. These psychological pressures constrained his artistic development. He failed his father by flunking as an architecture student, made no headway in the atelier of Gérôme at the École des beaux-arts, and, by the time he wrote the autobiographical *Le Fakir* in 1870, was steeped in narcissistic self-pity. The Franco-Prussian War of 1870–1 jerked him out of this. Redon enlisted and distinguished himself, shoring up his self-confidence and reinforcing his admiration for his ordinary countrymen with whom he had served. The 1870s were a time, we are now led to believe, not when Redon's grotesque and uncomfortable imagery was self-obsessed almost to the point of autism, but rather when his view of the world coalesced with the tortured national mood, troubled by military defeat and the fratricide of the Commune. In the following decade Redon was less the protégé of certain 'decadent' literary intellectuals than the shrewd manipulator of his own reputation, cautious about being identified too closely with writers. The 1890s now look not so much like a decade of triumph as one of transition, during which Redon had to negotiate a somewhat uncertain position vis-à-vis a younger avant garde whose work was both more radical and more comprehensible than his own. By the new century it could even be argued that Redon's career had a similar character to the more illustrious Monet's, the maxim being that there was a good living to be made out of accepted standards, so why buck the market.

Eisenman's distinguished book is a coherent focus on the first half of Redon's career. There are three main chapters: one on the 1860s, another on the *noirs* of the next decade, and a third on the images Redon drew from Flaubert's *Tentation de Saint-Antoine*. Eisenman is frankly dubious about the late work, questioning whether Redon's involvement with Symbolist circles was not merely taking the line of least resistance, and dismissing the final two decades' output as formless and Utopian, a glib recreation of fantasy nature after the sale of Peyrelebade in 1897. Eisenman hangs his account of Redon's career on the Lukácsian notion of romantic anti-capitalism, the critique of nineteenth-century social and economic progress from an ingenuous viewpoint 'in which art and nature, self and community, and action and desire are harmonised'. Redon was in essence an allegorist, Eisenman effectively argues, because like fellow romantic anti-capitalists such as Flaubert, Baudelaire and Bresdin, he found that allegory best expressed his 'simultaneous sense of estrangement from the past and a longing for its verities; no other form so well articulated the degradation of meaning and value effected by modernity and yet so well outlined, by implicit opposition, a dream of redemption.' Redon was torn between the cultured, land-owning bourgeoisie from which he sprang and *le peuple*, with whose children he had played and alongside whose menfolk he had borne arms. His adoption of lithography was not merely as an effective method to circulate his drawings, we gather, but also a commitment to craft as well as art, to the artisan's workshop as well as *l'atelier du peintre*. Eisenman prefers the early *noirs*, with their straightforward homomorphy, to the later ones, which he suspects of playing to the literary gallery. He convincingly shows that Redon's imagination in the 1870s was stocked with a menagerie — skeletons, floating winged heads, *femmes–fleurs* — to be found in the often grotesque and violent political caricatures of those troubled years and also in the slightly earlier imagery of Grandville, whose current reputation was subversive and anti-bourgeois. Less persuasive, perhaps, is the evidence for the intriguing idea that Redon was also indebted to the mythic creatures of the Médoc folk tales he would have heard touted as a child, monsters such as the Cyclopean le Bécut. For Eisenman, the unforgettable *noirs* of the 1870s and early 1880s derive from a potent combination of the popular culture of rural fairy tale and the urban culture of political caricature; in other words, from the angst of the romantic anti-capitalist struggling to come to terms with his world.

Redon's career up to 1890 is also extensively tackled by Douglas Druick and Peter Zegers in the exhibition publication, making in effect a distinct monograph within the larger volume. Their emphasis is more biographical than Eisenman's, working out from the details of Redon's life into the intricately woven and richly researched text we have come to expect from these two authors. They provide clear pictures of, for example, the cultural life of Bordeaux during the artist's youth or his fascination with the Pyrenees, where he went for recuperative breaks and felt at home among the great mountain chain redolent not only of Roland's epic stand at Roncevaux but also, we are told, of the name 'Redon', once an ancient Gallic tribe. Whereas Eisenman tends to see Redon as haunted by class guilt, Druick and Zegers suggest that his position was more ambiguous, not least because the declining fortunes of the Peyrelebade estate rendered Redon's position as both *propriétaire* and *ami du peuple* increasingly precarious. They too see the *noirs* of the 1870s as Redon's response to the national torment which followed military humiliation, and in the artist's images of devils and primitive anthropoids a pictorial realization of the ideas of Darwin and Michelet about evolution and the ascent of man: 'Redon's satyr and black angel are not so much fallen as not yet risen.' In other words, these creatures are multivalent. Anguished and confused by their lot, they stand for postwar France; coarse but rich in energy to be awakened, they are metaphors for the people; striving for self-expression, they are alter egos of Redon, struggling for creative maturity after the death of his father. Druick and Zegers have also trawled widely through the imagery of the 1870s,

and they show us popular scientific representations of lunar landscapes, posters for slide shows of microbes, natural history museum installations, illustrations by Doré and Chifflart, and grisly fairground illusions in which guillotined heads 'spoke'. They explain that Redon attended lectures at the École de médecine, shared the popular interest in phrenology, and drew the 'primitive' people of Tierra del Fuego who were camped at the Jardin d'acclimatation in 1881. In so doing, they prove conclusively that Redon extracted as much from his cultural context as he gave; that he was truly an artist 'in' history.

The second half of the exhibition book is made up of essays by different authors. There is excellent material here, provided by MaryAnne Stevens, on Redon's critical fortunes; by Kevin Sharp on his market position; by Gloria Groom on his later and especially decorative projects; and by Harriet Stratis on the often extraordinary techniques the artist employed. Fred Leeman offers an effective account of Redon's crafty positioning of himself in the later 1880s and 1890s. Aware of being considered too much of a literary artist, Redon increasingly distanced himself from writers, but also kept cannily clear of other equivocal associations, refusing to become involved with Péladan's cranky Rose + Croix. By keeping his options open, by producing images which had a generically spiritual or mystical character, Redon sustained his independent credibility by steering away from the tricky shoals of satanism, theosophy and Catholicism. Leeman also mounts a counter to Eisenman's difficulties with the late work, arguing that Redon powerfully and suggestively deployed formal means such as colour, the profile and the arabesque to give his images a sense of moral life via abstract equivalents. It must be said that this clutch of essays, interesting as they are individually, do register a degree of overlap. This raises the problem of a multi-author publication being produced to the deadline of an exhibition, with its attendant problems such as loan arrangements, and yet also expecting to stand post hoc scrutiny as a major scholarly publication. The retrospective team's volume certainly has such intellectual weight and will be a lasting contribution to the field, but it would have been enhanced by a trifle more editorial coherence and the addition of an index which surely the reader needs in a monumental book. That said, the design is impressive and the scope of the illustrations enormous; the reconstructions of Redon's one-man exhibitions and lithographic albums in clusters of small images which can be taken in at a glance are a particularly welcome initiative.

The cultivated strangeness of Redon's images has inevitably led commentators to attempt to analyse the mind that made them, and the example of Redon might almost stand as a paradigm for the efficacy and difficulties of psychology in art history. Druick and Zegers, using the new evidence of the Mellerio papers, emphasize how much the artist manipulated his biography. Angered by the willingness of his mother and brothers to sell his beloved Peyrelebade in 1897, for instance, Redon played up the solitude and alienation of his childhood. We now know that A soi-même, the posthumously published compilation of Redon's meditations on art and life, is far from being a reliable chronological account of the development of his thought, but rather an arbitrary, self-serving splicing of the material, the better to retain control of his biography and thus the future interpretation of his art. Eisenman intriguingly sees Peyrelebade as a prison as well as a paradise. Stimulus to the imagination and window onto nature it may have been, but it also involved the stigma of loneliness and the guilt of ownership. According to his account, Redon sublimated his own class guilt onto imaginary alter egos, his monsters. They do not threaten but suffer. The male figures among them lack genitals; the artist denied them adulthood as he pursued the mother and child bond denied him as a boy. Druick and Zegers use Freud's theory of the 'family romance': the disguise of old wounds by denying one's own family for fantasy families. This too seems apt, helping to explain the slow development of Redon's work, the picking up of pace after the death of his father in 1874, the more confident emergence in public after his 1880 marriage, and the

efflorescence of colour following the birth of his son Arï in 1889. The security of his own family finally cowed the demons of his childhood and released him from the 'family romance'. As well as text and image, we are most helpfully instructed that the making of work also carried with it the resonance of Redon's inner life. Unlike so many artists, Redon happily left visible pentimenti. Thus the process of evolution was retained innately in the work, the pentimenti charting the catharsis of creation. Groom effectively follows through the questioning of Redon's inner life, stressing the psychosexual character of his later imagery of wiltingly organic female figures enwrapped in natural surroundings into which dynamic male figures intervene, suggesting that Redon shared the common patriarchal anxieties about women's evolving role in society. To be sure, the artist who, in his seventies, installed a vulva-like pastel of a seashell over the mantelpiece of his Paris apartment must be a case for art-historical counselling.

One important initiative in both these books is the use of comparative illustrations, previous monographs on Redon having usually adhered too closely to that rubric. Druick and Zegers, for instance, demonstrate how sinister physiognomies in the *noirs* are derived from Delacroix's *Faust* lithographs. Eisenman's book, as I have mentioned, draws some very effective parallels between the imagery of Redon's *noirs* and the political caricature of the 1870s, but it is surely rash of him to claim that 'Redon's art reveals a strong degree of independence from art-historical traditions.' In several notable articles Ted Gott has demonstrated that Redon was an avid collector of Braun photographs of works from European museums, an ardent and quite extensive copyist, and an artist whose visual knowledge of past art regularly stimulated his own. Redon's imagination was not the tabula rasa his self-image would have us believe. Throughout these books one is often reminded of how Redon's work echoes or parallels other images. The dramatic etching *Fear*, made in 1865, shows a horseman pulling up his steed in a craggy landscape, much as in the elderly romantic Paul Huet's *Le Gouffre* (Musée d'Orsay), exhibited at the Salon of 1861. Redon made much of how he had suffered at Gérôme's studio in the mid-1860s, distancing himself from the academic establishment and promoting the legend of independence. But his drawing style at the time was not too far from Gérôme's, both favouring a sharp and precise pencil, a terse bounding contour, and rather flat and pernickety hatching. Dare one suggest that Gérôme's *Lion and Vulture*, a canvas of *c*. 1865,[1] represents a similar desert cave with an equivalent sense of threat, of mortality, to Redon's contemporary imagery?[2] The Art Institute of Chicago's haunting pastel *Melancholy* of 1876[3] is surely based on the suicidal Sappho, poised in profile on her high rock, as represented by late Romantics such as Chassériau (Musée d'Orsay; Salon of 1850–1). The parallels between Redon and Félicien Rops might be more fruitfully explored. Of similar age, both were at once leisured bourgeois and subversive image-makers; both juxtaposed unlikely motifs; both drew from Baudelaire and were fêted by the *littérateurs* of the Decadence. In Redon's third album after Flaubert's *Tentation de Saint-Antoine* (1896), plate 20, 'Death: It is I who make you serious', is evidently derived from Rops's *Prostitution and Folly dominating the World*, published to illustrate Barbey d'Aurevilly's *Les Diaboliques* (1883). Plate 16 in that album, 'I am still the great Isis', is a somewhat freer variation on Delacroix's *Medea* (1838; Lille, Musée des beaux-arts). Putting Redon back into history involves not only the history of ideas and social history, but the history of images too.

Reading these books was for me an exercise in trying to come to terms with Redon's complex work, a task greatly stimulated by the impressive and challenging work which Eisenman and Druick's exhibition team have done. From a substantial number of perspectives — psychological, ideological, commercial, iconographical, critical, technical and material — one's knowledge of Redon the man and artist has been greatly enriched, the material on which to reflect much deepened. The aim of putting Redon back into his

historical context has been roundly achieved, a process which has not oversimplified but has rather brought out yet more intricacies in Redon's achievement. Searching for an overview, it seemed to me that, paradoxical as it may sound, Redon was at base a history painter. He proceeded via copying and an elective knowledge of the old masters, the history painter's route to personal significance. He tackled great themes, probing the deep recesses of the human condition, dealing with hope and despair, redemption and loss, solitude and harmony. In the 1870s, that crucial phase when he first got to grips with a core moral matter, that of national collapse, he consorted with history painters such as Chenavard and Janmot who understood that painting should convey thought and belief, not mere anecdote. From the 1890s onwards his tackling of mythological subjects such as the *Chariot of Apollo*, *Perseus and Andromeda*, or the *Fall of Phaeton* was not only the conscious relay of Delacroix's torch, it was also the deliberate adoption of the grandest subjects: the triumph of good over evil, the primacy of the sexual imperative, the fallibility of hubris. Perhaps we have been too easily sidetracked by Redon's craftily oblique prescriptions, so that we look for mystical or Kabbalistic associations in the late *noir Walking Man*,[4] when it is simply Diogenes with his lamp, seeking an honest man: classical and moral, the very stuff of history painting. Of course, the bulk of Redon's output is on a small, private scale. But that does not, to my mind, necessarily obviate his fundamental status as an experimental *peintre d'histoire*. For there was a consistently significant moral impulse behind Redon's work, but one no longer traditionally geared to public, pedagogical expression, but more innovatively to private exploration and intimate instruction. The best Redon images — compact, intense, radiant, worked, magical — function almost like a Book of Hours: to be treasured by an individual, hauntingly dense, devoted to exclusive meditation on the depths of human experience.

<div align="right">

Richard Thomson
University of Manchester

</div>

Notes

1 G.M. Ackerman, *The Life and Work of Jean-Léon Gérôme*, London, 1986, no. 160.

2 For example, *Seated Woman with outstretched hands*, c. 1868, repr. *Odilon Redon: 1840–1916*, ed. D. Druick, 1994, fig. 65, p. 60; *Prometheus and the vulture*, 1865, repr. R. Bacou, *Musée de Louvre: La donation Ari et Suzanne Redon*, Paris, 1984, carnet II, Fo. 26, p. 228.

3 Repr. D. Druick (ed.), op. cit. (note 2), fig. 47, p. 95.

4 Repr. ibid., p. 205.

Museum Fiction

Jennifer Gordon

On the Museum's Ruins by *Douglas Crimp* with photographs by *Louise Lawler*, Cambridge and London: The MIT Press, 1993, 348 pp., 109 b. & w. illus., £26.95

The Cultures of Collecting edited by *John Elsner* and *Roger Cardinal*, London: Reaktion Books Ltd, 1994, 312 pp., 59 b. & w. illus., £25.00

Exhibiting Cultures: The Poetics and Politics of Museum Display edited by *Ivan Karp* and *Steven D. Lavine*, Washington and London: Smithsonian Institution Press, 1991, 468 pp., 81 b. & w. illus., £10.95 pbk

Inventing the Louvre: Art, Politics and the Origins of the Modern Museum in Eighteenth-century Paris by *Andrew McClellan*, Cambridge: Cambridge University Press, 1994, 289 pp., 84 b. & w. illus., £45.00

Art apart: art institutions and ideology across England and North America edited by *Marcia Pointon*, Manchester and New York: Manchester University Press, 1994, 292 pp., 39 b. & w. illus., £40.00 hdbk, £14.99 pbk

Museum/Culture: Histories Discourses Spectacles edited by *Daniel J. Sherman* and *Irit Rogoff*, London: Routledge, 1994, 301 pp., 25 b. & w. illus., £40.00

Until recently, I assumed that when reviewing more than one book the first order of business was to establish any similarities — subject matter, methodology — which allowed them to be reviewed together. At first, this seemed an easy task here as all six books appeared to contribute to the growing field of 'museology'. However, a recent visit to a bookshop and a university library made me question my initial assumptions. According to the bookshop, the majority of these books are about 'Museum Studies', whereas in the library they are either about 'Art' or 'Education'. According to their authors, they are about all of this and more, which suggests that none of these subject headings adequately represents their projects. To display a book (or object) under a specific 'label' confines and defines both its meaning and its reception. Since it is systems of 'knowledge' which these books address, it occurred to me that problems of classification underpin both their public and private histories.

The Cultures of Collecting 'probes ... into the nature of collecting'. The book's editors begin their introduction by claiming that 'Noah was the first collector. Adam had given names to the animals, but it fell to Noah to collect [and save] them.' (p. 1) They argue that the story of Noah and the ark, as quoted from *Genesis* 6.19–20, 'resonates all the themes of collecting itself: desire and nostalgia, saving and loss, the urge to erect a permanent and complete system against the destructiveness of time.' At first, the myth of Noah as 'ur-collector' seemed to me a worrying place to begin a study of collecting. It appeared not only to identify the moment from which its history began but also to establish a kind of universal collector. However, I soon realized that I had missed their point. In fact, it is this 'mirage of uniformity and orderliness' that they are trying to disrupt.

The disparate 'theoretical, descriptive and historical' essays contained in this volume explore from a variety of perspectives why people collect rather than what they have

collected. This shift in emphasis from the 'institutions' to the individual 'act' of collecting distinguishes this book not only from the others in this review but also from previous histories of the subject. By examining individuals at 'the margin of the human adventure' such as Robert Opie, Kurt Schwitters and postcard collectors, they are not attempting to fill gaps but to challenge 'traditional' representations of collecting, which see the collection as the permanent expression of past triumphs and aspirations. By shifting their focus from the finished product to the specific social and psychological activity of its making, they represent collecting as 'a narrative of how human beings have striven to accommodate, to appropriate and to extend the taxonomies and systems of knowledge they have inherited' (p. 2).

The subject of narrative is taken up in Mieke Bal's essay, 'Telling Objects: A Narrative Perspective on Collecting', where she examines 'the interplay between subjectivity and the cultural basis of understanding ...' (p. 98). Bal argues that collecting can be discussed as a narrative because it can be seen as 'a process consisting of the confrontation between objects and subjective agency informed by an attitude'. From her dense theoretical analysis of collecting, it occurred to me, on a much more simplistic, but I hope not reductive, level that collecting is like storytelling. Like the stories we tell ourselves, individuals collect objects of all sorts in order to make sense of their current world and their position within it. If collecting is a construction which is 'more or less fictional', then it cannot be reduced to a 'universal' impulse or effect.

Jean Baudrillard's essay, 'The System of Collecting' (1968), occupies a primary position within *The Cultures of Collecting*. It is the first essay to appear in the book and thus sets the agenda for the others which follow. Using psychoanalytical theory, he defines the act of collecting as 'a system [by] ... which the subject seeks to piece together his world, his personal microcosm' (p. 7). Not until the last chapter of the book, in Naomi Schor's 'Collecting Paris', is Baudrillard's analysis specifically challenged. Although she claims that it 'does yield a crucial insight into the psychology of the collector', she criticizes it for its 'extraordinary sexism', and argues that '[f]or Baudrillard the collector ... is unquestionably male' (p. 257). Interestingly, Schor's essay is the only one in this volume which addresses women as collectors and questions the effect of gender on collection and its theories. Her essay seems an appropriate close to the book as it refers back to the first chapter and opens the way for future studies. It is by challenging and expanding upon previous ideas and histories of collecting that the book offers ways of rethinking not only the nature of collecting, but also the nature of museum practices.

According to the editors of *Museum/Culture*, the four basic notions which 'underlie museums' institutional practices' are collecting, classifying, displaying and receiving. Having already discussed activities of classifying and collecting 'objects', it seems appropriate to turn my attention now to museums — those spaces in which 'objects' are displayed and received. Over the past twenty years there has been a growth of interest in the study of museums as institutions. As the editors of *Museum/Culture* point out, this recent 'fascination' with museums is partially due to the museum boom of the 1970s and 1980s which saw 'an unparalleled increase in the number of museums throughout the world and an unprecedented expansion and diversification of their activities' (p. ix). Recently, a steady stream of books and anthologies on museums has appeared which seems unlikely to let up.[1] It seems that what was once a minority area of study dominated by books and catalogues on the formation and collections of institutions has become an increasingly important area of study not only within museums but also within universities and the media. The books in my review, unlike those previously discussed in *Art History*,[2] are not specifically by and for museum professionals, but are collections of essays by academics, critics and museum professionals working in a variety of areas.

Although Andrew McClellan's book is the only one under consideration which is not

an anthology of sorts, it does not present a unified history of the Louvre, but a critical study of its invention. The book is divided into five chapters and covers a fifty-year period from 1750 to 1800. Instead of beginning at the end of the French Revolution, as most histories of the Louvre do, McClellan's book starts '[i]n the final decades of the *ancien régime* ...'. Rather than identifying the Louvre as 'the archetypal state museum', marking the end of the rule of the princely collection and the beginning of the era of the public museum, he establishes its origins in both. Thus, he argues that 'the model for subsequent national museums the world over' is not just the effect of change in the social and political order, but 'the end product and culmination of early initiatives' (p. 2). It is these initiatives which the book addresses.

The first four chapters of the book examine the 'key moments' which contributed to the creation of the Louvre. Chapters 1 and 2 examine two of its forerunners, the public exhibition of the King's pictures at the Luxembourg Gallery between 1750 and 1779, and the unrealized museum project of Comte d'Angiviller under Louis XVI. The next two consider the formation of the Louvre museum from 1793 to its 'apotheosis' as the Musée Napoléon. The final chapter is a study of a second institution, Alexandre Lenoir's Museum of French Monuments, whose formation and purpose was also the effect of revolutionary events and strategies, but which represents an early critique of modern museum practices.

McClellan is not interested in locating the original source of the Louvre's 'revolutionary' project, but in probing the ideological and political interests which underpinned its formation and purpose. He examines ideas about the collecting, classification, display, lighting and housing of objects, as well as the aims and purposes of the public museum of art which were being discussed and articulated in the second half of the eighteenth century. By examining early ideas and aims which informed and contested modern museum discourse, he shows that what and how art is displayed is not the effect of one group's or individual's interests and aspirations, but the result of both shifting and continuing aesthetic and political concerns. This is where McClellan's study goes beyond that of Carol Duncan and Alan Wallach's ground-breaking essay, 'The Universal Survey Museum',[3] and makes a valuable addition not only to study of the Louvre but also, and I think more importantly, to the study of museums and museum discourse.

Douglas Crimp's book contains ten essays by the author published in various journals and museum catalogues during the 1980s while he was editor of the journal *October*. One of the reasons Crimp gives for reprinting his essays is 'to present them alongside the parallel photographic work of Louise Lawler'. Like Crimp's essays, Lawler's photographs of the spaces in which works of art are displayed, sold and stored explore the objects' institutional framing conditions. Making the book a collaborative effort, he argues, 'strains ... conventions' of 'authorship and thematic coherence' (p. viii). It is not just the collaboration between Lawler and Crimp which challenges these 'conventions', but also Crimp's attempt to 'reframe' his early body of critical work. In addition to placing these essays in a new context, he provides them with new meaning. In his introduction, entitled 'Photographs at the End of Modernism', the only essay written specially for the publication, Crimp recollects the theoretical concerns and contemporary art practices which informed his earlier writing and examines the specific conditions which determined their production.

According to Crimp, the book's project is 'a theory of postmodernism in the visual arts based on a Foucauldian archeology of the museum'. Hence its title. However, the project is 'not so much realized as it is repeatedly reformulated'. As his introductory essay points out, over the years Crimp's theoretical interests and positions have changed as a result of specific events both within and outside the art world. Crimp concludes his introduction by discussing what he sees to be the limitations of his original project and its

152

failure to produce a 'genuine' postmodern critique of the museum. He argues that by examining the way in which 'the institution exerts its power only negatively — to remove the work of art from the praxis of life', he overlooked the way it exerts its power 'positively — to produce a specific social relation between artwork and spectator' (p. 27), and thus remained within the critical framework of modernism. It is the latter relationship between work and subject which now interests him, and is the area which his introduction explores.

The essays included in this volume are divided into three sections or forms of critical approach and thus together represent a kind of history of Crimp's theoretical interests and concerns. Although placed in roughly chronological order, they do not present a progressive development, but rather a continuous and shifting engagement with ideas and issues of modernism, postmodernism and art history. The five essays in the first section examine 'Photography in Museums' and offer a 'poststructuralist critique of authorship and authenticity'. The essay in the second examines what Crimp refers to as 'The End of Sculpture', and through a discussion of Richard Serra's work attempts a 'materialist critique of aesthetic idealism', while the final three essays, which appear under the heading 'Postmodern History', engage with 'the avant-garde critique of art's institutionalization'. In addition to examining the practices of contemporary artists such as Marcel Broodthaers, Louise Lawler and Hans Haacke — to name but a few — this final section, and in particular Crimp's essay on 'The Postmodern Museum', examines the changing functions and roles of public museums.

This collection of essays seems more than a clever marketing device, a way of recycling old work for new money. By re-collecting, re-classifying and ultimately re-framing his critical work, Crimp has established a new context and meaning for it, thus providing his readers with a useful study not only of the ways in which museums structure 'knowledge', but also of the ways in which these meanings have been sustained and contested by contemporary critics, artists, cultural managers and politicians at what he calls 'the end of modernism'.

Art apart offers a series of well-documented and critical case studies on the origins and practices of some of England's and North America's major 'art institutions'. Its contributors challenge conventional ideas of the museum as an objective institutional space. Their essays fall into two categories: 'those that deal with the structures of organization and those that deal with specific instances of how those organizations work, such as exhibitions' (p. 4). However, whether examining the founding of the National Portrait Gallery in Washington, DC, the representation of 'English' modernism in 1914 at the Whitechapel Art Gallery in London, or the construction of 'MoCA' in Los Angeles, they all investigate the ways in which institutions contribute to the production and dissemination of 'knowledge'.

One of the book's recurring themes is what its editor, Marcia Pointon, describes as 'the dialogue between the inside and outside: the interior of the building versus its exterior; the curators versus the visitors; the objects contained within in relation to identical, comparable or different objects not inside the museum ...' (p. 2). Alan Wallach's essay, which examines the 'large-scale' exhibition of 'The West as America: Reinterpreting Images of the Frontier', held at the Smithsonian Institution in Washington, DC, in 1991, is useful for exploring 'this oscillation'. As the show's subtitle suggests, the pictures were the same, but their explanations had been changed so that the supposedly true history of the American West could finally be told. The exhibition, or rather its catalogue and the explanatory texts which accompanied its display, triggered a larger debate not only about the concepts of 'history' and 'nationhood', but also about the role and funding of the arts within the United States.

'The Battle Over "The West as America"', as Wallach has titled his study, is useful

because it demonstrates the ways in which an institution produces and reproduces meaning through its objects, displays and reception. In addition, it raises questions about the effectiveness of some revisionist art histories. As he shows, no matter how long the 'new' explanations may have been, replacing one narrative of 'art' or 'history' with another simply produced another story of the American West. Although it differed from earlier representations, the show both contributed to and sustained that which it was trying to challenge. The reason for this, Wallach's argument suggests, is that its organizers failed to recognize not only the museum's 'traditional function ... to produce an eternal image of the past' (p. 89), but also the beliefs and interests which permeate and shape their practices.

One of Pointon's aims in producing this book was to fill what she sees as a gap in the current literature on museums by bringing together a group of essays which link the theoretical concerns of 'museology' with specific situations. Although the book's contributors share and demonstrate a critical awareness of the work of Adorno, Benjamin, Foucault, Bourdieu, Baudrillard and others who have addressed 'issues of space, viewing and spectatorship, power and control', they have not burdened their essays with 'theory know-how' and jargon. Instead, the contributors have supported their analyses with 'documentary evidence', some of which has never been published before. Not all the essays contained in the book succeed in exposing the systems and structures which underpin their organizations. In fact, some still produce a kind of modernist analysis of their 'objects' of study — reinscribing the authority and uniqueness of their institution. Nevertheless, the book is a welcome introduction to the study of museums. Its accessible language, useful definitions and detailed case studies make it a valuable source, particularly for undergraduates either new to the subject or pursuing their own critical/ historical investigations of institutions.

Unlike the other books in my review, *Exhibiting Cultures* is the only one tied to the museum world. It grew out of the 1988 conference 'The Poetics and Politics of Representation' held at the International Center of the Smithsonian Institution, which perhaps explains why many of its contributors are museum professionals. As with the conference, the book is concerned with 'the presentation and interpretation of cultural diversity in the museum'. Its essays offer a broad range of studies about the ways in which museums structure particular conceptions of 'art', 'nation' and 'identity'. In addition, certain of its contributors explore what, in general, is overlooked by the other books: non-western exhibition practices and issues of multiculturalism. However, by focusing on what is *in* the museum, the majority of their essays fail to explore fully the ways in which concepts of 'culture' are produced and received both inside and outside the institution.

In their Introduction, the editors of *Museum/Culture* criticize *Exhibiting Cultures*, along with other recent anthologies on museums,[4] for 'hav[ing] remained within the boundaries of particular disciplinary concerns'. They argue that such studies 'have looked at museums as sites, whether of architecture, of exhibitions, of national or cultural narratives, or of political and pedagogical projects aimed at different constituencies', and thus fail to inquire fully into 'modes of cultural construction'. The contributors to *Museum/Culture* go beyond these studies by focusing on museums as 'the intricate amalgam of historical structures and narratives, practices and strategies of display, and the concerns and imperatives of various governing ideologies'. Their interrogations of museums address not only what institutions display but also the interests, ideas and values that 'pervade and shape the practice of exhibiting' (p. ix).

The contributors to this book work in a variety of fields from art history to philosophy. However, their analyses of specific case studies attempt to go beyond these disciplinary boundaries in order to explore museum practices in relation to wider cultural discourses. The book's essays are divided into three sections: 'histories', 'discourses' and

154

'spectacles'. The editors, aware of the problems of classification, are quick to point out that these should not be seen as fixed definitions, but areas which all the contributors address to varying degrees. By discussing the function of classification in their Introduction, the editors raise questions about the ways in which meaning is constructed not only by organization(s) but also by the various histories, theories and discourses which inform its making and reception. It is these notions of collecting, classifying, displaying and receiving which the contributors to this volume explore in their essays.

What distinguishes these studies from others on museums is their investigation of ideas about 'public' and 'reception'. Instead of assuming the museum's public to be an 'average' representation of society, the contributors to *Museum/Culture* raise questions about the ways in which institutions structure their audiences as 'interpretative communities' and thus conceal gender, class and race differences. Rather than claiming exhibitions to be the effect of the ideological interests and aspirations of the institution's owners, Seth Koven, in his essay on 'The Whitechapel Picture Exhibitions', explores 'the tensions' between these aspirations and 'the ways in which different groups of people experience and give meaning to exhibitions'. He argues: 'if the organizers scripted the text of the exhibition by selecting, exhibiting and describing the pictures, the working-class public could and did read against this text by bringing the realities and presuppositions of their own lives to bear on what they saw.' (p. 24) By showing that many often contradictory meanings and realities coexist within an institution, he exposes the limitations of analyses which argue that the visitor simply swallows whole that which she or he experiences in the museum.

The contributors to these six books examine some of the ways institutions and individuals have represented notions of 'art', 'history', 'nation' and 'identity'. By examining the structures, narratives, practices and ideologies which order and construct knowledge, these studies go beyond previous histories of collecting and museums. However, despite many of these authors' efforts to blur the distinctions imposed by institutional boundaries, most of them remain within their limits. Instead of moving beyond discrete 'objects' of studies, many have simply shifted it from artwork to museum or from artist to collector. By raising questions of subjectivity in relation to ideas of 'public', the contributors to *Museum/Culture* no longer see the institution as the origin of meaning, and thus attempt to go beyond the disciplinary boundaries of both 'art history' and 'modernism' which have traditionally framed the study of museums.

Jennifer Gordon
London

Notes

1 Since beginning this review, at least two more books have appeared on the subject: C. Duncan's *Civilizing Rituals: inside public art museums*, London, 1995; and T. Bennett's *The Birth of the Museum: history, theory, politics*, London, 1995.

2 S. Selwood, 'Museums, heritage and the culture industry', *Art History*, vol. 16, no. 2, June 1993, pp. 354–8.

3 C. Duncan and A. Wallach, 'The Universal Survey Museum', *Art History*, vol. 3, no. 4, December 1980, pp. 448–69.

4 *Museum/Culture*, note 1, p. xix.

Art History ISSN 0141-6790 Vol. 19 No. 1 March 1996 pp. 156–162

SHORTER REVIEWS

Domestic and Divine: Roman Mosaics in the House of Dionysos by *Christine Kondoleon*, Ithaca and London: Cornell University Press, 1995, 361 pp., 4 col. plates, 202 b.& w. illus., £50.95

Christine Kondoleon's new book is the most comprehensive discussion in English of the mosaic floor decorations of a single ancient house. It is a *tour de force* of detailed iconographic parallels for each of the mosaics discussed, coupled with a careful integration of the imagery into the wider social and cultural concerns that have recently informed much excellent archaeological and art-historical work on Roman housing. The fact that Kondoleon's house is from the Roman period at Paphos in Cyprus allows her to extend issues of power and patronage in the private sphere — so well explored for Italy (and particularly Campania) — into a discussion of the important topic of Romanization, the cultural alignment of the provinces with the impetus of the centre.

The book is strong throughout on matters of iconography, with good discussions of technique and style (in particular chapter 2, pp. 25–84), and useful considerations of the adaptation of models and of possible workshop practices (for example, the discussions on pp. 36–8, 220–1). In addition, Kondoleon interprets the meanings of the images, attempts to read the social circulation of the house through its imagery and ties the art to the dynamics of Romanization. In each of these cases, there are difficulties in adapting the specific concerns of particular images in their distinct archaeological and iconographic contexts to the wider issues confronting the study of Roman culture.

In the reading of specific meanings, Kondoleon's understanding of the dynamics of east Roman domestic culture leads to an emphasis on the positive or socially integrative meanings of images. One might argue, however, from her own visual and textual comparisons, that such meanings could be more deconstructive and at least potentially double-edged. For example, in chapter 3 (p. 86), she takes a group of rooms with images of the Seasons, Narcissus and a peacock to 'express a delight in the beauty and abundance of the material world with the attendant implications of the "good life" led by the inhabitants [of the house]'. This reading excludes the negative implications of the Narcissus motif. Although Kondoleon refers to a key text by Philostratus on a purported painting of Narcissus contemporary with her mosaic, she reads Philostratus to evoke 'reception and a sign of luxury' (p. 86) rather than to see the connotations of disaster in what she accepts as a text with 'multiple meanings'.[1] The potential suggestions of doom implied by Narcissus (but not mentioned by Kondoleon) are extended by the visual comparisons she chooses for the inscriptions in the Seasons room. These (XAIPEI, meaning 'welcome' but also 'farewell' or 'goodbye', and KAICY, meaning 'and you' or 'you too') do not necessarily bear 'benevolent connotations, that is to return the good wishes of welcome visitors' (as suggested on p. 106). On the contrary, KAICY is an apotropaic inscription returning *any* wishes of visitors — including *bad* feelings and the evil eye (see figs. 62 and 63, p. 107).

This keenness to suppress subversive or negative readings (repeated in the elision of

156

the rape theme for Ganymede in favour of an emphasis on 'divine banquets and pleasures', pp. 119, 133–46) is part of a project where the imagery of the house is read in terms of its 'desired effects ... on its audience, the inhabitants and their guests' (p. 191). These desires, which appear to result in an assumption of the eastern provinces of the Roman Empire as being a socially integrative culture, are interpreted in terms of significant recent literature on the social construction of the Pompeiian house.[2] Thus, Kondoleon attempts to reconstruct itineraries and room functions. Yet one may argue that 'desire' is far more complex (and more destructive) than the assertion of increased status in a perceived social hierarchy.[3] In the Greek-speaking part of the Roman Empire, no desires were more complex than those related to Romanization — that immensely intricate process of reconstructing identity whereby the realities of the Roman present had to be somehow integrated with the glories of the Greek past. Here Kondoleon is unfortunate in not having had access to a most important recent rethinking, which sees the Greek world of the Roman period as an extremely interesting case of self-assertion, and even resistance, within constraints.[4] As a result, her discussion of Romanization in the conclusion (despite an interesting section on the arena, pp. 308–13) is insufficiently nuanced.

Jaś Elsner
Courtauld Institute of Art

Notes

1 For complex art-historical readings of Philostratus's *Narcissus*, see S. Bann, *The True Vine: On Visual Representation and the Western Tradition*, Cambridge, 1989, pp. 108–13, and J. Elsner, 'Naturalism and the Erotics of the Gaze: Intimations of Narcissus' in N.B. Kampen (ed.), *Sexuality in Ancient Art*, Cambridge, 1996, forthcoming. On the 'negative dimension' of Philostratus's *Imagines*, see N. Bryson, 'Philostratus and the Imaginary Museum' in S. Goldhill and R. Osborne (eds.), *Art and Text in Ancient Greek Culture*, Cambridge, 1994, pp. 255–83, esp. pp. 270–83, reviewed elsewhere in this issue.
2 In particular, see A. Wallace-Hadrill, *Houses and Society in Pompeii and Herculaneum*, Princeton,

1994; E. Dwyer, 'The Pompeiian Atrium House in Theory and in Practice' in E.K. Gazda (ed.), *Roman Art in the Private Sphere*, Ann Arbor, 1991, pp. 25–48; P. Zanker, 'Die Villa als Vorbild des späten pompejanischen Wohngeschmacks', *Jahrbuch des deutschen Archäologischen Instituts*, vol. 94 (1979), pp. 460–523.
3 I argue precisely this in my own chapter on Roman housing in *Art and the Roman Viewer*, Cambridge, 1995, pp. 49–87.
4 See especially S.E. Alcock, *Graecia Capta: The Landscapes of Roman Greece*, Cambridge, 1993; and G. Woolf, 'Becoming Roman, Staying Greek: Culture, Identity and the Civilizing Process in the Roman East', *Proceedings of the Cambridge Philological Society*, 40 (1994), pp. 116–43.

The Role of Art in the Late Anglo-Saxon Church by *Richard Gameson*, Oxford: Clarendon Press, 1995, 312 pp., 32 b. & w. illus., £40.00

The period in the history of art which Dr Gameson has chosen for this detailed and fascinating study, a period of roughly two hundred years dating from the reign of King Alfred (871–99) to the generation after the Norman Conquest, has justly been named the 'Golden Age of Anglo-Saxon Art'. With its wealth of high-quality manuscript painting, sculpture, ivory carving and fragments of superb embroidery, it provides a very suitable field for this analysis of the nature of the art and the relationship between patrons and

artists, for Dr Gameson interprets the word 'role' in the widest possible sense. Nor does he limit his inquiry to art produced for the church, or by churchmen and churchwomen. He cites examples of works made for lay patrons, works made by secular artists, and even, with the use of the Bayeux Tapestry (whose imagery plays an important role in his argument), a work whose role and function had nothing to do with the Anglo-Saxon church.

The nature of the survival of this art means that the greatest emphasis has to be placed on manuscript illustration, because in this context enough survives to make useful comparisons possible; but reference to architectural remains, to stone sculpture and to the minor arts help to substantiate the author's conclusions. He compares the organization of the decoration, its subject matter and its relationship to its context in a stimulating analysis, which both illuminates and encourages the reader to return and examine the art more closely. However, more importantly, he reminds us again and again that the justification of this art was its teaching role: 'Orthodox teaching required the Christian to look for the inner spiritual meaning of each recorded happening; correspondingly, the aim of the artist was to present in his depiction both the historic event and its Christian significance.' Illustrations illuminate the psalmist's text, underline its message and even sometimes provide added commentary, while inscriptions, such as that over the arch of the south porticus of Breamore church in Hampshire, encourage the reader to link the building of stone with the church of God's promised people.

It is in the nature of the paucity of surviving works, and of the limits of our information about the people who ordered and produced them, that many of the speculations of the author cannot be fully substantiated. As he admits, we do not know enough about the conditions in which the works were produced to be certain about the intentions of the artist, and in my view it can be dangerous to make presumptions about the nature of art appreciation in tenth- and eleventh-century England from the evidence we have at present. Art patronage was certainly valued as an expression of piety, and even with the greatest of the patrons, such as Bishop Aethelwold of Winchester, learned as we know he was, there is no certainty that he directly influenced the type of art his artists produced for him, nor that he appreciated its subtleties.

This book will be an invaluable accompanying volume to the discussions of style, provenance and dating which usually dominate the discussion of art of this period. As the author reminds us, this is a new way of looking at medieval art, and there are surely other periods which would benefit from such a well-documented and thought-provoking survey.

Nora Courtney
University of Surrey

The Expression of the Passions: The Origins and Influence of Charles Le Brun's Conférence sur l'expression générale et particulière by *Jennifer Montagu*, New Haven and London: Yale University Press, 1994, 234 pp., 209 b. & w. illus., £35.00

> Scorn is expressed by the eyebrow frowning, with the inner end drawn down towards the nose and the other very much raised, the eyes wide open, the pupils in the middle, the nostrils drawn upwards, the mouth shut, with the corners slightly lowered, and the under lip thrust out beyond the upper.

The scorn which Charles Le Brun's lecture on the expression of the passions now often

158

invites, and as he there described it, is wholly undeserved. As Jennifer Montagu argues in this thorough study, Le Brun's lecture with its accompanying illustrations became a vital tool for generations of artists who were required to narrate the feelings of the participants in their paintings. Le Brun, basing himself upon the theories of Descartes, explained the different ways in which the face mechanically responded to different emotions, founded not on mere observation, with all its possibilities for individual error, but, as he saw it, on the far superior resource of reason. By providing a classification based on reason, Le Brun attempted to provide universal and infallible rules which would enable the narrative in paintings to be communicated.

Le Brun's lecture was therefore like an illustrated dictionary providing two-dimensional translations of human emotions, a dictionary to be consulted mainly by artists, and intended to avoid just the kind of more open-ended narrative which today can seem so appealing in works of late Rembrandt and Watteau, say.

Although no edition of it was published until after his death, as Montagu shows, Le Brun's Lecture on Expression was delivered in 1668. His career was then at its height, and for the next fifteen years or so he was to continue vast schemes of decoration for the royal palaces, supervising large teams of artists and artisans. Given the nature of the painted decorations which frequently commemorated the great events of the ancient or recent past, a common vocabulary of expression was highly desirable, and the French Academy of Painting and Sculpture, which was primarily a teaching institution and which Le Brun then effectively controlled, was the appropriate place to expound it. And if criticism of Le Brun's lecture was expressed from the end of the seventeenth century, and so long thereafter as it continued in use by students, nothing better was produced to meet artists' needs on how to make different emotions recognizable and distinguishable from each other.

Montagu's book, like its subject, is both reasoned and exhaustive, admirably fulfilling the promise of its title. All Le Brun's drawings and diagrams of the expressions are reproduced and discussed, as are his écorché heads after Vesalius. Most usefully, she includes Claude Nivelon's accounts of Le Brun's Lecture on Physiognomy, also delivered in 1668. Le Brun's Lecture on Expression is thoughtfully translated as well as printed in French (in Montagu's own rendering of the original, based primarily on Picart's 1698 edition) and she also gives a more complete account of its numerous editions, versions and derivations than ever previously published.

Le Brun's lecture itself is scarcely exciting reading and its main use for later generations of artists lay in its accompanying illustrations. From this it may be thought that Montagu's account is of concern only to those fascinated by French seventeenth-century art theory. The book's appeal, however, should be far wider. By placing Le Brun's lecture in the context of the traditions of expression in both the visual and other arts, and by devoting a chapter to explaining its rejection by neo-classicists, this book will be of interest to anyone wishing to understand one of the central problems faced by West European artists since the Renaissance.

There are some proof-reading errors, as well as design problems where it is difficult immediately to distinguish text from photograph captions. These, however, are minor quibbles which do not dull Montagu's scholarship, or the clarity with which she expresses it.

Humphrey Wine
The National Gallery, London

Painters and Politics in the People's Republic of China, 1949–1979 by *Julia F. Andrews*, Berkeley, Los Angeles and London: University of California Press, 1994, 568 pp., 12 col. plates, 138 b. & w. illus., £50.00

The study of art in China in the twentieth century has sometimes been doubly marginalized outside that country. Its modernity and its subservience to political ends have rendered it somehow 'un-Chinese' and inauthentic to the discourse of sinology, a sad coda to a great tradition, while its geographical and institutional remoteness from the perceived core of that modernity in the West has written it out of the major narratives of 'modern art'. The broad effects of that marginalization, and the strategies by which it has been enforced are only now coming to be understood, often in the light of work done in recent years by cultural theorists such as Homi Bhabha. However, until very recently linguistic and historical barriers could still be adduced by anyone who just did not want to engage with what has gone on in China. Such alibis are looking thin, as books like Joan Lebold Cohen's *The New Chinese Painting, 1949–1968* (1987), Ellen Johnson Laing's *The Winking Owl: Art in the People's Republic of China* (1988) and now Julia Andrews's current work provide a considerable body of material in English for anyone who needs or wants to find out.

The sheer quantity of information never previously available will ensure Andrews's book a central status in all further investigations of the field. As well as a text thickly studded with names and dates, and copious reproductions of works both seen and unseen previously, she provides appendices which list all the members of governmentally sponsored bodies in the fine arts for the years 1949, 1960 and 1979, and lists of participants in crucially important classes in oil painting held in Beijing in the 1950s and early 1960s. Her footnotes and bibliography will be mined for years, even if circumspection means that one of her most important sources, her series of interviews with (anonymous) figures of the Chinese art world remain inaccessible for the time being. This empirical data is rigorously and effectively marshalled, and is an achievement of the very highest order, which will permanently reconfigure the study of modern Chinese art in English, and which sets new standards of scholarship in that field.

However, it would be unfair to view this book simply as a mine of information for others to dip into. Professor Andrews knows well that there is no such thing as 'raw' data. It is all cooked, all directed, even if not explicitly, in support of positions. These are often the positions of her informants, the grand narrative favoured by intellectuals within China in the 1980s, which divides history since the foundational moment of 1949 into three acts. In Act I (1949–66) optimism gives way to disillusion which is still not terminal. In Act II (1966–76) the Ten Years of Chaos mindlessly devastate the scene. In Act III (1976–89) things return to a measure of sanity and stability after the death of Mao and the 'pragmatic' policies of Deng Xiaoping. This is the structure of a popular success like Jung Chang's *Wild Swans*, and of numerous other English-language memoirs of modern China, which tend to end before the shock of Tiananmen Square and the more problematic 1990s. It is not the fault of the author that this is the story her informants have told her, though I think the book would have been even better for seeing it even more *as* a 'story about art', while readers should be aware of the constructed nature of this framework, into which all debates of the era are inserted.

A good half of the book covers the period from 1949 to 1957, a period now historicized enough in China for people to speak freely. The coverage of the complex interplay between political views, personal and clique affiliation, and artistic choices over questions like medium and style is fascinatingly written, and unlikely to be bettered. All scholars of China in the period should read this, whether they are interested in art or not,

for its lucid exposition of how 'factionalism' actually worked at the personal level during the Anti-Rightist Campaign. The title of the book is absolutely accurate, focusing as it does on individual artists, their training in newly constituted academies, their institutional affiliations and personal networking, their job prospects and their salaries. The prominence of political discourse in China may force relationships of the personal and the political to centre stage, but on one level this book provides a model of how such relationships can and should be studied in other geographical and historical contexts.

There are close readings too of individual works of art, few more telling than the account of Dong Xiwen's celebratory canvas *The Founding of the Nation* (1952–3), repainted three times by the artist to remove or insert politicians as they dropped in and out of Mao's favour, then copied and repainted again by others after his death. The care and seriousness Professor Andrews devotes to this vast piece (which, as she admits, tends to make students burst out laughing) seems to me to be exemplary art *history*, eschewing any urge to make cheap shots at the picture on the grounds of quality, and instead dealing fully with the how and the why of its tortured biography.

Although the author attempts the same seriousness when dealing with the period of the Great Proletarian Cultural Revolution, she is here slightly more in thrall to her informants. This may be due to the lack of contemporary literature with which to cross-check people's memories. She admits the central problem of her study, which is the cultural amnesia preventing anyone from remembering enthusiasm for the extreme Maoist project. This is beginning to change in the fields of Chinese cinema and literature, as voices are found to proclaim the pleasure and exhilaration felt in what one writer has described as Chinese youth's answer to Woodstock. Just as in Paris or London, *some* art students must have rejoiced at the destruction in August 1966 of the Central Academy of Fine Art's collection of plaster casts from the antique (was there a direct imitation here by western Maoists?). However, not only casts were smashed, and the intensity and quantity of suffering within the artistic community perhaps still make a truly historical account a thing of the future. One striking feature which emerges from the book, and which might be a profitable vein of future research, is the role of women artists and administrators in the period of the Cultural Revolution. The demonized and reviled figure of Jiang Qing is to the fore here, but so is the shadowy Wang Mantian, Jiang's chief agent in the visual arts. Her suicide in 1976 means her side of the story is unlikely ever to be heard. The only example of Red Guard cartooning to be analysed here is also by a woman, Weng Rulan, pointing again to the role of those previously marginalized and dispossessed by an almost exclusively male arts hierarchy in the power struggles of the 1960s and early 1970s.

The dependence on interviews means that other alternative voices are silenced or at least muted as well. In the early 1970s considerable interest was evinced outside China in the 'peasant artists' heavily promoted by the regime. Many of these came from Huxian, in Shaanxi province, and produced work which not only decorated *gauchiste* walls across Europe (Dong Zhengyi's *Commune Fishpond* was a particular favourite), but which was toured under the auspices of the Arts Council of Great Britain and similar bodies in other European states (though not in the USA). Huxian itself, with its gallery of peasant art, was a much-visited spot on the itinerary of early 1970s tourists of the revolution. Andrews points out that much of the vaunted art of this type was in fact produced by or reworked by professional artists, but Huxian as a phenomenon finds no place in her text.

That is only to say that her book is exactly about what it says it is, namely 'painters and politics'. It is not about the entire field of artistic production (sculpture, graphics and design are barely mentioned), and it is not a 'history of art in China since 1949'. Nevertheless, its ambitions are considerable and are fully achieved in a work which is a pleasure to read and which is produced to the highest standards. The University of California Press are to be congratulated too for *not* feeling that one good book on modern

Chinese art (Laing's *The Winking Owl*) meant they had 'covered' the topic, but for going on to publish a second major intervention which will be of enduring value.

<div align="right">

Craig Clunas
University of Sussex

</div>

UNIVERSITY OF LEEDS
GRADUATE STUDIES

Art History, Visual Arts and Cultural Studies
MA Programmes

The Department of Fine Art in conjunction with the Centre for Cultural Studies, the Centre for Modern Jewish Studies and the Centre for Studies in the Decorative Arts and Architecture offers an array of interrelated or dedicated MA programmes of study both full-time and part-time for which it now invites applications.

The major focus of teaching and research falls in the period 1750 to the present with some specialist research and study in the Renaissance period. All courses offer major seminars in theoretical and methodological analysis along a number of critical tracks: historical materialist historiography; race, gender and sexuality; lesbian and gay studies; sculptural theory, history, exhibition and criticism from the Renaissance to the modern period; psychoanalysis and feminist theory; poststructuralism and theories of allegory; methods of cultural history. Courses offered are: **1. Social History of Art 2. Feminism and the Visual Arts 3. Cultural Studies 4. Sculpture Studies** funded with assistance from the Henry Moore Foundation and <u>Newly Introduced</u> **5. Country House Studies** providing a critical analysis of the social and cultural creation of the historical archive. One scholarship from the Harewood House Trust is available. **6. Modern Jewish Studies** placing particular emphasis on Jewish art and culture.

For further information and an application form contact:

**Graduate Admissions
Department of Fine Art
University of Leeds
Leeds LS2 9JT
Tel: (0113) 233 5260
Fax: (0113) 245 1977**

Promoting excellence in teaching, learning and research.

Yale Art History

Cézanne
Landscape into Art
Pavel Machotka

This beautiful book presents a new perspective on Paul Cézanne, one of the towering figures of nineteenth-century art. Pavel Machotka has photographed the sites of Cézanne's landscape paintings—whenever possible from the same spot and at the same time of day that Cézanne painted the scenes. Juxtaposing these colour photographs with reproductions of the paintings, he offers a dazzling range of evidence to investigate how the painter transformed nature into works of art.

**176pp. 47 b/w illus.
+ 123 colour plates £25.00**

The Grosvenor Gallery
A Palace of Art in Victorian England
Edited by Susan P. Casteras and Colleen Denney

London's notorious Grosvenor Gallery was founded by Sir Coutts Lindsay and his wife, Lady Blanche Lindsay, to serve as an alternative to the Royal Academy. Although it existed only from 1877 to 1890, the gallery displayed the works and advanced the careers of many progressive artists such as Burne-Jones, Whistler, the Newlyn School and the Glasgow Boys. This abundantly illustrated book is the first in-depth study of the Grosvenor Gallery and consists of essays by noted scholars in nineteenth-century art and culture.

**Co-published with the Yale Center for British Art
April 272pp. 90 b/w illus.
+ 24 colour plates £30.00**

A. W. N. Pugin
Master of Gothic Revival
Edited by Paul Atterbury

This catalogue and the American exhibition it accompanies establish Pugin as a figure of worldwide significance. The objects in this catalogue, which are illustrated primarily in colour, reflect Pugin's pioneering diversity as a product designer and the modernity of his design principles. Ten essays and their illustrations have been prepared by scholars of international stature. They show the development of pre-Puginian Gothic and underline the revolutionary nature of Pugin's role in the history of architecture and design.

**Co-published with the Bard Graduate Centre for Studies in the Decorative Arts, New York.
416pp. 216 b/w illus.
+ 171 colour plates
Cloth £45.00 Paper £25.00**

Modern Art in the Common Culture
Thomas Crow

In this stimulating book, a prominent art historian shows that the links between advanced art and modern mass culture have always been robust, indeed necessary to both. Thomas Crow focuses on the continual interdependence between the two phenomena, providing examples that range from Paris in the mid-nineteenth century to the latest revivals of Conceptual art in the 1990s.

**April 288pp. 54 b/w illus.
+ 37 colour plates £25.00**

Ornament
A Social History Since 1450
Michael Snodin and Maurice Howard

This wide-ranging and richly illustrated book surveys the Western tradition of ornament from Renaissance interiors to gypsy caravans to the decoration of airliners. The first book to place ornamental design in a social context, it traces the various ways ornament has been used, the rules of decorum and etiquette associated with it, and the social, moral, and spiritual values ornament has conveyed and represented through the past five centuries.

**Co-published with the Victoria and Albert Museum, London
232pp. 102 b/w illus.
+ 139 colour plates £25.00**

The Age of Caricature
Satirical Prints in the Reign of George III
Diana Donald

The late eighteenth century in England was the first great age of cartooning, and English caricature prints of the period have long been enjoyed for their humour and vitality. Now Diana Donald presents the first major study of these caricatures, which challenges many assumptions about them. She shows that they were a widely disseminated form of political expression and propaganda as subtle and eloquent as the written word.

**Published for the Paul Mellon Center for Studies in British Art
256pp. 183 b/w illus.
+ 27 colour plates £45.00**

Yale University Press • 23 Pond Street • London NW3 2PN

BLACKWELL
Publishers

on the Internet
http://www.blackwellpublishers.co.uk

SEARCH

NEWS & EVENTS

BOOKS

JOURNALS

RESOURCES

SERVICES

Internet

Full details of Blackwell Publishers books and journals are available on the internet.
To access use a WWW browser such as Netscape or Mosaic, and the following URL:
http://www.blackwellpublishers.co.uk

BLACKWELL
Publishers

Features:

- Easy to navigate graphical interface
- Fully searchable product databases - search for our books and journals by subject, by author and editor, by title or free text
- Includes full descriptions, tables of contents, prices - all updated weekly
- Integrated ordering system - order free examination copies of textbooks for classroom use, and sample copies of all our journals
- Contact a commissioning editor in your subject directly by email
- Our complete conference programme
- Online mailing list - keep up to date in your chosen subject areas

Blackwell Publishers 108 Cowley Road Oxford OX4 1JF UK
Phone: +44 (0) 1865 791100 Fax: +44 (0) 1865 791347
e-mail: spearson@blackwellpublishers.co.uk